VITAL FORMS

AMERICAN ART AND DESIGN IN THE ATOMIC AGE

1940

1960

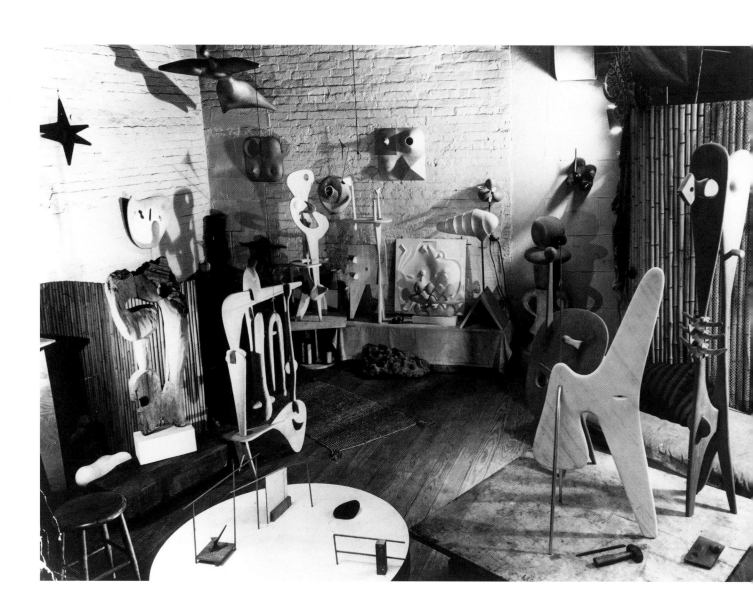

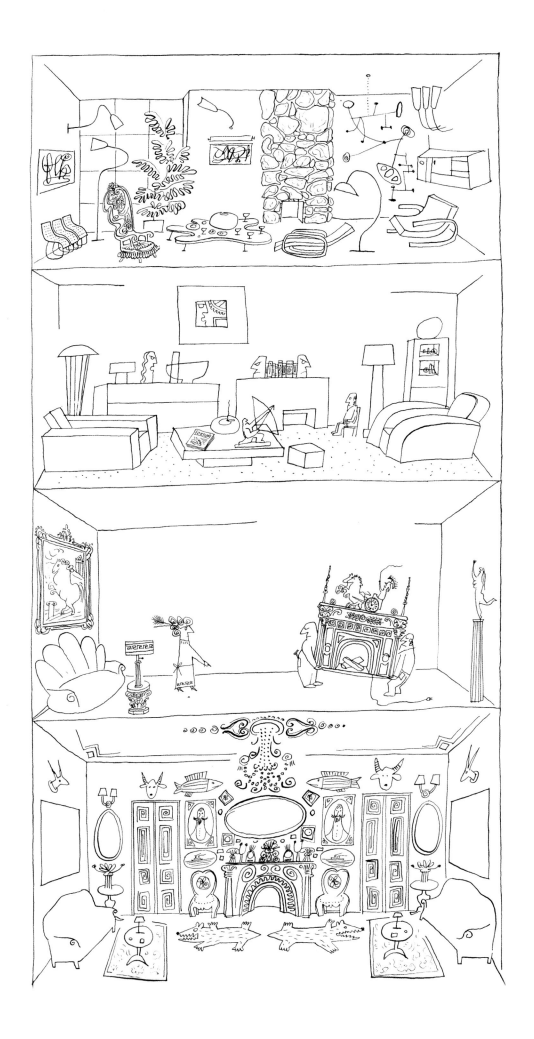

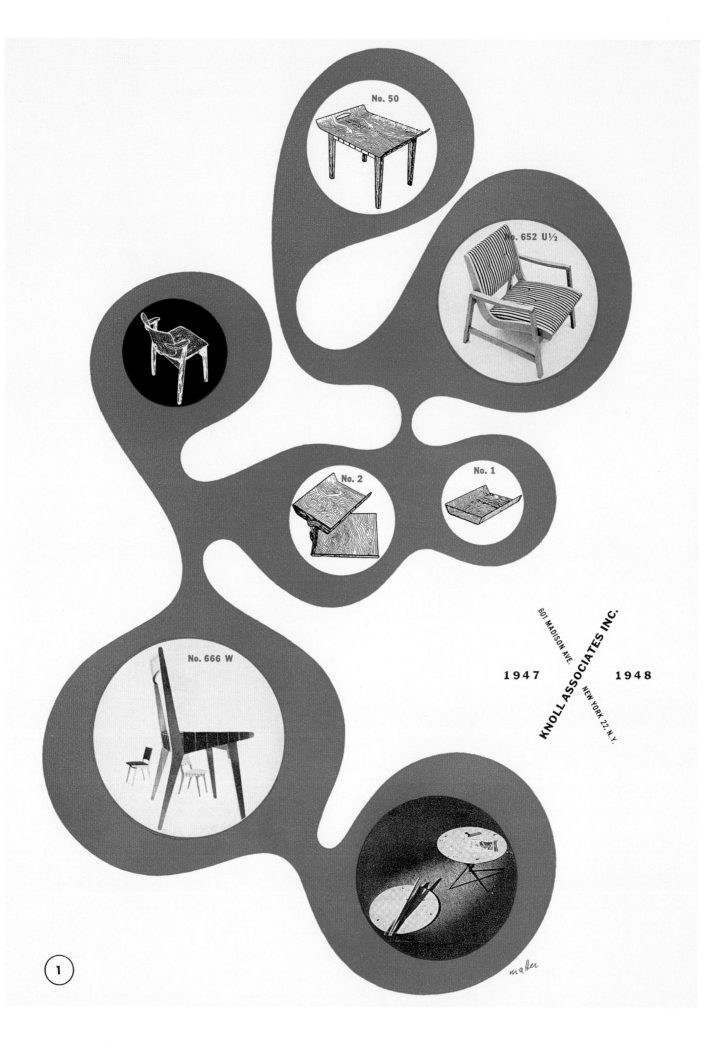

No. 50

No. 652 U½

No. 2

No. 1

No. 666 W

601 MADISON AVE.
KNOLL ASSOCIATES INC.
NEW YORK 22, N. Y.

1947 1948

matter

①

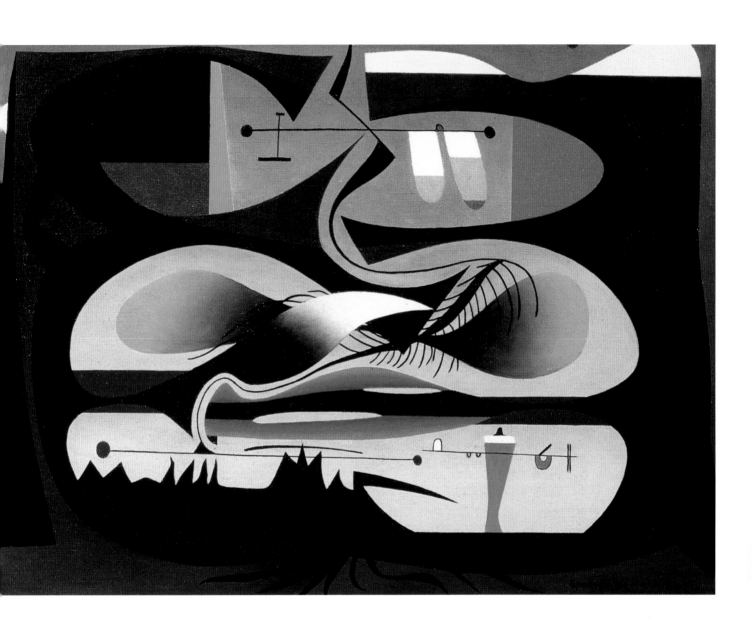

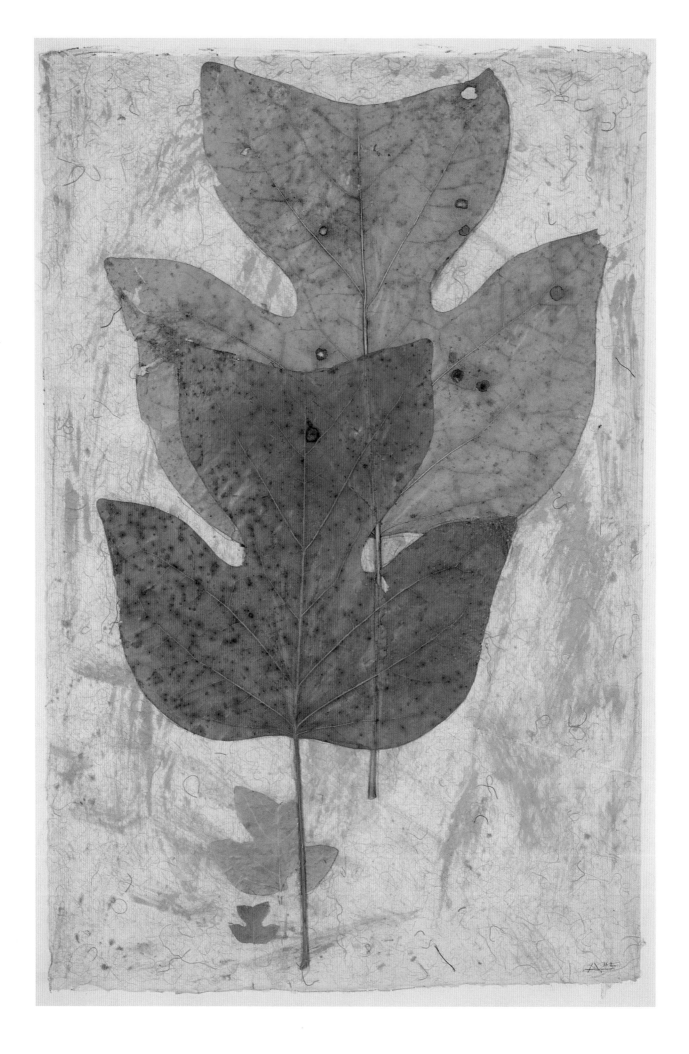

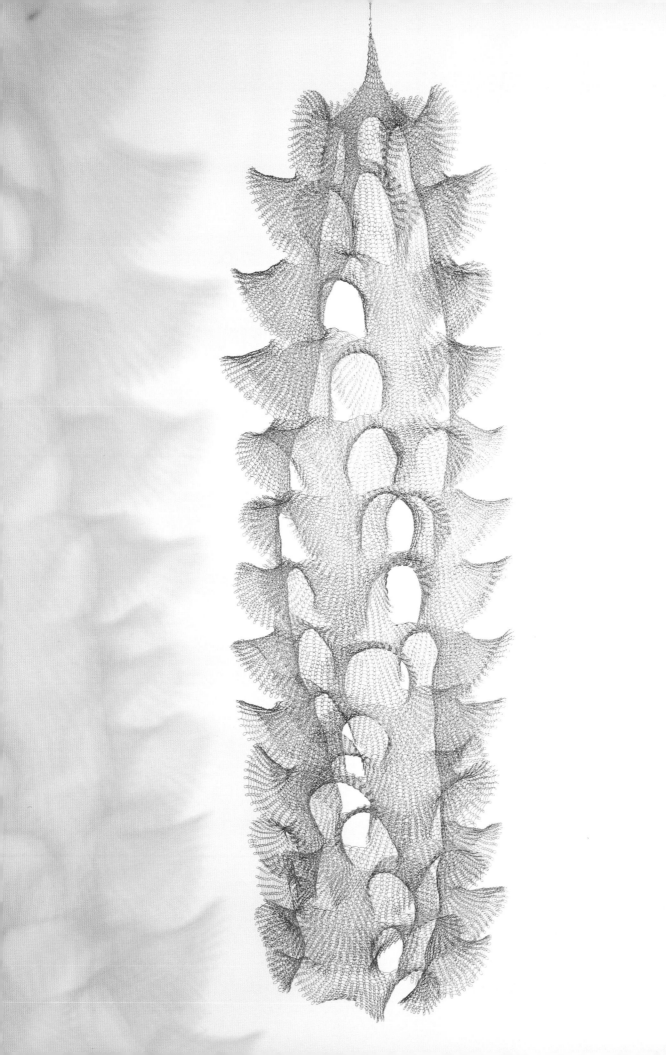

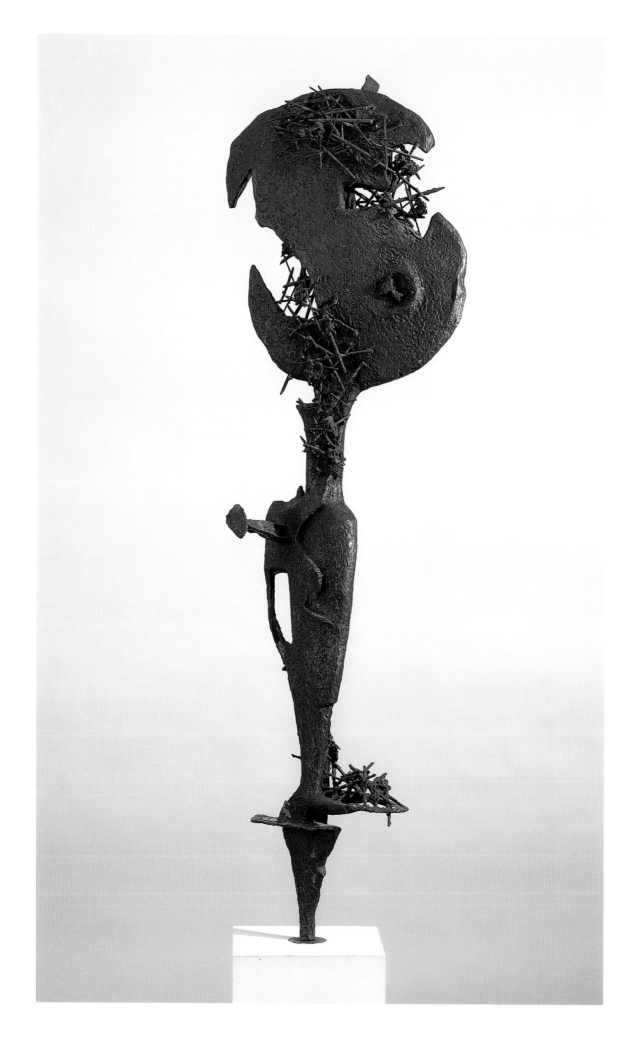

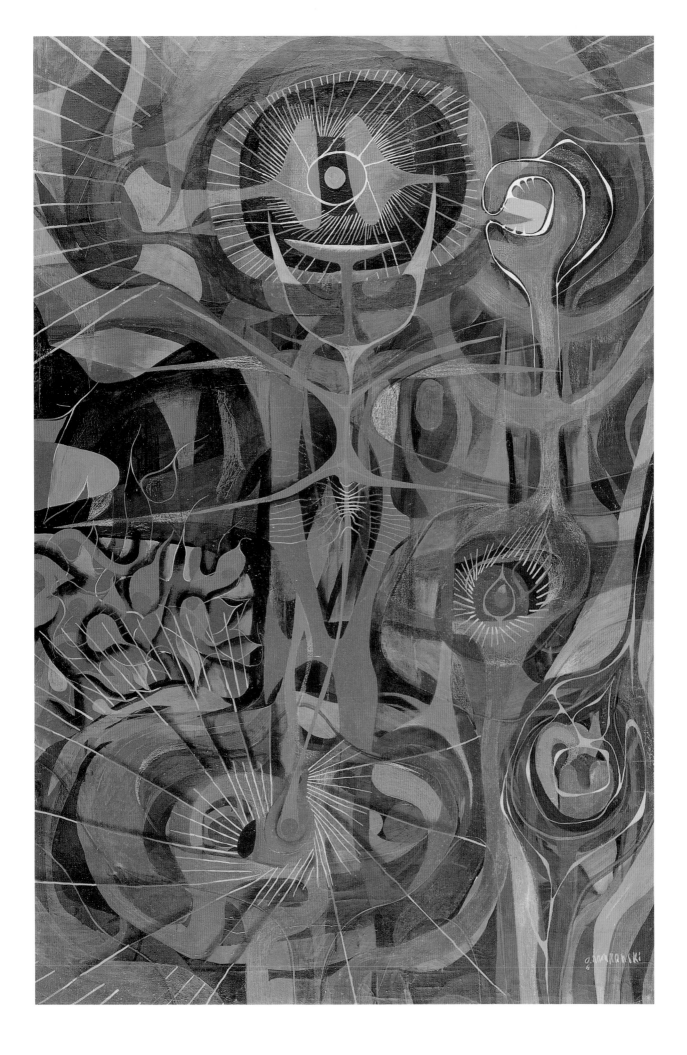

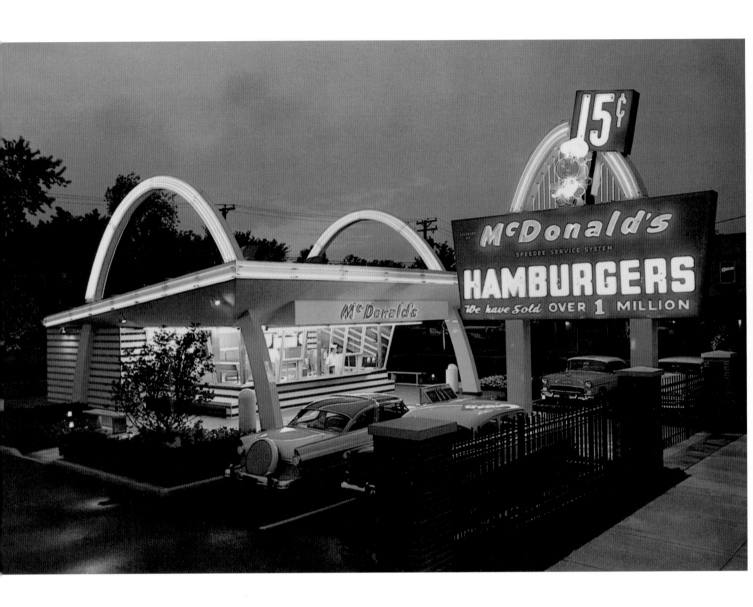

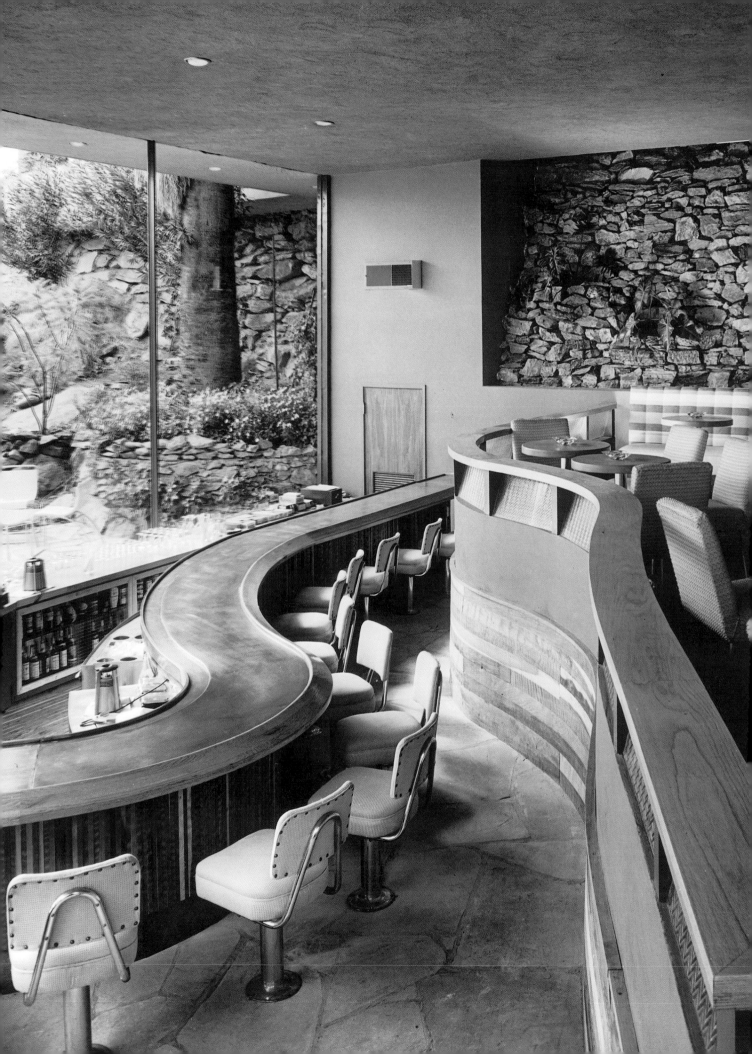

DECEMBER 1946

arts & architecture

PRICE 50 CENTS

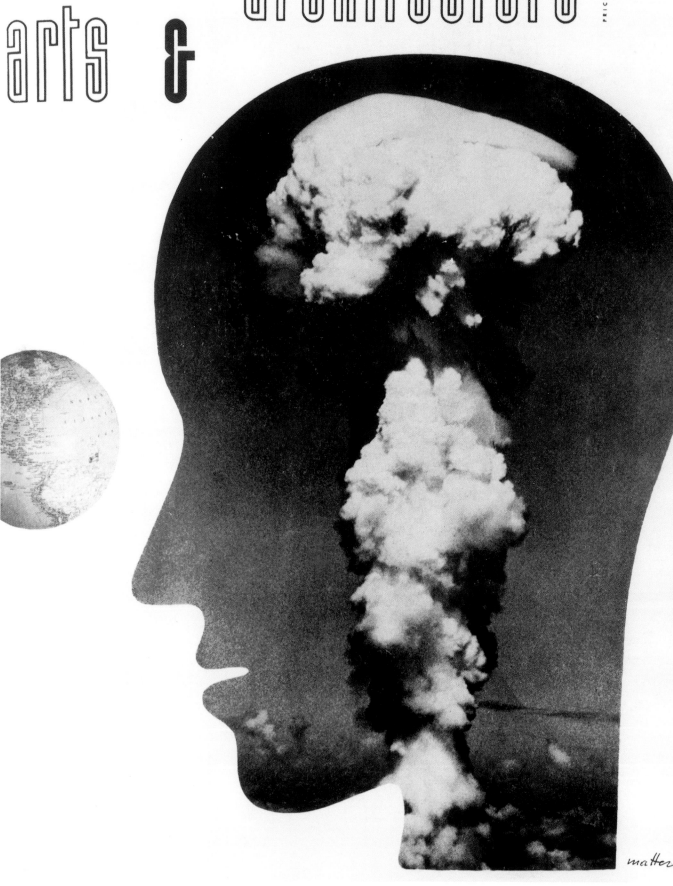

matter

VITAL FORMS

AMERICAN ART AND DESIGN
IN THE ATOMIC AGE, 1940–1960

Brooke Kamin Rapaport
Kevin L. Stayton

WITH CONTRIBUTIONS BY
Paul Boyer
Martin Filler
Mildred Friedman
Karal Ann Marling

BROOKLYN MUSEUM OF ART
IN ASSOCIATION WITH
HARRY N. ABRAMS, INC., PUBLISHERS

Published on the occasion of the exhibition *Vital Forms: American Art and Design in the Atomic Age, 1940–1960*, organized by the Brooklyn Museum of Art.

The exhibition was made possible, in part, by generous grants from the National Endowment for the Humanities and the National Endowment for the Arts.

Additional support was provided by the Mary Jean and Frank P. Smeal Foundation, the Samuel I. Newhouse Foundation, and the Gramercy Park Foundation.

Support for the catalogue was provided through the generosity of Furthermore, the Publication Program of The J. M. Kaplan Fund, as well as a BMA publications endowment created by the Iris and B. Gerald Cantor Foundation and The Andrew W. Mellon Foundation.

EXHIBITION ITINERARY

Brooklyn Museum of Art
October 12, 2001–January 6, 2002

Walker Art Center, Minneapolis
February 16–May 12, 2002

Frist Center for the Visual Arts, Nashville
June 21–September 15, 2002

Los Angeles County Museum of Art
November 17, 2002–February 23, 2003

Phoenix Art Museum
April 4–June 29, 2003

FRONT COVER: Richard James, *Slinky*® Toy, designed 1945. *Slinky*® and Spring Image are registered trademarks of James Industries, Inc., Plymouth, Michigan. Photo: © Michel Tcherevkoff
BACK COVER: George Nelson, *Ball* Wall Clock, designed 1947. Brooklyn Museum of Art, New York; H. Randolph Lever Fund, 2000.101.1; Isamu Noguchi, *Figure*, 1945. The Isamu Noguchi Foundation, Inc., Long Island City, New York. Photo: © Bill Jacobson; Eero Saarinen, Trans World Airlines Terminal, Idlewild (now John F. Kennedy International) Airport, Queens, New York, 1956–62. Photo: Ezra Stoller © ESTO

THIS PUBLICATION WAS ORGANIZED AT THE BROOKLYN MUSEUM OF ART
James Leggio, *Head of Publications and Editorial Services*
RESEARCH ASSOCIATE: Robbin Lockett
PROJECT MANAGER: Joanna Ekman
EDITOR: Stephen Robert Frankel

FOR HARRY N. ABRAMS, INC.
PROJECT MANAGER: Margaret L. Kaplan
EDITOR: Nicole Columbus
DESIGNER: Miko McGinty

LIBRARY OF CONGRESS CATALOGING-IN-PUBLICATION DATA
Rapaport, Brooke Kamin.
Vital forms : American art and design in the atomic age, 1940–1960 / Brooke Kamin Rapaport, Kevin L. Stayton with contributions by Paul Boyer ... [et al.].
 p. cm.
Published on the occasion of an exhibition held at the Brooklyn Museum of Art, New York, and four other institutions between Oct. 12, 2001, and June 29, 2003.
Includes bibliographical references and index.
ISBN 0-8109-0619-8 (hardcover) — ISBN 0-87273-145-6 (pbk.)
1. Art, American—20th century—Exhibitions. 2. Form (Aesthetics)—Exhibitions. I. Stayton, Kevin. II. Brooklyn Museum of Art.

N6512 .R35 2001
709'73'07474723—dc21

2001022877

Page 192: "Cadillac Ranch" by Bruce Springsteen. Copyright © 1980 by Bruce Springsteen (ASCAP). Reprinted by permission

Printed and bound in Japan
10 9 8 7 6 5 4 3 2 1

Harry N. Abrams, Inc.
100 Fifth Avenue
New York, N.Y. 10011
www.abramsbooks.com

Contents

Foreword

The Brooklyn Museum of Art is delighted to present *Vital Forms: American Art and Design in the Atomic Age, 1940–1960*, the third in a series of exhibitions exploring the intersection of the visual arts in America. The series began in 1979 with *The American Renaissance, 1876–1917*, an exhibition that reviewed the arts in America in the crucial coming-of-age period between the 1876 Centennial and the entry of the United States into World War I. It continued in 1986 with *The Machine Age in America, 1918–1941*, the groundbreaking examination of the profound impact of the image of the machine on American art in the years between the two world wars. *Vital Forms* completes the series with a careful examination of the pervasive presence of organic forms in the postwar years, when the booming economy of the new American world power was shadowed by the threat of the atomic bomb. It is appropriate that the Brooklyn Museum of Art organize this exhibition, not only because of its tradition of interdisciplinary study of the arts in all mediums, but also because the Museum has had, throughout the twentieth century, a resolute interest in the art and design of the present day. Indeed, many of the works and artists included in *Vital Forms* were exhibited at the Brooklyn Museum in the 1940s and 1950s, the decades spanned by the exhibition.

The exhibition series was conceived by Dianne Pilgrim, Brooklyn's former Curator of the Department of Decorative Arts, who oversaw the success of the first two exhibitions, and we remain grateful to her for her initial professional leadership. Brooke Kamin Rapaport, Associate Curator, Department of Contemporary Art, has been exemplary in leading the team of scholars who worked on the third component of the series. This endeavor also benefitted from the able advice and support of Kevin L. Stayton, Chair of the Department of Decorative Arts. Special mention should be made, as well, of the exhibition's consulting curators, Mildred Friedman and Martin Filler, who have been part of the project from its early stages and who assisted in forming the ideas that define it, as well as selecting the objects that illustrate those ideas. Their essays for

this book are all especially revelatory. Project consultant Paul Boyer, Merle Curti Professor and Chair of the Institute of Humanities at the University of Wisconsin at Madison, shared his broad knowledge of the postwar period by providing a thoughtful essay that grounds this examination in its historical context. Karal Ann Marling, Professor of Art History and American Studies at the University of Wyoming at Laramie, contributed an essay that is both insightful and amusing in its examination of the popular culture of the era. I am grateful to our curators and consultants for sharing their vision and expertise with our visitors and readers.

Vital Forms would not be possible without critical loans from private collectors and public institutions throughout the country, and I extend a special thanks to all our lenders for this generosity. I also thank my colleagues at our four exhibition venues after Brooklyn for their participation and encouragement. Chase W. Rynd at the Frist Center for the Visual Arts in Nashville, James Ballinger at the Phoenix Art Museum, Andrea Rich at the Los Angeles County Museum of Art, and Kathy Halbreich at the Walker Art Center have been exceptionally supportive of this project.

Just as it would be impossible to undertake such a project without objects or intellectual substance, it would be impossible to do so without funding. We are enormously grateful to the National Endowment for the Humanities and the National Endowment for the Arts for their early and generous support of *Vital Forms*. We are grateful as well to the Mary Jean and Frank P. Smeal Foundation, the Samuel I. Newhouse Foundation, and the Gramercy Park Foundation for their financial encouragement. Support for the catalogue was provided through the generosity of Furthermore, the Publication Program of The J. M. Kaplan Fund, as well as from a BMA publications endowment created by the Iris and B. Gerald Cantor Foundation and The Andrew W. Mellon Foundation.

For the ongoing support of the Museum's Trustees, we extend special gratitude to Robert S. Rubin, Chairman, and every member of our Board. Without the confidence and active engagement of our Trustees, it would not be possible to initiate and maintain such a high level of exhibition and publication programming as is exemplified by *Vital Forms: American Art and Design in the Atomic Age, 1940–1960*.

Arnold L. Lehman
Director
Brooklyn Museum of Art

Lenders to the Exhibition

Philip E. Aarons

The Josef and Anni Albers Foundation, Bethany, Connecticut

Estate of Leo Amino, Courtesy Douglas Berman and Peter Daferner

The Art Institute of Chicago

Ruth Asawa

Frances Baer

The Baltimore Museum of Art

Louise Bourgeois, Courtesy Cheim & Read, New York

Brooklyn Museum of Art

Calder Foundation, New York

Simona and Jerome Chazen

Elaine Lustig Cohen

Cooper-Hewitt, National Design Museum, Smithsonian Institution, New York

Georgia and Michael de Havenon

Department of the Navy, Naval Historical Center, Washington, D.C.

Michele Oka Doner

Sandra Donnell

Garrett Eckbo Collection, Environmental Design Archives, University of California, Berkeley

ESTO, Mamaroneck, New York

Daphne Farago

Edith Ferber

Fogg Art Museum, Harvard University, Cambridge, Massachusetts

Gordon Onslow Ford

Formica Corporation, Cincinnati

Barry Friedman

Gansevoort Gallery, New York

Adolph and Esther Gottlieb Foundation, New York

Grant Selwyn Fine Art, New York/ Los Angeles

Solomon R. Guggenheim Museum, New York

Hamilton and Goody, Architects with Goody, Clancy & Associates, Boston

Barry R. Harwood

Samuel and Ronnie Heyman

Galen Howard Hilgard

International Center of Photography, New York

Louis I. Kahn Collection, University of Pennsylvania and the Pennsylvania Historical and Museum Commission, Philadelphia

Gerome Kamrowski

Alexander Kaplen

Robert Landrio

Estate of Morris Lapidus

Jack Lenor Larsen

Estate of Madeleine Lejwa

Levittown Public Library, New York

Los Angeles County Museum of Art

The Metropolitan Museum of Art, New York

Herman Miller, Inc., Zeeland, Michigan

The Minneapolis Institute of Arts

The Montreal Museum of Fine Arts

Munson-Williams-Proctor Institute, Utica, New York

Museum of Contemporary Art, Chicago

The Museum of Modern Art, New York

National Gallery of Art, Washington, D.C.

Naval Supply Systems Command, Mechanicsburg, Pennsylvania

New School University, New York

The New York Public Library

The Isamu Noguchi Foundation, Inc., Long Island City, New York

Oakland Museum of California

Herbert Palmer Gallery, Los Angeles/New York

Pollock-Krasner Foundation, Inc., Courtesy Robert Miller Gallery, New York

Joel Press

Peter Reginato

Michael Rich

Rowe International, Inc., Grand Rapids, Michigan

Charles L. Russell

Saarinen Archive/Kevin Roche John Dinkeloo & Associates, Hamden, Connecticut

Fayez Sarofim

Deborah Schwartz

Scripps College, Claremont, California

Seattle Art Museum

Julius Shulman

Estate of David Smith

Allan Stone Gallery, New York

Blake Summers

Tupperware Americas, Orlando, Florida

Wadsworth Atheneum Museum of Art, Hartford, Connecticut

Westvaco Corporation, New York

The Minor White Archive, Princeton University, New Jersey

Whitney Museum of American Art, New York

The Frank Lloyd Wright Foundation, Scottsdale, Arizona

Yale University Art Gallery, New Haven, Connecticut

Richard York Gallery, New York

Jane Voorhees Zimmerli Art Museum, Rutgers, The State University of New Jersey, New Brunswick

Private Collections

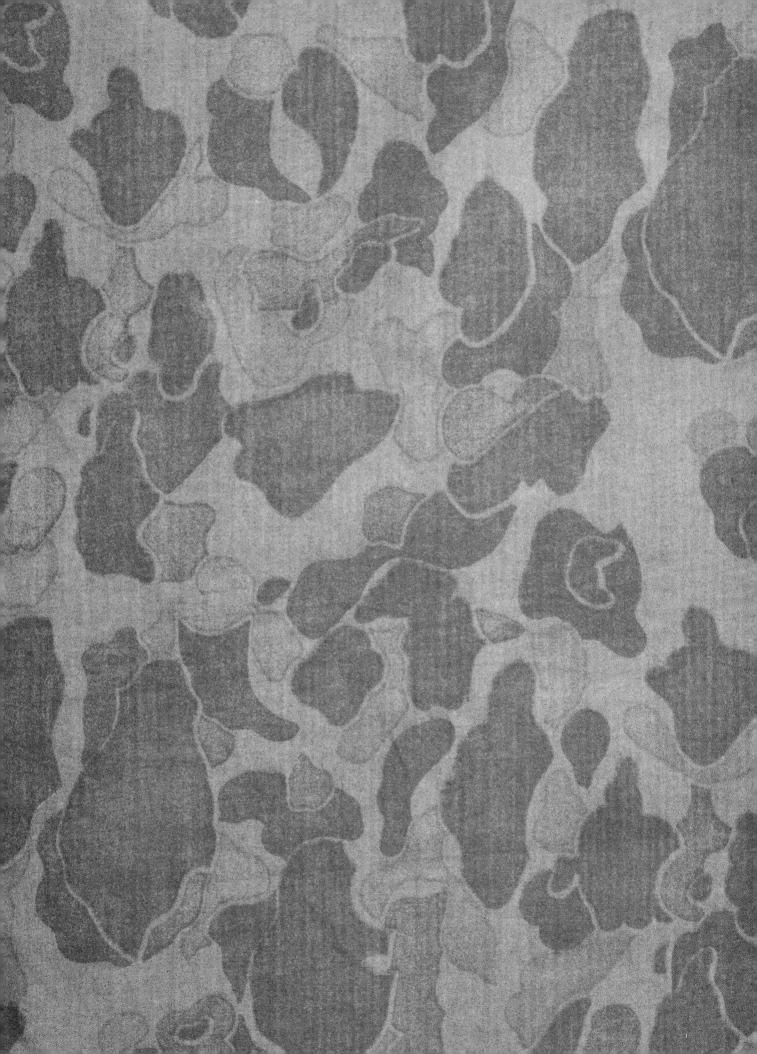

INTRODUCTION

Introduction

Kevin L. Stayton

In 1957 the Brooklyn Museum of Art organized an exhibition entitled *Table Settings: The Old with the New*. Among the designers contributing work to the show were Eva Zeisel and Russel Wright (figs. 1, 2). Works by both artists are featured prominently in *Vital Forms: American Art and Design in the Atomic Age, 1940–1960* more than forty years later. Although the theme of the earlier exhibition might be described as eclecticism, or at least freedom of choice,[1] photographs of the exhibition reveal the preponderance of the softly curving line, the contour that reflects and evokes the human body—in short, vital forms. At the same time painters and sculptors also developed a renewed fascination with the human form and the mysteries it suggested. Writing more than a decade earlier, in the catalogue of the 1944 exhibition *Abstract and Surrealist Art in America*, Sidney Janis emphasized the pivotal role of the human body:

> What has happened to the human form? A process of conversion takes place here, too. The human form is changed into an image or idol, primitive, deified on the altar of a new orientation, science.... With emphasis on other realities, the outlines of the human form become absorbed into the environment, and commonplace representation is reduced to a minimum. Neither the human form nor the idol now exists. In their place is an object which can be dissembled and the parts used to create another object—the picture.... This is not a mechanical process but a poetic one, requiring imagination and invention.... As if by magic whole new worlds of the spirit are lit up, worlds of poetic inference, mythological worlds, worlds of haunting reminiscence, of unearthly fantasy and of disquieting dreams.[2]

Just as the machine—manmade and nonliving—had been the raw material for American arts in the prewar period, living forms—vital forms—are the source that provides the key to the postwar imagination.

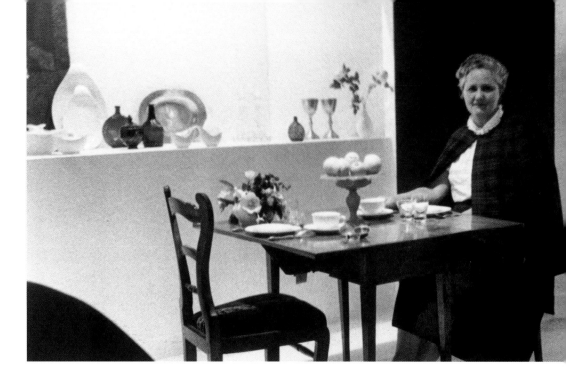

1.
Eva Zeisel (American, b. Hungary, 1906) in the exhibition *Table Settings: The Old with the New* (May 15–June 16, 1957). Brooklyn Museum of Art Archives, New York; Records of the Edward C. Blum Design Laboratory

2.
Russel Wright (American, 1904–1976) in the exhibition *Table Settings: The Old with the New* (May 15–June 16, 1957). Brooklyn Museum of Art Archives, New York; Records of the Edward C. Blum Design Laboratory

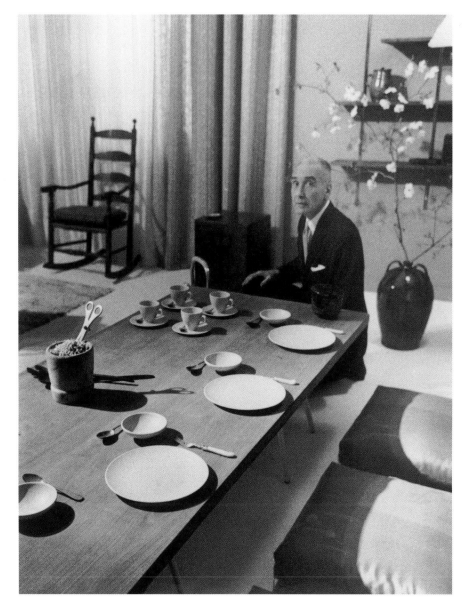

Vital Forms is the third in a series of exhibitions organized by the Brooklyn Museum of Art to examine American arts and culture from an interdisciplinary and humanistic point of view and thus to define the aesthetic impulses of an era. The initial exhibition in the series, *The American Renaissance, 1876–1917,* dealt with the arts in the United States at a pivotal turning point, when the country was entering the international scene as an emerging power and at the same time searching for roots that its short history seemed to deny. It was a time of boundless energy, generated by the tension between new wealth and increasing power on the one hand and lingering feelings of inferiority to Europe on the other. The result was a conscious reworking of the ideals of the Renaissance to suit American needs and a flourishing of cooperative artistic endeavors that transcended mediums and categories much as they had in Renaissance Italy. The Renaissance, and all it implied, became the ideal of a nascent and self-conscious American culture, building for a bright future.

At the end of World War I, however, the European cultural model emerged badly tarnished. The growing power of the United States suggested a different, more modern, and more native aesthetic dialect. The rejection of stale European traditions paralleled an unapologetic acceptance of America as the land of the future—modern, energetic, and powerful. The machine became the icon of the era. During not only the halcyon days of prosperity and change in the 1920s but also the dark years of depression and social upheaval during the 1930s, the machine retained its power as the image of a savior. Unabashedly iconoclastic, untraditional, and carrying the implications of speed, power, and modernity, the machine summed up the promise of the twentieth century in good times and in bad. Machine imagery and streamlining emerged as an aesthetic response that defined the aspirations of an era documented and explored in the exhibition *The Machine Age in America, 1918–1941*, held at the Brooklyn Museum of Art in 1986.

But once again the promise was betrayed by European conflagration. America's entry into World War II marked the culmination of a long process of maturation as a world power, and with the end of the war, it assumed a role of leadership in the world—and in the arts, as well. The Machine Age was over, and a new age in America had begun. This exhibition, then, explores that new age, in which the promise of the machine was replaced—or at least exponentially expanded—by the promise of the atom and the energy it produced. But it was a promise that had been born in the horror of the atomic holocaust that had ended the old order, and it was also a promise that had, embedded within it, the

terrifying threat of nuclear annihilation. Since the Industrial Revolution the machine had always signified a tension between the potential of progress toward the new order and the destruction of the old order, but never before had the stakes been so high. The turning away from the old aesthetic of hard-edged machine imagery toward an aesthetic based on the fluid, organic—indeed, vital—forms of the postwar era was at least in part a response to the unsettling ambivalence and anxieties of the new age.

America's entry into World War II is the fulcrum of the twentieth century. Not only did the balance of political power shift inexorably away from Europe during that war, but, it can be argued, so did leadership in art and design. The emergence of the Abstract Expressionists of the New York School in the late 1940s put the United States at the center of a new aesthetic map. Even before that, however, new style trends were emerging from both European and American roots, and much of the development was in America, albeit often led by emigrant artists fleeing Fascist oppression. Just as hard-edged, machinelike imagery had characterized the prewar period, softer forms and undulating lines with organic or biological sources defined the most innovative and "modern" art forms of the postwar period. From swimming pools to bicycles, from Eames chairs to the imagery of artists such as William Baziotes, Willem de Kooning, and Gordon Onslow Ford, it is organic imagery—the human body, the microbe, the amoeba—that informs the morphology. Following the war, an explosive growth in the economy fueled consumption on a level never before seen, and technological lessons learned in the war years were practiced in the pursuit of the material benefits of peace. It would take nearly half a century for the wartime developments in computer technology to transform society, but other technologies became a part of the new domestic scene immediately. From molded plywood technology and new plastics, both of which evolved out of military needs, to the contours of camouflage, many of the developments of the war years were perfect vehicles for the new style of vital forms.

This is not to say that organic form was the only, or even the most prevalent, expression of style in the period. Just as machine-age imagery had been a polished and sophisticated veneer covering a core of historical, traditional, and conventional styles still preferred by the preponderance of the American population, so too were vital forms just the tip of an iceberg with an enormous underwater mass that remained frozen in tradition. Only a small proportion of the goods produced in the two decades under discussion were the shoots of organic roots. Moreover, the organic style was not even the only *modern* style.

Just as vigorous, especially in the corporate world, was the International Style, featuring clean glass-and-steel forms that still recalled the aesthetic of the machine. Nevertheless, vital forms of organic derivation came to define the look of the era in "high art" and in popular culture. Mention the 1950s, and immediately kidney-shaped coffee tables, boomerang-pattern Formica, and daring gestural paintings come to mind, rather than the Early American dens or French Provincial bedrooms or School of Paris–style still lifes that then actually formed an intimate part of the personal lives of most Americans (fig., p. 3).

What was the source of this newly prominent imagery and what is the impetus behind it? Among its forebears were Surrealism and vitalism, and among its causes, the age-old tension between geometric and organic styles and the revitalized interest in creating objects whose design relates to their use in terms of the human body.

Surrealism was a strong undercurrent in European art in the prewar years, and although its impact in America was limited then, it percolated through the intellectual and artistic community, providing an alternative to machine-age rationalism and suggesting a different vocabulary that would flourish in the postwar era. The dreamlike hallucinations of Surrealists such as Max Ernst and Salvador Dalí were antithetical to the ordered rationalism of the Bauhaus. The anxiety they reflected and provoked ran counter to the hopeful trust in the future that was reflected in American streamlining (no matter how much that hope was centered in anxieties of its own). The Surrealist interest in psychiatry and the unconscious elicited imagery that was simultaneously sexual and biological, producing organic allusions as a counterpoint to the machine. Even the methodology (if not the theory) of Ernst, in his use of semiautomatic drawing meant to exorcise paranoia and exhort an underlying vitality, prefigures work of the 1950s. It remained only for the anxieties of one age to replace those of another for the visual vocabulary to be transformed.

More closely akin theoretically to the organic art of the postwar period is vitalism. The philosophy of vitalism posits a life force or essence in the world that distinguishes living things from nonliving material, a force that is shared by all living organisms and holds the secret of life itself. Although this belief can be traced to the ancient world—the "vital force" is what Aristotle called the *psyche*—its modern manifestation dates from the writings of Georg Ernst Stahl (1660–1734). Because vitalism requires acceptance on faith of a concept that is outside the realm of scientific proof, its influence was much diminished in the twentieth century. Nonetheless, the philosopher Henri Bergson (1859–1941)

could not escape the thrall of the idea, and for him the *élan vital,* as much poetic as scientific, was a compelling force itself. Vitalism was never a major philosophical trend of the century, but its concepts nonetheless entered the realm of art history in the writings of Sir Herbert Read. Instead of a strict reading of the theory, however, Read's view was a variation on the original. Just as the vital force of the natural world entered inert, inorganic matter to give it life, so the sculptor, reversing the process, approached his material in such a way as to release or discover the vital force hidden within it, or at least to *represent* this *élan vital.*[3] So vital forms entered the artistic vocabulary of the late twentieth century, in opposition to the antithetical forms of the machine age.

A discussion of the vital forms of the mid-twentieth century requires the examination of two other terms that are frequently associated with the artistic production of the era—*organic* and *biomorphic.* It is tempting to define *organic* in terms of a word that is formally descriptive. In other words, an organic object would be one that resembled a living form. And, indeed, that is one way in which the word is used in this and other texts. A more complex and more interesting usage, however, derives from a whole set of relationships between an object, its production, and its purpose. In this sense, the organic object is one that develops naturally into a form that is appropriate to both its formation and its ultimate use. As Jack Burnham notes in this regard, "Expressed as a conscious concern of the designer, *organicism* could be defined as the awareness of the interrelation between systems and their components within larger systems so that behavior of the whole ensemble can be understood and manipulated." Later he continues, "The modern meaning of the organic lies in *the gradual moving away from biotic appearances toward biotic functioning.*"[4] This, of course, is a theory more easily applied to the decorative arts than the fine arts, and it is in the decorative arts where the connection between organic process and organic form can best be understood in this context.

The work of the Eameses in plywood both during and after the war is one example. In designing the now-famous, pivotal leg splint, and the chairs that followed, they embarked upon an organic process of design in which the process and the final use of the objects determined their form. Since both the leg splint and the chairs were meant to conform to the human body—that was their defining purpose—by necessity, they emerge from the shape of the living body, they are "biomorphic." The mid-twentieth-century interest in ergonomics—the science of designing an object to fit its use by the body—naturally led

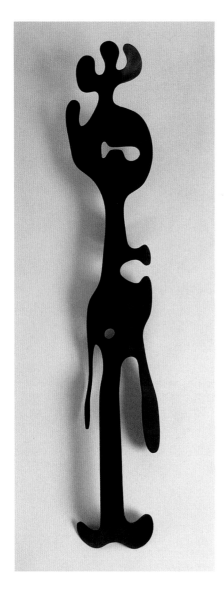

3.
Ray Eames (American, 1912–1988). *Splint Sculpture*, c. 1943. Saw-cut molded plywood with flat black painted finish, 42 x 8 x 4½ inches. Collection Michael Rich, courtesy Wright 20, Chicago

to forms that were biomorphic. These forms, in turn, sometimes suggested purely aesthetic expressions, even to their creators, as Ray Eames's use of the bent-plywood leg splint as a point of departure for an abstract, organic sculpture testifies (fig. 3).

Another demonstration of the relationship—or lack thereof—between organic design and organic (or biomorphic) form is illustrated by an anecdote told by Eva Zeisel. While teaching a course at Pratt Institute in Brooklyn in the years following the war, Zeisel carefully outlined the meaning and importance of an organic design process. The design of an object that is both beautiful and appropriately functional, she cautioned, needs to grow out of a thought process that considered the ultimate use of the object—the way it would be held in the hand, for example, and the way the hand might pour it, hold it, or lift it to the mouth. Her own work in ceramic design provided for the students an eloquent example of forms that are well suited to their place in the human hand and their role as useful objects; and, because they had emerged from a thought process that considered their intimacy with the human body, they were also defined by gentle sensuous curves. But when the student design projects came in, many of them revealed a comprehension of only the most superficial aspects of the "organic" result. Kidney-shaped objects whose forms were "biomorphic" but had no relation to their purpose abounded. What had begun as a sophisticated theory of design had become a style, losing its meaning and forgetting its purpose, but retaining its formal characteristics. This transformation of art from theory to style is not unique to the postwar period; in fact it is a constant pattern in movements in design philosophy. We see the cycle repeated over and over again in the preceding century, from the reform teachings of Charles Locke Eastlake to the Arts and Crafts movement and on to the Bauhaus and the streamlining trend during the 1930s. It is therefore no surprise that in the 1950s what had started out as a "look" resulting from the careful consideration of human needs ultimately became a style in which the look outweighed the careful consideration. The style, in turn, was flexible and adaptable enough to span the brilliance of Isamu Noguchi's chess table, the amused intelligence of Robsjohn-Gibbings's *Mesa* table, and the triteness of countless low-end knock-offs as it moved down the scale (figs. 4–6).

Similarly, the work of Morris Lapidus illustrates the transition of organic form from functionalism to style, but in a way that takes into consideration a practical, commercial purpose rather than ergonomics. His original use of the curving, organic form in the store interiors of the late 1930s and 1940s reflected,

according to his recollection, the solution to a marketing problem—how to draw the female customer along and pull her into the maze of sales space (see figs. 110, 111). This the sweeping arc of an organic form was able to accomplish, and with a concealed light source strategically placed in the heart of the space, the customer was drawn "like a moth to a flame," according to Lapidus. But if the organic forms in these commercial spaces had a clear function, what was their function in the later hotels, where they had evolved from interior forms confined by existing architecture to architecture itself (see fig. 219)? "I loved those curves and I wanted more curves. I wanted to do something different. Something different."[5] The vocabulary had been established for function, but it took on a life of its own as style. Here, in order to understand the sequence more fully, we must consider again the tension between geometric forms and forms based on nature, that swinging pendulum of taste that gives style a life of its own. Organic forms provided an antidote to the Bauhaus-inspired geometry of International School architecture, and the hard-edged shapes of the Machine Age were giving way in popular taste to the softer, vital forms of the Atomic Age. Speaking of this new "style" in 1952, George Nelson wrote: "...we have something that has been generally accepted as a style, a word which less than a decade back caused serious designers to tear out what was left of their hair. The word was anathema because it was the 'styles' which were being fought. Only now that the smoke has cleared away, we find that we are saddled with exactly what we thought we were fighting...a style with which we must now cope, whether we like the idea or not...."[6]

These complicated crosscurrents all came together in the pool where vital forms were bred. And there was one further essential ingredient—the nuclear power that gives the Atomic Age its name, as well as its most pervasive imagery. The war years and their aftermath are marked, in retrospect, by an unavoidable dichotomy of positive and negative forces, epitomized by the specter of atomic power. First, during the war, the fear of world domination by an unholy power was countered by a unified determination (at least on society's surface) to persevere and triumph together, a commitment as universally held as at any time since the country's founding. Likewise, the terrible engines that powered the horrors of war led to technological developments that would soon fuel the engines of peace. Even the domestic arena would be altered by wartime developments in plastics, which would give us Tupperware and sculptural materials such as polyester resin, among other things. Molded plywood developed for leg splints and body litters would lead to award-winning chairs that hugged the

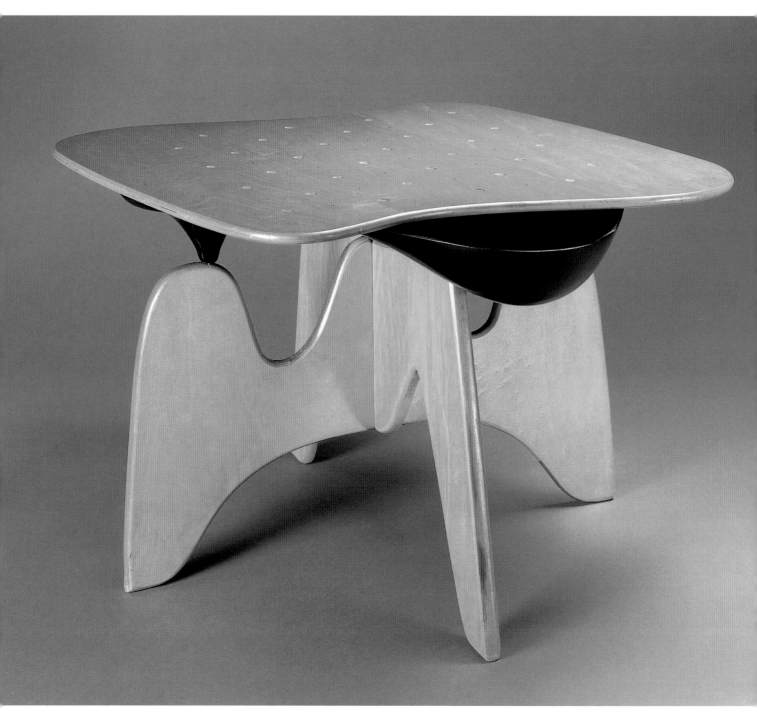

4.
Isamu Noguchi (American, 1904–1988). Chess Table, Model IN-61, designed c. 1947, manufactured by Herman Miller Furniture Company, Zeeland, Michigan. Laminated birch, plastic insets, cast aluminum tray, 19¼ x 33⅞ x 30⁹⁄₁₆ inches. Collection Michael Rich, courtesy Gansevoort Gallery, New York

5.
T. H. (Terence Harold)
Robsjohn-Gibbings (American,
b. London, 1905–1976). *Mesa*
Table, 1950s, manufactured by
Widdicomb Furniture Company,
Grand Rapids, Michigan. Wal-
nut veneered free-form surface
and base, 16½ x 42 x 73½
inches. Courtesy Los Angeles
Modern Auctions

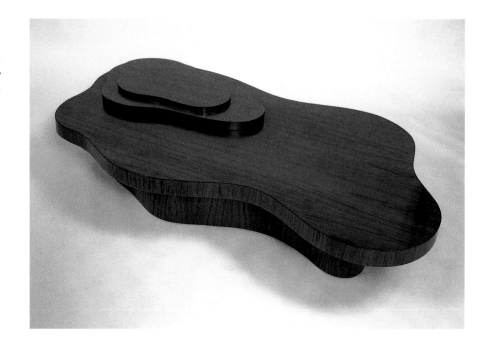

6.
Unknown American. Low
Coffee Table, c. 1955. Walnut
and glass, 16½ x 53 x 29
inches. Brooklyn Museum of
Art, New York; Gift of Paul F.
Walter in memory of May E.
Walter, 1994.21.2a, b

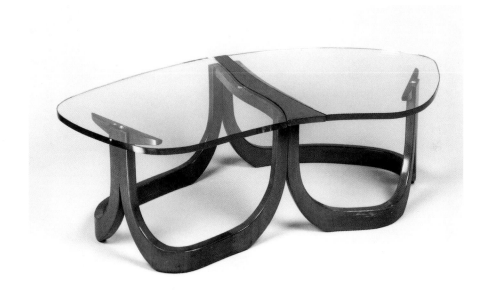

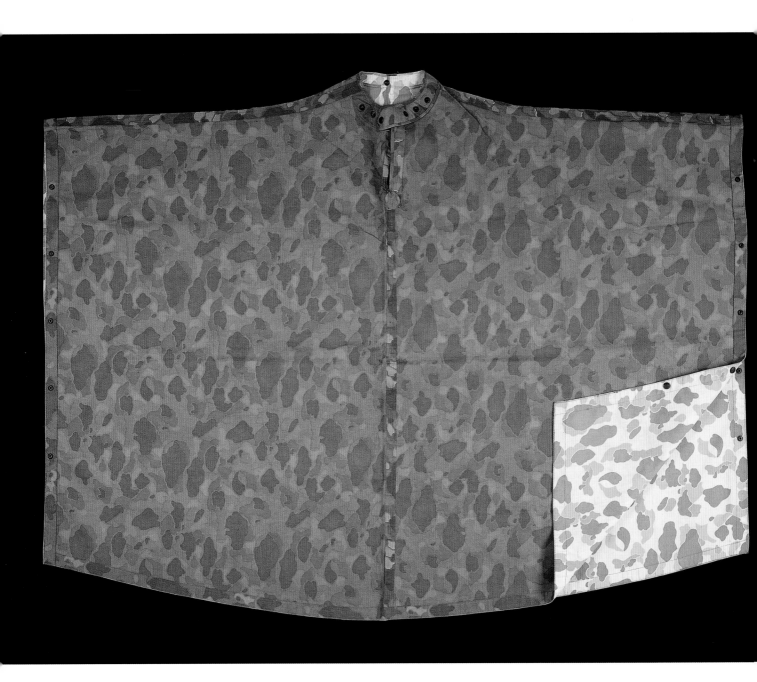

7.
United States Navy. Marine
Corps–Type Camouflage
Poncho, designed for the
U.S.S. *Casablanca* CVE-55,
c. 1941. Cotton, 47 x 62 x ½
inches. Department of the
Navy, Naval Historical Center,
Washington, D.C.

body; and camouflage, the very purpose of which was to imitate the organic forms and colors of nature for the purely practical reason of providing cover, would introduce to a wide audience the vocabulary of vital forms (figs. 7, 8). In this climate of change, the body and other forms from the natural world were a comforting and humanizing antidote to the sharper forms of an older technology that had promised so much but delivered destruction. But it is the atomic bomb that most fully signifies the tension between the twin forces—optimism and anxiety—of this age. Destroyer and savior, it ushered in what Paul Boyer has called the schizophrenia of the postwar years. At the same time that artists responded to the profoundly disturbing implications of nuclear annihilation

8.
Louis I. Kahn (American, b. Estonia, 1901–1974). *Civilian Camouflage Drawing*, 1943. Ink and graphite on brown line print, 20 x 18 inches. Louis I. Kahn Collection, University of Pennsylvania and the Pennsylvania Historical and Museum Commission, Philadelphia

9.
"Atomic Genie." Illustration
from *The Walt Disney Story of
"Our Friend the Atom"* by
Heinz Haber (New York: Golden
Press, 1956). Collection of
Deborah Schwartz

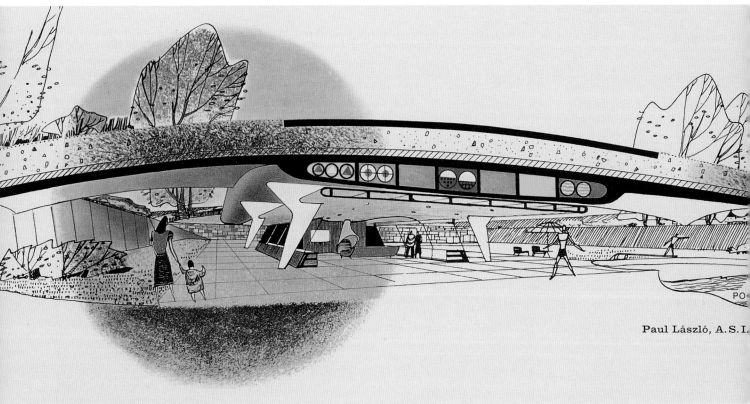

Paul László, A.S.I.

10.
Paul László (American,
b. Hungary, 1900–1993).
Atomville, USA, designed
1950. Illustration from *Paul
László* (Zurich: Conzett &
Huber, 1950). Courtesy Paul
Donzella, Donzella Gallery,
New York

with ominous images evoking deep despair (see fig. 62), Walt Disney published a children's book extolling the bright new world opened up by our new friend the atom (fig. 9). And Paul László formulated the relentlessly upbeat design for Atomville, USA (fig. 10), a comforting counterpoint to the anxiety-producing images showing Americans how to survive an atomic blast (see figs. 35–37). The image of the atomic model became the logo of the postwar years.

How, though, does this atomic imagery unite with biological imagery? Any amateur scientist understands that there is a wide gulf between the power of the atom and the life force itself. The atom is not a living thing. Public perception, however, may not be so clear, or have any reason to be. The active and vital orbit of the protons around the nucleus of the pervasive atomic model resembled, in its miniature universe, the microscopic amoeba, and it *implied* a life force. The knowledge that this invisible power also had the ability to mutate—or indeed to end—the life process gave it further resonance as a live power in the public mind. So the imagery of the atom joined the vocabulary of vital forms. After all, style and art are not sciences. Like the tenets of vitalism, the underlying physics and philosophy of the atom were adapted to suit artistic needs.

The two-decade span examined in this exhibition is a period of contradictions, ambiguities, and complexity. Vital forms, born of many sources, were the imagery that infused the arts of the mid-century. Organic, vital forms, based on a biological model, mutated by atomic energy, suggest a nature undergoing constant change. Like biological entities themselves, they metamorphose and eventually die. This protean imagery was appropriate to the era that gave birth to the last half century.

The United States, 1941–1963

A HISTORICAL OVERVIEW

Paul Boyer

The characteristic forms of any era's material culture, whether high art, folk crafts, architecture, advertisements, or mass-produced consumer goods, do not take shape in a vacuum. They arise from a complex synergy between the personal, even idiosyncratic, impulses and imagination of individuals (artists, craftspersons, illustrators, product designers) and the larger historical realities of the time.

In this exhibition, *Vital Forms*, that historical context becomes particularly relevant. The time period covered, 1941 to 1963,* is one of the most memorable and portentous in all American history: the years of World War II and of the early Cold War, when the White House was occupied by a succession of larger-than-life presidents—the near-mythic Franklin D. Roosevelt, the feisty Harry Truman, the war hero Dwight D. Eisenhower, and finally the glamorous John F. Kennedy, struck down at the pinnacle of his popularity and power after less than three years in office (see figs. 11–13). But presidential politics, fascinating and important as it may be, tells us little about the deeper dynamics of this two-decade period of our history.

At first glance, this linking of the 1940s, the 1950s, and the early 1960s may seem an awkward melding of impossibly disparate eras. The opening phase, 1941–45, was the time of the "Good War," a dangerous yet exhilarating time of crisis when Americans stood united in a struggle against enemies who threatened all that the nation held dear (see figs. 14, 15). But then came the postwar era, when the nation turned from sacrifice and high resolve to an apparently mindless orgy of materialistic self-indulgence, escapist mass culture, and consumer-oriented suburban living—an era that one critic called the Great Barbecue. But this was also a contentious and anxiety-ridden period, shadowed by

11.
Franklin Delano Roosevelt and Eleanor Roosevelt, January 20, 1941, at the inaugural ceremonies for President Roosevelt's third term in office, Washington, D.C.

*A small point about chronology: historians and museum curators alike prefer to deal in round numbers—"the 1950s," "the 1960s," the twentieth century—and this exhibition, with its framing dates of 1940 and 1960, reflects that preference. In reality, of course, the unfolding course of history does not always fall neatly into these artificial chronological categories. In many ways, a more historically precise beginning date for the exhibition might be 1941, the year the United States entered World War II, and a more historically salient end date would be 1963, the year the Limited Nuclear Test Ban Treaty significantly propelled forward the long and tortuous process of Cold War détente. Accordingly, for purposes of this essay, I have taken slight liberties with the designated time frame in order to discuss some social and cultural developments relevant to the theme of the exhibition that fall a few years beyond the 1960 cutoff date.

nagging nuclear worries, fears of Communism and the Soviet Union, and accusations of treason and subversion. Then at the tag end of the period came the early Kennedy years, marked by what appeared to be a sense of bright promise and new beginnings. How can such diverse periods possibly have much in common? How can they form the basis of an exhibition that assumes a degree of continuity and coherence, both historical and aesthetic?

Yet in many respects, the 1941–63 era *is* of a piece, its continuities at least as important as its disjunctures. One way to grasp that continuity is to recognize how deeply divided and ambivalent about the future Americans were in these years. If one had to comprehend early postwar America in a single adjective, "schizophrenic" might come to mind. Of course it is always misleading to impute human diseases, mental disorders, or even stages of life to entire cultures. But in a loosely metaphorical sense, at least, the era did display distinct schizoid tendencies. On the surface: a booming economy, a soporific politics, a seemingly escapist and upbeat mass culture. Beneath the surface: half-acknowledged anxieties, vague discontents, and early rumblings of social and political conflict ahead.

Once we move beyond the clichés and understand the complexity of the 1950s, the historical logic underlying the time frame of this exhibition begins to become apparent. Nearly all of the decade's most characteristic features—not only its bland surface but also the darker realities beneath—are rooted in World War II and its aftermath.

World War II was a sophisticated technological conflict. It was waged by scientists, engineers, and highly trained production specialists as much as by combat troops or munitions workers on the assembly line. Radar, computers, long-distance rocketry, jet aircraft, and, of course, atomic energy were only the best known of the war's technological products. Certainly Americans took pride in the technological feats and the military-production achievements trumpeted by the Office of War Information: the thousands of ships launched, the steady stream of tanks and bombers spilling off the assembly line, the scientific breakthroughs that would help win the war. Newspapers marveled at the mile-long Ford bomber plant at Willow Run, Michigan, with its main building covering sixty-seven acres, employing more than forty thousand workers. One awed observer, invoking the aesthetic of the American sublime, called it "a sort of Grand Canyon of the mechanical world." Americans cheered when California shipbuilder Henry J. Kaiser slashed the construction time for cargo carriers from a year to two weeks. It took just three years for a team of scientists and

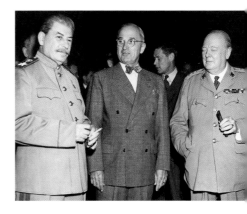

12.
Soviet Prime Minister Joseph Stalin, President Harry S. Truman, and British Prime Minister Winston Churchill pose for the first time before the opening of the Potsdam Conference, July 17, 1945

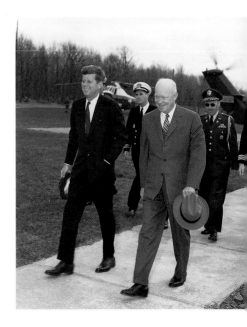

13.
Meeting between former President Dwight D. Eisenhower and President John F. Kennedy with military aides at Camp David, Maryland, April 22, 1961

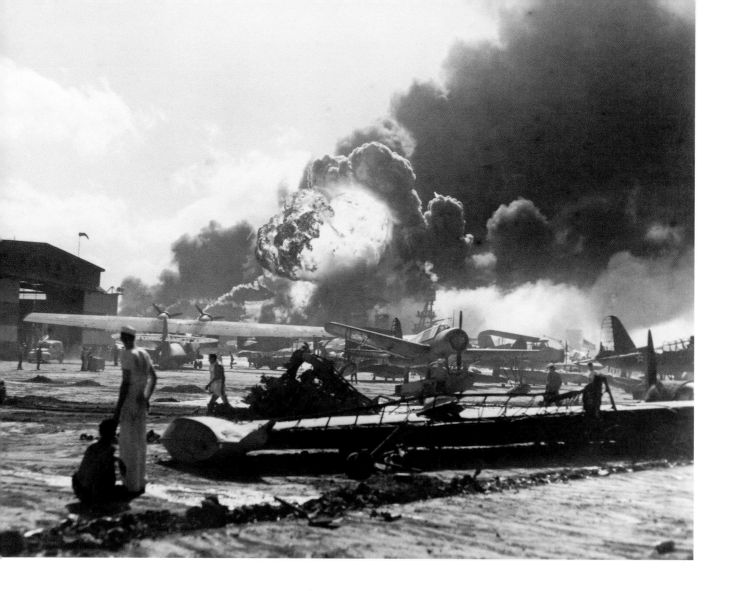

14.
Damage at Pearl Harbor,
Hawaii, from Japanese attack,
December 7, 1941

15.
Female worker with B-29
Superfortresses at the Boeing
Aircraft Company, Renton,
Washington, c. 1942–45

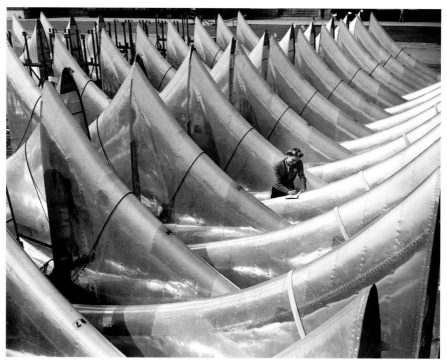

engineers, under the direction of a U.S. Army general, to design and build the world's first nuclear weapons, with the goal of using them to end the war. The top-secret program, code-named the Manhattan Project, achieved that goal when two of the atomic bombs were dropped on the Japanese cities of Hiroshima and Nagasaki in August 1945, causing unprecedented destruction and forcing Japan to surrender. Many editorials about the atomic bomb, following President Harry Truman's lead, hailed it as a triumph of American science, technological know-how, and ability to organize a vast project involving thousands of workers of whom only a few had any idea of the overall objective. (Dwight Macdonald found the compartmentalized impersonality of the Manhattan Project a cause not for celebration but for deep apprehension; this, however, was a minority view.)

The media might trumpet the contribution of scientists and engineers and corporate America's technological achievements, but it was the war's human dimension, conveyed through soldiers' stories and popular images, that caught its meaning for most Americans. War correspondent Ernie Pyle, himself a kind of everyman, recounted his conversations with ordinary G.I.'s at the front. Cartoonist Bill Mauldin viewed the war through the eyes of "Willie and Joe," a pair of bedraggled, unshaven draftees who exchanged sardonic comments as they slogged through the mud or sprawled in total exhaustion (fig. 16). It was Ernie Pyle's soldiers, and "Willie and Joe," not the Willow Run plant or the Kaiser shipyards, that wartime Americans took to their hearts.

Norman Rockwell's 1942 illustrations of the "Four Freedoms" proclaimed by President Roosevelt and Prime Minister Churchill became (along with the U.S. soldiers raising our nation's flag on Iwo Jima's Mount Suribachi, and the mushroom cloud) perhaps the war's most familiar visual icons. Rockwell's homely, utterly accessible nostalgic representations—a family's Thanksgiving dinner (for "Freedom from Want" [fig. 17]), parents watching over their sleeping children ("Freedom from Fear"), men and women praying ("Freedom of Worship"), an earnest young man expressing his views in a town meeting ("Freedom of Speech")—represented a semi-mythic past remote from the actual experience of most Americans of the 1940s, but perhaps for that reason all the more compelling.

In World War I, President Woodrow Wilson, the erstwhile political-science professor, had formulated the nation's war aims in Fourteen Points that few could remember, whereas in World War II U.S. war aims were conveyed in elemental human terms. When represented in female imagery (as it often was), this iconography took many forms. It could be reassuringly maternal (the

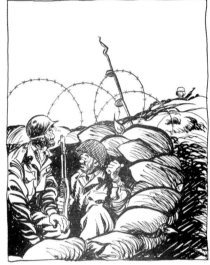

V-E Day
"Th' hell with it. I ain't standin' up till he does!"

16.
Bill Mauldin (American, b. 1921). "Willie and Joe V-E Day," from *European Stars and Stripes*, May 8, 1945

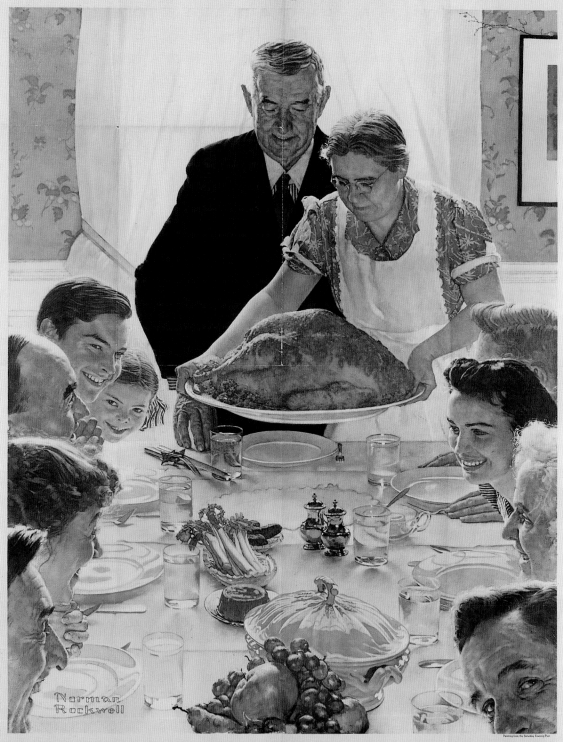

OURS...to fight for

FREEDOM FROM WANT

Norman Rockwell

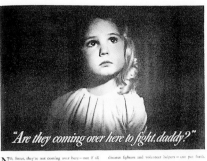

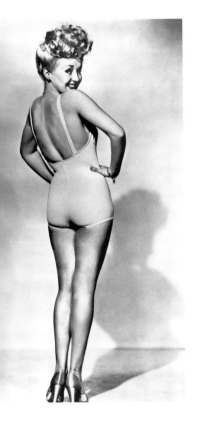

18.
Betty Grable in 1942

grandmother in Rockwell's scene of Thanksgiving dinner); erotically charged
(the Betty Grable pinup beloved of sex-starved G.I.'s [fig. 18]); tough and almost
masculine ("Rosie the Riveter" flexing her muscles on a 1943 *Saturday
Evening Post* cover [fig. 20]); or prepubescent and appealingly winsome (the
sad-eyed little girl in the 1942 Red Cross ad with its caption: "Are they coming
over here to fight, daddy?" [fig. 19]). For all their diversity, however, these rep-
resentations of appealing, recognizable men, women, and children were instant-
ly accessible in human terms, in stark contrast to the rarefied scientific
research, technological innovations, and weapons-plant logistics on which the
outcome of the conflict ultimately depended.

 In implicit counterpoint to the war's horrendous human carnage, these
images were reassuringly whole and complete. Indeed, as George Roeder has
shown in *The Censored War* (1993), the U.S. government carefully monitored
the battlefront images released to the American people; photographs of dead or
maimed soldiers were isolated in a file dubbed the "Chamber of Horrors." Willie
and Joe might be exhausted and dirty, but they were intact. Only toward the
war's end, and then in carefully selected, aesthetically soothing long-distance
shots, did dead Americans appear in photos released to the media. *Life* maga-
zine published shocking photographs of a Japanese soldier burning to death
after being flushed from a cave by a flame-thrower, but in the context of

17.
Norman Rockwell (American,
1894–1978). *Freedom from
Want* from the *Four Freedoms*
series, 1942. War Bond poster,
Government Printing Office for
the Office of War Information.
The Norman Rockwell Museum
at Stockbridge, Massachusetts

wartime propaganda, in which the Japanese were represented as monkeys, cockroaches, or subhuman brutes, *Life*'s photographs hardly seemed to relate to a common human experience at all.

The images of America's postwar consumer culture—the preternaturally cheerful families of the T.V. sitcoms and the magazine ads for refrigerators, washing machines, and other appliances—were in a direct line of descent from the inspiring or comforting wartime images. Willie and Joe metamorphosed into smiling suburban dads. The sweater-girl pinups and the vulnerable children of wartime propaganda became Mrs. Cleaver and the Beaver.

The pent-up demand of the war years, when paychecks were fat but consumer goods scarce, helped trigger the consumer binge of the 1950s. Economist

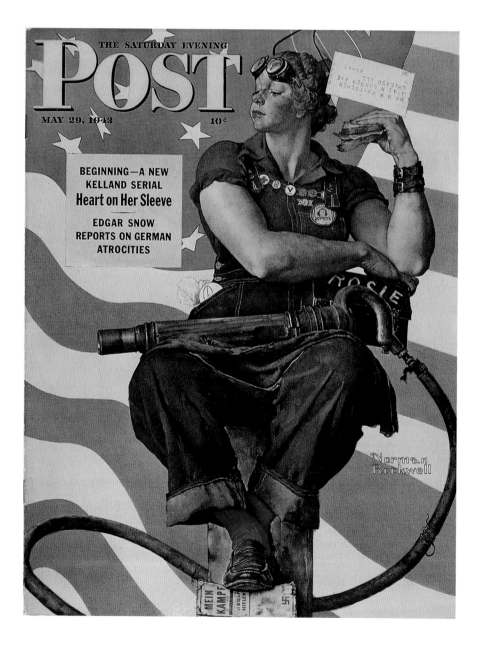

20.
Norman Rockwell (American, 1894–1978). *Rosie the Riveter* from the *Saturday Evening Post*, May 29, 1943. The Norman Rockwell Museum at Stockbridge, Massachusetts

John Kenneth Galbraith, in titling his 1957 book *The Affluent Society*, also named the era. *Life* magazine, in staged photographs of a young couple moving into a new home amid an array of major appliances (fig. 21), or of a housewife on her suburban front lawn surrounded by a year's supply of detergents and other household consumer goods, offered indelible images of 1950s abundance.

With postwar prosperity came a vast migration to the suburbs. Levitt & Sons, Inc., the legendary shapers of Long Island suburbia, gained their first experience in mass-produced construction by building housing for war workers. Their first postwar development project, which they began building in 1947 (and modestly called Levittown), foreshadowed an explosion of suburban housing growth in the early postwar era.

As Americans flocked to the burgeoning suburbs, few observers commented on the obvious class and racial issues underlying this exodus. Those abandoning the old urban neighborhoods were overwhelmingly white and at least incipiently

21.
"Family Utopia," *Life* magazine, November 25, 1946

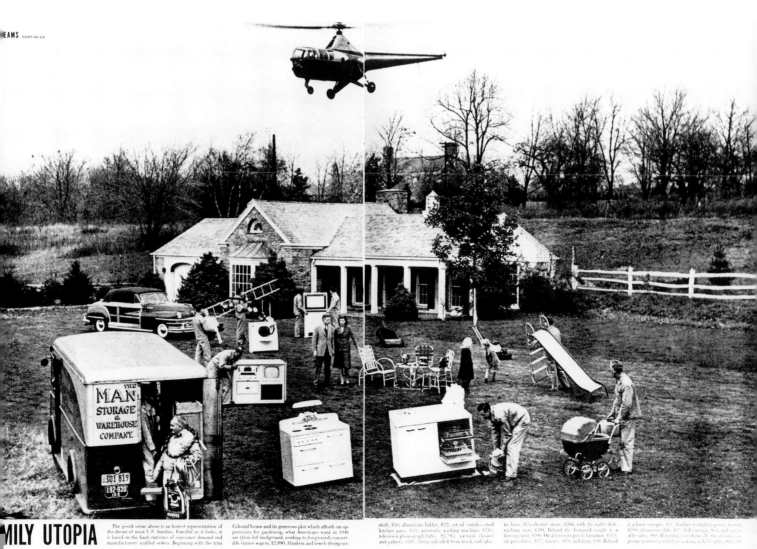

CONTINUED ON NEXT PAGE 59

middle-class; their flight eroded the urban tax base and left the inner cities to African Americans, Hispanics, and other low-income, often low-skilled minorities. Bypassed by the postwar boom, the residents of these decaying urban districts were left behind in an economic as well as a geographic sense.

The consumer binge unleashed by the return of peace took many forms, even including Hollywood parodies of excessive abundance (see fig. 22, for example). Americans replaced appliances that had wheezed and sputtered through the war. By the millions they snapped up new cars (mostly American-made in that now-distant era), which after the war rolled off assembly lines that a few months before had been producing tanks and bombers. (A joke of the time insisted that the first postwar cars still had machine-gun mounts on their fenders.) To accommodate the surge of new cars, the Federal government in 1956 undertook a massive program of interstate highway construction—one of the great public-works projects of all time.

And Americans bought their first T.V. sets. Television had been introduced to the general public in 1939, when NBC televised to several thousand owners of the first T.V. sets the opening ceremonies of the New York World's Fair featuring President Roosevelt. (The new gadget would never replace radio, predicted the *New York Times*; Americans were much too active to sit passively in front of a television set. The *Times* was dead wrong, as figure 23 illustrates.) The war brought a hiatus in T.V. production and marketing, but with the return of peace, the television age began in earnest. The number of sets soared from 1 million in 1950 to 50 million in 1960.

World War II was also the seedbed of the Cold War—the ensuing forty-year power struggle between the Western nations and the Communist bloc—which

22.
Scene from the film *The Jackpot*, 1950, with James Stewart and Barbara Hale, directed by Walter Lang. Twentieth Century Fox Films

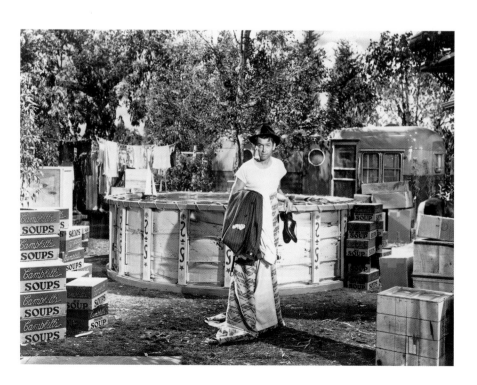

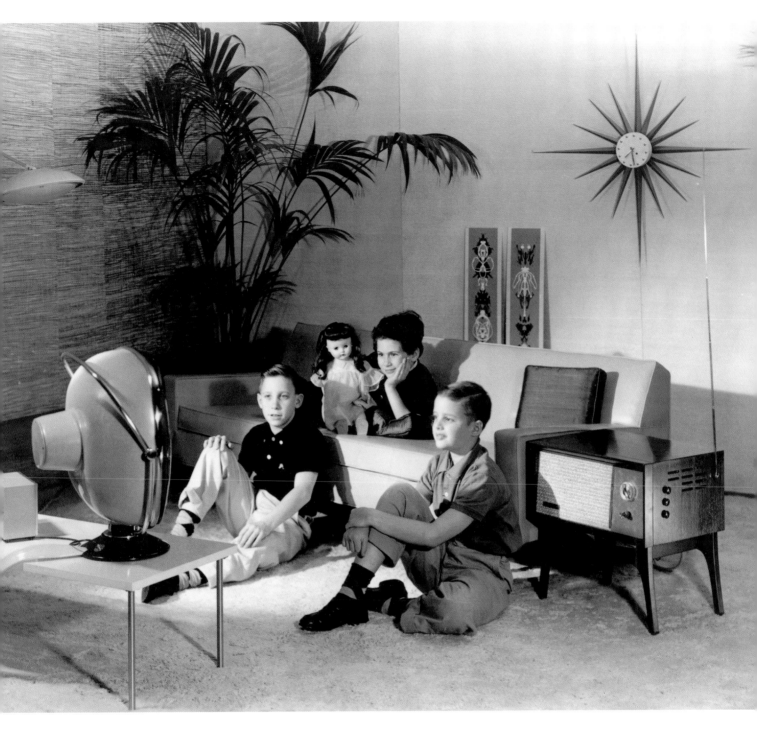

23.
Family watching *Predicta* television set, June 15, 1958

became the ever-present subtext of postwar American life, and a principal context for this exhibition. The defeat of Germany and Japan, the devastation of Western Europe, and the weakening of the French and British colonial empires created a power vacuum not only in Europe, but in much of Asia and Africa as well. Alerted by several early postwar confrontations with Moscow, alarmed by blustery pronouncements from Soviet dictator Joseph Stalin, and roused by Sir Winston Churchill's March 5, 1946, "Iron Curtain" speech, the Truman administration moved quickly, first in Europe and then globally, to check Moscow's alleged master plan to spread Soviet Communism worldwide. George Kennan's Containment doctrine, first formulated in a famous "long telegram" from Moscow and then in an influential 1947 *Foreign Affairs* article, laid the ground-

24.
"Jackson Pollock," *Life* magazine, August 8, 1949. Photograph of **Jackson Pollock** (American, 1912–1956) by **Arnold Newman** (American, b. 1918)

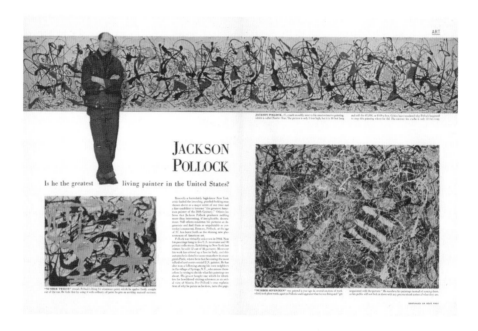

25.
Senator Joseph R. McCarthy points to a map headed "Communist Party Organization U.S.A.–Feb. 9, 1950" during testimony on June 9, 1954, in Washington, D.C.

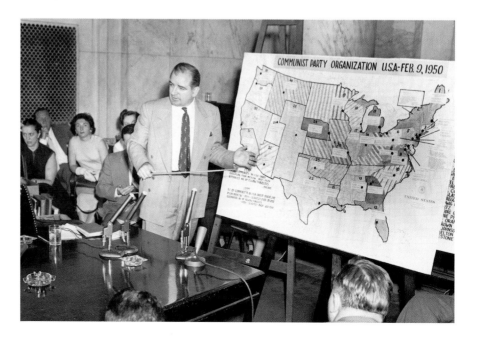

work for early postwar American foreign policy, in which preventing the expansion of Soviet power and influence anywhere in the world became the overriding—indeed, nearly the only—objective.

The moral clarity of the United States' role in World War II, a battle against racist, dictatorial, militarist regimes recognized as evil by all right-thinking citizens, was replayed during the Cold War, adding a holy-war aura to the strategic chess game. This quasi-religious component of the Cold War gained particular intensity during the years when John Foster Dulles, a Wall Street lawyer and Presbyterian elder with the grim moral intensity of an Old Testament prophet, served as Eisenhower's secretary of state (1953–59). With his lawyerly approach and moralistic fervor, Dulles concentrated on hedging in the Soviets with a network of pacts and treaties that committed the United States to resist Communist expansion throughout the world. The ideological groundwork of the Vietnam War—like the social groundwork of 1960s urban unrest and turmoil—was laid in the 1950s.

The Cold War penetrated the culture in countless ways. The Central Intelligence Agency funded cultural periodicals and conferences. The State Department sent jazz artists such as Dizzy Gillespie and Louis Armstrong abroad as cultural ambassadors. The publisher Henry Luce promoted Jackson Pollock and Abstract Expressionism in *Life* magazine as proof of America's cultural freedom (fig. 24). Simultaneously, fears of Communist subversion spawned a repressive, conformist intellectual climate. Senator Joseph R. McCarthy streaked across the horizon as the nation's premier Communist hunter (see fig. 25). Technically, the McCarthy era began in February 1950 when the Wisconsin lawmaker dramatically told a West Virginia audience that he held in his hand a piece of paper listing a great number of Communists in the State Department, and ended in December 1954 when the U.S. Senate voted, 67 to 22, to censure him. In a larger sense, however, the political and cultural phenomenon encompassed by the term "McCarthyism" neither began nor ended with the trajectory of McCarthy's brief moment in the sun. As early as 1947, largely for reasons of domestic politics, the Truman administration had introduced a draconian loyalty program under which homosexuals, ideological mavericks, and radicals of all kinds were forced out of government service. And as recently as the early 1980s, accusations of being "soft on Communism" could still be trotted out to discredit anyone with whom the accuser happened to disagree.

But the peak of the hysteria came in the early 1950s. Arthur Miller captured the mood in his 1953 play *The Crucible*, which treated the 1692 Salem witch-

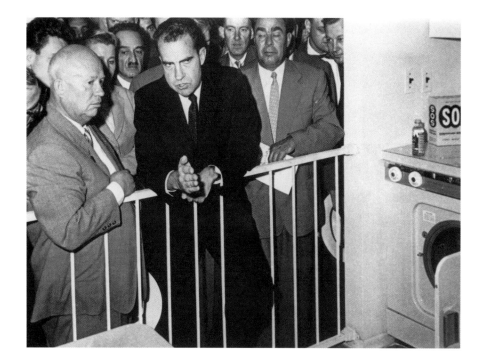

craft trials as an allegory of the anti-Communist witch hunt and the agonizing dilemma of the individual pressured not only to confess his own alleged misdeeds but to "name names" of others who could then be summoned before the inquisitors. Cold War anti-Communist obsessions had a chilling effect on the arts and popular culture—not only in the obvious ways, such as the blacklisting of Hollywood writers and actors and radio and T.V. personalities accused of a radical taint—but in more amorphous ways as well.

In the Cold War's ideological dialectic, the United States' material abundance—readily apparent in its torrent of automobiles, T.V. sets and other home appliances, and suburban housing developments—proved the West's ideological superiority. This, for example, was the central theme of Richard Nixon's famous 1959 "kitchen debate" with Soviet premier Nikita Khrushchev in the unlikely venue of a model kitchen at a U.S. exhibition in Moscow (fig. 26). An idealized America of white, affluent, churchgoing, firmly patriarchal families—celebrated in countless advertisements and in such T.V. sitcoms as *Leave It to Beaver* and *Father Knows Best* (figs. 27, 28)—stood in the sharpest possible contrast to a grim, gray, collectivized, atheistic Soviet Union.

Hence the ambivalence. To question this impossibly idealized "American way of life" was to undermine the nation's Cold War ideological position. It was

letting down the home team. The inevitable consequence was the muffled, inconclusive nature of 1950s political discourse and cultural criticism. For example, the historian Daniel Boorstin (a 1930s radical turned conservative) in *The Image* (1961) scathingly criticized mass culture and the synthetic pseudo-events fostered by television, without once mentioning the larger context of consumer capitalism. Dwight Macdonald, another ex-radical who became a conservative cultural critic after the war, in an influential series of 1950s essays, echoed the art critic Clement Greenberg's elitist disdain for kitsch—adding an even more insidious category he called "midcult"—while ignoring the economic system that spawned these horrors. Sociologist David Riesman in *The Lonely Crowd* (1950) decried the bland conformism of what he generically called "*the* American character," while paying little attention to the nation's economic and political order, ethnic or racial diversity, class structure, or gender inequality.

In a climate where America's superiority over the Soviet Union in every realm—political, moral, and cultural—had to be endlessly affirmed, too vigorous a cultural criticism, too much attention to the potential for domestic conflict, too vigorous a probing of the darker corners of American life could rouse suspicions of ideological naïveté, or worse. For example, it is obvious in retrospect that the vaunted prosperity of America during the 1950s was uneven at best, with poverty and deprivation endemic in the inner cities and across large swaths of rural America. In the ideological climate of the day, however, even this obvious fact was largely ignored. Not until 1962, with Michael Harrington's *The Other America*, did poverty come out of the closet, as it were, setting the stage for President Lyndon Johnson's ambitious if ultimately inconclusive War on Poverty during the mid-1960s.

The insistently conformist Cold War climate shaped the mass culture as well. Most movies, T.V. shows, and popular music affirmed the status quo. Rock and roll offended some middle-class sensibilities, and to that extent may have been a culturally subversive force, but it mainly stimulated sales of records, radios, phonographs, and concert tickets. In any event, first television and then Hollywood quickly coopted and tamed rock-and-roll sensation Elvis Presley's raw, anarchic energy. In literature, the Beat generation—Allen Ginsberg, Jack Kerouac, and others—became a caricatured media cliché. (Kerouac played his sullen "rebel" persona to the hilt in an appearance on Steve Allen's T.V. show on November 16, 1959.) The footloose, pill-popping drifters of Kerouac's novel *On the Road* (1957) epitomized a rebellious strand in 1950s culture, but John Updike's *Rabbit, Run* (1960) captured an even more important aspect of the

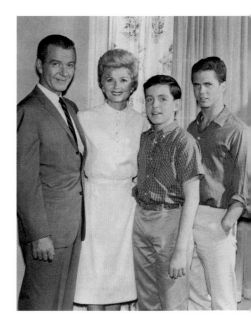

27.
Actors from the television situation comedy *Leave It to Beaver*, broadcast from October 4, 1957, through September 12, 1963

28.
Actors from the television situation comedy *Father Knows Best*, broadcast from October 3, 1954, through September 17, 1962

decade when the hapless protagonist of Updike's novel, "Rabbit" Angstrom, drives away from his cramped apartment, alcoholic wife, dead-end job, and fading dreams of high-school basketball glory, only to return a few days later. Angstrom, too, was briefly "on the road"—trying to live out the old American dream of breaking free of society's constraints—but found that he had no place to go.

Even allegedly subversive movies proved surprisingly timid. James Dean, in the role of a teenage malcontent (fig. 29) in *Rebel Without a Cause* (1955), falls into the hands of a therapist who soon straightens him out; the motorcycle-gang leader played by Marlon Brando in *The Wild One* (1953), when asked what he's rebelling against, can only mumble: "What have you got?" The decade's barely contained paranoia about subversion perhaps came closest to the surface in a science-fiction movie, *Invasion of the Body Snatchers* (1956), in which aliens invade a tranquil suburban community, taking over the bodies of men and women who remain indistinguishable from their former selves (see fig. 30). In short, 1950s culture provides much evidence that all was not well in America, but powerful Cold War constraints inhibited intellectuals or culture producers alike from saying so too explicitly.

In this setting, much of postwar American social commentary, cultural production, and artistic expression is best read as a kind of hidden code. Knowing the context, one can sometimes discern the code, but just as often the meaning

29.
Scene from the film *Rebel Without a Cause*, 1955, with James Dean and Natalie Wood, directed by Nicholas Ray.
Warner Brothers

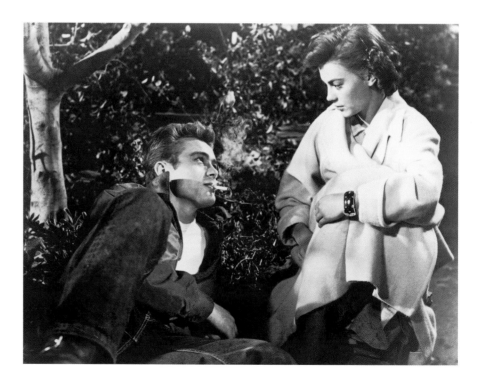

30.
Scene from the film *Invasion
of the Body Snatchers*, 1956,
with Kevin McCarthy, directed
by Don Siegel. Walter Wanger
Productions, Inc., Allied Artists

remains elusive, as the writer or artist offers hints and suggestive gestures, but avoids the more overt forms of critical expression that could prove dangerous in a climate of conformity and insistent affirmation.

If the Cold War, with its roots in World War II, represents one key to understanding postwar America, another is surely the nuclear-arms race, which hovers ubiquitously over this *Vital Forms* exhibition. The threat of nuclear war provides another powerful context spanning the time period of this exhibition. The atomic bomb was President Franklin Roosevelt's final, ambiguous legacy to the United States and the world. Alerted by émigré physicists Leo Szilard and Albert Einstein to the possibility of such a weapon, Roosevelt authorized a modest research grant in 1939. The Manhattan Project was set in motion in 1942 under General Leslie R. Groves, the Presbyterian minister's son who had earlier supervised construction of the Pentagon. Shrouded in deepest secrecy, development went forward at Oak Ridge, Tennessee; Hanford, Washington; the University of Chicago; and Los Alamos, New Mexico. The first bomb was tested in the predawn darkness of July 16, 1945, at Alamogordo, New Mexico—Ground Zero of the atomic age.

A few Manhattan Project scientists frantically proposed alternatives to full military use of the bomb—a demonstration before world leaders, perhaps, followed by an opportunity for Japan to surrender. But their effort failed. The project's inexorable momentum, together with the appeal of ending the war by means of a spectacular display of U.S. firepower and the added bonus of enhancing America's postwar bargaining position vis-à-vis the Soviets, proved irresistible. President Truman gave the go-ahead, and the world's second atomic bomb, "Little Boy," exploded over Hiroshima on August 6; "Fat Man" hit Nagasaki three days later (fig. 31). In the space of seventy-two hours, the Atomic Age began, changing the world forever.

The development and use of the atomic bomb in World War II, and the long aftermath of these events, shaped the contours of the postwar era in almost incalculable ways. The Soviet Union tested its first atomic bomb in 1949, and President Truman, prodded by the physicist Edward Teller, responded by authorizing development of the hydrogen bomb. The Russians followed suit, and the nuclear-arms race roared forward. By the late 1950s, scientists had attached thermonuclear warheads to rockets (another World War II legacy), creating intercontinental ballistic missiles (ICBMs). With this innovation, which had actually been anticipated in the popular culture since 1945, the nuclear-arms race took on a terrifying new dimension. The advent of the Space Age,

31.
Army Air Forces. *Nagasaki under Atomic Bomb Attack*, Japan, August 9, 1945. Gelatin silver print, 10 x 13½ inches. Brooklyn Museum of Art, New York; Gift of the Army Air Forces, 46.17

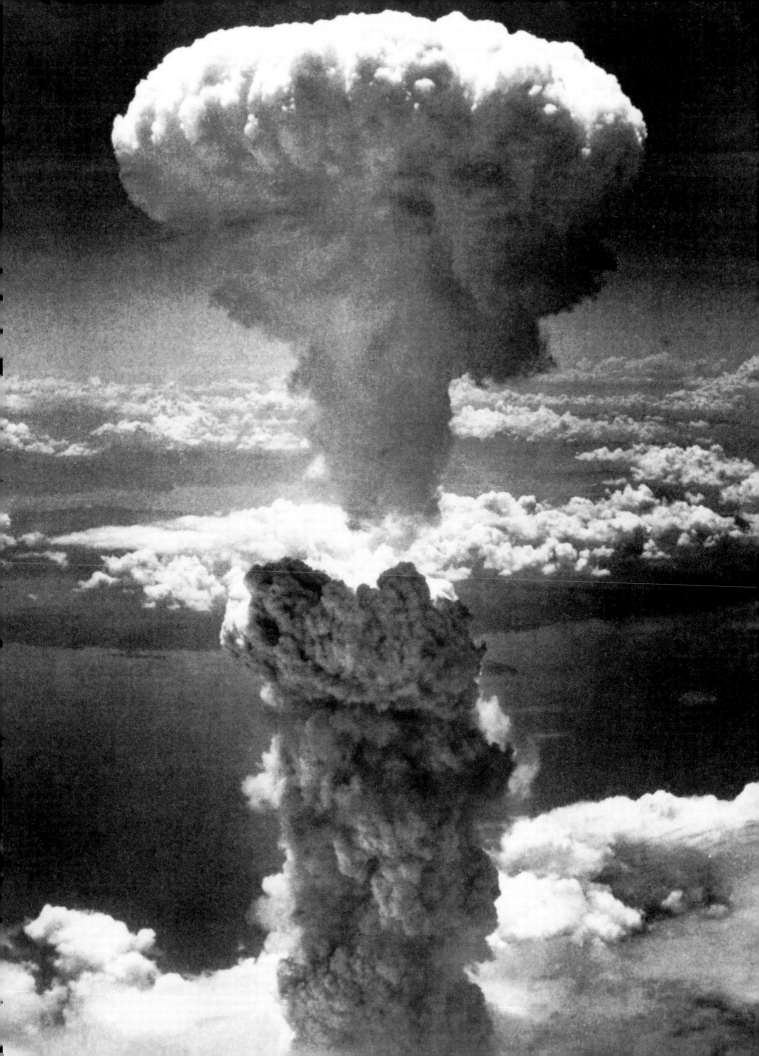

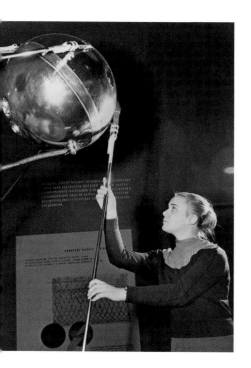

32.
Tamara Borisova, a Russian
guide-engineer at a Moscow
exhibition, displaying a replica
of the Soviet satellite *Sputnik 1*,
November 19, 1957

signaled by the Soviets' launch of the *Sputnik* satellite in 1957 (see fig. 32), added a further layer of potential menace and another arena of Cold War conflict.

From the dawn of the Atomic Age in 1945, the threat of nuclear war had not only a strategic and political dimension, but a cultural component as well. Nuclear awareness seeped into the inner recesses of the American consciousness, where it remained firmly embedded throughout the period explored in the *Vital Forms* exhibition, and far beyond.

What I've loosely called the "schizophrenia" of postwar American culture becomes evident in the response to the nonmilitary uses of atomic power as well. Government propaganda, abetted by corporate interests and a complaisant media, insistently struck an upbeat note, assuring all Americans of the wonderful benefits they would reap from atomic power applied to peacetime purposes. The rosy rhetoric was not entirely unrealistic. By the early 1950s, radioactive isotopes were being used in medicine for diagnosis, therapy, and research, and in industry for micromeasurement, monitoring certain processes, and testing for corrosion; and the first commercial-scale nuclear-power plant in the United States (viewed at the time as a technological triumph) began operating in Shippingport, Pennsylvania, in 1957, providing cheaper electricity for millions of people. But the hype far outran the reality, as the Atomic Energy Commission and corporations involved in nuclear-power development, such as General Electric and Westinghouse, promoted visions of an atomic utopia ahead.

Along with the largely unrealized promise of the peaceful atom came the all-too-legitimate fear of the destroying atom. The logo of the peaceful atom (the proton nucleus with its orbiting electrons) did battle in the iconographic arena with the logo of the destroying atom (the mushroom cloud)—and the mushroom cloud proved more potent. Within hours of the dropping of the bomb on Hiroshima, news commentators and editorial writers had projected onto American urban centers the fate that had befallen a distant Japanese city. New Haven and Denver, they noted ominously, were about the same size as Hiroshima.

The immediate surge of raw fear soon abated, and gave way to nervous jokes, as Americans sought to exorcise their feelings of terror through humor. Within a few weeks, in a macabre biomorphic pun, a Hollywood studio persuaded *Life* magazine to publish a full-page photo of a rising starlet in a bathing suit, with the billing of "Anatomic Bomb" (fig. 33). Further linking atomic fission to orgasmic pleasure, a French designer in 1946 christened his new bathing suit the "bikini"—the name of the Pacific atoll that was the site of America's first postwar atomic tests. The linkage persisted in the 1950s, as is clear from the title of Reginald Marsh's drawing *Atomic Blonde* (fig. 34).

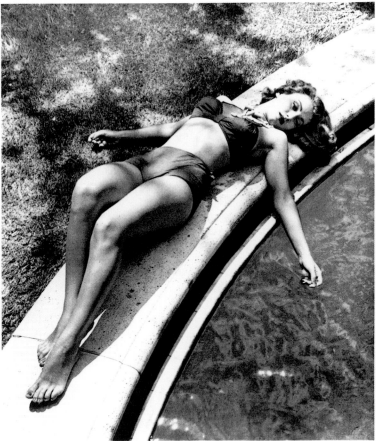

SPRAWLED GRACEFULLY ON THE CURVING EDGE OF A SWIMMING POOL, STARLET LINDA CHRISTIANS, HOLLYWOOD'S ANATOMIC BOMB, SOAKS UP SOLAR ENERGY

ANATOMIC BOMB

**Starlet Linda Christians brings
the new atomic age to Hollywood**

Almost before ink was dry on headlines announcing the crash of the first atomic bomb, Hollywood had turned the event to good publicity. At the Metro-Goldwyn-Mayer studio Miss Linda Christians, a hitherto obscure starlet, was solemnly proclaimed the Anatomic Bomb. Half-Mexican, half-Dutch, Linda was born in Tampico, Mexico, thinks it was 22 years ago. Her real name is Blanca Rosa Welter. Her father, an oil executive, traveled widely,

taking his family with him. They were in Palestine in 1941 during a bomb scare. Linda was evacuated to Mexico with a bad case of malaria, recovered, went to Hollywood to join her brother, got a job modeling hats, was seen and signed by M-G-M. So far she has been in no pictures, the publicity role of the Anatomic Bomb being her first important assignment. With long residence in Holland, Italy, France and Switzerland, Linda thinks Hollywood is wonderful.

33.
Linda Christians posed as the
"Anatomic Bomb," *Life* maga-
zine, September 3, 1945

34.
Reginald Marsh (American,
b. Paris, 1898–1954).
Atomic Blonde, 1952. Ink and
pencil on paper, 22¼ x 30⅞
inches. Private collection,
courtesy Leslie Rankow Fine
Art, New York

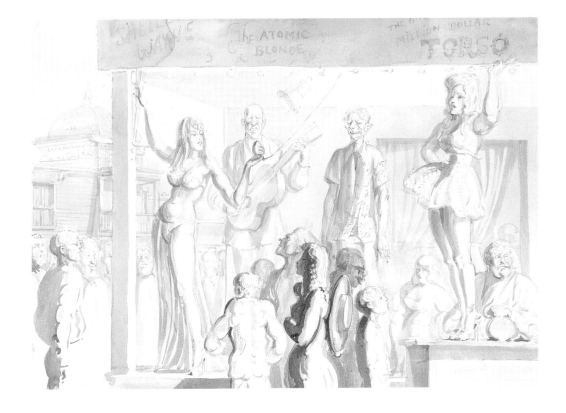

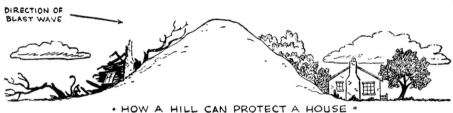

DIRECTION OF
BLAST WAVE →

• HOW A HILL CAN PROTECT A HOUSE •

35.
Illustration from *How to Survive an Atomic Bomb* (Washington, D.C.: Combat Forces Press, 1950)

The Truman administration, meanwhile, shifted attention from the international control of atomic energy to the more urgent task of containing Communism. Downplaying the threat of nuclear annihilation, Washington officials insisted that a timely civil-defense program could reduce casualties to acceptable levels and make atomic war manageable. One government-sponsored civil-defense manual, *How to Survive an Atomic Bomb* (1950), in addition to advocating bomb shelters (see figs. 35–37), advised women to wear long-sleeved blouses and men to wear hats to minimize radiation hazards. This same publication urged homeowners to rake leaves away from their houses, to reduce the risk of fire after an atomic blast. Amazingly, in that pre-Vietnam, pre-Watergate era, when most Americans still trusted their government, such propaganda appears to have achieved its intended effect. By the early 1950s, atomic terror, so pervasive a few years earlier, seemed on the wane.

But nuclear fear surged back in the mid-1950s, now with a new focus: radioactive fallout from hydrogen-bomb tests in the Pacific. The first U.S. H-bomb tests at Eniwetok Atoll in 1954 spewed radioactive ash over a wide area of the Pacific, and subsequent U.S. and Soviet tests compounded the problem. Soon, scientists reported, radioactive waste carried by prevailing winds in

36.
Illustration from *How to Survive an Atomic Bomb* (Washington, D.C.: Combat Forces Press, 1950)

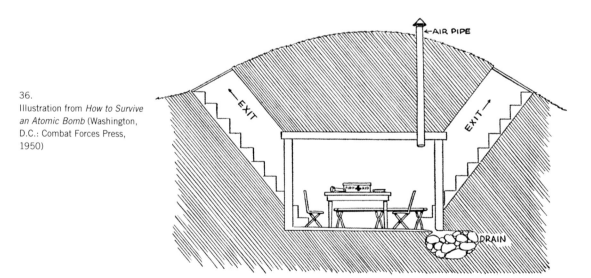

One type of good bomb shelter which can be dug in anyone's yard. There should always be two exits, and the ideal covering should include a foot or more of concrete plus three or four feet of earth.

the upper atmosphere was spreading from the test sites and drifting back to earth over agricultural regions and populated areas.

A full-blown fallout scare gripped the nation (see fig. 38). Despite the Atomic Energy Commission's soothing reassurances, scientists reported rising levels of deadly strontium 90 in the atmosphere, from which it entered the food chain. Mothers feared for their babies. Mainstream publications spread the alarm. The *Ladies' Home Journal* warned of "Fallout: The Silent Killer."

As in the immediate postwar period, a torrent of novels, poems, movies, and science-fiction stories explored themes of radioactive menace. The popular genre of Hollywood mutant movies, beginning with *Them!* (1954), in which giant ants crawl from the atomic test site in New Mexico and begin a murderous

37.
Illustration from *How to Survive an Atomic Bomb* (Washington, D.C.: Combat Forces Press, 1950)

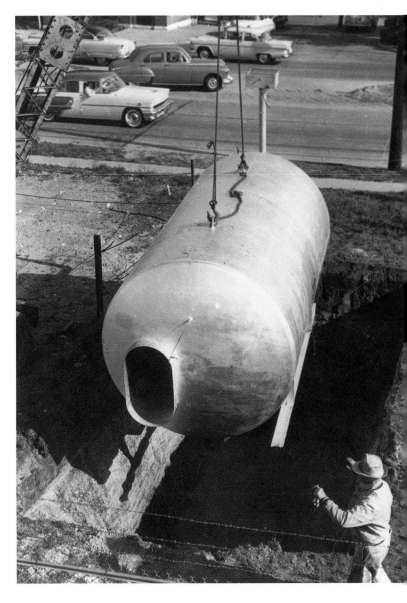

38.
Demonstration of a family H-bomb shelter being lowered into position, Garden City, New York, May 19, 1955

rampage in their quest for sugar, was clearly a manifestation of nuclear fear. The story lines of two popular T.V. science-fiction series, *The Twilight Zone* and *The Outer Limits*, often featured nuclear war or radiation dangers. For example, in one *Outer Limits* episode, bees that have been genetically enhanced as a result of atomic tests transmute their queen into a beautiful young female humanoid as part of their plot to take over the world. Insinuating herself into a suburban household, she attempts to seduce the weak-willed husband. The wife realizes the danger one night when she spots the mysterious newcomer in the garden, pollinating flowers. The bee-woman murders the wife, and (not fully understanding human mating rituals) seductively presents herself to the distraught husband in the dead woman's bridal gown. In a fit of revulsion, he kills her. The bees' plot is foiled—for the moment.

The apocalyptic nightmare of all-out, world-destroying thermonuclear war, somewhat muted after the initial post-Hiroshima period, now resurfaced in such diverse cultural forms as the satirical songs of Tom Lehrer ("We'll All Go Together When We Go" of 1958 is one of his best known); the poems of Robert Lowell; and movies such as *On the Beach* (1959), *The Day the Earth Caught Fire* (1962), and Stanley Kubrick's classic *Dr. Strangelove* (1964). Alain Resnais's *Hiroshima, Mon Amour* (1959), widely shown in the United States, in which images of a devastated Hiroshima obsessively intrude upon images of the thriving rebuilt city, evoked the way nuclear fears still stirred uneasily in the deeper recesses of the culture, even as the events of August 1945 receded into the past.

The nuclear Armageddon envisioned in these cultural productions seemed terrifyingly close to reality during the Cuban missile crisis of October 1962. Tapes of the White House discussions during those tense days (recorded by President Kennedy himself, and released to the public in 1997) make clear that the terror was fully justified. Only in 1963, with the Limited Nuclear Test Ban Treaty, did the superpowers take a halting first step toward restraining the nuclear-arms race.

In short, much of 1950s culture, including its aesthetic aspects, makes no sense without awareness of the pervasive nuclear presence. But, again, the schizoid nature of that presence must be noted. Official propaganda insisted that the atomic bomb had ended the war in the Pacific and saved countless American lives, and that atomic power in its varied guises offered vast domestic benefits and an essential shield against Communist aggression. Yet nuclear weapons also threatened human extinction, and from the mid-fifties on, were spawning deadly radioactive fallout.

Thus, while upbeat government propaganda championed the peaceful atom and civil defense, and pooh-poohed the hazards of nuclear fallout, antinuclear activism steadily increased in the late 1950s and early 1960s. The famed pediatrician Benjamin Spock and other activists in an organization called the National Committee for a Sane Nuclear Policy (SANE) warned in rallies and advertisements of fallout risks. In one SANE ad, Spock gazed with furrowed brow at a young child under the caption: "Dr. Spock Is Worried" (fig. 39). The ad's text explained the reason for his worry: radioactive fallout. In the 1956 presidential campaign, Eisenhower's Democratic Party challenger, Adlai Stevenson, advocated a nuclear test ban. Predictably, however, in this Cold War context, the issue was framed very narrowly by the critics and protestors: they simply demanded that the U.S. stop atmospheric testing, with its obvious health hazards. Few questioned the underlying assumptions of the Cold War or the nuclear buildup itself.

Nineteen-fifties religious life further illustrates the complex cultural fallout caused by nuclear-weapons fear. While the staccato-voiced revivalist Billy Graham was calling for all to repent before the imminent atomic apocalypse, the Reverend Norman Vincent Peale, in such early postwar bestsellers as *A Guide*

39.
"Dr. Spock Is Worried," 1962 advertisement for National Committee for a Sane Nuclear Policy (SANE). Swarthmore College Peace Collection, Swarthmore, Pennsylvania

to *Confident Living* (1948) and *Faith Is the Answer* (1950), offered a more soothing message: overcome your fears by repeating comforting mantras and ridding your mind of negativity. Both preachers flourished in a culture gripped by atomic fear that, owing to Cold War constraints, could be only partially acknowledged.

Another exception to the acquiescent postwar social and political climate was the beginnings of a civil-rights movement that would radically transform American racial relations. Both World War II and the Cold War stimulated civil-rights activism, another social movement spanning the time period of the *Vital Forms* exhibition. As early as 1941, to forestall a march on Washington, D.C., threatened by the African-American leader A. Philip Randolph, President Roosevelt issued an executive order barring racial discrimination in defense plants and creating a Fair Employment Practices Committee to enforce the order. In *An American Dilemma* (1944), the Swedish sociologist Gunnar Myrdal reported on his study of U.S. race relations and pointed to the paradox of a nation fighting racism abroad while tolerating it at home.

As the Cold War began and the U.S. government sought the support of African and Asian nations, the persistence of domestic racism became a major diplomatic liability. In this climate (and facing an uphill re-election campaign) President Truman in 1948 desegregated the military and sent a variety of civil-rights bills to Congress.

When the Supreme Court outlawed school segregation in the landmark 1954 decision *Brown* v. *Board of Education of Topeka*, the pace of events quickened. Racial segregation in the transportation system of Montgomery, Alabama, which had relegated African Americans to the back of the city's buses, was successfully challenged by a bus boycott in 1955–56, propelling Montgomery minis-

40.
The Reverend Martin Luther King, Jr., speaking at the Holt Street Baptist Church during the Montgomery bus boycott, March 22, 1956

41.
Students with National Guard escort during desegregation of Central High School, Little Rock, Arkansas, October 15, 1957

ter Dr. Martin Luther King, Jr., the campaign's leader, to prominence (fig. 40). President Eisenhower, despite his personal antipathy to forced integration, ordered Federal troops to Central High School in Little Rock, Arkansas, in 1957 to enforce a court-ordered school-desegregation ruling (see fig. 41)—an event memorialized by Norman Rockwell in a celebrated painting of a diminutive black girl being escorted to school by two burly Federal marshals.

But again, the Cold War constraints against radical critiques of the status quo helped confine 1950s civil-rights activism to the narrow and relatively clear-cut issue of legally enforced segregation, and to keep it localized in the South. Only in the 1960s and after would Americans confront the full complexity and national scope of America's racial dilemmas.

In summary, the basic paradox of 1950s culture is clear: all thoughtful persons could recognize serious problems in American life, from poverty and racism to nuclear dangers. Yet the prevailing if unevenly distributed material abundance, the influence of a mass media driven by advertising and commercial calculations, and, above all, the ideological dynamic of the Cold War all worked against the open confrontation of these social issues. The result was an indirect, allusive, and hesitant variety of cultural expression and critical commentary, creating the schizoid patterns that our imaginary psychiatrist would quickly diagnose had he been able to put this decade on the couch.

———

Within this quite specific historical setting—the century's second Pan-European conflagration that turned into an all-encompassing world war, followed by the confused and unstable social, political, and cultural situation in the United States arising from the war—the architecture, paintings, sculpture, arts and crafts, commercial products, and pop-culture ephemera from the 1940s through the early 1960s were created and entered the stream of American life. Beyond establishing a general framework, does this history shed any further light on this exhibition's theme, biomorphism? Obviously it is risky, especially for someone who is a historian, but not an art historian, to speak too confidently of specific linkages between historical realities and aesthetic trends. Art and

43.
George Nelson (American, 1908–1986). *Ball* Wall Clock, Model No. 4755, designed 1947, manufactured by Howard Miller Clock Company, Zeeland, Michigan, c. 1948–69. Painted birch, steel, brass, 14 x 14 x 2¼ inches. Brooklyn Museum of Art, New York; H. Randolph Lever Fund, 2000.101.1

42.
Alvin Lustig (American, 1915–1955). *Incantation*, Model No. L-335, Laverne Originals Contempora Series, designed c. 1946–47, manufactured by Laverne Originals, New York, 1948–c. 1951. Linen, plainweave, silkscreen print. Collection of Elaine Lustig Cohen

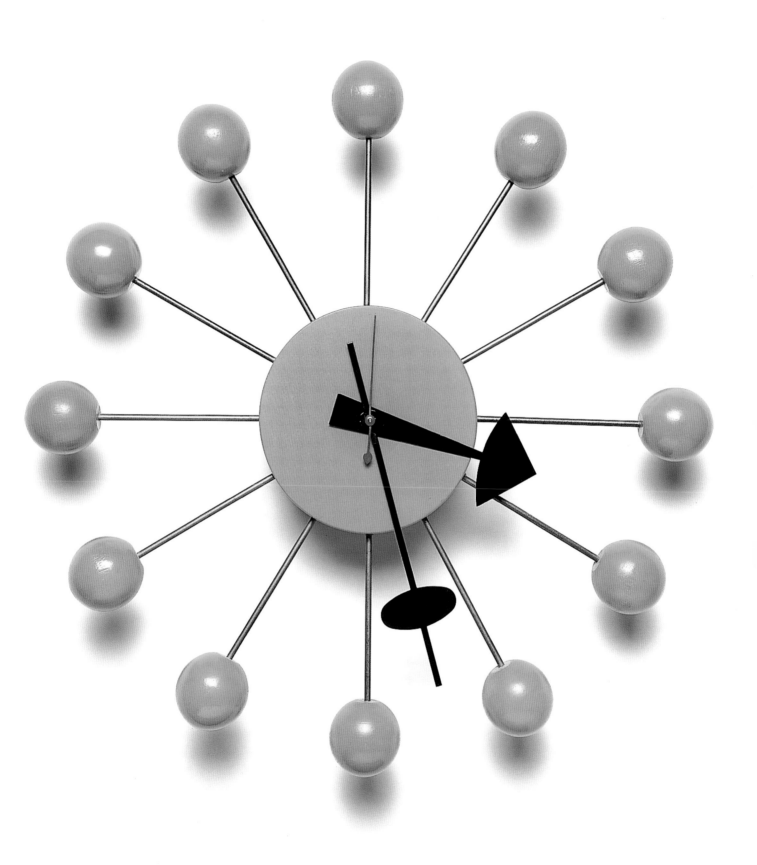

44.
Ruth Adler Schnee (American, b. Germany, 1923). *Swizzles*, Adler-Schnee Associates, Inc., Detroit, 1949. Printed textile. Brooklyn Museum of Art, New York; H. Randolph Lever Fund, 2000.100.1

design, even pop-culture fads, possess their own dynamic and integrity. They are not simply "reflections" of other historical developments. And the availability of new materials—plastics, most obviously—that lent themselves to more fluid, molded, flowing shapes no doubt encouraged artists to exploit these possibilities. Despite these caveats, however, some general reflections, offered in a speculative vein, may help stimulate reflection and discussion.

Sometimes, of course, the effort to link "art" and "history" is deceptively easy. In this exhibition, for example, objects such as George Nelson's 1947 wall clock (fig. 43) and Ruth Adler Schnee's 1949 textile design *Swizzles* (fig. 44) seem clearly to suggest, in a fairly straightforward way, the structure of the atom. Alvin Lustig's linen print *Incantation* of c. 1946–47 (fig. 42) offers a whimsical parody of the incomprehensible mathematical formulas of the quantum physicists. *Female Figure* by Robert Rauschenberg and Susan Weil (1950) evokes a person caught at the moment of an atomic blast, rendered almost transparent by a deadly flash of light (fig. 45). Alexander Calder's two circular brooches (fig. 46) recall the concentric circles of wartime and atomic devastation, centering on ground zero, that U.S. newspapers superimposed on maps of their cities in these years.

45.
Robert Rauschenberg (American, b. 1925) and **Susan Weil**
(American, b. 1930). *Female
Figure*, c. 1950. Monoprint:
Exposed blueprint paper,
105 x 36 inches. Collection of
Robert Rauschenberg, on loan
to the National Gallery of Art,
Washington, D.C., 49.E001.
© Robert Rauschenberg/VAGA,
New York

46.
Alexander Calder (American, 1898–1976). Two Circular Brooches, undated. Silver, each 3 inches in diameter. Private collection

As the *Vital Forms* exhibition impressively documents, this protean biomorphic aesthetic surfaces in countless paintings, textiles, and sculptures of the postwar years. It appears in the cloverleaf intersections of the new interstate highway system, the swooping curves of Saarinen's Trans World Airlines Terminal at Idlewild (later John F. Kennedy International) Airport (see figs. 99–101) and his Ingalls Rink at Yale (see figs. 96–98), the spiraling concentric circles of Frank Lloyd Wright's Guggenheim Museum (fig. 47), and Bertrand Goldberg's Marina City in Chicago (see fig. 116). It pervades the consumer culture as well, from the soaring tail fins of the 1959 Cadillac *Eldorado* (fig. 48) and many other automobile brands (one critic called them "insolent chariots") and the swirling free-form design of suburban swimming pools and bar lounges to a dizzying array of ceramics, sofas, chairs, neckties, brooches, and lamps. Biomorphism is apparent in the movement of the ubiquitous hula hoop (fig. 49) and the *Slinky* toy (see figs. 223, 224) no less than in Sally Victor's wonderful *Airwave* hat (see fig. 203) designed for Mamie Eisenhower.

Bearing in mind the historical context, what is one to make of the amazing ubiquity of this biomorphic aesthetic? Any larger interpretation must go beyond the obvious to more generally applicable connections. Are there aspects of this aesthetic impulse, broadly understood, that relate in some way to the historical

47.
Frank Lloyd Wright (American, 1876–1959). Solomon R. Guggenheim Museum, New York, 1943–45, 1956–59. Exterior view

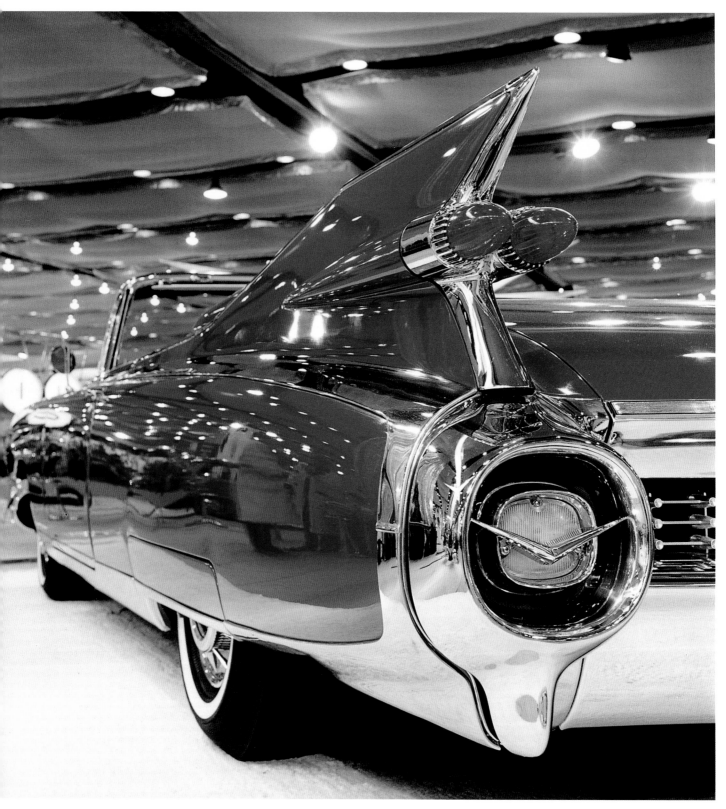

48.
Harley Earl (American,
1893–1969). Cadillac
Eldorado Biarritz Convertible,
for General Motors, 1959

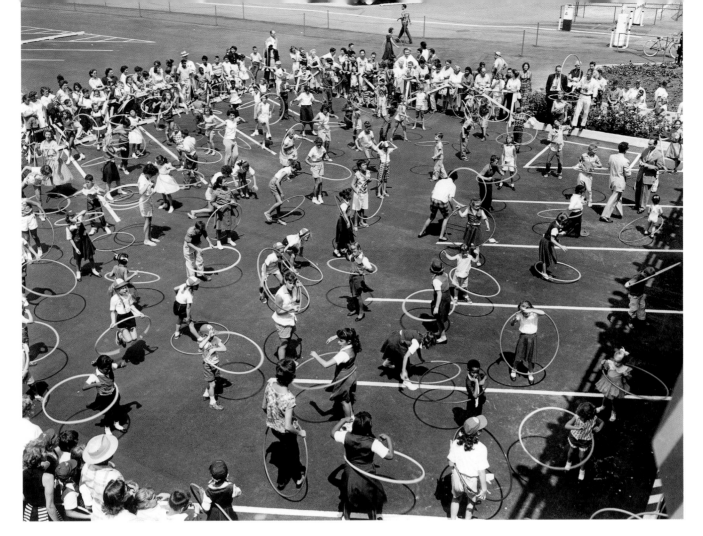

49.
Children ages two to sixteen
playing with hula hoops in
a competition for prizes on *Art
Linkletter's House Party*, CBS
Television City, Los Angeles,
October 20, 1958

50.
Al Capp (Alfred Gerald Caplin)
(American, 1909–1979) with
Peter Poplaski. Shmoo charac-
ters from the comic strip *Li'l
Abner*, 1948

preoccupations of these years? On one hand, of course, one might suggest that these protean, embryonic, fluid creations, somehow frozen in the process of becoming, embodied the upbeat mood of a people confidently looking to a future of progress, prosperity, and material well-being. Or, in the same positive vein, one might see this almost tender preoccupation with living, organic forms—albeit imagined ones—as an affirmation of renewed life and promise as America moved from war to peace.

But postwar America's darker, more anxiety-ridden side found expression in this biomorphic imagery as well. Awareness of the human body's awful vulnerability in the face of the technology of modern war, repressed during the war itself, belatedly burst into the cultural sphere after 1945, supplemented by the post-Hiroshima recognition that not just human life, but life itself, in all its forms, was jeopardized by the prospect of atomic war. (This larger awareness became fully explicit only much later, in Jonathan Schell's remarkable 1983 work *The Fate of the Earth*.)

Of all the arresting images of the bomb's human meaning in John Hersey's *Hiroshima* (1946), the most horrifying was certainly that of the soldiers blinded by the atomic flash, their melted eyeballs literally running down their cheeks. Then came the photographs from the Nazi death camps: the living skeletons staring blankly at the camera; the stacks of bodies about to be bulldozed into mass graves. Susan Sontag's account of encountering these appalling images as a teenager browsing in a quiet bookstore probably applies to almost all Americans of a certain age. I myself recall a comparable moment in a Paris theater as I watched Alain Resnais's 1956 Holocaust documentary *Nuit et Brouillard* (*Night and Fog*) (fig. 51); a woman in the audience moaned an anguished "Non" at a particularly horrific moment in the film.

Whatever its other sources, the fluid, indeterminate, nearly amorphous quality of scores of objects in this exhibition surely reflects this post-Hiroshima, post-Holocaust sensibility. Like the Shmoo characters in Al Capp's *L'il Abner* comic strip (fig. 50)—recalling a wonderful salt-and-pepper set designed by Eva Zeisel (see fig. 129)—these biomorphic forms always seem on the verge of melting down into some shapeless, primordial puddle. Where were Ernie Pyle, Bill Mauldin, and Norman Rockwell, with their solid, reassuring realism, their confidence of human endurance in the face of adversity, now that we really needed them?

The 1954 film *Them!* was only one of many in which the nuclear fears of the 1950s and early 1960s found expression in grotesque and unsettling images of

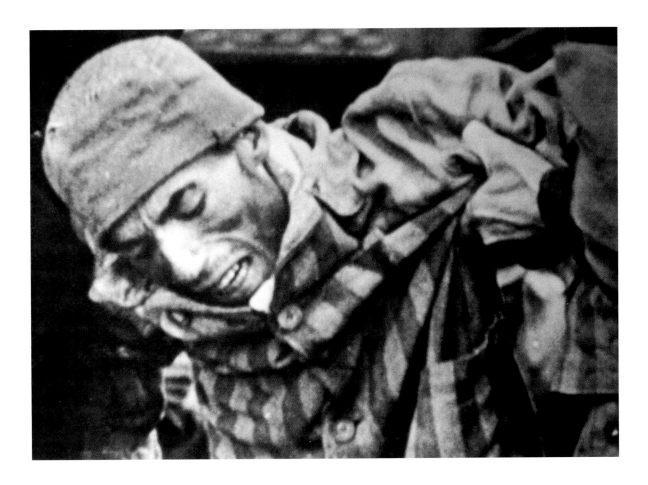

51.
Scene from the Holocaust documentary film *Nuit et Brouillard (Night and Fog)*, 1956, directed by Alain Resnais

familiar life forms mutating into bizarre and frighteningly sinister shapes—often after exposure to radiation. The monsters of the postwar imagination were not typically clanking robots or the sinister HAL-like computers of a later generation, but living creatures (see figs. 52–54): the shapeless but menacing blob buried in the Arctic ice in Howard Hawks's *The Thing from Another World* (1951); *Creature from the Black Lagoon* (1954); *Godzilla* (1956), awakened from his long sleep in Tokyo Harbor by atomic explosions; the marauding crustaceans of Roger Corman's *Attack of the Crab Monsters* (1957); the suburban husband whose pleasure boat passes through a radioactive cloud on a Sunday cruise, turning him into *The Incredible Shrinking Man* (1957). Even allowing for the imitative propensities of Hollywood filmmakers, and despite the tongue-in-cheek quality of some of these productions, the mutant-creature movies of these years were an authentic expression of the era's nuclear fears. Laughable today, these films, in their fumbling way, groped for ways to represent terrors

that were only too real at the time. Many of the objects in this exhibition are products of the same historical moment.

Perhaps the cultural power of the biomorphic aesthetic so effectively on display in this *Vital Forms* exhibition lay precisely in its indeterminacy, fluidity, and permeability. Endlessly melting, mutating, and flowing into new shapes, or trembling on the verge of total disintegration, this aesthetic of plasticity could express wildly divergent cultural moods, from soaring optimism to stomach-churning fear. These objects, from the most sophisticated to the most mundane, captured and fixed in time some aspect of the American psyche at the moment of their creation.

Certainly a historical perspective can enlarge our appreciation of the objects represented in this exhibition. But just as surely, a thoughtful examination of these objects can deepen our understanding of the period to which they bear witness.

52.
Poster advertising the film *Creature from the Black Lagoon*, 1954, with Richard Carlson and Julia Adams, directed by Jack Arnold. Universal-International

53.
Poster advertising the film *Attack of the Crab Monsters*, 1957, with Richard Garland, Pamela Duncan, and Russell Johnson, directed by Roger Corman. Allied Artists

54.
Scene from the film *Godzilla, King of the Monsters*, American version, 1956, with Raymond Burr, directed by Terry Morse (original Japanese version, 1954, directed by I. Honda). Trans World

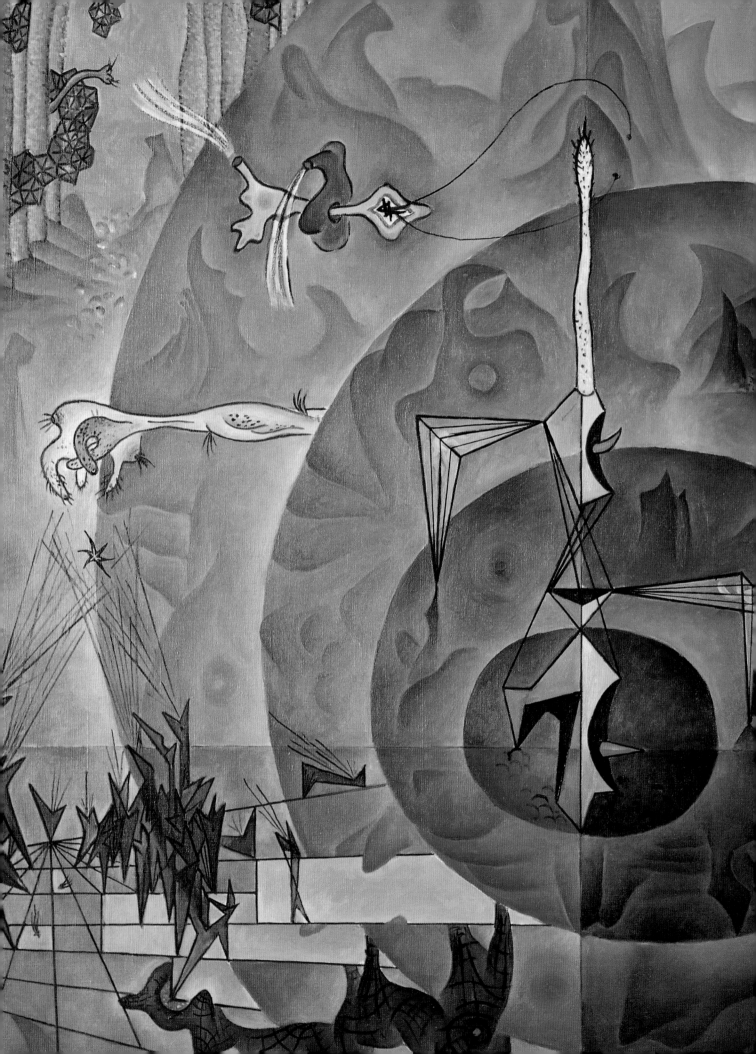

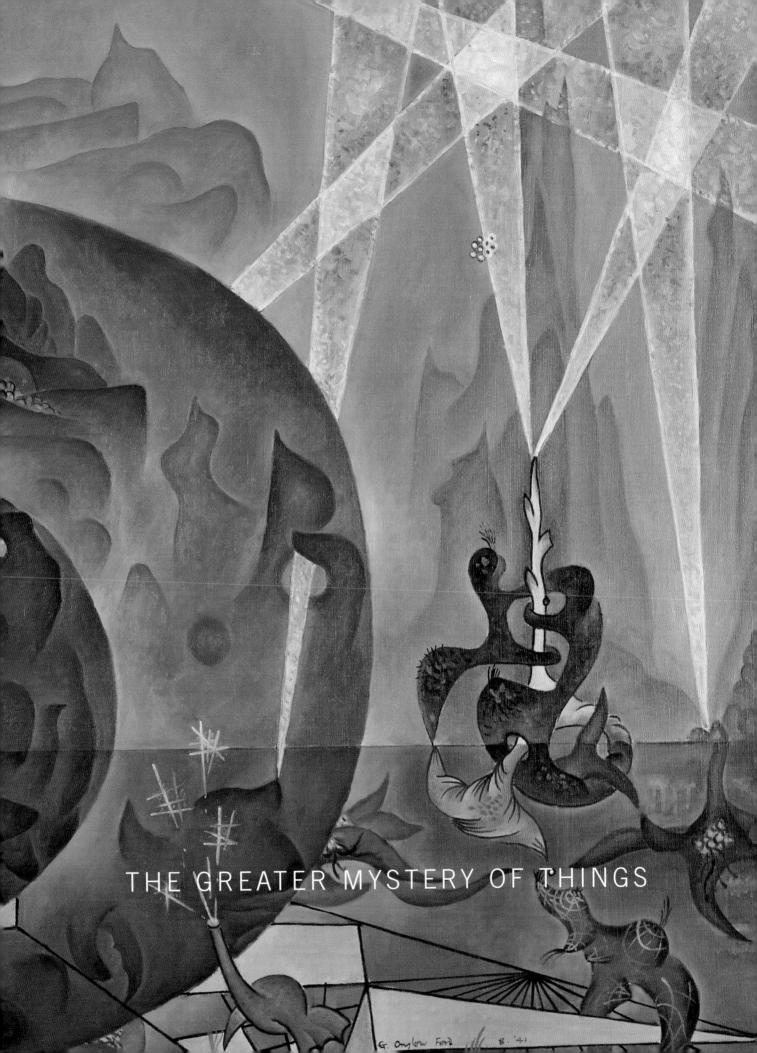

THE GREATER MYSTERY OF THINGS

G. Onslow Ford 8. '41.

The Greater Mystery of Things
ASPECTS OF VITAL FORMS IN AMERICAN ART

Brooke Kamin Rapaport

An existential feeling of crisis influenced American artists and resonated in their work in the mid-twentieth century, from the war years through the 1950s. Amid this cultural climate, an innovative artistic vocabulary of vital forms (also described as organic or biomorphic) emerged in American painting, sculpture, and photography of the 1940s and 1950s.[1] These natural forms could abstractly suggest the origins of life, the evolution into being, or the manipulated representation of a human being. In urban centers such as New York, San Francisco, and Chicago, artists used this particular language to assert a continuing life force at a time of worldwide conflagration. World War II was an immediate catalyst for this interest in natural forms, but the artistic development was also a result of the evolution of modernism and the ongoing philosophy called vitalism, and it was inflected by a range of other inspirations such as Freud's vision of the unconscious and Jungian myth.

WORLD WAR II AND ITS AFTERMATH

For artists who came of age in the 1940s, World War II was an immediate and consequential life experience. During the war, when the body was under siege, abstraction with a humanistic content was a viable artistic means of communicating the sustainability of all organic forms. Many artists during this period began to evoke natural forms and their metamorphosis through the life processes of genesis, growth, and decay.

The lives of a number of American artists were directly affected by the war. Some painters saw active duty—among them, James Brooks, George Cohen, and Frank Lobdell. Others, such as Leon Golub and Lee Mullican, served as mapmakers in the Army Corps of Engineers. Adolph Gottlieb—who, like Jackson Pollock and Mark Rothko, was rejected for military service—worked as a

welder in the Brooklyn Navy Yard.[2] The painter Steve Wheeler worked in Hoboken, New Jersey, as a shipfitter in the early 1930s and again in 1942. Among the sculptors, David Smith became a welder in a munitions factory in Schenectady, New York, and Theodore Roszak was employed at an aircraft company, where he learned industrial welding and brazing. Another sculptor, Ibram Lassaw, had access to oxyacetylene welding equipment at Camp Lee (now Fort Lee) in Virginia. A son of the sculptor Louise Nevelson was a merchant marine, stationed in Egypt and Russia.[3] Ruth Asawa and Isamu Noguchi, both Japanese-American sculptors, spent part of the war in relocation camps for people of Japanese ancestry.

These artists reacted to the worldwide cataclysm in their work. Gottlieb grappled for an appropriate form to communicate man's base failings, which he interpreted both inwardly in the subconscious and outwardly in the earliest forms of human conflict. He spoke of a kinship with what he called "the art of primitive men" and its relevance during harrowing times for contemporary society: "In times of violence, personal predilections for niceties of color and form seem irrelevant. All primitive expression reveals the constant awareness of powerful forces, the immediate presence of terror and fear, a recognition and acceptance of the brutality of the natural world as well as the eternal insecurity of life."[4]

Soon after the war, Gottlieb painted *The Prisoners*, 1946 (fig. 55)—one of his series of *Pictographs* of 1941–53—a work in which swirling segments of the human form are isolated and imprisoned in a grid pattern. In one section of the grid, a creature bares its teeth as an apotropaic gesture to fend off an intruder,

55.
Adolph Gottlieb (American, 1903–1974). *The Prisoners*, 1946. Oil, gouache, and tempera on canvas, 24⅞ x 31¹⁵⁄₁₆ inches. © Adolph and Esther Gottlieb Foundation/VAGA, New York

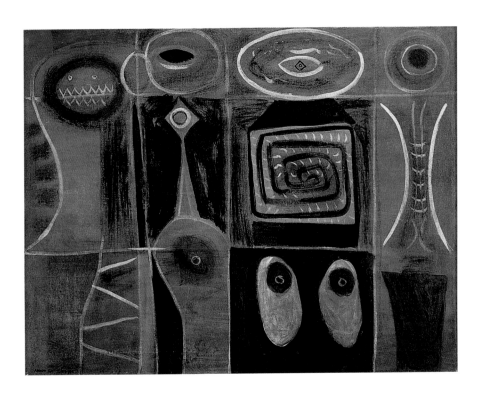

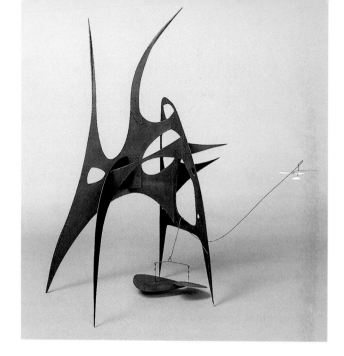

56.
Alexander Calder (American, 1898–1976). *Bayonets Menacing a Flower*, 1945. Painted sheet metal and wire, 45 x 58¼ x 19 inches. Washington University Gallery of Art, Saint Louis; University Purchase, McMillan Fund, 1946

while in another, an eye sits in the stomach of a quasi-abstract figure whose head is also an eye. Gottlieb frequently depicted searching eyes in his *Pictographs*,[5] either as witnesses to history or windows into the soul; here, hollow eyes are captives that stare out from adjacent cells, as the artist alludes to the war years.

The emotional angst that came out of the World War II experience was alluded to by Rothko in his paintings and watercolors of the mid-1940s, many of which have religious titles. *Entombment #1/The Entombment*, 1944 (fig. 57), refers to the entombment of Christ and evokes the wartime death of innocents. It shows a biomorphic form that might be seen as a figure with its arms raised over its three heads, perhaps representing the Virgin Mary, Mary Magdalene, and John the Evangelist.

Because of wartime restrictions on civilians' use of metal, Alexander Calder resorted to dismantling the aluminum sailboat from his pond in Roxbury, Connecticut, to use as material for his sculpture. Calder, known for his mobile constructions of organic abstract forms and gently humorous images of circus animals, entertainers, or sea creatures, also made a number of works relating to war, such as *Bayonets Menacing a Flower*, 1945 (fig. 56). The bayonets of the title are suggested by the dark, spindly, looming forms of this stabile (Calder's term for his earthbound, stationary sculptures), jutting upward and outward like tentacles about to snatch the delicate white petals of a vulnerable flower suspended in space nearby. Here, Calder has created a multilimbed weapon as a force that threatens nature and, by extension, humankind. Similarly, *The Root*, 1947 (fig. 59), created soon after the war, implies dark forces threatening the free-flowing organic leaves.

57.
Mark Rothko (American, b. Russia, 1903–1970). *Entombment #1/The Entombment,* 1944. Oil on canvas, 29⅝ x 39½ inches. Collection Mrs. Edith Ferber

Louise Nevelson later recalled how the restrictions on the use of metals needed for military equipment affected sculptors during and after the war: "Don't forget that during the Second World War all the metals were difficult to get and consequently particularly in America men and women artists, male and female, began to use torches. First they also went into the factories to produce for war and then they began to use torches." For Nevelson, however, "the whole performance of the torch, and the word torch and the performance of the torch just went against my feeling."[6] She preferred to make sculpture in wood, a

material that was not forged by the oxyacetylene torch, but a natural material that she could paint or stain and that symbolized birth, growth, and decay.

Noguchi's view of war is reflected in *This Tortured Earth*, 1943 (fig. 58), a bronze model for a proto-earthwork, in which he proposed transforming gentle contours of land into contorted hills and ridges. Rather than creating the jubilant playground for children that he had planned in 1941 for a Central Park site (see fig. 117), two years later Noguchi envisioned a tormented Mother Earth laid bare, scourged by battle. He later wrote, "The idea of sculpting the earth followed me through the years, with mostly playground models as metaphor, but then there were others. *This Tortured Earth* was my concept for a large area to memorialize the tragedy of war. There is injury to the earth itself. The war machine, I thought, would be excellent equipment for sculpture, to bomb it into existence."[7] In 1950, he went to Japan and spent two years engaged primarily in creating memorials to the war dead: two sculptural concrete bridges (completed 1952) for Peace Park in Hiroshima, and two proposals (never realized) for a memorial to those who perished in the bomb blast.

In a 1951 radio interview, Jackson Pollock pointed to world-changing developments such as the explosions over Hiroshima and Nagasaki to explain his looking out, beyond the self, for sources in his work. "It seems to me," he said, "that the modern painter cannot express this age, the airplane, the atom bomb,

59.
Alexander Calder (American, 1898–1976). *The Root*, 1947. Sheet metal, wire, and paint, 48 x 26 x 33 inches. Collection Calder Foundation, New York

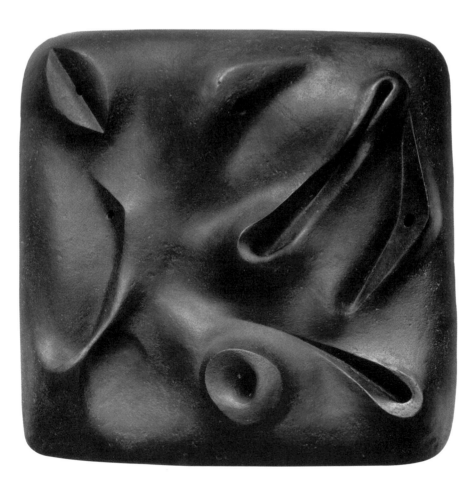

58.
Isamu Noguchi (American, 1904–1988). *This Tortured Earth*, 1943. Bronze relief model, 3 x 26 x 26 inches. The Isamu Noguchi Foundation, Inc., Long Island City, New York

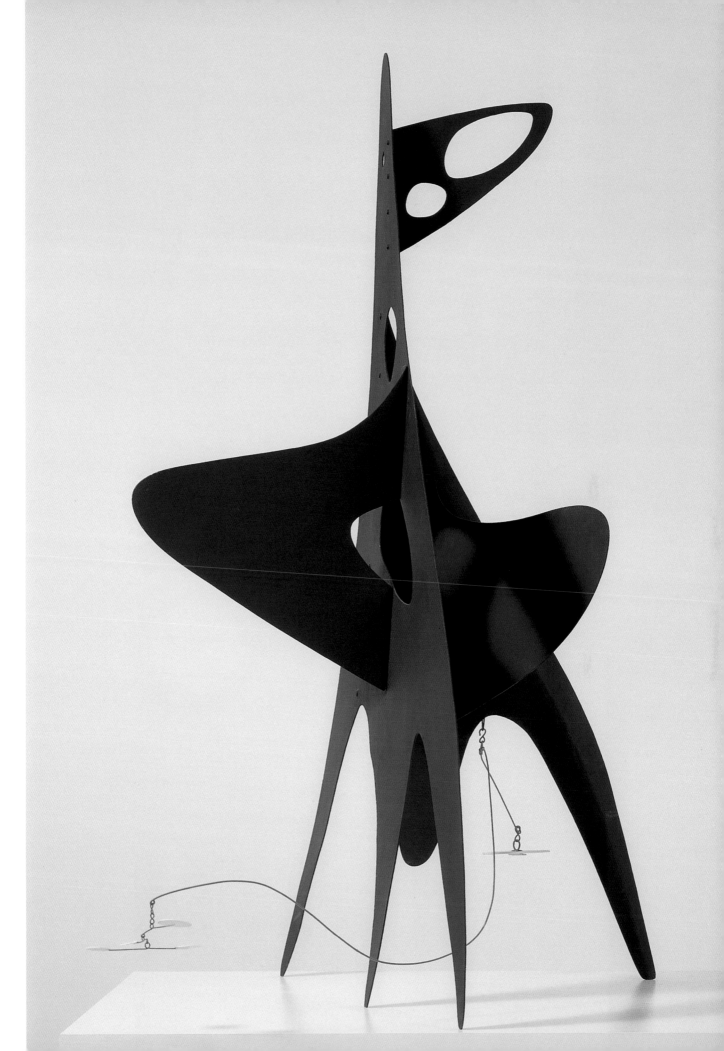

the radio, in the old forms of the Renaissance or of any other past culture. Each age finds its own technique."[8] In this public statement, Pollock was making a connection between his vanguard—and, at the time, controversial—work and the necessity for its creation during a period of cataclysmic change. The technique that won Pollock notice was his method of dripping and pouring paint onto a canvas placed directly on the floor, which he began using about 1947, creating works featuring densely layered, overlapping loops of pure pigment, obscuring easily recognizable signs, symbols, or images.

Discussions of Lee Mullican's work often focus on postwar sources such as the year he spent on Native American lands in New Mexico or his association with the Dynaton group in San Francisco, but his service in the U.S. Army as a topographical draftsman in the Engineer Corps from 1942 to 1946, including twenty-one months in the Pacific and Japan, was a formative experience artistically. His job involved transcribing land contours, waterways, vegetation, and camouflage patterns from aerial photographs. Immediately following the dropping of the bomb, he expected to return to his family in Oklahoma. He was shipped to Yokohama, Japan, however, and later recalled that "there was nothing but rubble. Between Yokohama and Tokyo, it was absolutely leveled…[and] during that time I had a sense of what war was really like."[9] Mullican's allover compositions of the postwar period feature decorative patterning that calls to mind aerial views of topography, and the structured areas of a somewhat later work, *Fable*, 1957 (fig. 60), suggest the undulating lines of terrain in the maps he made (see fig. 61). He used the edge of a palette knife to render matchstick-like brushstrokes that grow from and within natural forms as background and foreground meld together.

Barnett Newman's *Pagan Void*, 1946 (fig. 62), is simultaneously contemporary and primordial, featuring a motif that stands metaphorically as an atomic cloud that blocks the sun, yet also harks back to prehistory, evoking a life force that will grow from a central void. Such paintings attest to the intensity with which contemporary issues and concerns propelled this generation of artists, and how much the overwhelming feelings of crisis and angst generated by the war resonated in their work. Reflecting back on the period, Newman declared that "the history of my generation begins with the problem of what to paint. During the war it became sort of nonsensical to get involved in painting men playing violins or cellos or flowers…[and] the war…made it impossible to disregard the problem of subject matter."[10] Rather than address these subjects in a documentary manner, the artists found that abstraction was the sincerest metaphor, the most viable means to address some of the darkest questions that the war provoked.

60.
Lee Mullican (American, 1919–1999). *Fable*, 1957. Oil on canvas, 30 x 40 inches. Estate of the artist, courtesy Grant Selwyn Fine Art, New York and Los Angeles

61.
Lee Mullican (American, 1919–1999) and others. Third Army U.T.P. Training Test, 1943. Printed paper, 22¼ x 20 inches. Estate of the artist, Los Angeles

VITALISM

One source for vital forms in American art of the 1940s and 1950s was the philosophy of vitalism, which interested many painters and sculptors of the period because of its resonance in contemporary life as a poetic tenet. Vitalism posits that the essence of life cannot be explained solely in material terms through science and must be attributed to a vital force, shared by all living things, which can best be apprehended by intuition.[11] This philosophy, which has its origins in seventeenth-century European thought, underwent a revival toward the end of the nineteenth century and is still known today through the writings of the French philosopher Henri Bergson (1859–1941) and encapsulated in his notion of the "vital impulse" or "life force" (élan vital).[12] Bergson emphasized the dualism of existence, with its two opposing tendencies: the dynamic life force and the material world that resists it. In his view, humans know matter through the intellect, by which the world is interpreted in terms of separate, measurable (i.e., scientific) entities; but we also possess intuition, giving us the ability to understand the importance of the life force and its governance of the true reality of time as duration, perpetual flux, and continuity, which constitute the innermost reality of all things. The world is in perpetual evolution, with the vital impulse continuously developing and generating new forms; and our fluid consciousness, which enables us to understand the world's dynamic qualities and our own existence in time, gives us the ability to act freely, intuitively, and spontaneously, rather than just rationally.

Vitalism was initially appealing to artists in the twentieth century as an explanation for the mysteries of life that were not observable. As Willem de Kooning remarked in 1951:

> The argument often used that science is really abstract, and that painting could be like music...is utterly ridiculous. That space of science—the space of physicists—I am truly bored with by now. There seems to be no end to the misery of the scientists' space. If I stretch my arms next to the rest of myself and wonder where my fingers are—that is all the space I need as a painter.[13]

While these artists may not have declared themselves as vitalists per se, ideas inherent to vitalism appear to have affected their work, and sometimes to have been directly considered. The English art historian and literary critic Herbert Read was instrumental in disseminating vitalist ideas as they applied to the evolution of modern art in the twentieth century.[14] Although Read referred to

62.
Barnett Newman (American, 1905–1970). *Pagan Void*, 1946. Oil on canvas, 33 x 38 inches. National Gallery of Art, Washington, D.C.; Gift of Annalee Newman in honor of the 50th Anniversary of the National Gallery of Art, 1988.57.1

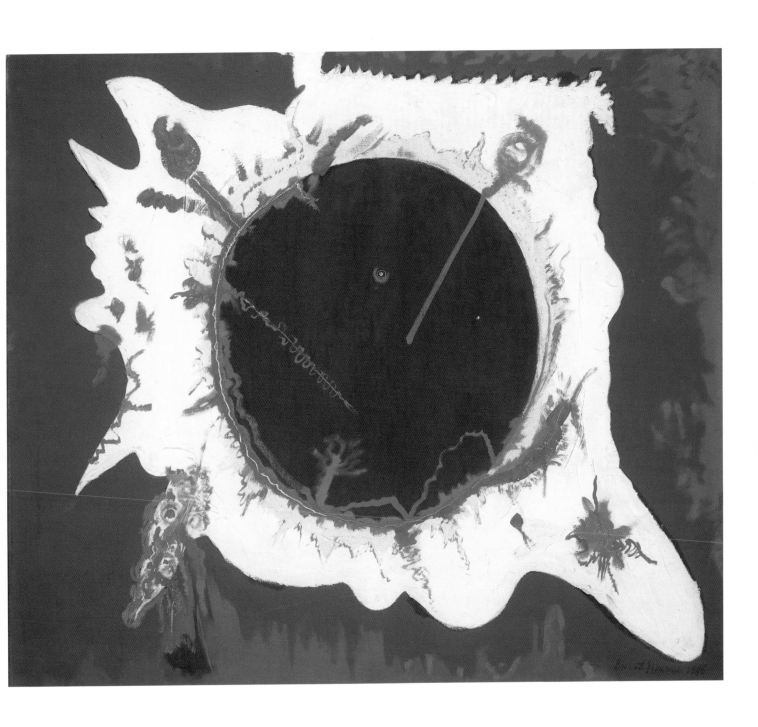

"vitalism" explicitly only in connection with sculpture, most prominently in his book *A Concise History of Modern Sculpture* (1964), in several earlier essays and books he articulated the notion of an underlying "vitality" of a particular kind of organic abstract art and described the "vital forms" created by various modern artists (including the painters Wassily Kandinsky, Paul Klee, Pablo Picasso, and Pollock, and the sculptors Constantin Brancusi, Auguste Rodin, Henry Moore, and Picasso again).[15]

One of the earliest examples of Read's linking Bergsonian vitalism and organic form in art occurs in his book *Art and Society* (1937), where he declares that the forms created by the abstract artist "repeat in their appropriate materials and on their appropriate scale certain proportions and rhythms which are inherent in the structure of the universe, and which govern organic growth, including the growth of the human body."[16] In his introduction to a 1944 book on Moore's sculpture, Read explains in detail his conception of an art of vitality and its use of vital forms. After asserting that "there will always be a tendency to associate the organic with the vital and therefore with the human," he questions "why the artist who frankly resorts to vital or organic forms does not literally reproduce them, but recombines them or distorts them in an apparently willful manner." The answer, he responds, lies in the belief of Moore (and artists like him throughout the ages) "that behind the appearance of things there is some kind of spiritual essence, a force or immanent being which is only partially revealed in actual living forms...."[17] Through this process, a work of art achieves "vitality," by which Read means (quoting Moore) "not...a reflection of the vitality of life, of movement, physical action...but...a pent-up energy, an intense life of its own, independent of the object it may represent" and thus "may be a penetration into reality,...an expression of the significance of life"— which Read categorizes as "the direct expression of an organic vitalism."[18]

Jack Burnham, in a comprehensive account of vitalism in twentieth-century sculpture in his book *Beyond Modern Sculpture*, made a similar connection between organic processes and the making of art as he described vitalists' interest in "the natural process, an abiding awareness of the living characteristics of natural forms."[19] It was as if the artist were endowed with the power to evoke life in the objects he created. Like Read, Burnham identified vitalistic sculpture as "cop[ying] nature through example and metaphor, not primarily through mimeticism."[20]

Revealing his work's affinity with vitalism, the painter Steve Wheeler stated that a painting is "a fluid drama" shaped by "the undulating line [that] moves and turns back toward the starting point," thus creating forms of "a kind that

Bergson describes as 'impossible to say precisely where one ends and the other begins.'[21] Wheeler owned many books by Bergson, Read, and Alfred North Whitehead, and other documents related to vitalist philosophy in the large personal library that he amassed during his lifetime.[22]

Although never a mainstream philosophy, vitalism was appealing to artists because it offered a way for them to evoke nature metaphorically, through an exploration of life processes and their own inner worlds by following what Read refers to as "the deeper intuitions of…the collective unconscious,"[23] borrowing Jung's term. The California painter Gordon Onslow Ford recently spoke of the "inner worlds" as central to the content in his painting (see figs. 69, 70) and of his goal to impart the core of life through his work.[24] Pollock spoke in 1947 of allowing this life to emerge while creating a painting: "I have no fears about making changes, destroying the image, etc., because the painting has a life of its own. I try to let it come through."[25]

Following Bergson's interest in metaphorically depicting what cannot be seen, Read wrote in his 1964 history of modern sculpture that the vital image emerged in the process of creating "a plastic symbol of the artist's inner sense of numinosity or mystery, or perhaps merely of the unknown dimensions of feeling and sensation."[26] Noguchi spoke of being "wedded to the idea of an intrinsic quality residing in the material" with which he worked.[27] Seymour Lipton, whose own sculpture, such as *Earth Forge II*, 1955 (fig. 63), burrowed into

63.
Seymour Lipton (American, 1903–1986). *Earth Forge II*, 1955. Nickel-silver over steel, 31⅛ x 52⅝ x 19¼ inches. Brooklyn Museum of Art, New York; Dick S. Ramsay Fund, 56.188

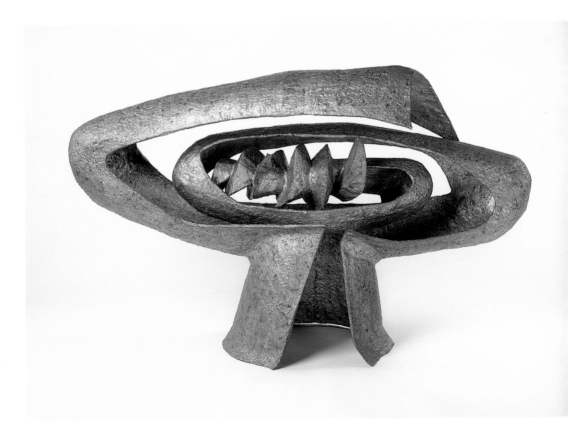

nature as a metaphor for the human condition, stated: "This particular perspective of the hidden processes of man, the hidden insides of nature, what goes on behind the flower in the bud, what goes on in wintertime under the ground, what goes on in the hidden recesses of the human heart and the human mind, these things are very real to me."[28] Regularly, Lipton represented the interior and exterior of a form in one sculpture, requiring the viewer to analyze what lies beneath the surface.

Mid-century abstract sculptors such as Lipton, Roszak, and David Smith, with their innovations in metalwork owing to the use of the oxyacetylene torch, could use welding techniques to evoke natural forms and communicate this inner, vital force—Lipton before 1951, Smith by the late 1930s (and in his *Tanktotem* sculptures, 1952–60), and Roszak after 1945. However, this established a complicated circumstance inherent in some war-period and postwar art. Even though vitalism was often opposed to the machine, artists often employed industrial tools to create these life forms in their work. Ironically, welded sculpture recalling natural forms was made with the same tools used for the production of wartime equipment.

By the mid-twentieth century, with new scientific advances and more accurate depictions of nature through photography, microscopy, and molecular biology, some makers of vital forms were more directly inspired by a scientific examination of nature to explore its heretofore hidden organic forms. Berenice Abbott's photograph *Soap Bubbles*, 1946 (fig. 64) recalls the asymmetrical structure of cells under a microscope in an image achieved by a strict and detailed focus through the mechanical lens of her camera. In 1930 the photographer Edward Weston had stated that this penetrating view was one that he longed for: "I want the greater mystery of things revealed more clearly than the eyes see, at least more than the layman, the casual observer notes. I would have a microscope, shall have one some day."[29] However, even Weston, in his precise photographic explorations of organic forms—focusing on such seemingly ordinary subjects as peppers and driftwood—sought to delve beneath the surface of reality, to create works that would take people "beyond the world we know in the conscious mind" and "into an inner reality—the absolute—with clear understanding, a mystic revealment" (see fig. 65).[30]

In the mid-1940s, Minor White studied photography with, among others, Ansel Adams, Alfred Stieglitz, and Edward Weston. White's acute perceptions of nature reveal the influence of those masters, as does his formalism, faithful tonality, and rich texture, and his practice of capturing nature in sequence,

65.
Edward Weston (American, 1886–1958). *Cypress and Stone Crop*, 1941. Gelatin silver print, 7½ x 9⅝ inches. Brooklyn Museum of Art, New York; Frank L. Babbott Fund and Frederick Loeser Fund, 1946.75.7

through a series of photographic images meant to depict the unfolding of the natural process. Although *Empty Head*, 1962, from the *Sound of One Hand Clapping* sequence (fig. 66), recalls a darkened, bulbous head, White actually photographed frost on a windowpane. Like Weston, White sought to convey the mystical details of nature through abstract means.

66.
Minor White (American, 1908–1976). *Empty Head*, 1962, from the sequence *Sound of One Hand Clapping*. Gelatin silver print, 11 x 8½ inches. The Minor White Archive, Princeton University, New Jersey, 62.9

MODERNISM, SURREALISM, AND VITAL FORMS

This desire to reveal the greater mystery of things by penetrating an "inner world" became a central idea that motivated a significant number of American artists almost simultaneously in the early 1940s. At that time, some artists turned away from geometric abstraction and its rational application that symbolized the promise of the machine, while others rejected the picturesque representational model of American Scene painting and Regionalism, which amid the gravity of war seemed innocent and nostalgic. These more progressive artists chose neither the static aspects of geometry nor folkloric subjects to express what they considered to be essential, but instead developed a fresh pictorial language that revealed humanistic content through abstraction. Among the sources of this new approach to art were European modernists such as Kandinsky, Paul Klee, Joan Miró, and Picasso and some of the influential

pioneers of modernism in America such as Arthur Dove and Georgia O'Keeffe, who focused on observed forms in nature.[31]

Herbert Read noted that Kandinsky's paintings from about 1912 to 1920 (particularly his *Improvisations*), with their "endlessly 'free,' and inexhaustibly evocative" abstract forms, "distinctly organic in feeling," constituted "a new power which would enable man to reach an essence and content of nature lying beneath the surface."[32] Read regarded the works of Klee, whose pictorial symbols are "an organic development of his feelings, [with] stems and roots in his individual psyche," as equally essential to the development of modern painting. Klee's particular importance, Read noted, lay in his realization that the formative process of creating art "takes place below the level of consciousness...[in a] process of gestation...involving observation, meditation, and finally a technical mastery of the pictorial elements."[33] Read also perceived vital forms in the paintings of Léger, the sculpture of Arp ("forms which seem to illustrate the essential modes of growth and organic function"), and the biomorphic abstraction of Picasso in the late 1920s and early 1930s, with its archetypal imagery, human figures "subjected to extreme degrees of metamorphosis," and "convulsive energy which seems to burst out of the boundaries of the canvas."[34]

The expressiveness, vitality, and flux that Read saw in the works of Kandinsky, Klee, and other European modernists are also apparent in paintings by Dove and O'Keeffe inspired by natural forms. Both of these American artists attempted in many of their works to evoke the processes of life and growth in organic terms, as in Dove's *Silver Sun*, 1929 (fig. 67) and O'Keeffe's *Blue No. 1*, 1916 (fig. 68). Dove's earliest abstractions were done about the same time as Kandinsky's. Dove's simplified forms from nature became, in his final years, before his death in 1946, even more abstract and primordial, in an attempt "to make concrete both the outer and inner reality of his experience in nature."[35] O'Keeffe, in abstract works such as *Blue No. 1*, evoked the world of nature without literally representing it, often suggesting the merging of body and landscape. She was deeply affected by the desert landscape of the American Southwest, and began spending her summers there after 1929, making a number of paintings featuring desert plant life and animal skulls and bones.

Although the American artists in the early 1940s had learned much from certain modernists, the arrival of several of the Surrealists in the United States about that time provided another catalyst for the new direction they sought. They had become familiar with much Surrealist art during the 1930s through various publications and, in New York, a series of small gallery exhibitions preceding the Museum of Modern Art's exhibition *Fantastic Art, Dada, and*

67.
Arthur Dove (American,
1880–1946). *Silver Sun*,
1929. Oil and metallic paint on
canvas, 21⅝ x 29⅝ inches.
The Art Institute of Chicago;
Alfred Stieglitz Collection,
1949.531

68.
Georgia O'Keeffe (American,
1887–1986). *Blue No. 1*,
1916. Watercolor and graphite
on very thin Japanese gampi-
fiber paper, 15⅞ x 11 inches.
Brooklyn Museum of Art,
New York; Bequest of Mary T.
Cockcroft, by exchange, 58.73

Surrealism in 1936.[36] A large group of Surrealists came to the United States between 1939 and 1942. Some ended up staying in or near New York for the duration of the war or longer, including Max Ernst, Gordon Onslow Ford, André Masson, Roberto Matta Echaurren, and Yves Tanguy, as well as André Breton, the founder and leader of the Surrealist group.[37] Only a few American artists had direct contact with them, but through publications, exhibitions, and lectures, the Surrealists' work became more widely known among the future Abstract Expressionists and other Americans during the 1940s.[38]

The Surrealists' interest in exploring the human psyche, particularly through the technique of automatic drawing (developed by Arp, Masson, and Miró in the 1920s), encouraged the Americans to experiment with dynamic, open, expressive forms guided by their own intuition and helped propel them toward organic abstraction. Matta—a Chilean-born painter who became a member of the Surrealist group in Paris in 1938, participated in the International Surrealist Exhibition there that year, and came to New York in 1939—was instrumental in promoting the automatist technique among a small group of artists (William Baziotes, Arshile Gorky, Robert Motherwell, and Pollock) in 1941–42.[39] In the first three months of 1941, some of these same artists had attended a series of four slide lectures on Surrealist art at the New School for Social Research in New York given by Gordon Onslow Ford, a close friend and colleague of Matta. The British-born Onslow Ford had gone to Paris in 1936, studied briefly with Fernand Léger, and met Matta there in 1937, the year Matta first experimented with automatism. Onslow Ford began making automatic drawings the following year, and in 1939 became a member of the Surrealist group and exhibited with them before returning to London; shortly after that, he came to New York to lecture. Among those who attended the lecture series, entitled "Surrealist Painting: An Adventure into Human Consciousness," were Matta, Tanguy, and several members of the future New York School, including Baziotes, Jimmy Ernst, Gorky, David Hare, Motherwell, Pollock, and Rothko.[40] In conjunction with his lectures, Onslow Ford organized a series of exhibitions at the New School, presenting works by himself, Arp, Ernst, Matta, Miró, Moore, Wolfgang Paalen, Tanguy, and others.

During the brief time that he was in New York (1940–41), Onslow Ford rented a studio on West Eighth Street, where he painted *Temptations of the Painter*, 1941 (fig. 70). In this work, Onslow Ford offers his vision of an insular world of biomorphic creatures and geometric forms floating in a surreal realm, with mountaintops reaching up to the cosmos within concentric circles superimposed on a grid of four rectangular planes. In 1948 he wrote, "My space is full

69.
Gordon Onslow Ford (American, b. England, 1912) with his wife, Jacqueline Johnson, at home on Chestnut Street in San Francisco, where they lived from 1948 to 1951

and forms a continuum of interpenetrating substance in which the parts have…
a changing relationship with each other." The complex composition here, as
in Onslow Ford's other paintings, suggests the flux and interconnectedness of
all of nature and evokes the artist's "inner world." His aim was to penetrate
beneath the visible surface of existence "to express a concept of space-time; to
paint things felt but not seen."[41] While living in Mexico (1941–47), Onslow Ford
resigned from the Surrealist group (in 1943). In 1948 he moved to San Francis-
co (see fig. 69), where he had a retrospective exhibition at the San Francisco
Museum of Art. Paalen had moved to nearby Mill Valley about the same time,
and Onslow Ford, Paalen, and Lee Mullican began exhibiting together as the
Dynaton group in 1950.

Three events in New York during 1942 were of particular significance for the
synthesis of modernist abstraction and Surrealism in which the younger genera-
tion of American artists participated. *VVV,* an avant-garde journal, was founded
jointly by Hare and Breton (with Hare as editor, and Motherwell as an editorial
advisor), with contributions by Surrealists and future Abstract Expressionists

70.
Gordon Onslow Ford (American,
b. England, 1912). *Tempta-*
tions of the Painter, 1941. Oil
on canvas, 46½ x 60 inches.
Collection of the artist

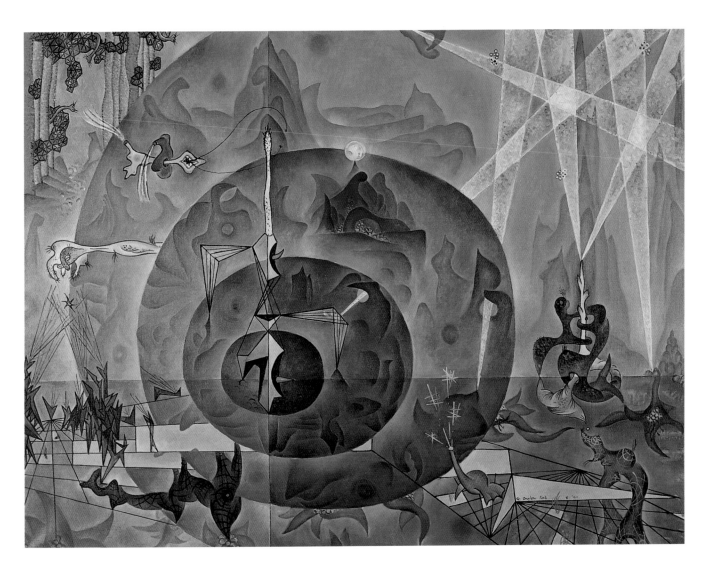

71.
Roberto Matta Echaurren
(Chilean, b. 1911). Cover of
VVV, February 1944. Published
June 1942–February 1944.
11¼ x 8¾ inches. Brooklyn
Museum of Art, New York; Art
Reference Library

72.
Arshile Gorky (American,
b. Armenia, 1904–1948). *The
Unattainable*, 1945. Oil on
canvas, 41¼ x 29¼ inches.
The Baltimore Museum of Art;
Blanche Adler Bequest;
Frederic W. Cone; William A.
Dickey, Jr.; Nelson and Juanita
Greif Gutman Collection;
Wilmer Hoffman; Mr. and Mrs.
Albert Lion; Saidie A. May
Bequest; Philip B. Perlman
Bequest; Leo M. Rogers, New
York; Mrs. James N. Rosenberg;
and Paul Vallotton Funds, by
exchange, 1964.15

(see fig. 71).[42] In October 1942, *The First Papers of Surrealism,* an exhibition organized by Breton and Marcel Duchamp, opened in a mansion on Madison Avenue, presenting works by more than three dozen European and American artists oriented toward Surrealism, including Onslow Ford, Baziotes, Calder, and Hare. That same month, Peggy Guggenheim opened her gallery, Art of This Century, featuring abstract and Surrealist art as well as Surrealist-inspired interiors designed by Frederick Kiesler (see fig. 167). It became a meeting place for European and American artists, and over the next several years, she presented the first solo exhibitions of Baziotes, Hans Hofmann, Motherwell, Pollock, Rothko, Charles Seliger, and Clyfford Still.

An important connection between the abstract Surrealists and the Abstract Expressionists was Arshile Gorky, who became a close friend of Matta's. For the first fifteen years of his career, until the early 1940s, Gorky was aware of Synthetic Cubism and Surrealist biomorphic abstraction, which became a dominant interest in 1936, when he looked to the work of Picasso and Miró. About 1940, as a pioneering Abstract Expressionist inspired by Kandinsky's early *Improvisations* and Matta's late 1930s automatist paintings, Gorky created biomorphic abstractions that were more complex and fluid, and he developed his mature style, as in *The Unattainable*, 1945 (fig. 72). Gorky died by his own hand in 1948. Two years later, Gottlieb wrote that "the vital task [for us] was a wedding of abstraction and surrealism. Out of these opposites something new could emerge, and Gorky's work is part of the evidence that this is true."[43]

During the 1930s, Gottlieb was painting somewhat expressionist representational figure studies and still lifes. His shift to a new approach in the 1940s in his *Pictographs* (see fig. 55), featuring flat images of human body parts, semi-abstract animals, and totemic signs, was influenced not only by the horror of World War II, but by his interest in archaic and American Indian art and by the Surrealists' automatist technique and painterly style.

Rothko, who had been painting the human figure in the 1930s, began to abstract the figure after experimenting with automatism about 1941. His paintings of the early 1940s feature totemic hybrids of natural and classical forms, often inspired by the timeless symbols of the myths of antiquity. In the mid-1940s he created freer organic shapes, either still based on the figure and incorporating Christian iconography or using forms resembling underwater life. In 1946, moving toward what would become his signature style, his work became increasingly abstract, and his forms more soft-edged and amorphous.

Baziotes met Matta in 1940, and in 1941 began using automatic drawing to paint abstractions exploring the kinds of pictorial space proposed by Matta and

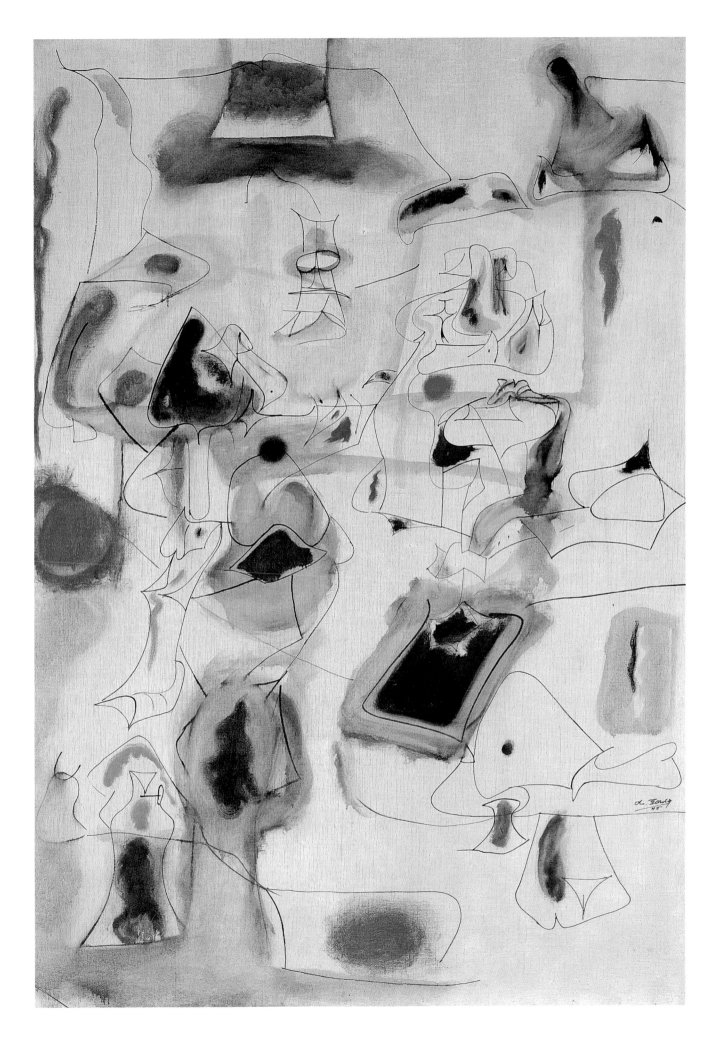

Onslow Ford.[44] During the mid-1940s, he tried to organize these forms within the structural framework of a loose grid, but about 1946 he started to create compositions that concentrated on one or two larger, simpler shapes, often suggesting abstract versions of aquatic organisms. This tendency continued into the 1950s, as, for example, in *The Flesh Eaters*, 1952 (fig. 73), which evokes an underworld gone awry. It features a Medusa-like creature, whose head menacingly sprouted branches instead of snakes, above which two hovering creatures are about to be consumed—or to consume each other.

Although in the early 1930s Pollock studied with the regionalist painter Thomas Hart Benton at the Art Students League in New York, by the late 1930s and early 1940s he would reject that style as not urgent enough for the contemporary world and turn to the work of modernists and Surrealists. Pollock, like Baziotes, Gorky, and Rothko, was impressed with biomorphic Surrealism and, through direct contact with Matta, began experimenting with automatism about 1941. Even before that, he had become aware of the role of the unconscious in enlarging the expressive possibilities of his art and was attracted to myth, archetypes, and totemic images. In the late 1930s and early 1940s, Pollock knew the work of Masson, Miró, and Picasso, and Klee's late pictographic forms, and in the mid-1940s, art by Kandinsky (which he saw firsthand when he worked as a custodian at the Museum of Non-Objective Painting in 1943). Between 1942 and 1946, Pollock began to eliminate his references to myths and to focus instead "on the mythic properties of his biomorphic forms in themselves."[45] Read found "the clue to Pollock's originality" in his art's foundation in immediate concrete pictorial sensations, which Read associated with vitality.[46]

Charles Seliger was one of the youngest artists to exhibit at Art of This Century, receiving his first solo show there in 1945, when he was only nineteen. He admired the gallery's vanguard position and was attracted to the idea of being in the same company as Baziotes, Jean Hélion, Kiesler, Motherwell, and Pollock. As a teen in Baltimore, Seliger had read Herbert Read's *Art Now* (1933) and particularly studied the chapter on Surrealism; and he later became familiar with Bergson's notion of *élan vital* and its fundamental role in a continually developing universe;[47] in the early 1940s he became personally acquainted with Breton, Ernst, and Tanguy. Seliger has always kept the scale of his canvases small, choosing to burrow down into his subject matter and make his paintings reflect this intensity. "I wanted to investigate the interior of shapes," he recalled in 1995. "In Lucretius's book on nature he talked about atoms. Science keeps breaking things down to smaller and smaller and smaller [things]."[48] Seliger's

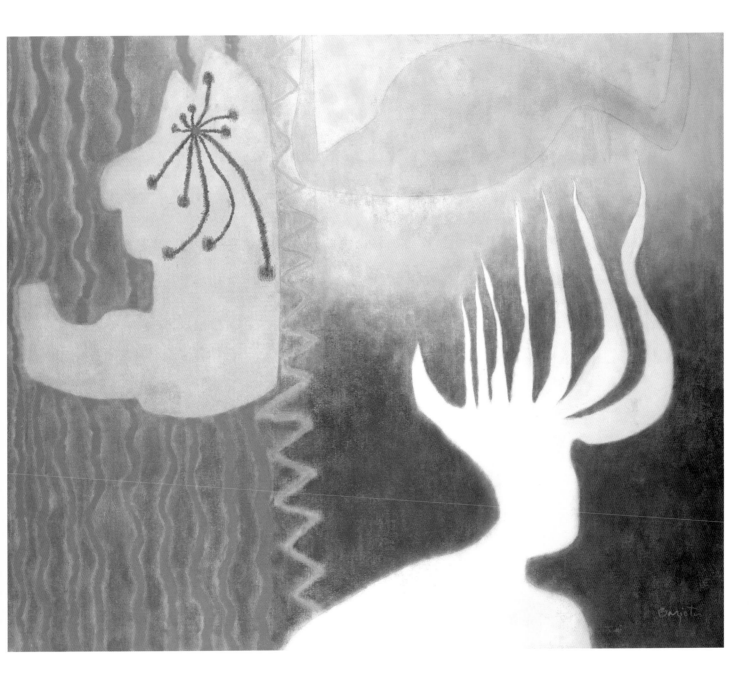

73.
William Baziotes (American, 1912–1963). *The Flesh Eaters*, 1952. Oil on canvas, 60 x 72 inches. The Metropolitan Museum of Art, New York; Purchase, George A. Hearn Fund, Arthur Hoppock Hearn Fund, and Hearn Funds, Bequest of Charles F. Iklé, and Gifts of Mrs. Carroll J. Post and Mrs. George S. Amory, by exchange, 1995, 1995.234

paintings, such as *Cerebral Landscape*, 1944 (fig. 75), are intricate, detailed, and brilliantly colored. Avowing the vitalist content of his art, he remarked recently, "I think in the earliest paintings, the biologic content seemed more obvious.… I think of my painting as optimistic,…based on the realization that the universe is perpetually growing, renewing itself.… I must reflect the nature of becoming or metamorphosis."[49]

De Kooning began as a figure painter and never entirely abandoned allusions to the human figure, or to nature, in his mature works. During the 1930s and early 1940s, he made numerous paintings of figures that range from traditional representation to an abstract flattening or distortion of the image. Through the influence of Gorky (a close friend of his during this period) as well as his familiarity with works by Léger, Miró, and Picasso, he experimented with abstraction, and after 1942 began using automatic drawing. His paintings of the mid-1940s are characterized by a merging of figurative and abstract elements, as in *Backdrop for Labyrinth*, 1946 (fig. 76). This work was commissioned for fifty dollars as the stage set for a modern-dance performance in New York in April 1946. Taking his cue from choreographer Marie Marchowsky's scenario, in which four dancers each represented a persona (The Wish, The Repressor, The Mediator, The Dreamer), he included in each corner of the backdrop an organic abstract form of a human figure crouched or curled. De Kooning's charcoal and oil drawing *Judgment Day*, 1946 (fig. 74), which he made less than a year after the atom bomb was dropped and the war ended, is considered the source for *Backdrop for Labyrinth*.[50] De Kooning stated that the four figural forms in *Judgment Day* represented the four angels of the Gates of Paradise,[51] a characterization that could also apply to *Backdrop for Labyrinth.* These floating

75.
Charles Seliger (American, b. 1926). *Cerebral Landscape*, 1944. Oil on canvas, 24³⁄₁₆ x 18³⁄₁₆ inches. Wadsworth Atheneum Museum of Art, Hartford; Gift of Mr. and Mrs. Alexis Zalstem-Zalessky, 1956.76

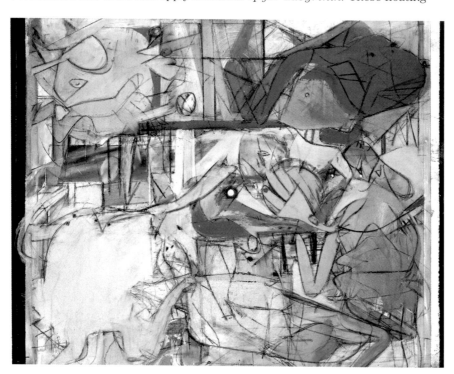

74.
Willem de Kooning (American, b. Holland, 1904–1997). *Judgment Day*, 1946. Oil and charcoal on paper, 22⅛ x 28½ inches. The Metropolitan Museum of Art, New York, from the Collection of Thomas B. Hess, Gift of the heirs of Thomas B. Hess, 1984, 1984.613.4

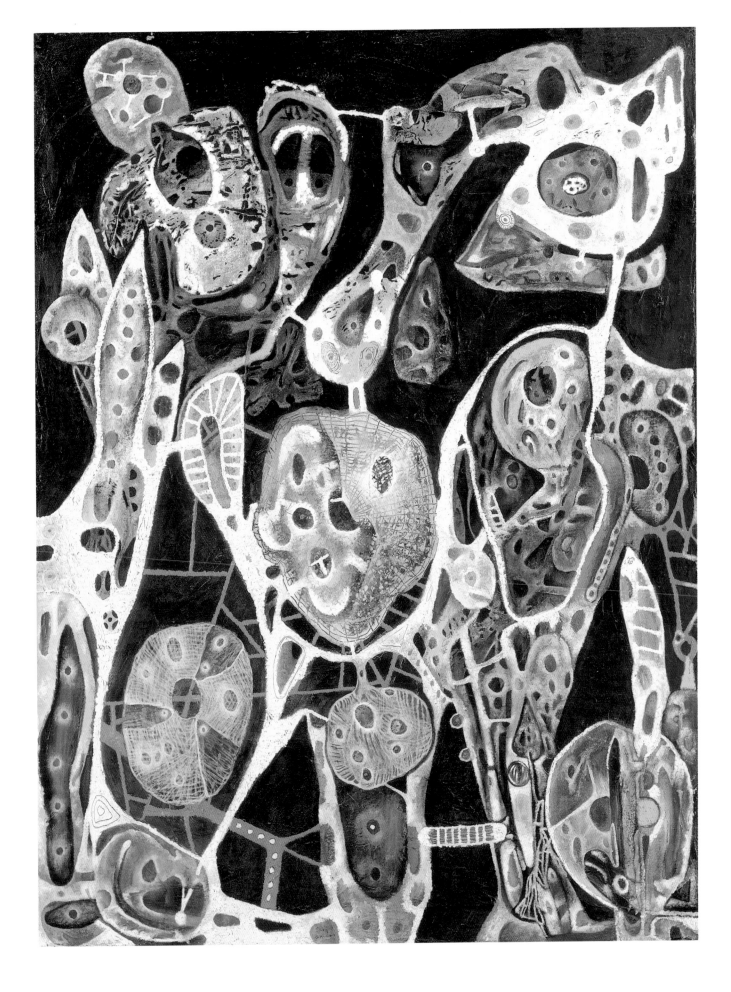

figures suggest a religious metaphor, as de Kooning looks to a higher power—the heavenly judge ruling on mankind—to explain a man-made terror.

The Indian Space painter Steve Wheeler, an artist from the same period and the same part of New York as the Abstract Expressionists, pursued an independent mode of expression that combined Cubist fragmentation of the figure, Surrealist subjects, and a unique narrative, eschewing the spontaneous forms and free gesture of the New York School.[52] His works are small, highly structured, and intensely personal.[53] The term "Indian Space" refers to an overall flatness of surface and equal treatment of the space inside and outside the work's main subject, with sinuous forms largely inspired by Northwest Coast Native American art. From the early 1940s on, Wheeler created complex, labyrinthine compositions filled with interlocking ideographic figures and forms, often recognizably animal or human. In his watercolor *The Clarinet Player*, 1943 (fig. 77), the fractured forms of the clarinet and the musician are among the interwoven areas of curved and angled lines and patterns.

Lee Mullican's work was influenced not only by his wartime mapmaking experience, but by connections with modernist abstraction and the Surrealists. Mullican had come across Paalen's avant-garde art journal *Dyn* (published from April 1942 until 1944) at the library of the Honolulu Academy of Fine Art while stationed in Hawaii. The journal (whose name is Greek for "the possible") covered diverse subjects including art, science, prehistory, and philosophy, with contributions by Calder, Onslow Ford, Motherwell, Pollock, Smith, and others, and it inspired Mullican to explore different possibilities in his own painting. Mullican has retrospectively spoken of his art in contemplative terms reminiscent of vitalist philosophy: "It's based on cosmic ideas, introspection, things under a microscope.... All of this is a world that people don't really see. You can't walk into that, walk into nebulae, walk into constellations, and a lot of that is what I create. It's a matter of tuning in."[54]

Like these American painters, some American sculptors in the 1940s were developing a new approach based on a synthesis of certain aspects of European modernism and Surrealism. Calder and Noguchi had both begun using irregular, organic shapes in abstract metal sculptures—Noguchi in 1927–28, and Calder in the mid-1930s—when they were in Paris (where they met and became friends), inspired by the biomorphic forms of Arp and Miró. Calder met Arp and Tanguy in 1927, and in 1928 he met and became a lifelong friend of Miró's (and, in 1930, of Léger's). Calder made his first mobiles in 1931, with metal rods and wire supporting small, painted geometric solids and flat sheet-metal circles, but within a few years he shifted almost entirely to flat organic shapes—irregular ovals, leaves, and amoeboid forms, which he continued to use throughout his career in

76.
Willem de Kooning (American, b. Holland, 1904–1997). *Backdrop for Labyrinth*, 1946. Oil and calcimine on canvas, 17 x 17 feet. Courtesy Allan Stone Gallery, New York

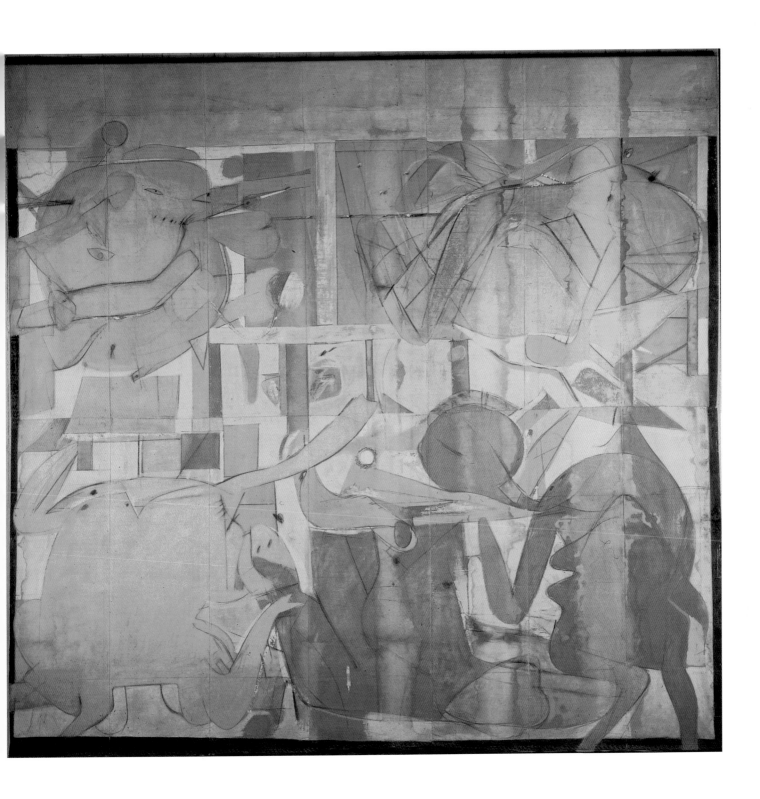

his mobiles (see fig. 193) and stabiles (see figs. 56, 59). Noguchi, after working in Brancusi's atelier for several months, experimented with free-form organic shapes in his first abstract sculptures but did not return to abstraction until 1944, when he began making a series of sculptures out of flat slabs of polished marble or slate. These feature interlocking arrangements of biomorphic forms, some resembling the bonelike motifs of Picasso or Tanguy, and with clear figural associations, as in *Figure,* 1945 (fig. 79, a later bronze casting of the marble original). He used similar biomorphic forms in the stage sets that he designed for the choreographer Martha Graham (see fig. 164) and in his 1940s furniture designs (see fig. 216).

Seymour Lipton had been making expressionist figure sculptures of wood and stone in the late 1930s and early 1940s. By the mid-1940s he had turned away from strictly narrative subjects. It was not until about 1950–51 that, seeking a controlled, organic dynamism, he began employing plant forms to evoke "the struggle of growth, death and rebirth in the cyclic renewal process," and by the mid-1950s was making sculpture "as an evolving entity,…a thing suggesting a process…." (see fig. 63).[55] Smith made his first welded-steel sculpture in 1933, and by the 1940s, he was creating sculptures of iron, steel, or bronze in a highly personal vocabulary that melded abstract forms with biomorphic and figural motifs, influenced by the Spanish sculptor Julio González and aesthetically by Kandinsky, Mondrian, Cubism, and Surrealism.

LANDMARK EXHIBITIONS

The synthesis of modernist abstraction and Surrealism was highlighted in two important exhibitions in the mid-1940s featuring works made by American artists and some of their European counterparts during the decade: *Abstract and Surrealist Art in America*, a show that opened at the Mortimer Brandt Gallery in New York in 1944 and traveled nationally, and *Abstract and Surrealist American Art*, held in 1947 at the Art Institute of Chicago. In both exhibitions, an avant-garde was identified, along with the symbiotic relationship between American and displaced European artists, brought together under global circumstances. *Abstract and Surrealist Art in America* was organized by the art dealer Sidney Janis in New York (in conjunction with the publication of his book of the same title) and traveled to the Cincinnati Art Museum, Denver Art Museum, Seattle Art Museum, Santa Barbara Museum of Art, and the San Francisco Museum of Art. In Chicago, *Abstract and Surrealist American Art*, planned by the curators Frederick Sweet and Katharine Kuh, similarly surveyed the contemporary scene.

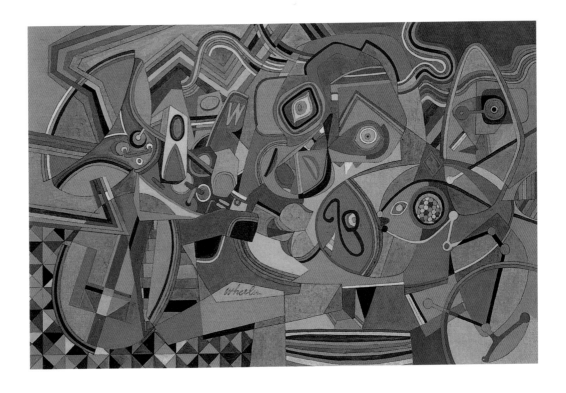

The Janis exhibition included works by fifty artists, bringing together paintings by members of the New York School such as de Kooning, Gottlieb, and Rothko, along with what Janis called "American paintings by artists in exile," including Léger, Matta, and Tanguy. In his book (which contained reproductions of works by some hundred artists), Janis wrote: "Though abstraction and surrealism are considered countermovements in twentieth-century painting, there is in certain painters a fusion of elements from each. American painters particularly have a strong inclination to develop interchanging ideas which may fit into either tradition...."[56]

For the Chicago exhibition, Sweet and Kuh traveled across the country and identified 250 painters and sculptors, including Abstract Expressionists and some artists in the Midwest, who worked in the "two leading tendencies in our painting and sculpture—Abstraction and Surrealism," which they described as practiced by "an overwhelmingly large number of American artists."[57] Artists in the show included Josef Albers, Ivan Albright, Baziotes, Calder, Gorky, Gottlieb, Hare, Lipton, Matta, Pollock, Rothko, Seliger, Smith, and Wheeler. The comparison of Abstract Expressionist art with work from other urban centers in the Chicago exhibition rendered the implicit message of regionalism obsolete. It also ennobled the efforts of local artists who belonged to a national avant-garde working in abstract or Surrealist modes.

In 1948, the following year, students from the School of the Art Institute of Chicago, many of them returning veterans on the G.I. Bill, attempted to

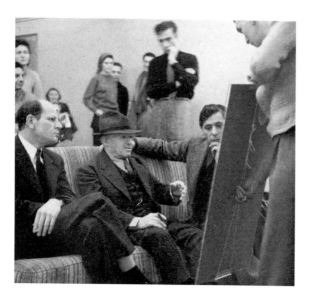

78.
Jurors **Jackson Pollock** (American, 1912–1956), **Max Weber** (American, b. Russia, 1881–1961), and **James Lechay** (American, b. 1907) reviewing *Exhibition Momentum*, Chicago, 1951, from the exhibition catalogue *Momentum 1951* (Chicago, 1951). Courtesy Leon Golub

participate in the museum's *Artists of Chicago and Vicinity Annual Exhibition* and found that, as students, they were no longer allowed to submit work to this long-standing competition for area artists. A group of them, including Leon Golub, Ted Halkin, Ellen Lanyon, and Franz Schulze, planned *Exhibition Momentum*, a contemporary *salon des refusés* (albeit a juried one), in protest against the Institute and its practice of prohibiting student participation in annual exhibitions.[58] *Exhibition Momentum* helped to define Chicago style, and to bridge the gap in exhibition opportunities for the local avant-garde. And while the stylistic devices utilized by the artists differed, a commonality was the use of the abstracted figure to comment on contemporary society.

So as not to distance themselves completely from the New York School and its impending hegemony, the Chicago artists annually invited important art-world figures (primarily from New York) to jury *Exhibition Momentum* (see fig. 78).[59] The former Museum of Modern Art director Alfred Barr, the editor and critic Clement Greenberg, the dealer Betty Parsons, and the artists Gottlieb, Motherwell, and Pollock were among the prominent New Yorkers who traveled to Chicago at the invitation of *Momentum*'s organizers. For the Chicago and New York artists, there was some common ground: like the work of the New York artists, aspects of Chicago painting mirrored what was happening in contemporary life; and although some of the Chicagoans perceived an anti-figuration bias within the New York School,[60] Abstract Expressionists such as Gottlieb, Pollock, de Kooning, and Baziotes in fact incorporated the abstracted figure in their work.

THE FRAGMENTED FIGURE

The feeling of crisis brought on by World War II during the early 1940s did not subside at the end of the decade, but instead continued on into the 1950s, fed

79.
Isamu Noguchi (American, 1904–1988). *Figure*, 1945. Bronze (cast 1979), 60 x 21⅜ x 13½ inches. The Isamu Noguchi Foundation, Inc., Long Island City, New York

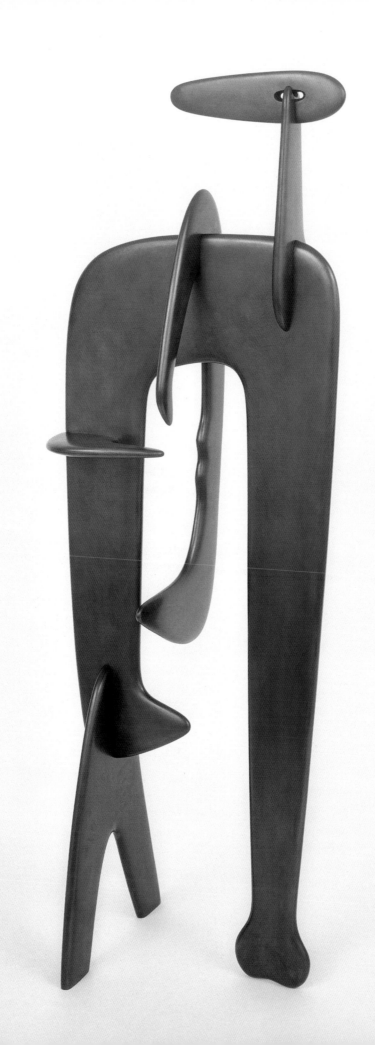

by the anxieties produced by the atom bomb, the Cold War, and the threat of Communism. For many artists, a sense of humanity's vulnerability only deepened during this period, and by the late 1940s some of them, such as Newman and Rothko, turned away from image-making and toward a more extreme form of abstraction to convey this tragic sense. However, as in the 1940s, much art of the 1950s continued to make reference to the body, even when the images were fragmented, distorted, or disfigured, signifying the endurance of the human form as a subject throughout a trying and complex period in American history. Artists who chose not to eliminate figuration through abstract means, but to incorporate the human form into their work, did so as a statement charged with humanistic values. As Rothko reflected in 1958:

> I belong to a generation that was preoccupied with the human figure....
> It was with utmost reluctance that I found that it did not meet my needs.
> Whoever used it mutilated it. No one could paint the figure as it was
> and feel that he could produce something that could express the world.
> I refuse to mutilate and had to find another way of expression.[61]

In the early 1950s, Pollock's desire to imbue his work with "meaningful content and potent symbols," which had driven his paintings of the early and mid-1940s, would meld with the "drip" technique in a series of works with figurative references that were limited to the stark contrasts of black and white.[62] In these works, such as *Echo: Number 25, 1951* (fig. 80), where Pollock has poured black enamel paint onto unprimed canvas, fragments of the human form can be detected within a complex painterly web.

De Kooning worked to reconcile the contradiction between abstraction and figuration in his *Woman* series of 1950–53 (fig. 81). When they were painted, the women were considered brutal depictions of the female form. Foreground and background come together as the woman melds into the abstract composition.

In contrast to de Kooning's fierce women, the organic forms of the human body are fragmented but not disfigured in the delicate *Butterfly Lady*, 1949 (fig. 84), a collage by the then-Chicago artist June Leaf. Here, the female form adheres to a crumpled brown-paper ground. While the torso is a thin stalk, the breasts and hips are rotund forms, like plant pods or the spread wings of a butterfly. Yet the figure is unable to take wing, as it is confined within the closely cropped composition. The limbless body with a tiny head could appear menacing or hostile were it not tempered by this gentle work's intimate scale and subtle coloration.

80.
Jackson Pollock (American, 1912–1956), *Echo: Number 25, 1951*, 1951. Enamel on unprimed canvas, 91⅞ x 86 inches. The Museum of Modern Art, New York; Acquired through the Lillie P. Bliss Bequest and the Mr. and Mrs. David Rockefeller Fund, 1969

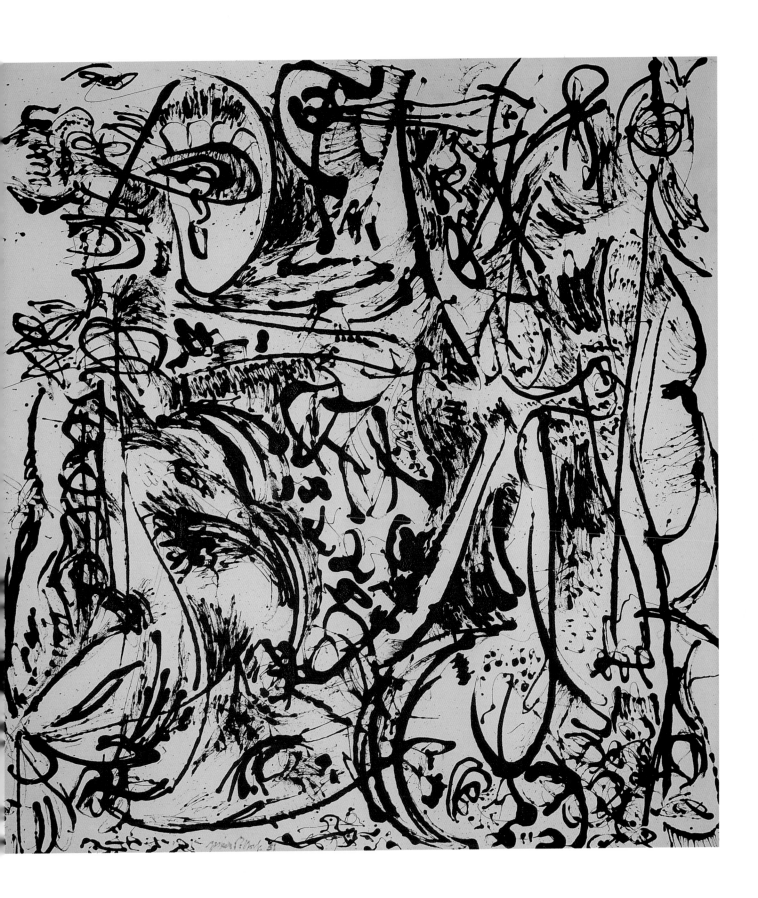

In the wide border of *Emblem for an Unknown Nation #1*, 1954 (fig. 83), by another Chicagoan, George Cohen, the human figure is fragmented in a decorative band of arms, mouth, legs, and hands, recalling Gottlieb's *Pictographs*. In the center of the painting is the image of a mythological figure that Cohen has identified as the Maenad, a female member of the orgiastic cult of Dionysus. Her churning form is repeated here several times in varying sizes. Cohen's mixed-media works of this period frequently incorporate small mirrors, which, he said, are intended to suggest dislocation.[63] Like the viewer's body parts reflected by those mirrors, the fragments of figures in *Emblem for an Unknown Nation #1* are similarly dislocated, floating in the canvas's spaces.

Leon Golub's *Damaged Man*, 1955 (fig. 82), from his *Victims* series, is also a body fragment. The surface of the canvas was literally scraped with metal dental tools in a measure of force that becomes a part of the image. The man looks blankly at the viewer, his innards peering through raw skin; only his head and segments of his body remain. This is a bleak work where the fragmented human body, held within an organic form, is violently abraded. Simultaneously with his *Victims* series, Golub was painting another series, *Burnt Men*, which, like *Damaged Man*, evokes the Holocaust. He said recently: "The Damaged Man is a victim, but given my fatalistic point of view, he is optimistic too, because he's there and he's screaming and he has no limbs, but he's a presence.... He's making his voice heard in a certain sense. Of course these paintings have reference to the Holocaust, or to Hiroshima—it's a very bleak post–World War II existential view of the world."[64] Although Golub painted this work after the Korean War, he says that World War II was the predominant reference in this series. Golub believes that his scarred figures retain a presence despite their dismemberment—that although they are fragmented and torn, a vitalism or life force remains.[65]

Louise Nevelson's *First Personage*, 1956 (fig. 85, see far right), represents psychological fragmentation as much as physical. The painted wood sculpture is composed of two sections: an outer, undulating slab that symbolizes the sinuous form of an upright figure and, behind it, spikes of wood pushing out from a central core. Nevelson wrote that the knot of wood on the outer area symbolized a mouth that actually spoke to her. She said that the monolith is the persona that each of us presents to the world—composed, orderly, whole; while the second piece of spikes emanating from a tall stalk is dissonant and agitated, much like the true inner self.[66]

In the 1930s and 1940s, Smith's work consisted mainly of hybrid figural sculpture made of welded iron and steel, often showing his study of Construc-

tivism and Surrealism. Just before World War II (1930–40), he also created a series of small relief sculptures, *The Medals for Dishonor*, recalling military medals. Yet rather than suggesting honorary objects, these medals depicted and exposed wartime atrocities. In the 1950s Smith turned to making anthropomorphic and totemic sculptures, which he called *Tanktotems* because they used the actual lids of industrial tanks. Because the curvilinear shapes of the human form attracted him, Smith succeeded in uniting an abstract language with

81.
Willem de Kooning (American, b. Holland, 1904–1997). *Woman*, 1953–54. Oil on paperboard, 35¾ x 24⅜ inches. Brooklyn Museum of Art, New York; Gift of Mr. and Mrs. Alastair B. Martin, 57.124

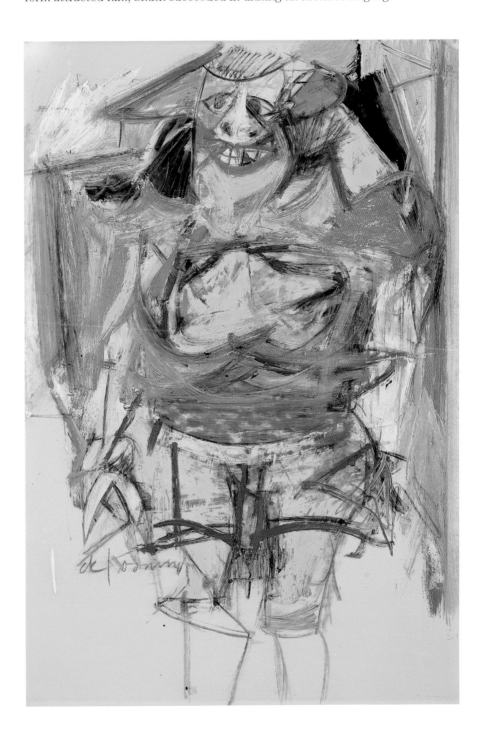

figural motifs in works where he evoked the body with industrial materials, as in *Detroit Queen*, 1957 (fig. 86), a bronze sculpture that reveals an undulating female form.

In 1959 the quasi-figuration that was the cornerstone of the Chicago artists—and would lead to the Chicago group called the Monster Roster in the early 1960s—came to New York in the form of a controversial, critically panned exhibition at the Museum of Modern Art, *New Images of Man,* organized by Peter Selz. The abstraction of the New York School was now under siege by artists such as Golub and the Californian Nathan Oliveira, whose paintings featured overt representations of the human figure. The exhibition included works

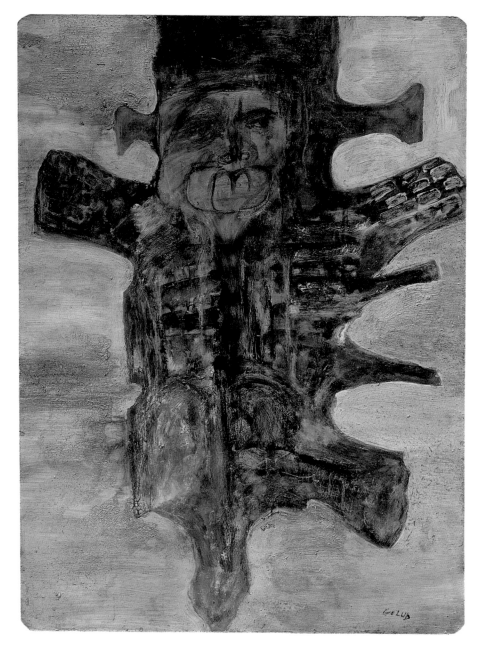

82.
Leon Golub (American, b. 1922). *Damaged Man,* 1955. Lacquer and oil on Masonite, 48 x 36 inches. Collection of Blake Summers

by the Europeans Karel Appel, Jean Dubuffet, and Alberto Giacometti, four faceless figures by Oliveira, Golub's *Damaged Man* (plus four more of his figure paintings), and even works by Abstract Expressionists (six paintings from de Kooning's *Woman* series and four black-and-white paintings by Pollock, who had died in 1956). The figures in this exhibition were not pristine and composed, but shattered and broken, torn and fragmented.

Golub's paintings of men and de Kooning's *Woman* series share certain characteristics: vigorous handling and treatment of paint, brutal facial features, and manipulated body parts. Golub chose the male form to communicate what he saw as the mid-twentieth-century collective condition; de Kooning chose

83.
George Cohen (American, 1919–1999). *Emblem for an Unknown Nation #1*, 1954. Oil on Masonite, 64¾ x 48 inches. Museum of Contemporary Art, Chicago; Gift of Muriel Kallis Newman, 78.45

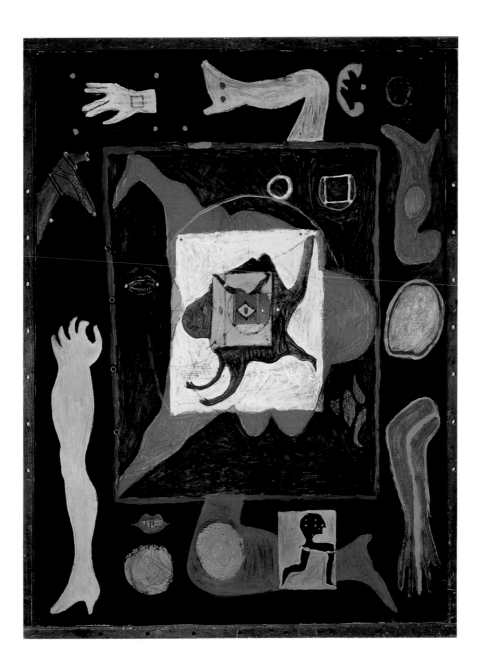

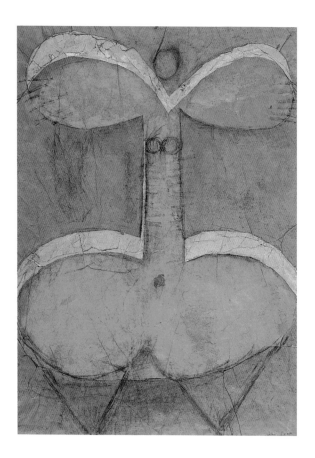

84.
June Leaf (American, b. 1929).
Butterfly Lady, 1949. Collage,
23½ x 17½ inches. Collection
of Joel Press

85.
Installation view of exhibition
of works by **Louise Nevelson**
(American, b. Russia,
1904–1988), Grand Central
Moderns Gallery, New York,
January 1957

86.
David Smith (American, 1906–1965). *Detroit Queen*, 1957. Bronze, 71¾ x 22¼ x 24⅜ inches. Fogg Art Museum, Harvard University, Cambridge, Massachusetts; Gift of Lois Orswell, 1994.15. © Estate of David Smith/VAGA, New York

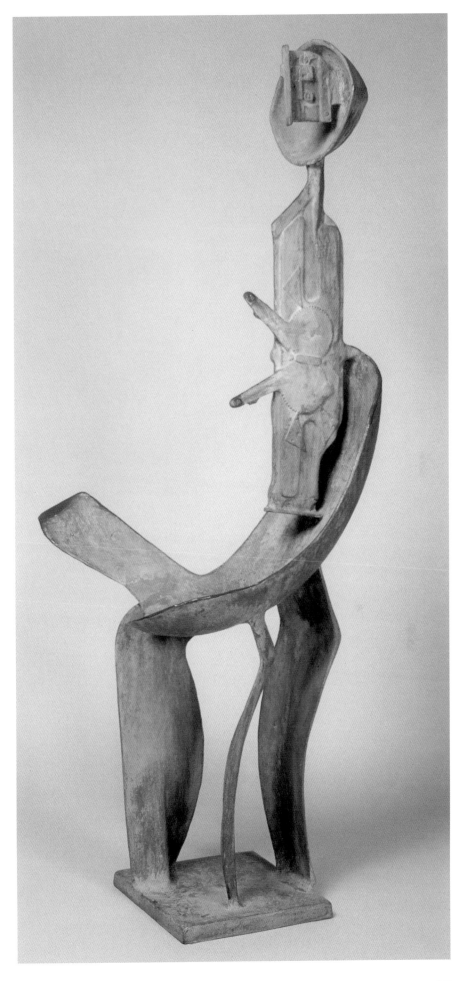

the female form as the manipulated muse of his individual consciousness. De Kooning and other Abstract Expressionists incorporated such fragmented or distorted elements of the figure in their work despite a prevailing view of New York School compositions as nonobjective, and despite art-world pressure to avoid the figure. In hindsight, in view of such works as Pollock's figural black paintings of the early 1950s, Gottlieb's *Pictographs*, David Smith's *Tanktotems* and *Detroit Queen*, and Louise Nevelson's *First Personage*, it is clear that the New York artists were not as resolutely, purely nonobjective as they had been perceived.

———

Although organic abstraction continued in the late 1950s and early 1960s in the works of such artists as de Kooning, Helen Frankenthaler, Lee Krasner (fig. 87), and Morris Louis, the rising vanguard no longer favored this mode of abstraction or any except the most ironic allusions to the human form. Of course, there had been insurrections against vital forms earlier in the decade as well— notably, the geometric abstractions of Ellsworth Kelly and Ad Reinhardt. Kelly's

87.
Lee Krasner (American, 1908–1984). *Upstream*, 1957. Oil on canvas, 55 x 88 inches. Collection of Fayez Sarofim

flat monochrome shapes were occasionally biomorphic in outline, however, as in *Bay*, 1959 (fig. 88), and *Black Venus*, 1959 (fig. 89), which balance hard-edged order with sensuous organic form.

As art evolved away from organic abstraction into the blatant representationalism of Pop art and later into the geometric equations of the Minimalist aesthetic, the significance of vital forms diminished; they were considered passé, too earnest and lacking a societal critique.[67] For American artists of the 1940s and 1950s, grasping for a sense of humanity when human life was in peril, however, they offered an abstract art that could convey essential issues during a critical period in this country's history.

88.
Ellsworth Kelly (American, b. 1923). *Bay*, 1959. Oil on canvas, 70 x 50 inches. Collection of Samuel and Ronnie Heyman

89.
Ellsworth Kelly (American, b. 1923). *Black Venus*, 1959. Painted ⅛-inch aluminum, 85 x 36 x 2⅝ inches. Private collection

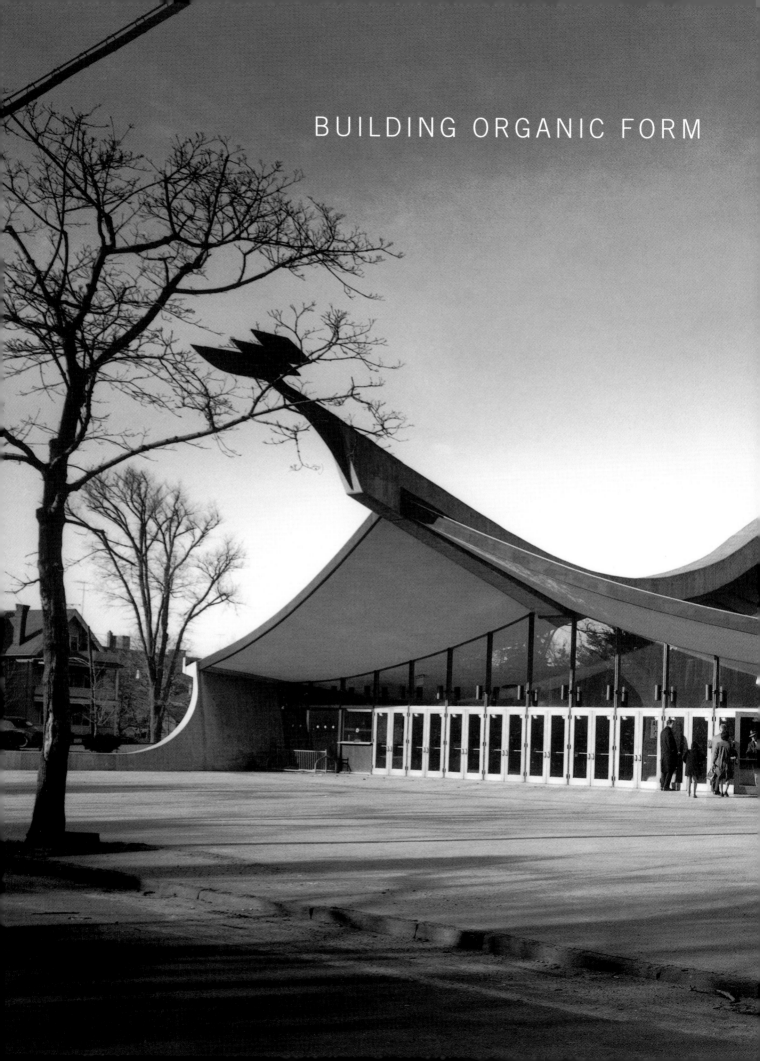

BUILDING ORGANIC FORM

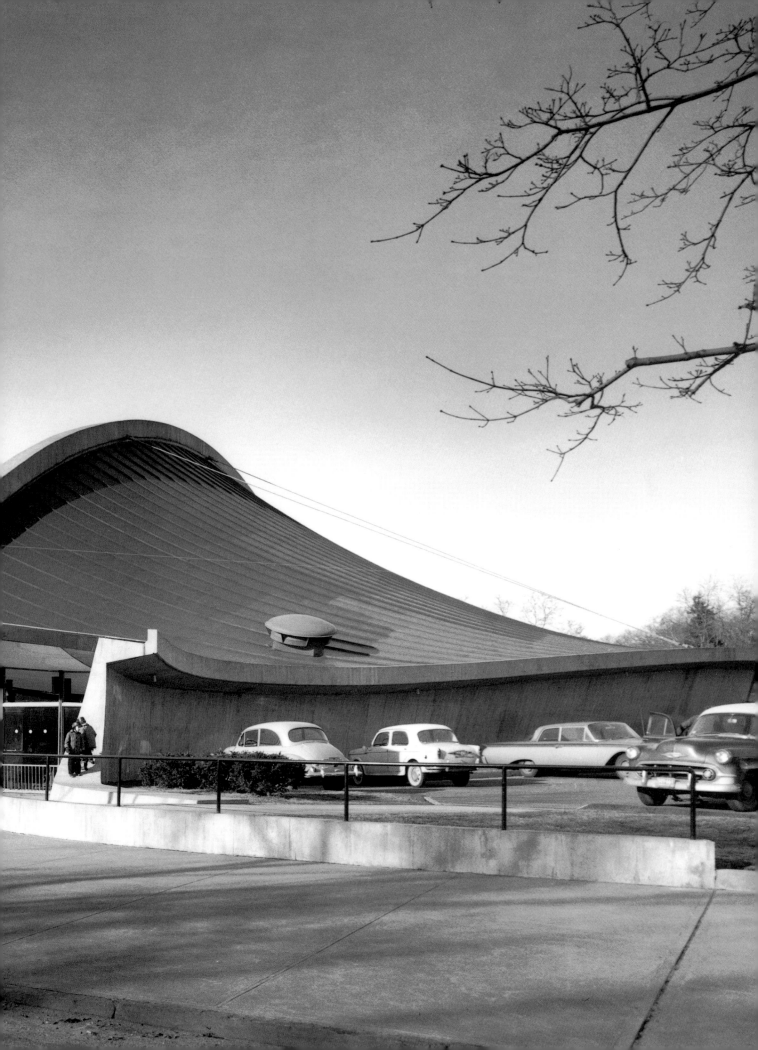

Building Organic Form

ARCHITECTURE, CERAMICS, GLASS, AND METAL IN THE 1940S AND 1950S

Martin Filler

In the same way that historians have viewed the Civil War as the Second American Revolution—a reaffirmation of the founding principles of the republic—so may the flourishing of the arts in the United States in the decades just before and after the midpoint of the twentieth century now be seen as the Second American Renaissance. What made that outpouring of creativity so extraordinary was the fact that it stemmed from so many artists who were not native-born Americans. Architectural education in this country was transformed in the years just before World War II by two immensely influential German architect-educators, Walter Gropius and Ludwig Mies van der Rohe, whose respective deanships at the Harvard Graduate School of Design and the Illinois Institute of Technology radically changed the course of professional practice here. Design education was similarly affected by the remarkable Finnish-born clan of the Saarinens, who, with their compatriot Majilis ("Maija") Grotell, made the Cranbrook Academy of Art into an international force. Although the United States has always been by definition a nation of immigrants, never before had the effects of cultural cross-pollination yielded such fruitful results.

In retrospect, it seems entirely appropriate that the biomorphic forms that so many American artists favored in the mid-twentieth century evoke the processes of fertilization, birth, and organic growth, apt metaphors for the astonishing regeneration that was seen in spheres from the environmental to the domestic. Traditionally, major shifts in style have been reflected first in the so-called minor arts and only later in the more slowly moving mediums of architecture and urban design. But biomorphism began to appear in the late 1930s with unusual simultaneity in everything from ceramics to town planning, signaling a consensual attitude that went much deeper than mere stylistic mimicry.

By 1940, American architecture, which only a half-century before was just beginning to break free of the cultural domination of Europe, had become the wonder of the world. The skyscrapers of New York and Chicago had mesmerized the first generation of European modernists, who justly saw in those marvels of engineering a wholly new and distinctively American approach to building. The machinelike, reductivist form of high-style modernism proposed after World War I by Le Corbusier, Mies, and other radical European architects made relatively few inroads on the American scene before World War II. The proselytizing of such polemicists as Henry-Russell Hitchcock and Philip Johnson, whose

90.
Alvar Aalto (Finnish, 1898–1976). Finnish Pavilion, 1939–40 New York World's Fair, Queens, New York, 1938–39 (demolished 1940). Interior view. Photograph by **Ezra Stoller** (American, 1915–1989)

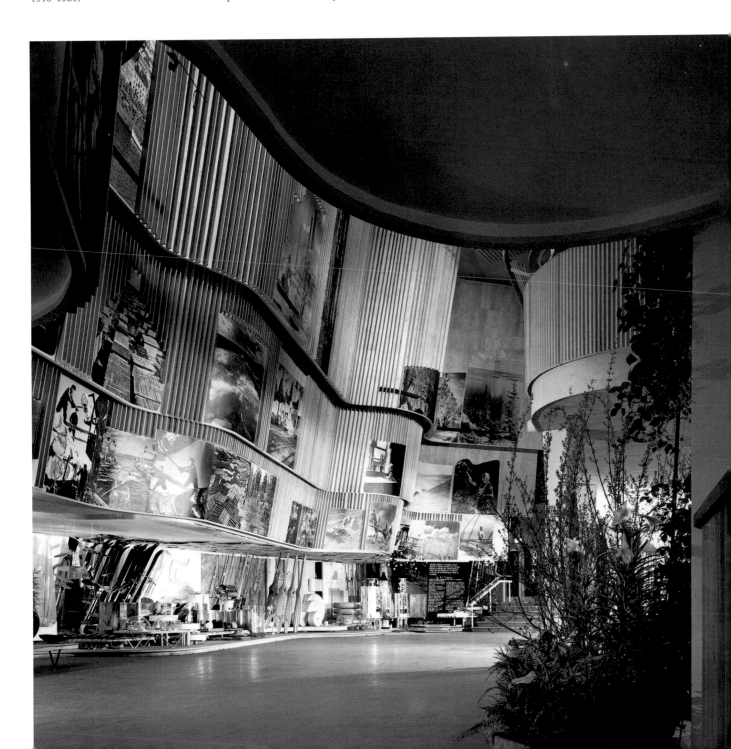

watershed *Modern Architecture: International Exhibition* at the Museum of Modern Art in 1932 and its subsequent national tour first brought the International Style to a wide audience in this country, still had little visible impact by 1940.

Stimulated by the outbreak of war in Europe in 1939, the American economy finally began to emerge from the decade-long Great Depression that had severely limited construction throughout the United States. All architects had been deeply affected by the economic downturn, even such major figures as Frank Lloyd Wright. Yet his astonishing resurgence of creativity during the second half of the 1930s reconfirmed him as America's greatest architect and gave new validity to his principles of organic design. Competitive with European architects whose work he saw as a direct threat to his livelihood, Wright nonetheless responded enthusiastically to Alvar Aalto's Finnish Pavilion at the New York World's Fair of 1939–40 (fig. 90). The freely undulating forms and natural wood surfaces of that organic scheme struck a sympathetic chord not only with Wright, but also among many younger American architects who likewise saw Aalto as a more humane practitioner of modernism.

91.
Frank Lloyd Wright (American, 1867–1959). Herbert Jacobs Solar Hemicycle House, Middleton, Wisconsin, 1943–48. Exterior view. Photograph by **Ezra Stoller** (American, 1915–1989)

92.
Frank Lloyd Wright (American, 1867–1959) with George Cohen, William Short, and Charles W. Spero viewing construction of the Solomon R. Guggenheim Museum, New York, 1957

"Modern-architecture is Organic-architecture deprived of its soul," Wright wrote of the International Style in 1952, just as its gridded glass-and-steel curtain-walled high-rises began their domination of our urban skylines. Wright's increasingly sculptural, anti-orthogonal work during the two decades before his death in 1959 must be seen in large part as a critique of the larger trend toward geometric uniformity and stylistic orthodoxy. At the turn of the century, Wright made architecture "break out of the box"; at mid-century, he tried to keep it from being put back into those rectilinear confines.

Wright's Solar Hemicycle House (Jacobs Second Residence) of 1943–48 in Middleton, Wisconsin (fig. 91) used curving forms, natural materials, and earth berms to create a man-made structure so thoroughly integrated into its setting that it seems to have been the result of a geological process such as erosion, rather than the product of construction. Wright had excelled at the harmonious siting of buildings in the landscape for a half-century by that time, yet never— even at his own two homes, Taliesin and Taliesin West—had he done so with such a powerful sense of abstraction or self-effacing deference as he did here. Furthermore, the energy-conserving, passive-solar scheme of this house antici-pated by three decades concerns that would arise as ecological awareness became widespread in the 1970s in the wake of disenchantment with high tech-nology and excessive fuel consumption.

The project that preoccupied Wright for the last fifteen years of his life, the Solomon R. Guggenheim Museum of 1943–59 in New York (see figs. 47, 92, 95), was also his most defiant rebuke to the orthodoxies of International Style

architecture. Wright's rebellious stance was compounded by the building's location in a metropolis with a gridded street plan that was being mimicked with relentless repetition in the facades of the new International Style towers, transforming Manhattan into the world headquarters of the corporate approach to modernism during the decade-and-a-half period of the Guggenheim project.

Although Wright here recycled the spiral-circulation concept he first devised for his unexecuted Gordon Strong Automobile Objective of 1924 for Sugarloaf Mountain, Maryland (fig. 94), he inverted the original ziggurat form so that the upward and outward flaring of the Guggenheim rotunda suggests the infinite expansion of space beyond the volume of the built work's eccentric structure. The curvilinear theme was particularly apt for the contents of the Guggenheim collection at that time: the Museum of Non-Objective Painting, as it was initially named, was particularly strong in the works of Wassily Kandinsky (see fig. 93), the organic shapes of which were echoed in Wright's helical gallery. Although subsequently condemned for its display space inhospitable to paintings, Wright's last masterpiece is at its best when filled with the kind of art that inspired the architect to create his most audacious structure. The irrational nature of Wright's Guggenheim Museum was best captured by the architecture historian Vincent Scully when he called it "a primitive drum beating in the heart of Fifth Avenue."

That same impulse to run counter to the increasing rationalization of American architecture—once large-scale construction resumed after the wartime ban

93.
Installation view of the exhibition *In Memory of Wassily Kandinsky* at the Museum of Non-Objective Painting, Guggenheim Collection, New York, 1945

94.
Frank Lloyd Wright (American, 1867–1959). Sketch for Gordon Strong Automobile Objective, Sugarloaf Mountain, Maryland, 1924. Pencil on tracing paper, 10¼ x 8¼ inches. The Frank Lloyd Wright Foundation, Taliesin West, Scottsdale, Arizona, 2505.023

95.
Solomon R. Guggenheim Museum, New York, under construction, 1956

on all building deemed nonessential to the war effort—affected several other noteworthy practitioners, from the mainstream to the maverick. Eero Saarinen, who in 1945 had collaborated with Charles Eames on the first version of the celebrated Case Study House designed for the Eameses' own use in Pacific Palisades, California (a landmark in the adaptation of industrial materials to a domestic setting), was searching for a more expressive design vocabulary by the early 1950s. That Saarinen never settled on a single voice, so to speak, has been held against him by those conditioned by the tenets of High Modernism, which included a preference for consistency in an artist's body of work. Yet his most successful buildings were precisely those in which he gave full rein to instincts at odds with the International Style tendencies of his corporate commissions. For example, Saarinen's David S. Ingalls Hockey Rink of 1956–58 at Yale University in New Haven, Connecticut (figs. 96–98), both in its crablike ground plan and dinosaurian roof profile, brings to mind the organic forms of the animal kingdom. And the architect's Trans World Airlines Terminal of 1956–62 at Idlewild (renamed John F. Kennedy International) Airport in Queens, New York (figs. 99–101) recalls the avian aspect of a bird in flight, a return to an *architecture parlante* (in which a building's form "speaks" quite

97.
Eero Saarinen (American, b. Finland, 1910–1961). David S. Ingalls Hockey Rink, Yale University, New Haven, Connecticut, 1956–58. Exterior view. Photograph by **Balthazar Korab** (American, b. Hungary, 1926)

98.
Eero Saarinen (American, b. Finland, 1910–1961). David S. Ingalls Hockey Rink, Yale University, New Haven, Connecticut, 1956–58. Interior view. Photograph by **Ezra Stoller** (American, 1915–1989)

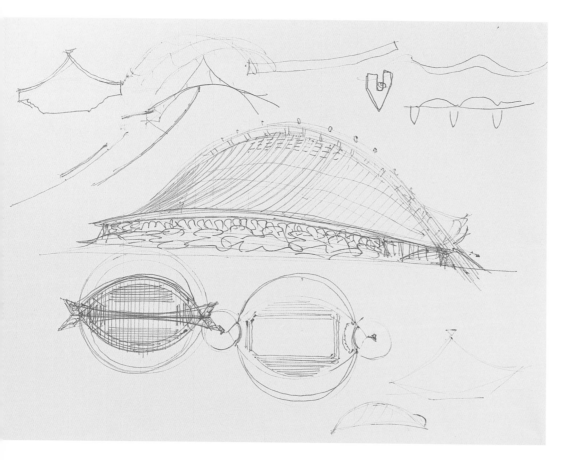

96.
Eero Saarinen (American, b. Finland, 1910–1961). Study Sketch for David S. Ingalls Hockey Rink, Yale University, New Haven, Connecticut, 1956–58. Ballpoint pen on lined notepad, 8½ x 14 inches. Saarinen Archive/Kevin Roche John Dinkeloo & Associates, courtesy of Peter Papademetriou

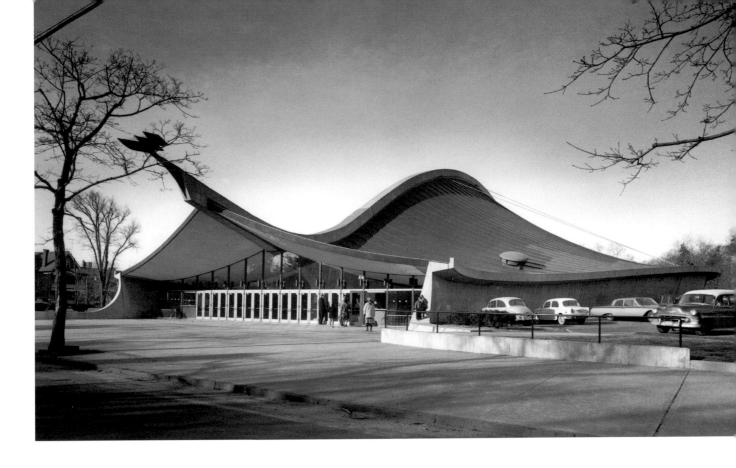

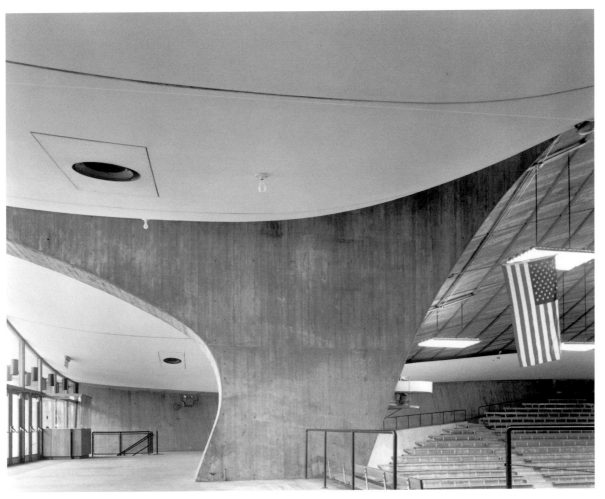

directly about its function). Even more so, the cavernous, indeed womblike, nature of the terminal's interior spaces made it the mainstream high-water mark of biomorphic architecture in the postwar period.

More typically, however, the pursuit of nonrectilinear architecture was the realm of anti-establishment figures who readily understood that the International Style represented a new kind of academicism, though one far less dependent on the detailed craftsmanship and applied ornament of the Beaux-Arts tradition that corporate modernism supplanted. Bruce Goff, who was born on the Great Plains and practiced there and in California, found his major inspiration in the philosophy (if less so in the actual designs) of Frank Lloyd Wright. Unlike Wright, he sought not so much the unity of his buildings and their settings as a dynamic relationship between the man-made and the natural. Certainly no American architect has ever been more experimental and inventive in his use of materials, which in Goff's case included everything from anthracite and steel cables to turkey feathers and shag carpeting. The teepee-like form of Goff's Bavinger

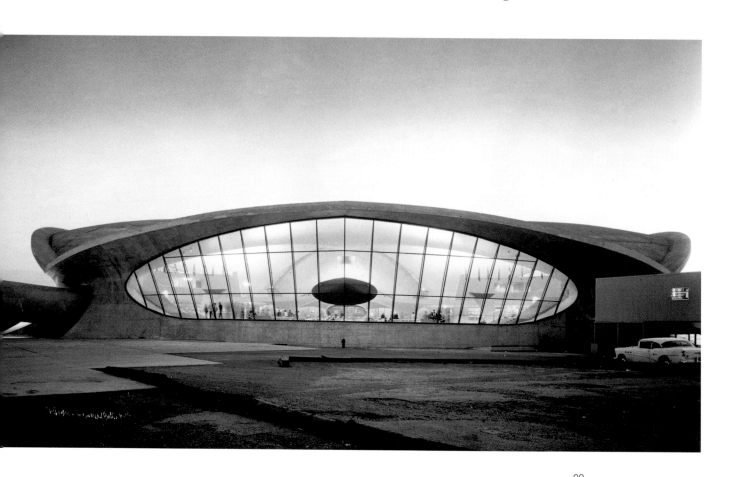

99.
Eero Saarinen (American, b. Finland, 1910–1961). Trans World Airlines Terminal, Idlewild (now John F. Kennedy International) Airport, Queens, New York, 1956–62. Exterior view. Photograph by **Ezra Stoller** (American, 1915–1989)

100.
Eero Saarinen (American, b. Finland, 1910–1961). Trans World Airlines Terminal, Idlewild (now John F. Kennedy International) Airport, Queens, New York, 1956–62. Exterior view. Photograph by **Ezra Stoller** (American, 1915–1989)

101.
Eero Saarinen (American, b. Finland, 1910–1961). Trans World Airlines Terminal, Idlewild (now John F. Kennedy International) Airport, Queens, New York, 1956–62. Interior view. Photograph by **Ezra Stoller** (American, 1915–1989)

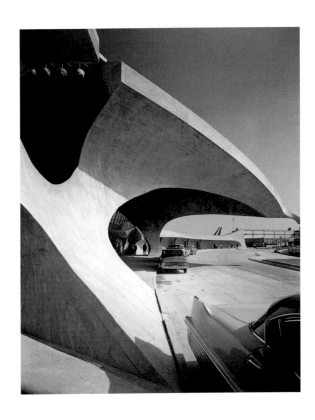

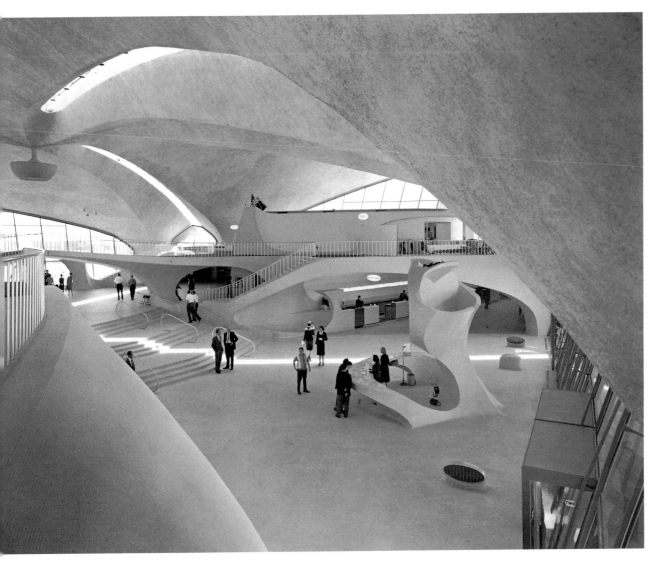

House of 1950–55 in Norman, Oklahoma (fig. 102), accentuated by its central mast and supporting cables, gives it an aura at once elemental and fantastic, the two qualities around which Goff's eccentric vision focused, in a dialectic play.

Frederick J. Kiesler, a Viennese-émigré artist, architect, and stage designer, created one of the most widely publicized biomorphic architectural schemes of the century, his 1959 model for the theoretical *Endless House* (figs. 103, 104). Throwing all programmatic concerns to the wind, Kiesler returned to the primeval notion of the cave as a formal analogue of the interior recesses of the human body, specifically the womb. As expressed in the large cement-and-wire-mesh model that was exhibited at the Museum of Modern Art just as the International Style was reaching its apogee, Kiesler's almost Freudian insight into the inherent sexuality of private living spaces was a provocation free from the constraints that construction and use would have imposed—hence, the basic difference between Saarinen's TWA terminal and this contemporary sculptural fantasy. Yet Kiesler's intriguing proposal still resounds with its implied critique of the lifelessness of so much mid-century architecture, and his insistence, however crudely set forth, that more could be asked of the mother of arts.

The American landscape, as well as its skyline across much of the country, underwent an immense transformation after 1945, to a great extent the result of the pent-up demand for new housing, which had gone largely unmet during the preceding fifteen years of economic depression and war. As millions of

102.
Bruce Alonzo Goff (American, 1904–1982). Design Drawing for Bavinger House, Norman, Oklahoma, 1950. *South Elevation Showing Suspension Bridge over Ravine.* Graphite on tracing paper, 11¾ x 16½ inches. The Art Institute of Chicago; Gift of Shin'enKan, Inc., 1990.811.5

103.
Frederick J. Kiesler (American, b. Austria, 1890–1965). Interior view of model for *Endless House,* 1959 (fig. 104)

104.
Frederick J. Kiesler (American, b. Austria, 1890–1965). Model for *Endless House,* 1959. Cement and wire mesh with Plexiglas, 38 x 96 x 42 inches. Whitney Museum of American Art, New York; Gift of Mrs. Lillian Kiesler, 89.8

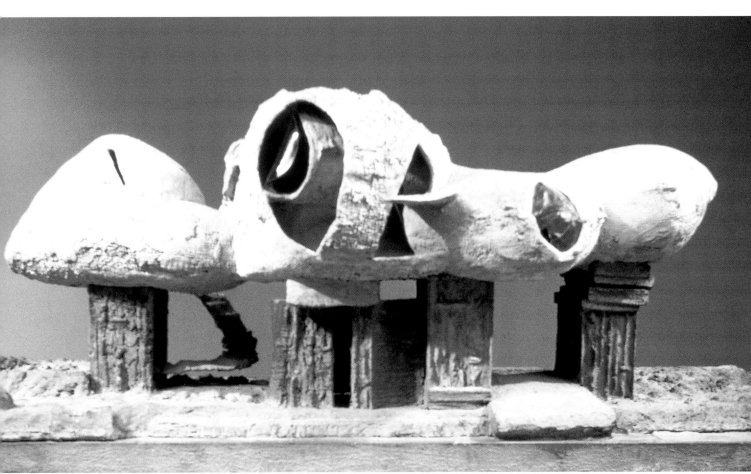

young American G.I.'s returned home to marry and start families, the suburban-ization that had been encouraged by the Federal government during the 1930s expanded into the most extensive domestic construction boom in American history. Following Federal Housing Administration (F.H.A.) guidelines that promoted the curvilinear layout of new suburban communities instead of the grid plan more typical of early American towns (see fig. 105), real-estate developers unknowingly harked back to the organic landscape forms advocated by Frederick Law Olmsted a century earlier. However, although such postwar schemes as Levittown, New York, and its imitators employed undulating street patterns to mitigate the uniformity of the mass-produced houses that made single-home ownership affordable to a wider audience than ever before (see figs. 106, 144), little thought was given to the deeper principles of organic land use in most suburban subdivisions.

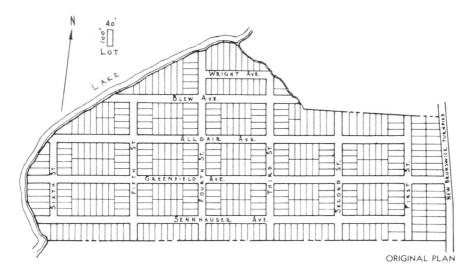

ORIGINAL PLAN

105.
Suggested revision of subdivision plan in the booklet *Planning Profitable Neighborhoods*, Technical Bulletin No. 7 (Washington, D.C.: Federal Housing Administration, 1938)

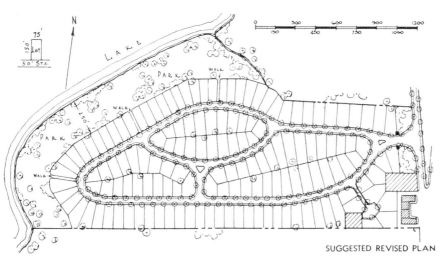

SUGGESTED REVISED PLAN

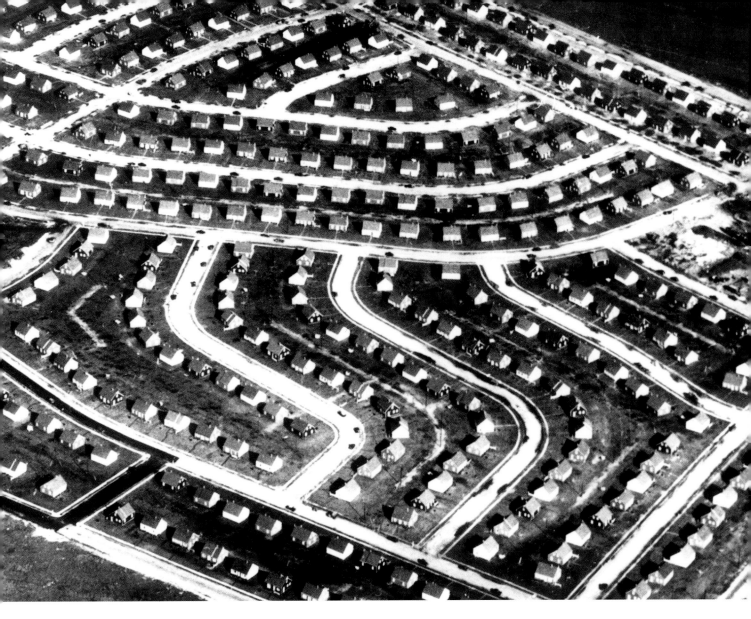

106.
Alfred Levitt (American, 1912–1966). Aerial view of Wolcott Road, Levittown, New York, 1947. Levittown Public Library, New York, 354

One rare exception was the plan for the Ladera Housing Cooperative of 1949 in Palo Alto, California, by the landscape architect Garrett Eckbo with John Funk and Joseph Allen Stein. Eckbo used biomorphic design as a means of creating less formal outdoor spaces than the Beaux-Arts axiality that still predominated in education and practice during his youth, while fulfilling the mandates of an acute social vision that saw organic planning as an agent for democratization. At Ladera, for example, the provision for extensive parklike commons (see fig. 107) was a distinct departure from the individual backyards that tended to make subdivisions so confining in both a physical and spiritual sense. Unfortunately, the full potential of Ladera was never realized, as this progressive

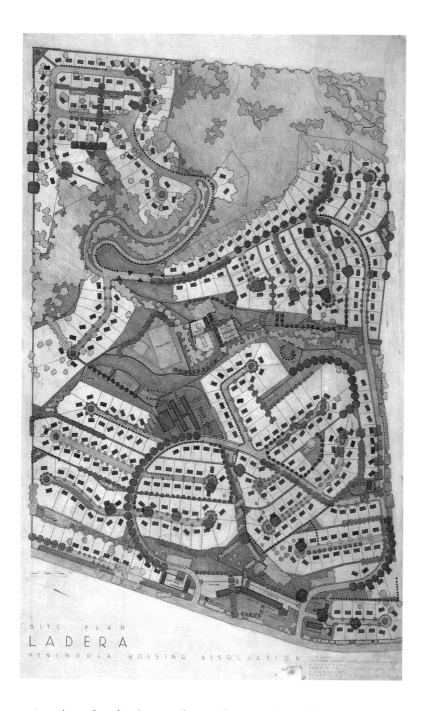

107.
John Funk (American, 1908–1993), **Garrett Eckbo** (American, 1910–2000), and **Joseph Allen Stein** (American, b. 1912). Site Plan, Ladera Housing Cooperative for the Peninsula Housing Association, Palo Alto, California, c. 1946. Colored pencil, tempera, and ink on diazo paper print, 51 x 32 inches. Garrett Eckbo Collection (1990–91), Environmental Design Archives, University of California, Berkeley

enterprise refused to impose the racial segregation policies that at the time were a prerequisite for F.H.A. mortgage approval. Levittown, which did not allow blacks, thrived, while Ladera, which was open to all, remained incomplete.

A more purely aestheticized version of postwar biomorphic landscape design was Thomas Church's Donnell garden and pool of 1948 in Sonoma, California (figs. 108, 109). Commissioned by a rich San Francisco family for their country house in an agricultural valley north of the city, the garden and its free-form swimming pool—the inspiration for innumerable kidney-shaped copies in the

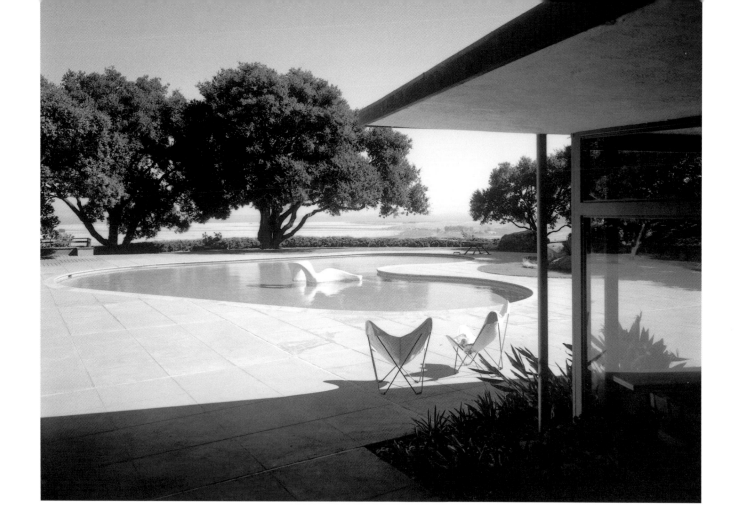

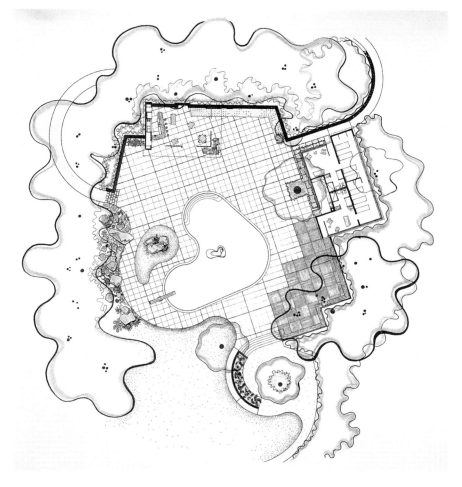

108.
Thomas Church (American, 1902–1978) with **Lawrence Halprin** (American, b. 1916). Donnell Garden and Pool, Sonoma, California, 1948. Pool sculpture by **Adeline Kent** (American, 1900–1957). Photograph by **Morley Baer** (American, 1916–1995)

109.
Thomas Church (American, 1902–1978) with **Lawrence Halprin** (American, b. 1916). Donnell Garden and Pool, Sonoma, California. Presentation drawing, 1948. Ink and watercolor on paper, 24 x 36 inches. Collection of Sandra Donnell

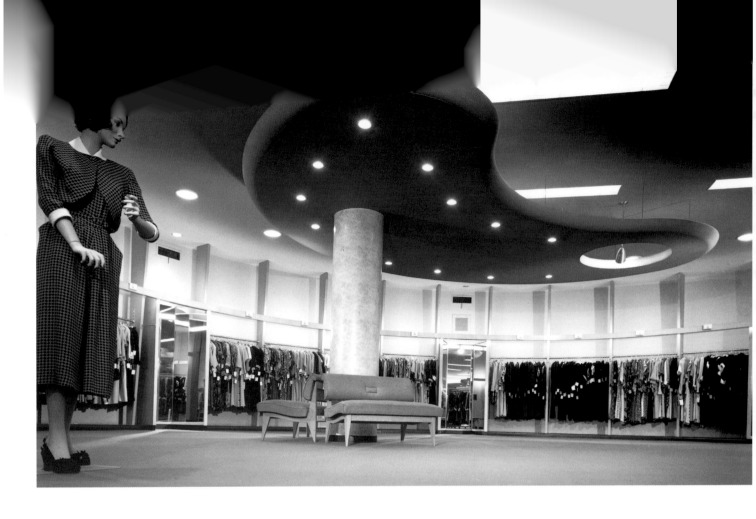

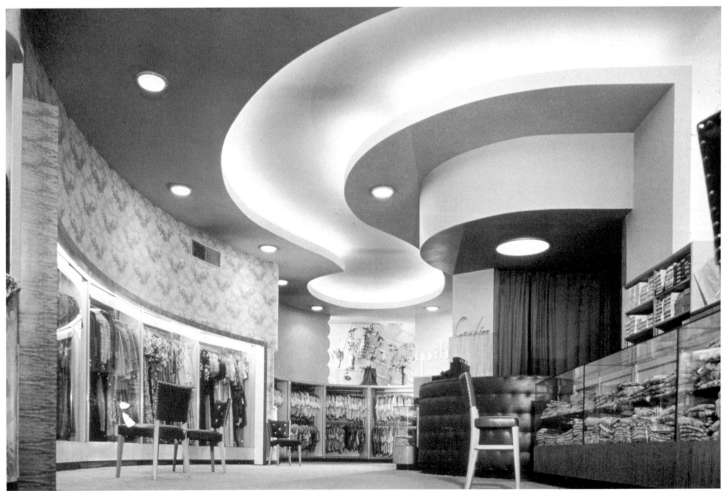

decades ahead—became, through the iconic completion photograph of Morley Baer, an influential image of the California good life that millions of postwar Americans wished to share, regardless of where in the nation they lived.

The quite literal way in which biomorphic form communicated a freer and more expansive way of life made it the natural vehicle for the postwar phenomenon that might most accurately be called the architecture of hedonism. The rapid rise of such postwar resort cities as Miami Beach and Las Vegas allowed ample opportunity for popularized versions of high-style biomorphic design to be applied in the hotels, casinos, and nightclubs of those and other pleasure-oriented leisure destinations. Most often, free-form elements in such settings would be indiscriminately combined with details of more traditional, even classical, derivation. Morris Lapidus, whose commercial schemes of the late 1930s and 1940s had featured amoeba and boomerang shapes (see figs. 110, 111), incorporated a wide variety of curvilinear motifs in a pastiche of styles for several 1950s hotels in the Miami Beach area, including the Sans Souci, the Americana, and the Fontainebleau (figs. 112, 114, 219). Given the need for novelty and change that has propelled so much postwar consumer design, few public interiors of that period remain intact. One happy exception is the Polo Lounge of 1948, designed by the architect Paul R. Williams at the Beverly Hills Hotel in California (fig. 113) (the hotel itself was designed and built in 1911–12 by Elmer Grey). The undulating walls of this cocktail bar–cum–patio restaurant (a hybrid-function concept that was typical of the postwar years) inscribe a free-form, indoor-outdoor plan that maximizes an awkwardly positioned portion of the Mission Style hotel building. The resulting space possesses an appropriately glamorous Hollywood atmosphere that survives as a testament to the evocative postwar intersection of design and pleasure.

Although the headlong rush toward suburbanization and the consumer culture made possible by postwar prosperity tended to efface the idealism that suffused the work of the Case Study group and other like-minded architects and designers, the experimental and improvisational spirit that was so evident in the engineering technology of the war years continued in American construction of the 1950s. Modular design, viewed by many as a means of making modernism available to a broader public, was most often expressed in the vocabulary of industrialism. Yet some architects made significant attempts to fuse the forms of organicism with modular production and the innovative use of materials. The highly publicized Monsanto House of the Future of 1957 (fig. 115), designed for the Tomorrowland section of Disneyland in Anaheim, California, by the M.I.T.-based architects Richard W. Hamilton and Marvin E. Goody with the engineer Albert G. H. Dietz, combined modern plastics manufactured by Monsanto with a

110.
Morris Lapidus (American, b. Russia, 1902–2001). Bond Clothing Store interior, Cincinnati, 1949. Hedrich Blessing Archives, Chicago Historical Society

111.
Morris Lapidus (American, b. Russia, 1902–2001). The Rainbow Shop, Brooklyn, New York, c. 1939. Interior view. Estate of Morris Lapidus

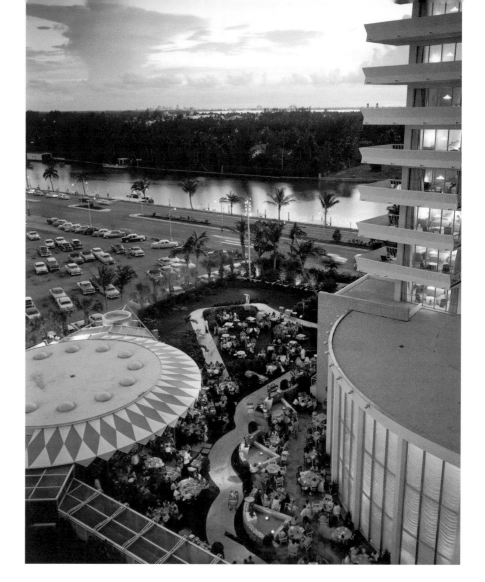

112.
Morris Lapidus (American, b. Russia, 1902–2001). Eden Roc Hotel, Miami Beach, Florida, 1955. View of outdoor restaurant. Photograph by **Ezra Stoller** (American, 1915–1989)

113.
Paul R. Williams (American, 1894–1980). Polo Lounge interior, Beverly Hills Hotel, California, 1948

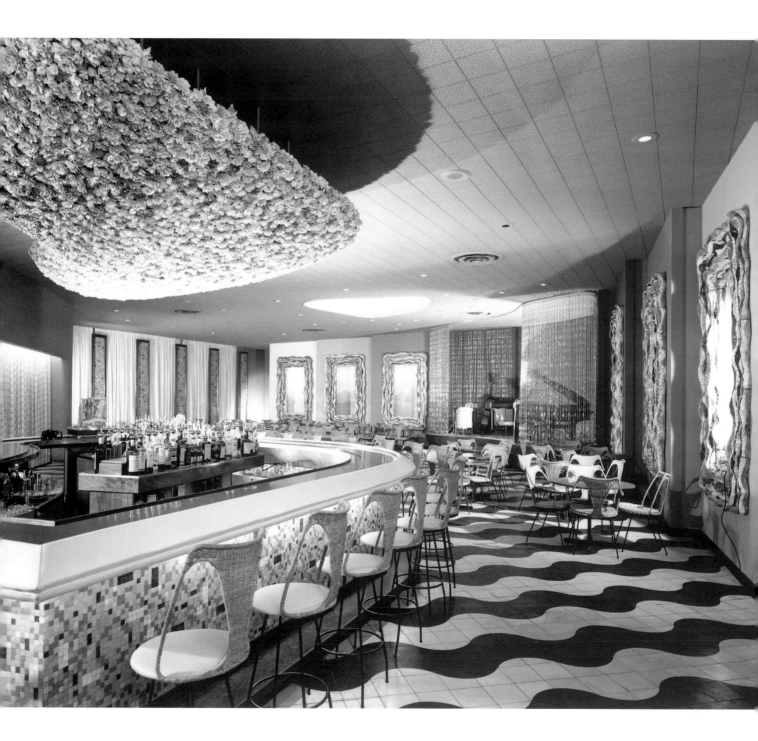

114.
Morris Lapidus (American,
b. Russia, 1902–2001).
Carioca Lounge, Americana
Hotel, Bal Harbour, Florida,
1956. Interior view. Photograph
by **Ezra Stoller** (American,
1915–1989)

flowerlike structure. A supporting "stem" elevated the living areas above ground level, with petal-like rooms radiating outward. The House of the Future undoubtedly seemed bizarre in contrast to the semi-traditional suburban split-levels, but it was closely related to the octagonal houses that were a utopian American fad of the mid-nineteenth century.

Similar in conception but far more impressively realized was the architect Bertrand Goldberg's Marina City mixed-use apartment and commercial towers of 1959–64 in Chicago (fig. 116). The floriform floor plans of these two sixty-story towers built atop a podium structure along the Chicago River in the heart of the city are very much like that of the Monsanto House of the Future, although the high-rise stacking of Marina City gives the overall impression not of a flower but of two enormous, upended ears of corn. One significant measure of how fully the International Style had come to dominate the American skyline by the end of the 1950s was how radical these graceful, poured-concrete cylinders seemed when juxtaposed against the conventional glass-and-steel boxes surrounding them.

115.
Richard W. Hamilton (American, d. 1957) and **Marvin E. Goody** (American, 1929–1980) with **Albert G. H. Dietz** (American, 1908–2000). Monsanto House of the Future, Disneyland, Anaheim, California, designed 1954–57, built 1957, demolished 1967. Exterior view. Courtesy Hamilton and Goody, Architects, successor firm Goody, Clancy & Associates, Architects and Planners, Boston

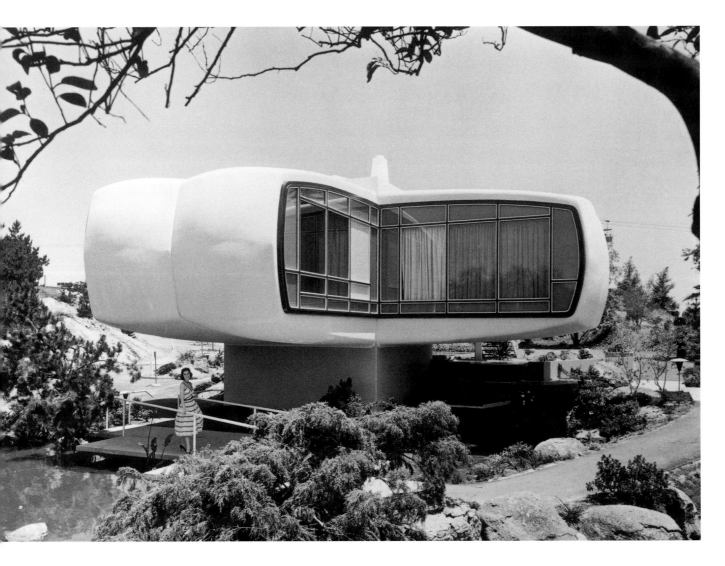

116.
Bertrand Goldberg (American, 1913–1997). Marina City Towers, Chicago, 1959–64. Exterior view with I.B.M. Building, 1969–71, by **Ludwig Mies van der Rohe** (American, b. Germany, 1886–1969) and **C. F. Murphy Associates**

Beyond stylistic issues, however, the biggest change in American architectural practice in the two decades after 1940 was the extent to which the organization and values of the corporations that embraced the International Style as the prevalent building mode of Big Business were echoed in the architectural firms that executed it. To be sure, there had been large architectural offices in the United States since the post–Civil War era, but such big operations were always paralleled by many practitioners who saw themselves as artists rather than technocrats. Frank Lloyd Wright, America's foremost example of the architect-artist, had come to seem like the quaint individualist vestige of a bygone age in the decade before he died in 1959. And it would be another two decades after that before the most important architect of the 1950s, Louis I. Kahn, would be recognized not only for his independence in steering clear of the snares and nets of corporate architecture, but also for his self-conscious

117.
Isamu Noguchi (American, 1904–1988) with model of Contoured Playground (unrealized), 1941. Model: Plaster and bronze relief, 26 x 26 x 3 inches. The Isamu Noguchi Foundation, Inc., Long Island City, New York

reassertion of the architect as artist, a role that earned lesser outsiders of the period, such as Goff and Kiesler, not respect but ridicule from their mainstream counterparts.

The one American mid-century figure who had no difficulty in establishing his identity as an artist in any medium he touched, from architecture and landscape to theater, product, and furniture design, was Isamu Noguchi. Primarily active as a sculptor, Noguchi refused to assign hierarchical importance to any one of his activities over the others (although late in life he seemed to resent the attention that his paper *Akari* lamps received at the expense, he believed, of his high-art production). He viewed his art as environmental in scope, most clearly in outdoor and indoor applications that blurred the lines between architecture, landscape design, and sculpture. Noguchi's unexecuted 1941 project for a children's playground (fig. 117) shows the clear influence of not only the biomorphic impulse in the work of such contemporary European sculptors as Jean Arp, but also the ancient earthworks of Native Americans, a cross-cultural fusion typical of his output in several different mediums. Noguchi's conception of a confined space as an infinite landscape was given very different expression in his remarkable ceiling of 1947–48 for the American Stove Company Building in Saint Louis (fig. 118). In the reception area of this low-rise office for a manufacturer of kitchen stoves, he devised an undulating plaster surface supported by a wire armature and embedded sporadically with aluminum and Plexiglas. Innovative not least of all for its audacious use of an area of architectural interiors most often ignored by designers in the modern age, this overhead sculpture, more than 40 feet square, survives (though now concealed by a later dropped ceiling) as a vivid example of American organic form at its best.

118.
Isamu Noguchi (American, 1904–1988). Ceiling for the American Stove Company Building, Saint Louis, 1947–48. Plaster, colored glass, and electric lights

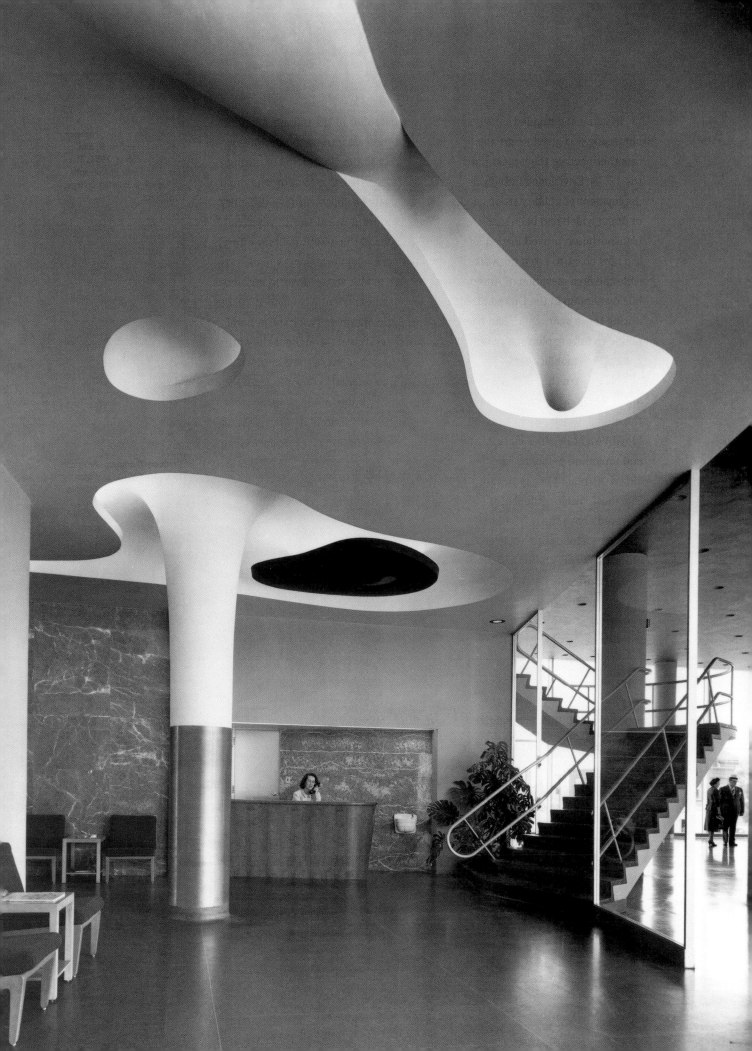

In its most extended sense, however, the metaphor of the infinite American landscape was given its greatest expression in the vast interstate highway system that became the largest public-works project in the United States during the 1950s. Envisioned initially as a strategic defense scheme to allow the rapid deployment of military troops and matériel across the continent (the difficulty of doing which had been made all too apparent during World War II, when rail transportation proved inadequate to the demands of the all-out military effort), the new coast-to-coast network of federally financed superhighways made possible the final elevation of America's car culture to cult status. Private automobile ownership in the United States had increased exponentially since 1920, but during those years there had been relatively little opportunity for the general public to fully exploit the potential of unrestricted travel throughout the entire nation. The mobility that has been an essential component of the American character from the outset was not only reconfirmed but also encouraged by the automobile and energy industries that found in the interstate highway system the ultimate marketing device for their products and services. Although Frank Lloyd Wright decades earlier had promoted the idea of universal car-ownership and unlimited personal transportation as a stimulus to democracy, by the late 1950s the reality began to catch up with the ideal, and quite unfavorably so. The most visible symbol of the biomorphic awareness that Lewis Mumford had elevated above the myth of the machine turned out to be a highway interchange structure. Mumford's ironic comment that the cloverleaf ought to be named the official flower of the United States was his way of saying that our national planning priorities had gone seriously awry (see figs. 119, 120).

CERAMICS

No material has historically lent itself to organic form with more ease and versatility than ceramics. Traditionally formed by hand, ceramic vessels since prehistoric times have mimicked the biomorphic shapes of the human body. Yet the new industrial capabilities that arose with the machine production of ceramics, especially from the eighteenth century onward, raised serious questions as to how—or even if—the long-standing organic basis of the medium should be preserved. For example, the classical forms of Josiah Wedgwood's ceramics—the first high-quality ceramics mass-produced in the West—concealed the means of their manufacture so well as to make such questions irrelevant. In contrast, by the late nineteenth century such modern industrial design pioneers as Christopher Dresser began to create machine-made ceramics that contrived to look like hand-modeled pieces. The constant push and pull between those two

119.
Interchange of State Highway 163 and Interstate 8, San Diego, California, 1951. The Fairchild Aerial Photography Collection at Whittier College, California

120.
Bradbury Thompson (American, 1911–1995). "Go and Stop," *Westvaco Inspirations* (Westvaco Corporation, New York), no. 194 (1954). 9 x 12 inches. Collection Westvaco Corporation, New York

impulses—the expression and the suppression of manual labor, whether real or simulated—became one of the central themes of twentieth-century ceramics.

The Studio Pottery movement in Britain, which began to attract international attention during the 1920s and 1930s, celebrated visible handcraft in form even more notably than the hand-painted surface decoration of American art pottery had during the first third of the century. The closest American equivalent to such British potters as Bernard Leach and émigrés to England including Hans Coper and Lucie Rie were the husband-and-wife collaborators Gertrud and Otto Natzler (fig. 121). Among the countless artists who fled Hitler and brought a reinvigorating spirit to their respective mediums in the United States, the Natzlers, whose sensuously contoured, vibrantly glazed, and richly textured pieces evoked the serenity of Far Eastern ceramics without direct historicizing references (see fig. 122), were among the most prodigiously productive and widely imitated.

121.
Gertrud Natzler (American, b. Austria, 1908–1971) and **Otto Natzler** (American, b. Austria, 1908) in their studio, 1950s

122.
Gertrud Natzler (American, b. Austria, 1908–1971) and **Otto Natzler** (American, b. Austria, 1908). Vase with Lava Glaze, c. 1950. Stoneware, approx. 14 inches high. Collection Philip E. Aarons

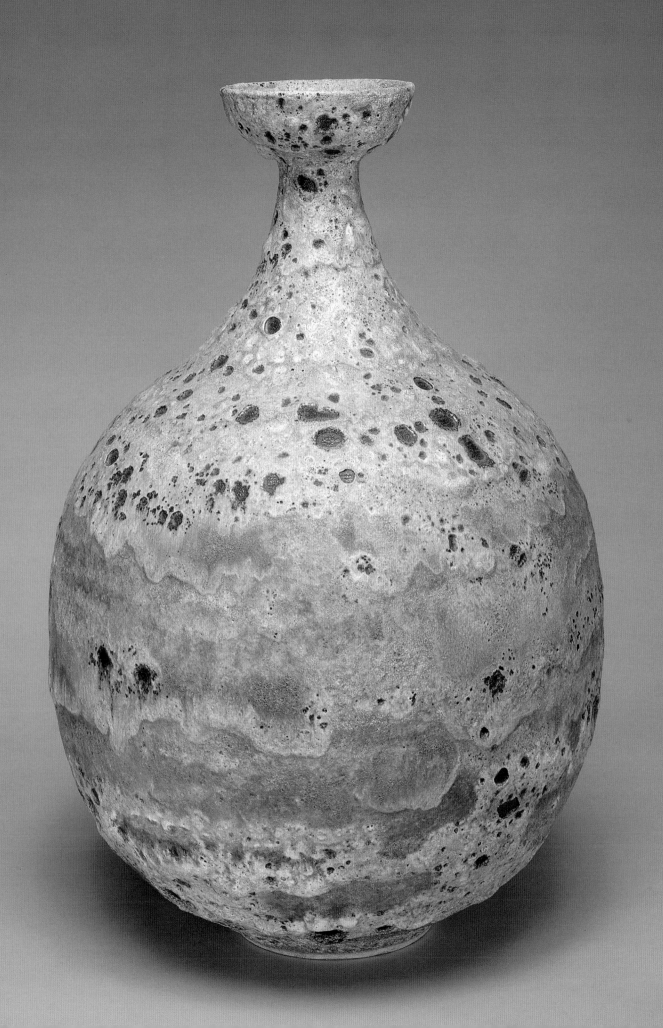

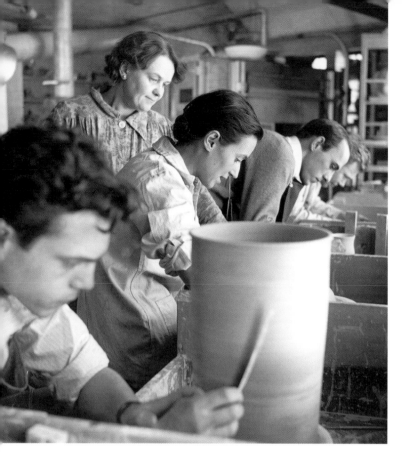

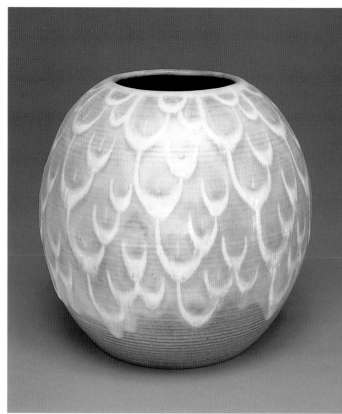

However, as the longtime head of the ceramics workshop at the Cranbrook Academy of Art, the Finnish-born potter Maija Grotell might be considered the most influential figure in mid-century American ceramics (see figs. 123, 124). At Cranbrook from 1938 to 1966, she taught several generations of potters, including Leza McVey and Toshiko Takaezu, whose works did not directly follow those of the master but which reflected her advocacy of voluptuously sculptural shapes of unmistakable biomorphic orientation.

Another important teacher, but one who took the Abstract Expressionist painters as his role models, was the Berkeley-based ceramist Peter Voulkos. No American potter of the postwar period better captured the dynamism of the Abstract Expressionists in clay than Voulkos did (see figs. 125, 126), and, indeed, he once tried to bridge the gap between his medium and painting by inviting Willem de Kooning to work in his ceramics studio. According to Voulkos, he planned to prepare a series of large, canvaslike slabs of clay on easels around his workspace and to have de Kooning work at them much as he would on a painting with a palette knife. Although de Kooning never took Voulkos up on his offer, and despite the insistently sculptural, rather than painterly, nature of Voulkos's own work—including large-scale, openly figural compositions at the end of the 1950s—this attempt at a crossover of mediums is emblematic of the shared biomorphic interests of many American artists at the time.

123.
Majilis (Maija) Grotell (American, b. Finland, 1899–1973) in the Ceramic Studio at Cranbrook Academy of Art, Bloomfield Hills, Michigan, March 1939

124.
Majilis (Maija) Grotell (American, b. Finland, 1899–1973). Vase, 1943. Ceramic, approx. 18 inches high. Collection Philip E. Aarons

125.
Peter Voulkos (American, b. 1924). *Sculpture*, 1957. Stoneware, thin colemanite glaze, 35 x 21 x 21 inches. Ruth Chandler Williamson Gallery, Scripps College, Claremont, California; Gift of Mr. and Mrs. Fred Marer, 82.2.1

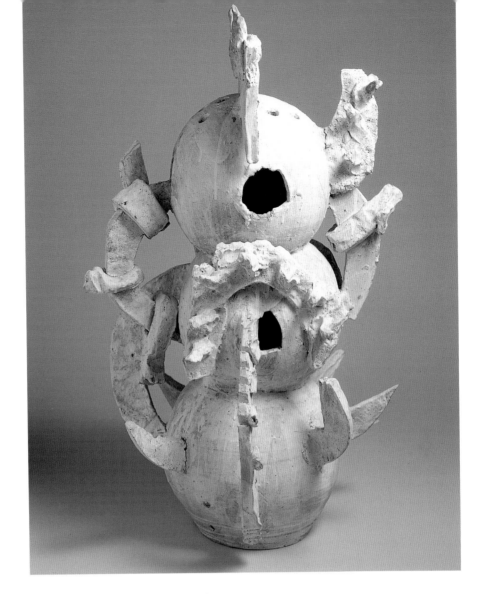

126.
Peter Voulkos (American, b. 1924) working on a ceramic form at the University of Montana, Missoula, summer 1958

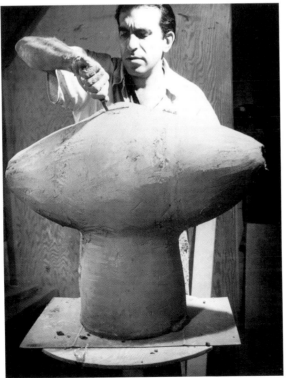

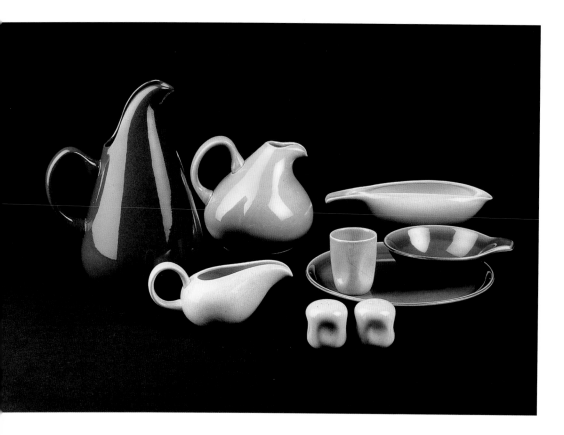

127.
Russel Wright (American, 1904–1976). *American Modern* Dinnerware, designed 1937, manufactured by Steubenville Pottery Company, Steubenville, Ohio, 1939–59. Glazed earthenware. Brooklyn Museum of Art, New York; Gift of Russel Wright, Paul F. Walter, and Ina and Andrew Feuerstein, 83.108.44; 84.124.3; 83.108.32, .35; 83.108.42–.43 and .21; 80.169.2, .5

In the realm of mass-produced ceramic manufacturing, the prewar success of Russel Wright's biomorphic *American Modern* range of glazed earthenware (fig. 127), designed in 1937 and produced 1939–59 by Steubenville Pottery, positioned him after the war as the foremost designer of popularly priced table-top objects. By far his most inventive (though commercially disastrous) enterprise was the *Russel Wright* line he designed for the J. A. Bauer Pottery Company and made by them in Atlanta in the late 1940s and early 1950s (fig. 128). Like Dresser, Wright was intrigued by the idea of machine-made objects that gave the appearance of being handcrafted. The boldly exaggerated profiles, heavily detailed textures, and lush multiple glazes of the twenty experimental Bauer forms were an unqualified artistic success, but their heaviness (some weighed more than five pounds) and the technical problems that caused a high degree of wastage in manufacturing led to the line's quick demise, hastened by poor public response (only one of the firm's six hundred vendors reordered the *Russel Wright* line).

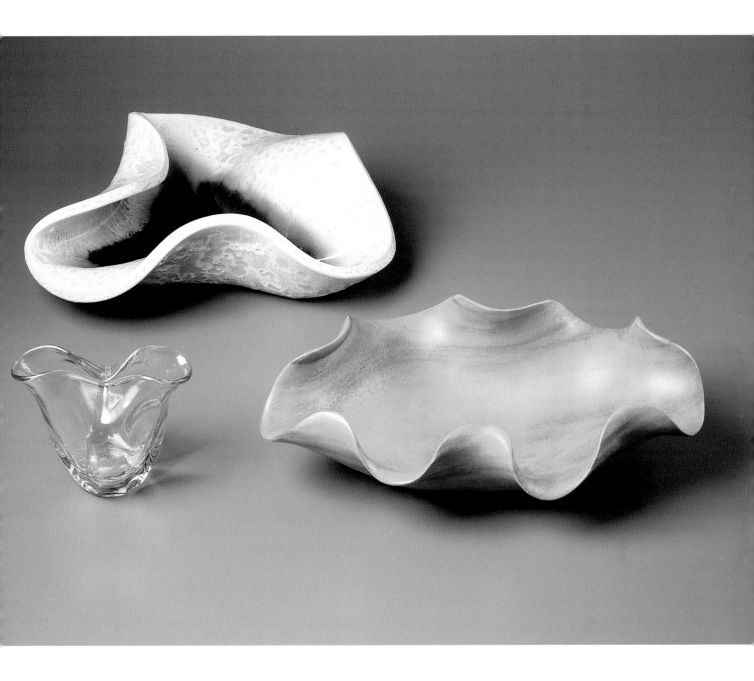

128.
Russel Wright (American, 1904–1976).

Clockwise: *Centerpiece* Bowl, *Russel Wright* Line, manufactured by J. A. Bauer Pottery Company, Atlanta, 1946. Porcelain, 4½ inches high, 14 inches wide. Brooklyn Museum of Art, New York; Gift of Paul F. Walter, 1994.165.30

Bowl, manufactured by Klise Woodenware, Grand Rapids, Michigan, c. 1935–50. Wood, 4½ x 13¾ x 9 inches. Brooklyn Museum of Art, New York; Gift of Paul F. Walter, 1994.165.62

Vase, manufactured by Imperial Glass, USA, c. 1951. Glass, 4½ x 5½ x 3¼ inches. Brooklyn Museum of Art, New York; Gift of Paul F. Walter, 1994.165.67

129.
Eva Zeisel (American, b. Hungary, 1906). Salt and Pepper Shakers, *Town and Country* Dinner Service (see fig. 131)

130.
Eva Zeisel (American, b. Hungary, 1906) with her daughter, c. 1960

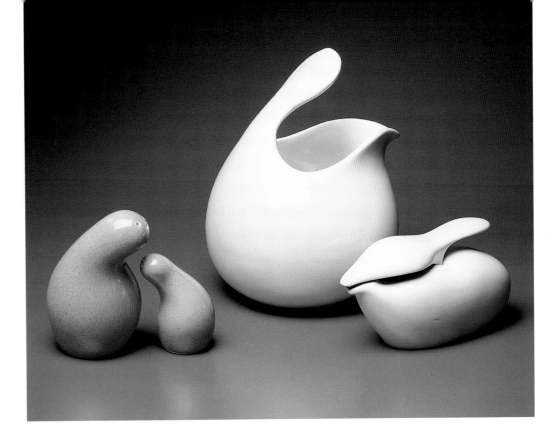

131.
Eva Zeisel (American,
b. Hungary, 1906).

Salt and Pepper Shakers and
Syrup Pitcher, *Town and Country* Dinner Service, designed
1945, manufactured beginning
c. 1946, Red Wing Pottery,
Red Wing, Minnesota. Glazed
earthenware; salt: 4½ x 3 x 2¼
inches; pepper: 3½ x 1½ x 2
inches; pitcher: 8 x 7 x 7 inches. Brooklyn Museum of Art,
New York; Gift of Eva Zeisel,
85.75.7, .9, .10

Baby-Oil Dispenser, prototype
c. 1940 (not manufactured).
Glazed earthenware, 3¼ x 6 x
3 inches. Brooklyn Museum of
Art, New York; Gift of Eva
Zeisel, 85.75.3a–b

Wright's closest contemporary counterpart, and in many ways his equal in
the invention of mass-produceable biomorphic ceramics, was the Hungarian
émigré Eva Zeisel. Her most memorable design, at least in the popular imagination, was the set of salt and pepper shakers from the *Town and Country* dinner service, first made by Red Wing Pottery about 1946 (figs. 129, 131). Each of
the complementary organic forms, which incline toward each other like a mother-and-child sculpture by Arp or Henry Moore (also see fig. 130), resembles the
cartoonist Al Capp's Shmoo, a whimsical creature in his *Li'l Abner* comic strip
(fig. 50)—a telling example of how high and low references were exchanged in
the realm of biomorphic design well before that phenomenon became more
widespread with the advent of Pop art in the 1960s.

As had happened with streamlining during the 1930s, biomorphism quickly
became a marketable fashion, and ceramics companies across the country
rushed to include the new look in their list of offerings. The Glidden Ceramics
Company, a number of whose designers were trained in the crafts department
of Alfred University in Alfred, New York, produced handsome glazed earthenware vessels with a pronounced biomorphic aspect, including a covered double
casserole with perfect (though not disturbingly representational) bilateral symmetry. George T. James's self-explanatory *Contours* dinnerware for Franciscan
China of California, and the exuberant products of Vernon Kilns in California
and Tamac Pottery in Oklahoma—the latter represented here by three pieces

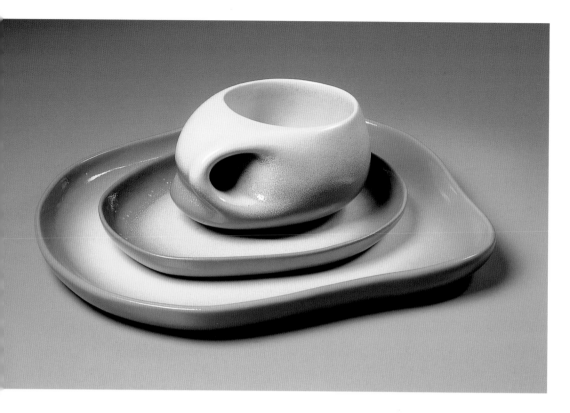

132.
**Marjorie and Leonard (Lee)
Tate, Betty and Allen McCauley**
(American, 20th century).
Tamac Pottery, Perry, Oklahoma
(in operation 1946–72). Plate,
Cup, and Saucer, mid-1940s.
Glazed earthenware; plate:
10½ x 9 inches; cup: 2½ x
5¼ x 4 inches; saucer: 7⅜ x
6⅛ inches. Brooklyn Museum
of Art, New York; Gift of Roy R.
Eddey and Joel E. Hershey,
1999.23.2–.3a–b

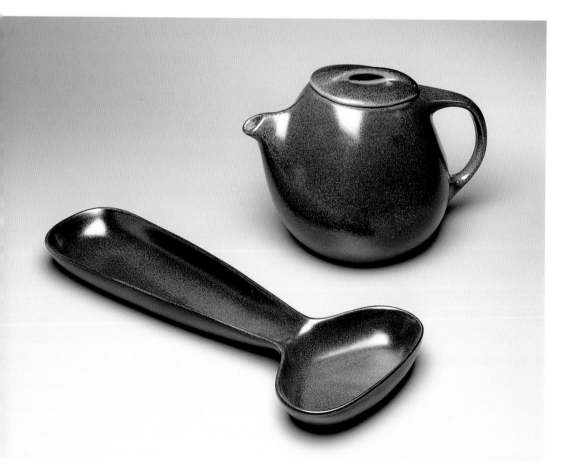

133.
Ben Siebel (American,
1918–1985). *Raymor* Teapot
and Celery Dish, manufactured
by Roseville Pottery Company,
Ohio, 1952. Glazed earthen-
ware; teapot: 7 x 9 x 7 inches;
dish: 15¾ x 6 inches. Brooklyn
Museum of Art, New York; Gift
of Rosemarie Haag Bletter and
Martin Filler, 1994.112.1–2

from a mid-1940s set (fig. 132)—and Ben Siebel's *Raymor* line from Roseville Pottery Company of Ohio in 1952 (fig. 133) together give some sense of the nationwide extent of the new taste for ceramics whose organic forms bespoke the informality and expansive sense of enjoyment that postwar consumers wished to embrace.

GLASS

The American studio-glass movement did not begin in earnest until the mid-1960s, but it drew on many of the tenets that its leading practitioners—such as the Cranbrook-trained ceramist-turned-glassmaker Harvey Littleton—had learned from biomorphic design of the preceding decades, including the work of several major figures in this medium. Alvar Aalto created a number of designs for free-form glassware in the late 1930s, including the ever-popular *Savoy* vase of 1936 (figs. 134, 135), produced first by Karhula Glassworks and later by Iittala (which still makes it), and a set of curvilinear nesting bowls of 1939 for Iittala. The International Style's fascination with laboratory glassware (several examples of which were enshrined in the Museum of Modern Art as vernacular modernism as early as 1934) was given a literally more human touch by Peter Schlumbohm with his highly practical Chemex coffeemaker of 1941 (fig. 196) and stoppered water kettle of 1949. More obviously influenced by the prewar Aalto designs were those of his Finnish-émigré compatriot Eva Lisa ("Pipsan")

134.
Alvar Aalto (Finnish, 1898–1976). Competition Drawing, *Eskimoerindens Skinnbuxa*, vase drawing submitted to Karhula Glassworks competition, 1936. Karhula-Iittala Glassworks, Finland

135.
Alvar Aalto (Finnish, 1898–1976). Glass (*Savoy*) Vase and Wooden Mold, Karhula Glassworks, 1936. Molded glass, 11¼ x 11⅝ x 11¼ inches. Alvar Aalto Museum, Jyväskylä, Finland

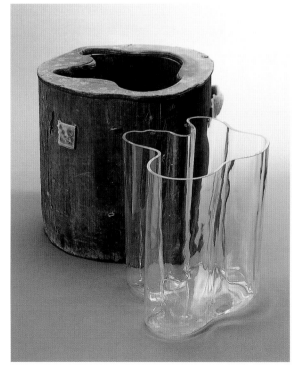

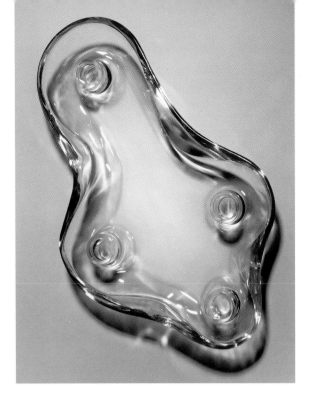

136.
Eva Lisa (Pipsan) Saarinen Swanson (American, b. Finland, 1905–1979). Flower Floater, manufactured by U.S. Glass Company, Tiffin, Ohio, 1948–50. Glass, 1½ x 14½ x 9½ inches. Brooklyn Museum of Art, New York; Gift of Lyman and Ruth Hemminger, 1999.25a–b

Saarinen Swanson, whose elegantly curvilinear clear glass candle holder and flower floater of 1948–50 for the U.S. Glass Company (fig. 136) harmonized just as effectively with traditional table appointments as it did with other biomorphic designs.

Like many successful mid-century modernist painters, Maurice Heaton specialized in variations on one essential theme: amoeba-shaped frosted-glass dishes enameled with a radiating pattern of thin gold lines (fig. 137). The realms of biological and nuclear science were simultaneously evoked, yet the monochromatic tonality of these mass-produced serving pieces (copied in even greater numbers) allowed them to be used in just as wide a variety of table settings as the Pipsan Saarinen table garniture.

By far the most inventive American glass designers of the postwar decades were the husband-and-wife team of Frances and Michael Higgins. Working in a broad range of techniques, the Higginses produced pieces for consumers in every price range, from unique studio sculpture displayed in art galleries to inexpensive gift items sold through dime stores. There was little stylistic consistency to their designs—although an overwhelming proportion of them incorporated biomorphic forms or motifs in some way—yet they tended to be united by strong colors, dynamic patterns, and varied textures. Organic influences abounded in their output, from the cellular outlines on a bowl of Tiffany-like delicacy, to their hauntingly sculptural *Bull Mask* bowl of c. 1955 (fig. 138), an object of almost shamanistic presence in which the power of their biomorphic vision is most palpable.

137.
Maurice Heaton (American, b. Switzerland, 1900–1990). *Amoeboid* Plate, c. 1950. Enameled glass, 20½ inches in diameter. Collection of Simona and Jerome Chazen

138.
Michael Higgins (American, b. London, 1908–1999) and **Frances Higgins** (American, b. 1912). *Bull Mask* Bowl, c. 1955. Enameled, slumped glass, 4½ x 20 x 15 inches. Collection of Alexander Kaplen

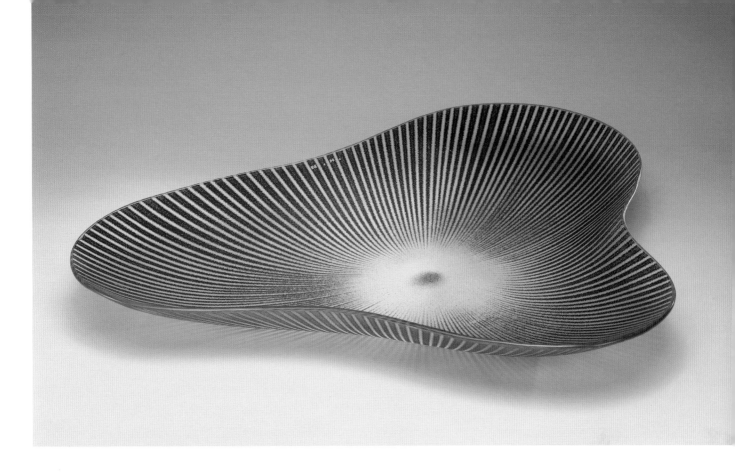

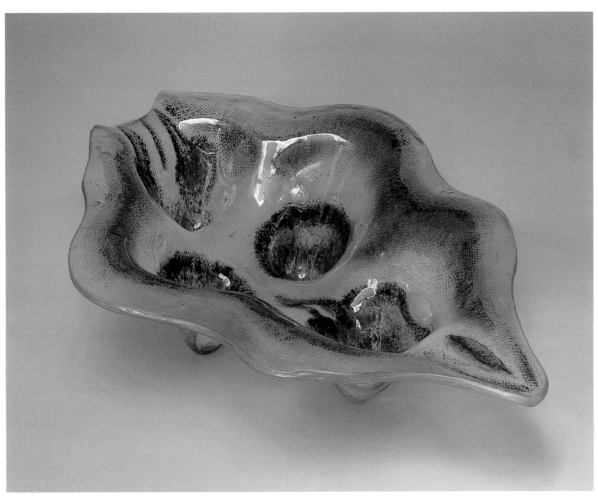

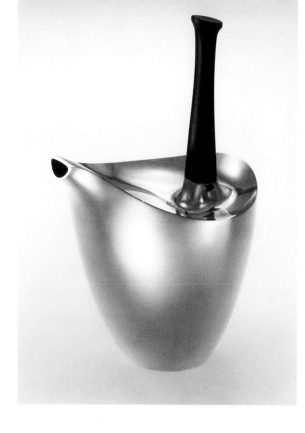

139.
Hans Christensen (American, b. Denmark, 1924–1983). Coffeepot, c. 1960. Silver with rosewood handle, 9⅝ inches high. Yale University Art Gallery, New Haven, Connecticut; American Arts Purchase Fund, 1978.90

METALWORK

No area of industrial design was more circumscribed by the war effort between 1941 and 1945 than metalwork, since nearly every kind of metal was restricted to military production. However, one of the most memorable pop icons of the 1950s grew directly out of its designer's wartime experience. The *Slinky* toy (see figs. 223, 224)—a simple, continuous metal coil—was invented by Richard James in 1945 after this naval engineer became aware, in an idle moment, that the kinetic properties of the metal spring would allow it to be used as a versatile plaything.

European directions in silver design, especially that of the Scandinavians, whose design culture burgeoned during the 1950s, had a direct impact on the impeccable linear elegance of a silver-and-rosewood coffeepot of about 1960 by the Danish-émigré metalsmith Hans Christensen (fig. 139). An unusual American example with a naval origin, but continuing a centuries-old regimental tradition, was the Gorham silver service designed by Richard L. Huggins for the Officers' Mess of the U.S.S. *Long Beach* in 1961 (figs. 140, 141). Though not significantly different from the symbolically ornamented ceremonial pieces of the past, this set was a striking departure in its decorative incorporation of stylized nuclear motifs in direct reference to the ship's strategic weaponry and fuel source.

By 1960, the threat of global annihilation had become the perverse antithesis of the benevolent life force implied in biomorphic design. Two years after

the start of that infinitely troubled decade, the world came to the very brink of
doom when the Cuban missile crisis brought the two nuclear superpowers to a
showdown of nearly apocalyptic consequences. It is not difficult to see the
immense social, cultural, and political upheavals of the late 1960s as having
their spiritual germination in a young generation's determination never to allow
such a suicidal confrontation to happen again. Though Lewis Mumford charac-
terized the competitive space programs of the United States and the U.S.S.R.
from 1957 onward as sublimated warfare, the probing of outer space did play an
important role in the growing perception of the earth as a fragile and finite
organism. The indelible satellite image of the beautiful blue-and-white Earth
floating in the blackness of the cosmos brought to mind echoes of something
e. e. cummings wrote in 1944, a very dark year for the planet: "Listen: there's a
hell of a good universe next door; let's go."

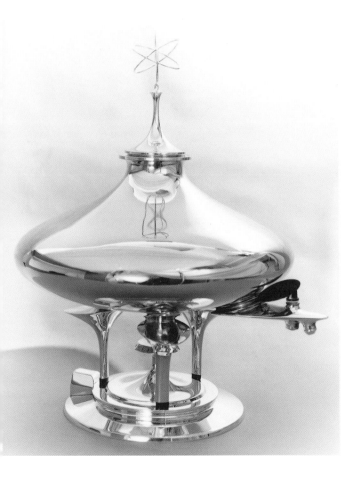

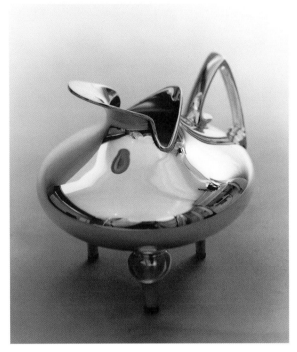

140.
Richard L. Huggins (American,
20th century). Coffee Urn
from the Silver Service for
the U.S.S. *Long Beach*
Missile Cruiser, 1961, manu-
factured by Gorham Manufac-
turing Company, Meriden,
Connecticut. Sterling silver,
12¾ x 9 x 10¼ inches. Naval
Supply Systems Command,
Mechanicsburg, Pennsylvania

141.
Richard L. Huggins (American,
20th century). Cream Pitcher
from the Silver Service for
the U.S.S. *Long Beach* Missile
Cruiser, 1961, manufactured
by Gorham Manufacturing
Company, Meriden, Connecti-
cut. Sterling silver, 4¾ x 4¾ x
5 inches. Naval Supply Systems
Command, Mechanicsburg,
Pennsylvania

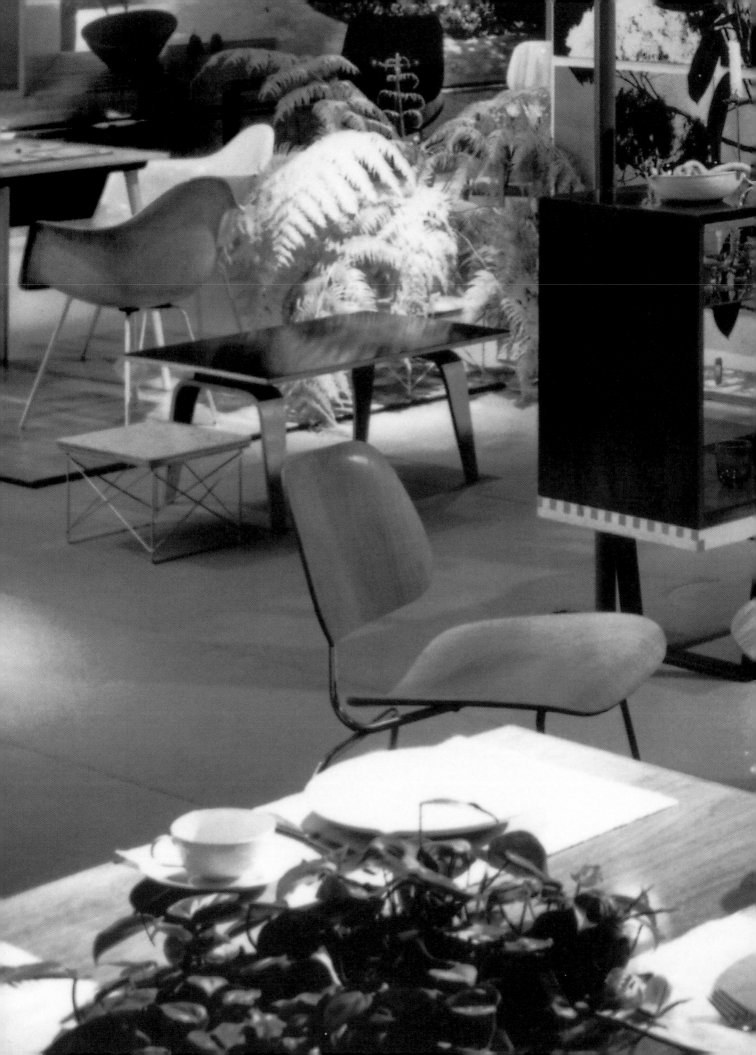

FROM *FUTURAMA* TO *MOTORAMA*

From *Futurama* to *Motorama*

Mildred Friedman

War is like an illness, and when it's over you think you've never felt so well.
—Anatole Broyard, *A Greenwich Village Memoir*, 1993

In the forties and fifties we were young, the war was over, we had
peace and prosperity; the negatives—pollution, energy shortages,
decay of cities—were that little cloud no larger than a man's hand.
—George Nelson, unpublished interview with the author, 1974

After seeing Norman Bel Geddes's exhibit *Futurama* at the 1939–40 New York
World's Fair (see fig. 142), visitors departing the General Motors Pavilion
received a clip-on badge that read, "I Have Seen the Future" and, metaphori-
cally, they proudly drove off into the "World of Tomorrow." Thus, the cult of the
automobile as equalizer was legitimized. The family car became an essential
element of the nomadism that has been a significant facet of American life since
Native Americans roamed the Plains and intrepid newcomers initiated the
nineteenth-century movement westward. But after the cataclysm at Pearl Harbor
and the United States' entrance into World War II, dreams of a technologically
advanced land of plenty (see fig. 143) were temporarily set aside. Americans
learned to pull together toward a single goal. Rosie the Riveter, national symbol
of the patriotic female, went to work in defense industries, planting the seeds of
feminist attitudes that would have a lasting effect on the generations to come.

At war's end, Americans were euphoric in their hard-won victory. Returning
veterans were eager to make up for lost years. There was an urgent need for
housing and related consumer commodities, long unavailable, owing initially to
the Great Depression and later to the war. New materials and technologies—
some developed to serve wartime needs—made possible an array of fresh prod-
ucts and led to the ubiquity of synthetics in today's world. A vast number of
opportunities were available to young architects and industrial designers who
brought "Yankee ingenuity" to a long list of postwar issues.[1] American designers,

164

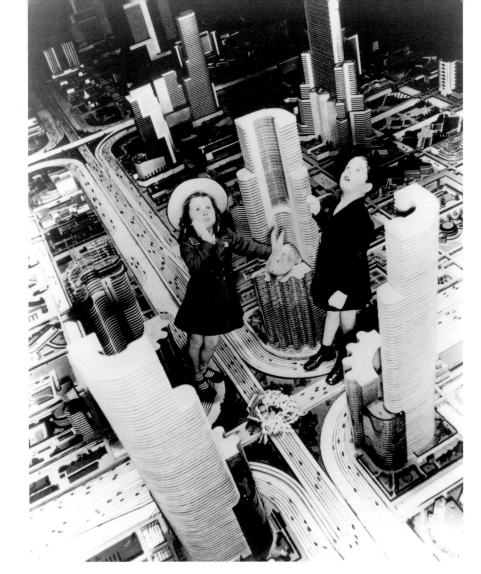

142.
Norman Bel Geddes (American, 1893–1958). Scale Model of America in 1960 as envisioned in *Futurama*, General Motors Pavilion, 1939–40 New York World's Fair, Queens, New York (demolished 1940). Courtesy Queens Museum of Art

143.
Russel Wright (American, 1904–1976). Installation view of *Miracle of Food* Display, Food Building South, United States Department of Agriculture, 1939–40 New York World's Fair, Queens, New York (demolished 1940). Syracuse University Library, Department of Special Collections—Russel Wright Papers, Syracuse, New York

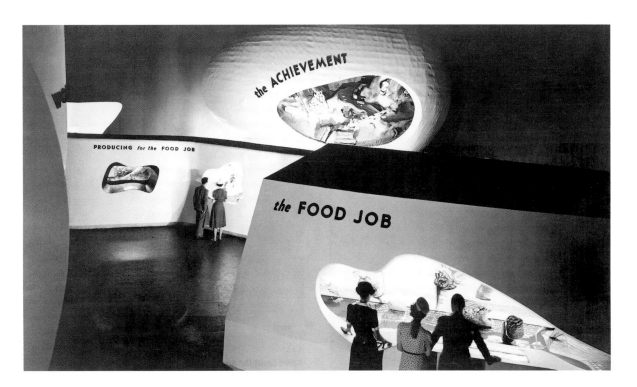

free of the devastations of war that temporarily entrapped their European counterparts, waded hip-deep into an ocean of needs and desires.[2]

The G.I. Bill (Serviceman's Readjustment Act of 1944) provided unprecedented access to housing and education in America. The single-family house, financed by banks and underwritten by the Federal government, became the accepted ideal for working Americans who became active consumers, greatly expanding the middle class.[3] In the postwar period there was a remarkable focus, clear in retrospect, on the design of high-quality utilitarian objects. For young families of limited financial means, the emphasis was on these "good goods," as they were characterized by the brilliant, unique "man of all work" Charles Eames.[4] They were essentials, substantively distinct from today's high-cost, so-called designer goods.

To meet the demand for housing in the postwar period, new suburban communities gradually surrounded America's major cities, setting the stage for what, fifty years later, many have come to believe is a less-than-wholesome lifestyle.[5] By the early 1950s, to reach an East Coast suburb of choice from a major city, a commuter could take a train. But in most parts of the country, he (in those days almost inevitably "he") chose to drive in his chrome-laden family sedan between home and work on freeways that, even then, did not accommodate the crush. Arriving at his ranch-style or, alternatively, Cape Cod–style house (fig. 144)—rarely as splendid as the "colonial" of Mr. Blandings's dream[6] (see fig. 145)—the commuter, greeted by Mom and the kids, sat down in the eat-in kitchen to an early supper. The dining table fit easily into a kitchen appointed with a dishwasher, refrigerator, deep freeze, washer and dryer, built-in oven, and range (fig. 146)—equipment that supported a lifestyle not even dreamed of in pre–World War II middle-class America.

145.
Still from the film *Mr. Blandings Builds His Dream House*, 1948, with Cary Grant, Myrna Loy, and Melvyn Douglas, directed by H. C. Potter. RKO Pictures, Inc.

144.
Alfred Levitt (American, 1912–1966). Drawing of a Levittown House, Cape Cod Type 1, 1947–48. Courtesy Levittown Public Library, New York

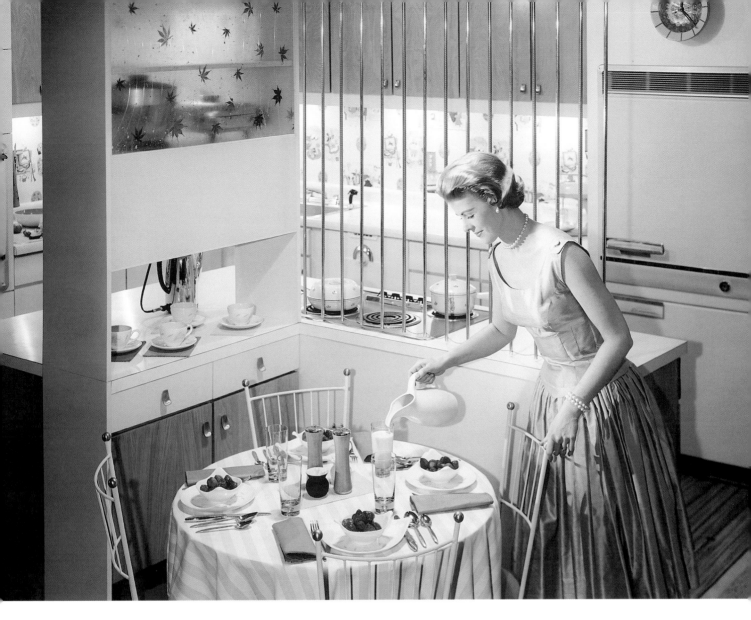

146.
An idealized 1950s kitchen

Innovations in the design of household appliances were accepted by a majority of Americans well before innovations in the design of architecture or furniture would be. While kitchens were modernized with modular appliances, the "decoration" of this most functional of all domestic areas became increasingly nostalgic, through the use of pastel colors and woods, or synthetics that "looked like" natural materials.[7] Conformity was the rule in the living rooms of many suburban homes that, for the most part, were filled with an unremarkable assortment of furniture in pseudo-historical styles made in Grand Rapids, Michigan. It was a slow, uphill struggle for contemporary furniture designed for the home, first reluctantly admired and finally embraced by a small number of adventurous cognoscenti. One way or another, America was on a buying spree. The 1950s was a material decade.[8]

Suburban and exurban life expanded broadly in the postwar years, yet, unfortunately, much of its architecture and industrial design was vapid, at best. But there were pockets of innovation. One of the most significant was found in the magazine *Arts and Architecture* (see figs. 147, 148), published and edited in southern California from 1938 to 1962 by John Entenza, a uniquely supportive advocate of new design. His magazine provided a platform for many avantgarde designers and writers including Margaret De Patta, Charles and Ray Eames, Garrett Eckbo, Esther McCoy, George Nakashima, Richard Neutra, Bernard Rudofsky, Paul Rudolph, Konrad Wachsmann, and many others. In 1945 the magazine's leadership in the development of innovative postwar architecture through its sponsorship of the Case Study House Program was remarkable. Commissioning and building eight houses designed by promising architects using new materials and techniques, the program was far in advance of any similar American efforts to follow. Like many early European modernists (especially members of the De Stijl group and the Bauhaus), Entenza and many of the designers he sponsored saw the new world of design in large part as a social movement that could someday lead to a long-dreamed-of utopia.

Looking back on the evolution of the visual arts in America, it is clear that those vital forms we have chosen to concentrate on here best represent the two mid-century decades. They reflect a renewed sensitivity to the curvilinear forms of nature, to the human body, to the plant and animal life ever present in the visual arts. Although biomorphic form, dominant in the postwar era, was strongly influenced by the Surrealism of the 1930s, its organic references have existed worldwide throughout design history. Organic forms were the basis of Art Nouveau, the Omega Workshops of 1913, Art Deco in the 1920s, furniture by Alvar Aalto and Bruno Mathsson in the 1930s, Gerald Summers's armchair of 1934, Fiesta Ware by Frederick Rhead in 1935, *American Modern* pottery by Russel Wright, 1937 (fig. 127), and Frederick Kiesler's nesting table, 1935–38 (fig. 149). Contemporaneous with such geometric movements as Arts and Crafts and the International Style, organic design has persisted—a constant that stems from our manifest place in the natural world.

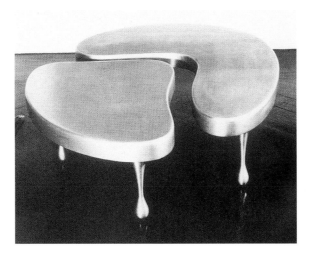

149.
Frederick J. Kiesler (American, 1890–1965). Two-Part Nesting Table, 1935–38. Cast aluminum, 9¾ x 34½ x 22¼ inches. Courtesy Jason McCoy Inc., New York

The so-called useful arts answered the needs and desires of a generation that came of age during World War II. As a result of the burgeoning postwar economy, Americans were able to buy cars, houses, furniture, clothes, and such luxuries as dishwashers, television sets, and stereos—and buy not once, but again and again, as styles changed. After years of doing without, Americans' postwar consumerism fed the need for expanded productivity that led to the wily strategy of planned obsolescence (a term coined by the industrial designer Brooks Stevens). This emphasis on style over durability actually began with the streamlining of consumer products (by way of making them more attractive to

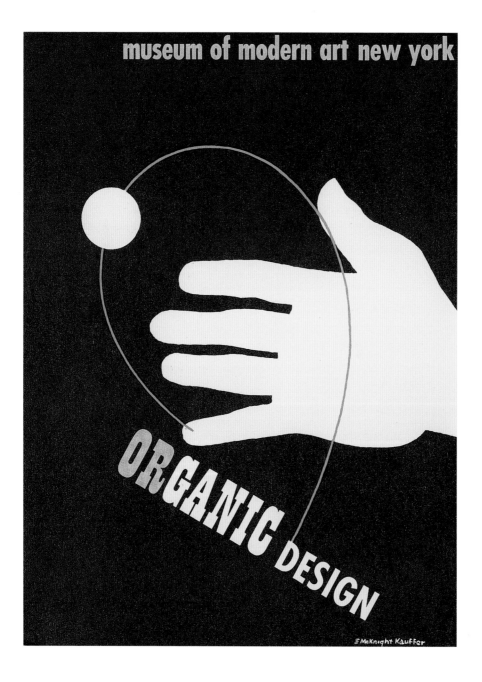

150.
E. McKnight Kauffer (American, 1890–1954). Cover of catalogue for the exhibition *Organic Design in Home Furnishings*, The Museum of Modern Art, New York, 1941. 10 x 7½ inches. Brooklyn Museum of Art, New York; Art Reference Library, Special Collection

the buying public) in the 1930s, and has persisted into the opening decade of the twenty-first century.

FURNITURE

In the 1940s and early 1950s New York's Museum of Modern Art presented projects such as *Modern Art in Your Life* and exhibitions of low-cost furniture. These exhibitions were aimed at an audience that was for the most part unsophisticated in its response to the design of useful objects and their place in the daily lives of American families. About a year before the United States entered World War II, the museum sponsored the competition *Organic Design in Home Furnishings*. Contracts with manufacturers were offered as prizes to the winners, and the winning entries were shown in an exhibition at the museum in 1941 (see figs. 150, 151). Eero Saarinen (who was in architectural practice with his father in Bloomfield Hills, Michigan)[9] and Charles Eames

151.
Installation view of furniture by **Charles Eames** (American, 1907–1978) and **Eero Saarinen** (American, b. Finland, 1910–1961) in the exhibition *Organic Design in Home Furnishings*, The Museum of Modern Art, New York, 1941. Courtesy The Museum of Modern Art, New York

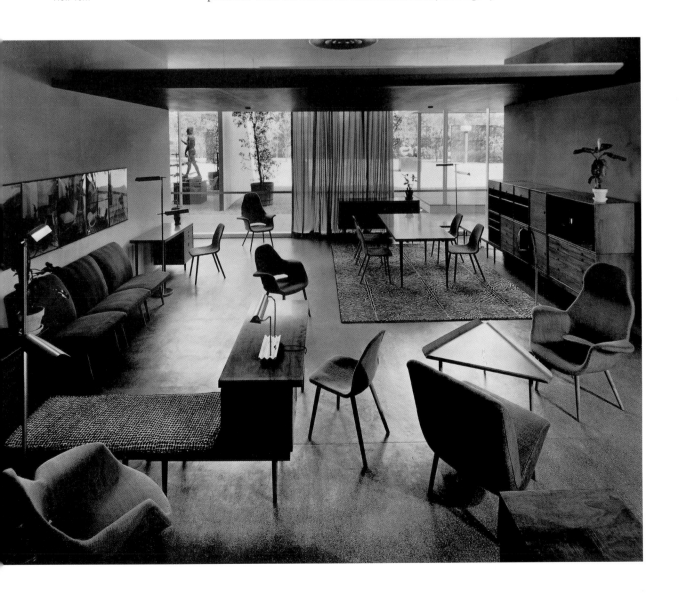

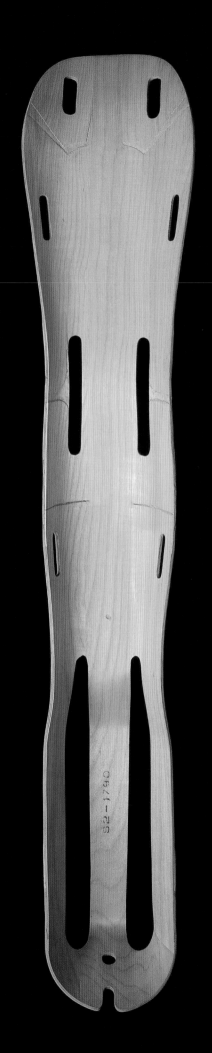

(then teaching with Eero at the Cranbrook Academy of Art) jointly won first prize with a series of upholstered, laminated wood-veneer chairs. Their inventive entries anticipated the molded-plywood and fiberglass furniture that they would each create independently at war's end.

Among the most significant designs of the 1940s were the molded-plywood "potato-chip" chairs created by the husband-and-wife team of Charles and Ray Eames in 1946. Although many designers created molded-plywood furniture in the 1920s and 1930s, the Eameses' production method was unique: they discovered how to form compound curves in more than one direction in a single operation using their home-made "Kazam" machine, a method that could be duplicated on an assembly line (see fig. 154). During the war, they employed this technology to create molded-plywood splints (see figs. 152, 153) and litters for the United States Navy, and later, molded-plywood parts for aircraft.[10] No doubt their intense work with splints—designed to embrace and support the human form—inspired the shaping of their plywood chairs that conform flexibly to the body. In addition to his inventive work with molded plywood, Charles Eames pioneered many other new technologies, among them the use of shock mounts between the wood and metal parts of the chairs, in order to increase flexibility, and electronic welding, used to join the chairs' various elements. "With one stroke," Eliot Noyes wrote of Eames in 1946, "he has underlined the design decadence and the technical obsolescence of Grand Rapids."[11]

154.
Assembly-line production of the Eameses' Dining Chair with Metal Legs (DCM), 1947

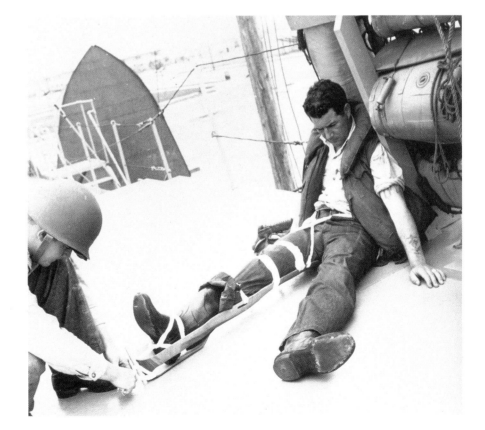

152.
Charles Eames (American, 1907–1978) and **Ray Eames** (American, 1912–1988). Leg Splint, designed 1941–42, manufactured 1942–43 by Plyformed Wood Company, Los Angeles; 1943–45 by Evans Products Company. Molded plywood, 4½ x 42 x 8 inches. Brooklyn Museum of Art, New York; Anonymous gift, 83.156

153.
Demonstration of the Eames Leg Splint in use

155.
Herman Miller Furniture
Company Showroom, Los
Angeles, 1950, with furniture
by **George Nelson** (American,
1907–1986), **Charles Eames**
(American, 1907–1978), and
Ray Eames (American, 1912–
1988)

In 1945, even before war's end, George Nelson and Henry Wright introduced
the "storage wall," a concept as sophisticated as that of the new Eames furni-
ture.[12] Published first in *Life* magazine, it was not furniture in the conventional
sense. They demonstrated, instead, that by thickening an interior wall from the
4-to-6-inch norm to 12 inches, storage for the family's sporting equipment, tools,
picnic baskets, and off-season clothing could be created without sacrificing the
space—scarce in small-scale postwar housing—required for traditional storage
units. Constructed between two rooms, the storage wall could be accessible
from both sides. This idea (perhaps influenced by traditional Shaker cabinetry)
was the basis for much of the later built-in furniture characteristic of contempo-
rary architecture in both domestic and institutional environments.

In 1945 Nelson became design director of the Herman Miller Furniture Com-
pany, a small, Midwestern family-owned business, and he created seventy

pieces of furniture in the first year and a half of his tenure there. In the beginning, products were made as they were ordered, in what was essentially an oversize cabinet shop. There was no market research. Nelson assumed that if he liked a design, others would too. In the next year he brought Charles and Ray Eames to Herman Miller as consulting designers, and, somewhat later, Alexander Girard. In those early days, in addition to designing furniture and fabrics, the designers often worked on the advertising, graphics, and design of the showrooms (see fig. 155), and as a consequence, a consistent, unmistakable identity was created for the company.

The other groundbreaking American furniture manufacturer to emerge in this period was Knoll Associates. Eero Saarinen, Arieto ("Harry") Bertoia, and Florence Knoll were its chief innovators at that time; its business head was Florence Knoll's husband, Hans Knoll; and Florence designed the company's showrooms. Knoll produced classic designs from Europe such as those by Ludwig Mies van der Rohe and Alvar Aalto, as well as those created in America, and in many ways Knoll predicted the internationalism that would characterize the furniture market in the 1960s and 1970s.

In Minneapolis, the Walker Art Center initially published *Everyday Art Quarterly* (later renamed *Design Quarterly*) in 1946 (see fig. 156), and that same year inaugurated the Everyday Art Gallery. Their purpose: to spread the word about new products, materials, and attitudes that could improve the lives of all Americans in the postwar world. The publication and gallery were created to bring the most innovative contemporary design to a public that was longing

156.
Cover for *Everyday Art Quarterly*, no. 3 (Walker Art Center, Minneapolis), Winter 1946–Spring 1947. 11 x 8½ inches

for domestic products of all kinds. Objects selected for display were chosen "on the basis of simplicity, intelligent use of materials, straightforward design, and pleasant appearance."[13]

One aspect of the postwar economic boom was the unabashed entry of commerce into the art world via exhibitions. Among the most memorable was Alexander Girard's 1949 *For Modern Living* at the Detroit Institute of Arts (fig. 157). In addition to the many objects displayed, Girard included complete room environments created by George Nelson, Charles and Ray Eames, and Florence Knoll, plus examples of furnishings by many other designers who would have a major impact on American design throughout the latter half of the century. In the Museum of Modern Art's annual *Good Design* exhibitions of the early 1950s, Edgar Kaufmann, Jr., director of the museum's department of industrial design, brought products selected by himself, designers, and retailers from among wares available at Chicago's Merchandise Mart to exhibitions at the museum, after their initial showings at the Mart (see fig. 158). For many young people unschooled in art and design, the museum's "good design" imprimatur provided a reassuring endorsement of what may have been their first selections

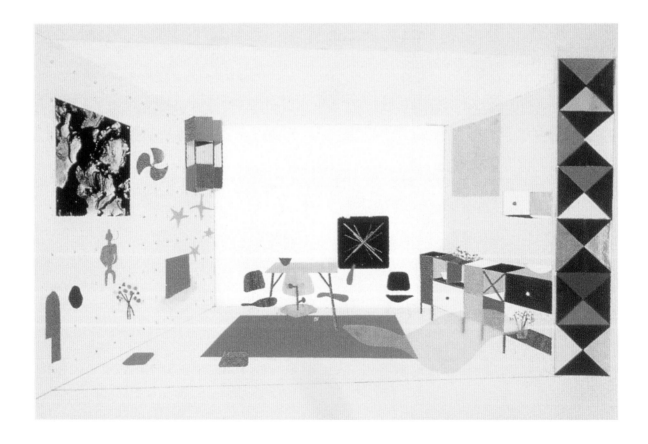

157.
Ray Eames (American, 1912–1988). Plan of the Eames Office room display for the exhibition *For Modern Living*, The Detroit Institute of Arts, 1949

158.
Installation view of the exhibition *Good Design*, Merchandise Mart, Chicago, January 1950. Organized by the Merchandise Mart and The Museum of Modern Art, New York. Installation designed by **Charles Eames** (American, 1907–1978) and **Ray Eames** (American, 1912–1988)

of home furnishings. (Then as now, a "high" and "low" version of almost everything was created: for example, the Eames 1956 rosewood-and-leather lounge chair and ottoman [fig. 213] and their counterparts, innumerable Grand Rapids recliners.)

In the 1950s, a new kind of domestic furniture was shown in American museums and available in the marketplace. It was portable, small-scale, and designed to withstand the onslaught of tiny peanut-butter-and-jelly-covered hands, and the cats and dogs essential to a happy, child-oriented suburban home of that era. These young households were not organized around the parlor but around the kitchen, as had been true in colonial days. The kitchen often expanded into what became known as the family room. The small suburban house, with its relatively open plan, consisted, to a large degree, of "areas" rather than traditional rooms. (Perhaps this arrangement was inspired by the open plans characteristic of Frank Lloyd Wright's best Usonian houses, a series of small, single-family houses designed for maximum economy, convenience, and comfort.) Backyard entertaining around the barbecue created a need for lightweight, weather-resistant seating. Two inventive examples were made of bent metal rods with removable covers: the 1946 *Barwa* lounge chair (fig. 159), designed by Edgar Bartolucci and Jack Waldheim, and the *Hardoy* chair (fig. 160), designed in 1938 by three architects (Antonio Bonet, Juan Kurchan, and Jorge Ferrari-Hardoy), and manufactured in the United States by Knoll Associates after World War II.

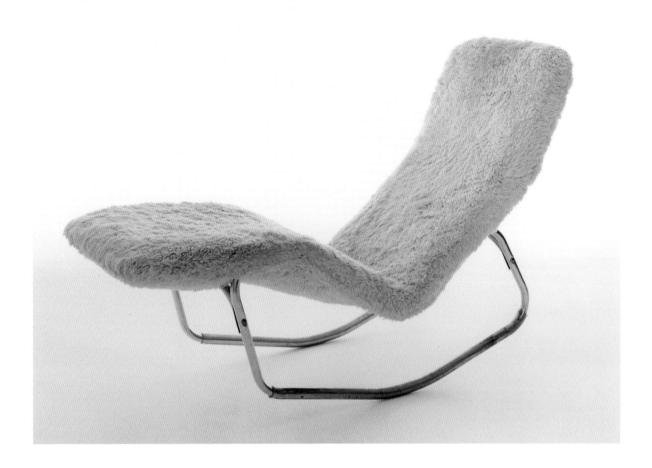

159.
Edgar Bartolucci (American,
b. 1918) and **Jack Waldheim**
(American, b. 1920). *Barwa*
Lounge Chair, manufactured
by Barwa Associates, Chicago,
1946. Tubular aluminum frame
with synthetic lambskin uphol-
stery. Collection of James Elkind

160.
Jorge Ferrari-Hardoy (Argen-
tine, 1914–1977), **Antonio
Bonet** (Spanish, 1913–1989),
and **Juan Kurchan** (Argentine,
b. 1913). *Hardoy* Chair, No.
198, 1938, manufactured by
Knoll Associates, Inc., New
York, 1947–1973. Tubular steel
frame with leather sling seat,
34¼ x 31 x 27 inches

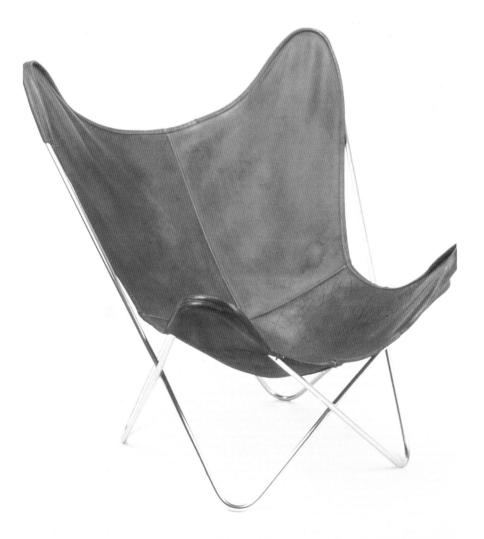

Although a broad domestic market did not immediately accept "modern" furnishings or architecture, commerce provided a vast arena for advanced design. The 1950s New York City office-building boom that spread throughout America's major cities in the 1960s (tagged "urban renewal" by its energetic developers) created acres of office floors that would be furnished with the innovations of avant-garde designers. By the early 1960s, Herman Miller (with its "Action Office") and a number of other manufacturers became systems businesses rather than furniture businesses.

Because of his premature death in 1961 at the age of fifty-one, Eero Saarinen was a less prolific designer of furniture than the Eameses. Nevertheless, he created some extraordinary chairs and tables for Knoll, which were derived from his early organic designs developed with Charles Eames. Saarinen wrote that "a building is custom built—a solution to a specific problem. Furniture's client is Everyman." He believed that the primary issue in furniture design is the relationship of the chair to the rectilinear room. He felt that the compound curves of the plastic shell are most appropriate for twentieth-century furniture, generating a sculptural rather than a constructivist solution. With the 1946 *Womb* chair and ottoman (fig. 161), he created a handsome replacement for the traditional overstuffed chair; and his pedestal furniture cleaned up the ubiquitous "slum of legs" that dominated contemporary interiors.[14]

161.
Eero Saarinen (American, b. Finland, 1910–1961). *Womb* Chair No. 70 and *Womb* Ottoman No. 74, designed c. 1946, manufactured by Knoll Associates, Inc., New York, 1948 to present. Chromium-plated tubular steel frame, compound of molded fiberglass, plastic and wood particle, fabric-covered latex foam upholstery; chair: 35½ x 40 x 34 inches; ottoman: 16 x 25½ x 20 inches

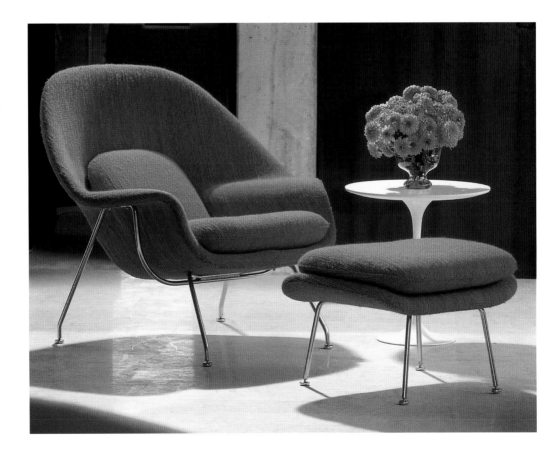

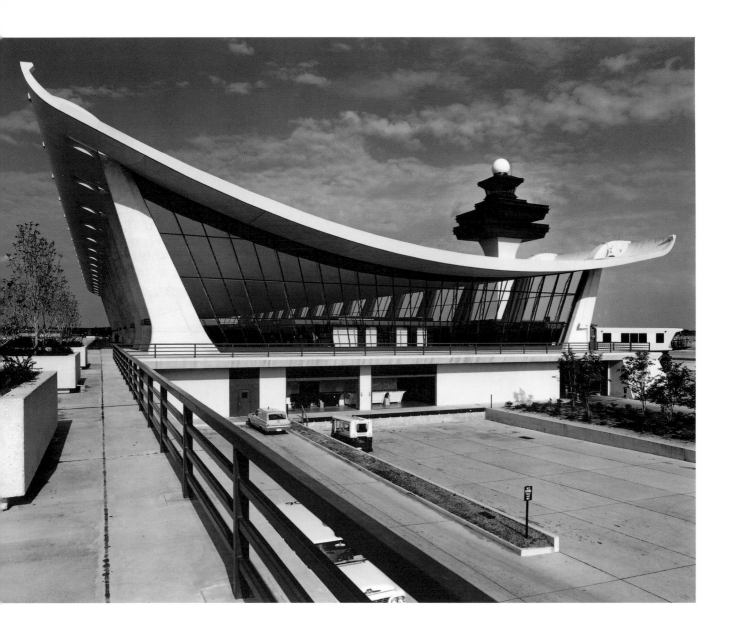

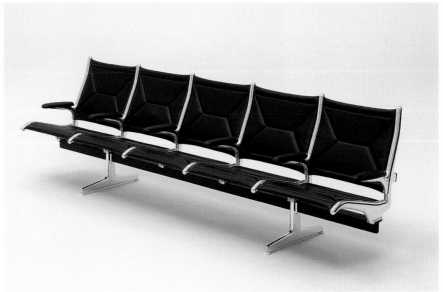

162.
Eero Saarinen (American, b. Finland, 1910–1961). Dulles International Airport, Washington, D.C., 1958–62. Exterior view. Photograph by **Ezra Stoller** (American, 1915–1989)

The formal relationship of the new furniture to contemporary architecture is most evident in such projects as Eames's 1962 Tandem Sling Seating (fig. 163), designed initially at the request of Eero Saarinen for the Dulles International Airport, outside Washington, D.C. (fig. 162). The initial Tandem installation was at C. F. Murphy's O'Hare International Airport in Chicago, and only later at Dulles. However, a fascinating, though perhaps serendipitous aspect of this design is the relationship between the shape of the aluminum chair's frame castings and the form of the colonnade of concrete piers from which the Dulles roof is suspended. Both seating and building create a sense of movement, of hovering in space.

One of the most fascinating interdisciplinary artists of this era was Isamu Noguchi, whose work was not limited to any single category of expression. He had no qualms about simultaneously creating stage props for the great dancer Martha Graham (see fig. 164), and earthworks, gardens, furniture, lamps, and sculpture for a variety of clients (see figs. 58, 79, 117). His penchant for biomorphic form is as apparent in his furniture and lighting designs as it is in his sculpture. The iconic glass-and-wood table he created for Herman Miller in 1944 (see fig. 216) is characteristic of postwar biomorphic tendencies. Less well known, but equally significant, were Noguchi's *Lunar* lighting elements (fig. 165). These large-scale lamps and light fixtures were molded of magnesite (a malleable plasterlike compound), contained tiny hidden lightbulbs, and were designed to be suspended from ceilings or walls. In 1947–48, Noguchi created an entire ceiling for the American Stove Company Building in Saint Louis, in which he used sculptural forms embedded with light fixtures, creating a lively sky over the building's entrance lobby (fig. 118).[15] Two related works from 1947–48, a ceiling in the Time-Life Building in New York City and a stairwell for the S.S. *Argentina*, have been destroyed.

163.
Eames Office in collaboration with **C. F. Murphy Associates** and the **Special Products Division of Herman Miller Furniture Company**. Eames Tandem Sling Seating, designed 1958–62, manufactured by Herman Miller Furniture Company, Zeeland, Michigan, 1962. Installed at Dulles International Airport, Washington, D.C., and O'Hare International Airport, Chicago

Another artist whose work bridges a number of disciplines, in a way similar to that of Noguchi, was Harry Bertoia. He emigrated from Italy in 1930 and was a student at Cranbrook at the same time as Florence Knoll. A sculptor, furniture and jewelry designer, printmaker, and painter, Bertoia created cellular constructions that reflected his abiding concern with the composition of living organisms. The same sensibility was at work in his airy steel-wire-and-rod chairs designed for Knoll in 1952 (see fig. 199) as in his openwork metal sculpture and jewelry (see fig. 166).

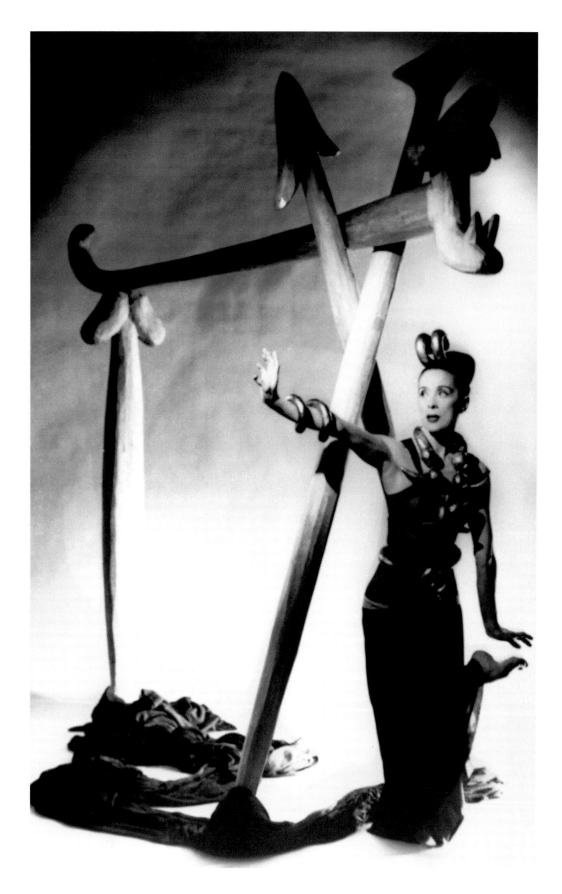

164.
Martha Graham (American, 1894–1991) with stage set for "Tent of Holofernes" from *Judith*, c. 1955, designed by **Isamu Noguchi** (American, 1904–1988). The Isamu Noguchi Foundation, Inc., Long Island City, New York

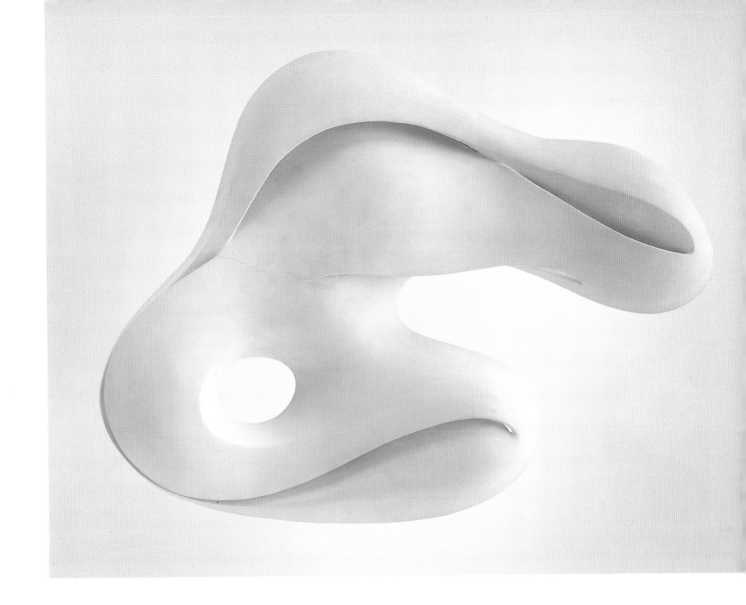

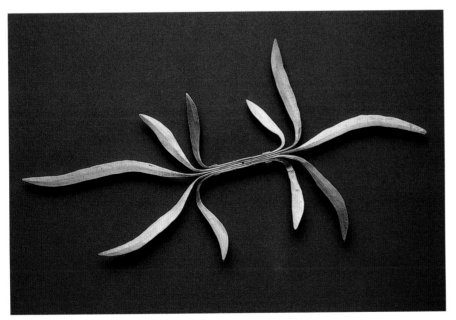

165.
Isamu Noguchi (American, 1904–1988). *Floating Lunar*, 1945. Magnesite, plastic, and electric wiring, 32½ x 23½ x 3⅛ inches. Collection of Georgia and Michael de Havenon

166.
Arieto (Harry) Bertoia (American, b. Italy, 1915–1978). Brooch, designed and executed 1942. Brass, 6½ x 3⅜ x ¼ inches. Collection Michele Oka-Doner

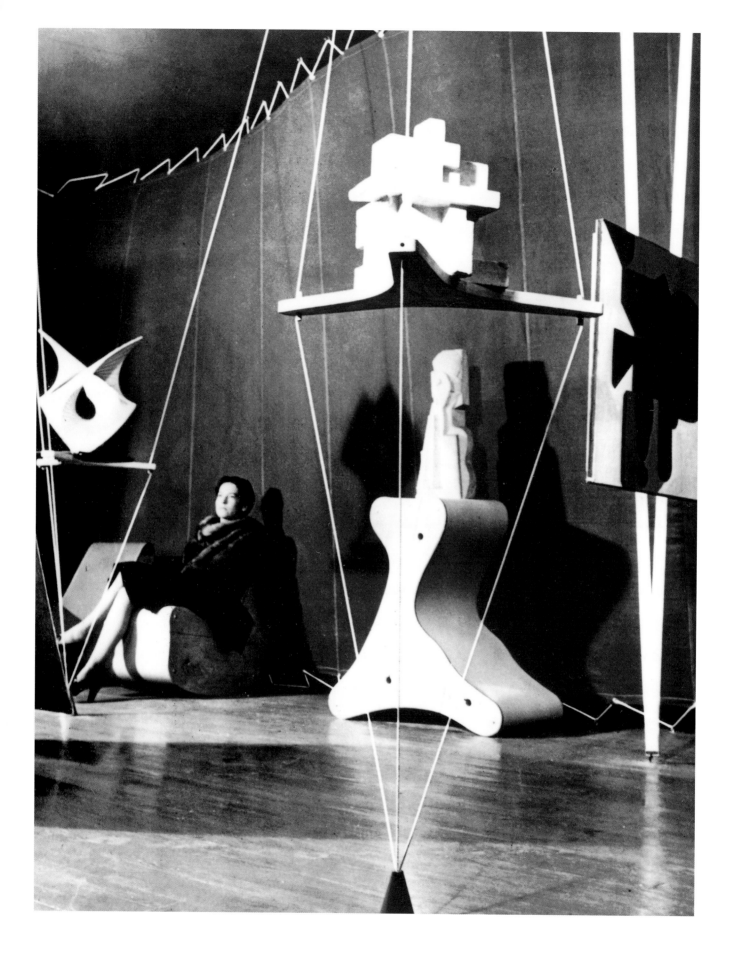

167.
Frederick J. Kiesler (American, 1890–1965). The Abstract Room in Art of This Century gallery, New York, 1942

An enigmatic designer whose work is difficult to classify, but whose influence continues to be widely recognized among designers is the architect and designer Frederick Kiesler, who was often described as "the greatest non-building architect of our time."[16] His 1942 design for Peggy Guggenheim's Art of This Century gallery in New York consisted of four sections. In one room, which had navy blue stretched canvas walls, works of abstract art were suspended from rope structures (fig. 167). In a second room, Surrealist works projected from tunnel-like concave wood walls at different angles, which visitors could adjust. Multi-purpose seating and sculpture bases were created out of organically shaped plywood, covered with linoleum (fig. 168). These elements, though abstract in form, were eminently practical in their application to the gallery's needs.

168.
Frederick J. Kiesler (American, 1890–1965). Rocking Chair for Art of This Century gallery, 1942. Plywood and linoleum, 29⅛ x 15⅝ x 30⅛ inches. Brooklyn Museum of Art, New York; Gift of Ruth Abrams, 76.169

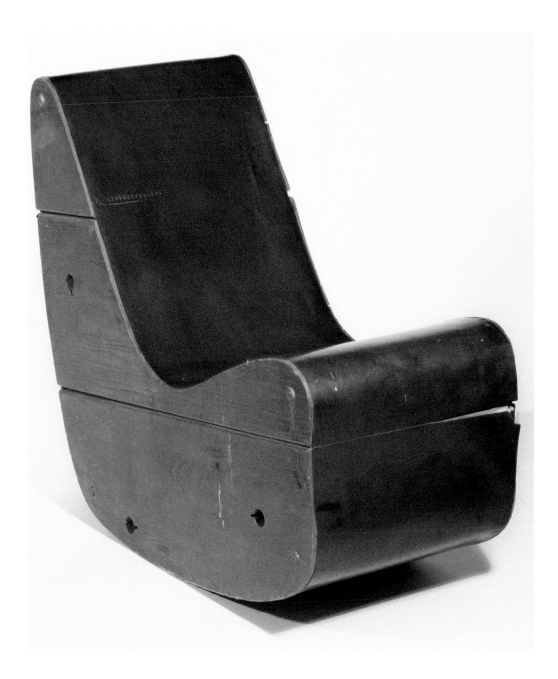

TEXTILES

Because woven textiles are inherently geometric in their warp/weft construction, most of them are not formally organic in design and, consequently, the woven work in this predominantly organic period of American design remained essentially geometric. One of America's great innovators of both woven and printed textiles (where organic forms prevailed), Jack Lenor Larsen (see figs. 169, 170) continues to create brilliant new designs today. He came out of Cranbrook in 1951 to begin a long career in which he not only worked from his New York studio but traveled and worked extensively in Asia and Europe, bringing an unprecedented worldview to American textiles.

Other printmakers such as Ruth Adler Schnee, who worked out of Cranbrook, and Eszter Haraszty, designer for Knoll, created colorful printed designs (figs. 44, 171), which often brought movement and vitality to large areas of otherwise undynamic glass-curtain walls.

NEW MATERIALS, TECHNOLOGIES, AND DESIGNERS

In the early 1940s, household products were made of nonpriority materials: substitutes for steel, aluminum, copper, and other metals and for some woods essential to the war effort. Corning introduced Pyrex (heat-resistant glass) cookware, and many products were made of paperboard and plywood. "Twentieth-century industrial design," wrote the art historian R. Craig Miller, "has largely

171.
Ruth Adler Schnee (American, b. Germany, 1923). *Germination*, Adler-Schnee Associates, c. 1948–49. Printed textile. Cranbrook Academy of Art Museum, Bloomfield Hills, Michigan, Z01982.23

169.
Jack Lenor Larsen (American, b. 1927) in his New York studio, c. 1955

170.
Jack Lenor Larsen (American, b. 1927). *Aurora*, Larsen Design Studio, New York, 1961. Printed textile. Collection Jack Lenor Larsen

been shaped by three materials: tubular steel, molded plywood, and polymers, popularly known as plastics."[17] The first two materials were developed in Europe between the two world wars, but plastics, as we know them today, are largely an American achievement.[18] Less expensive to produce than metal die-castings, plastics also made the creation of a wide variety of free-flowing organic forms possible (see fig. 172). Thus, many products made in the 1930s, 1940s, and 1950s—radios, phonographs, irons, vacuum cleaners, television sets—were enclosed in plastic housings that were lightweight, easy to keep clean, and portable. And because plastics could be made to look like more expensive natural materials, they were often created to visually simulate them: for example, plastic laminates were often produced with wood and marble grains. Henry Ford promised to introduce a plastic-bodied automobile to a broad market, and he might have achieved that goal if his efforts had not been thwarted during World War II. Instead of in experimental cars, plastics were used in many other products—most important, in airplanes and boats. Ford's dream would be realized later by General Motors, with its introduction of the fiberglass Corvette in 1953 (figs. 173, 174).

172.
Eva Zeisel (American, b. Hungary, 1906). *Cloverware* Serving Platter and Serving Spoons, designed c. 1947, manufactured by The Clover Box and Manufacturing Company, New York, c. 1947. Plexiglas; platter: 2½ x 12⅞ x 10⅞ inches; spoons: each ¾ x 10⅞ x 3 inches. Collection of the artist

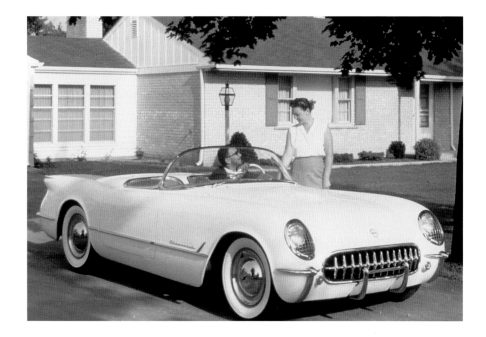

173.
Harley Earl (American, 1893–1954) with **Robert McLean**, **Ed Cole**, and **Maurice Olley**. Chevrolet *Corvette*, General Motors Corporation, Flint, Michigan, designed 1952–53

174.
Harley Earl (American, 1893–1954) with **Robert McLean**, **Ed Cole**, and **Maurice Olley**. Fiberglass body parts of the Chevrolet *Corvette*, General Motors Corporation, Flint, Michigan, designed 1952–53

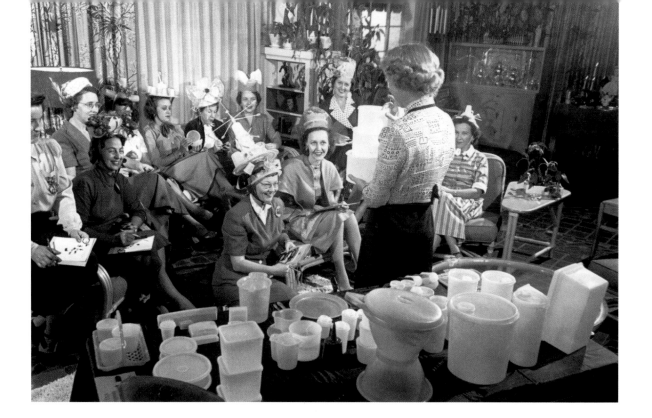

175.
Tupperware Home Party,
c. 1950

Immediately after World War II, Earl S. Tupper began the injection-molding of the flexible, durable plastic called polyethylene, a system that produced the ubiquitous Tupperware food containers of suburban party fame (see figs. 175, 207, 208). But Tupperware was not simply a fad. It was not made to look like another material. It was what it was: lightweight, unbreakable, and its covers had an airtight seal.

But not all the news about plastics was good. The promise of the so-called miracle materials was not always realized when "plastic sink strainers melted in hot water or buttons became greasy blobs at the dry cleaners."[19] The potential widespread use of plastics in the construction industry was frustrated by local building codes and the building trades that questioned the reliability of plastics, whose long-term durability was untested, just as earlier they had questioned the widespread use of prefabrication. This, in combination with the inherent conservatism of the American home buyer (except in the case of bathrooms, kitchens, and, to a lesser degree, furniture), temporarily defeated the effort to bring plastics to the "house of tomorrow."

Many American industrial designers who achieved prominence in the 1930s and 1940s had advertising backgrounds and were brought into corporations to improve the salability of products during the Depression. Raymond Loewy was a master of the genre, with an uncanny ability to combine the avant-garde with the popular.[20] His clients included Coca-Cola, Lucky Strike, Studebaker, Formi-

ca (for which he designed the recently reissued boomerang pattern), TWA, Greyhound, Exxon, Shell, and, finally, NASA. Other industrial designers who attained public recognition included Walter Dorwin Teague, Norman Bel Geddes, Henry Dreyfuss, and Gilbert Rohde. By the 1950s, giant corporations all employed brilliant designers whose names were unknown to the general public: Raymond Sandin at General Electric, Dave Chapman at Montgomery Ward, Peter Müller-Munk at Dow Chemical, and many others.

AUTOMOBILES

Raymond Loewy's Studebaker of 1953 (fig. 176) was the exception to the postwar rule of bigger and gaudier cars, but it did not sell as well as its flashier competition. Loewy called the new American cars "jukeboxes on wheels," and he revealed his loyalty to modernism when he maintained that "form, which should be the clean-cut expression of mechanical excellence, has become sensuous and organic."[21] There was, indeed, a "bloated" look to many industrial products of that era. Harley Earl's infamous tail-finned "dream car," the 1959 Cadillac, for example, was in many ways similar to the "New Look" of popular

176.
Raymond Loewy (American, b. France, 1893–1986) pointing out Studebaker design features to his students at the exhibition *Ten Automobiles*, The Museum of Modern Art, New York, 1953. Studebaker *Commander Starlight* Coupe, designed 1953, manufactured by the Studebaker Corporation, South Bend, Indiana

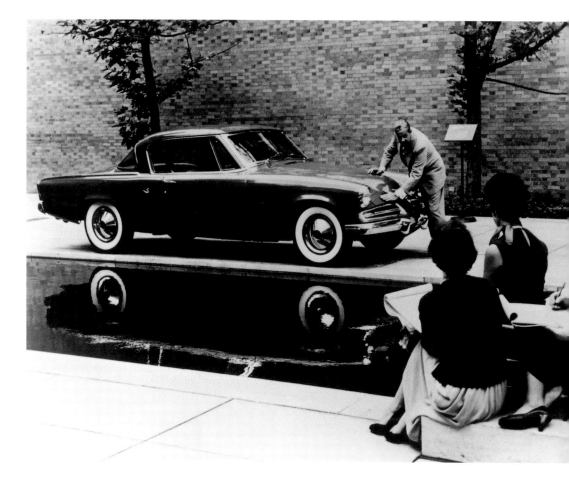

postwar clothing: the more-of-everything-than-was-required syndrome was a reaction to making do with less, which had characterized design in wartime America. The British critic Reyner Banham noted, "Whilst the Russians had been developing 'Sputnik,' the Americans had been debauching themselves with tail fins."[22] By 1950, Americans owned three-quarters of all the automobiles in the world; by 1955, cars were 20 percent of the gross national product. In television commercials and at automobile trade shows, they were shown on revolving pedestals, like works of art. "The car was the new Conestoga wagon on the frontier of consumerism."[23] And America's love affair with the automobile lingers on.

Bruce Springsteen recalled the period when he wrote:

> Eldorado fins, whitewalls and skirts
> Rides just like a little bit of heaven here on earth,
> Well buddy when I die throw my body in the back
> And drive me to the junkyard in my Cadillac.[24]

In 1955, freeways and the family car made Disneyland, a newly conceived theme park that was a relative of the circus and the World's Fair, possible. Similarly, the suburban shopping mall, cousin to the theme park, provided one-stop shopping and entertainment for the whole family.[25] The substitution of today's on-line shopping (the replacement of one method of consumerism with another) for the formerly ubiquitous shopping mall was, of course, inconceivable in the 1950s.

GRAPHIC DESIGN

How do the corporate giants sell their wares? ADVERTISING! "The sizzle was becoming as important as the steak."[26] Thus, by the 1950s, the ability to communicate in visual as well as verbal terms became an increasingly significant marketable talent. Through the proliferation of periodical and television advertising, the immediacy of the way an ad looked became equal in importance to the words that described the product.

One of the most outstanding pioneers in American graphic design of the period was Paul Rand, who by his early twenties was already art director of *Apparel Arts* and *Esquire* magazines. Rand always acknowledged his debt to European modern painting, and his series of covers for the magazine *Direction* (see figs. 177, 178) reflects that influence, for they were powerful in both their messages and their formal qualities. In the postwar era, there was a great

177.
Paul Rand (American, 1914–
1996). Cover for *Direction*, vol.
5, no. 3 (Summer 1942).
10½ x 8 inches

178.
Paul Rand (American, 1914–
1996). Cover for *Direction*, vol.
6, no. 3 (November 1943).
10½ x 8 inches

Harper's BAZAAR

August 1940
COLLEGE FASHIONS
25 fr. in Paris · 50 cents · 2/6 in London

179.
Herbert Bayer (American,
b. Germany, 1900–1995).
Cover of *Harper's Bazaar*,
August 1940. 12¾ x 9¾
inches. Herbert Bayer Collec-
tion and Archive, Denver Art
Museum, 1986.1756

deal of reciprocity between the so-called high and low arts: modern painting
influenced graphic design, and popular culture influenced a group of young
artists whose vernacular images, later known as Pop art, began to appear in the
late 1950s.

Separation of "commercial art" from the more exemplary graphic design was
a perceptible postwar change in America, stimulated by the lessons inherent
in the works of many European émigrés who arrived on our shores in the 1930s
and 1940s (see fig. 179). Trained in modernism's ideals and art movements,
these brilliant outsiders transformed typography and graphic imagery in Ameri-
ca. In 1934, Alexey Brodovitch, who was then living in Paris, was recruited to
become the art director of *Harper's Bazaar* magazine, a post he held until 1958.
There, he demonstrated his innate ability to relate typography to image, most
particularly to the female form. With this ability, he predicted the biomorphic
shapes characteristic of much that was innovative in postwar graphic design.

During the war years, the Office of War Information commissioned designers
such as Herbert Bayer and Herbert Matter, both European émigrés, to create
posters relative to the war effort. Well known before their arrival in the United
States in the late 1930s, these designers had no difficulty finding American
clients. The Container Corporation of America, because of the predilection for
the avant-garde of its president, Walter Paepcke, became the patron of a
number of the era's most innovative designers in the 1950s. In the C.C.A.'s ad
series "Great Ideas of Western Man," many designers were given the freedom to
create some of their most thoughtful images. Similarly, Westvaco's sponsorship
of the imaginative work of the designer Bradbury Thompson set a unique
standard of excellence for American industry's involvement in the arts. As edi-
tor and designer of the paper and printing periodical *Westvaco Inspirations*,
Thompson was encouraged to experiment with all aspects of graphic design
(see figs. 120, 180, 181). His pioneering typography, photography, and printing
techniques are as challenging today as they were fifty years ago.

Book and periodical publishing, which again flourished at war's end, were
significant clients of imaginative graphic designers. Alvin Lustig (see fig. 182),
Matter, Rand, Ladislav Sutnar, and Thompson were some of the most advanced
in that field. Lustig and Matter worked together on the design of John Entenza's
magazine *Arts and Architecture*. The magazine's covers and advertisements
set a new standard of excellence for that genre. Rand produced many paperback

Line

Tone

Form

Texture

Color

Inspirations for Printers number 216

Westvaco

Printed by letterpress
on Sterling Letterpress Enamel,
25x38–85.

WESTVACO INSPIRATIONS 216

Photograph: Rollie Guild.
Engraving: Halftone, 120 line screen,
printed in three colors of ink.

START HERE • You're a cube (a square from squaredom, that is) if you don't dig the doings in disc- and dungaree circles. Fact is, the cats are real gone about painting and paper glue with visual rhythms (that's higher than cops. dadd-o) when the B-H gang comes on. A newly issued album is the summit. photographic design. pasquerrano sewicara papelreano by original photographic design.

ROCK ROLL

4188

4189

180.
Bradbury Thompson (American, 1911–1995). "Basic Elements of Art," title page of *Westvaco Inspirations* (Westvaco Corporation, New York), no. 154 (1945). 9 x 12 inches. Collection Westvaco Corporation, New York

181.
Bradbury Thompson (American, 1911–1995). "Rock and Roll," *Westvaco Inspirations* (Westvaco Corporation, New York), no. 210 (1958). 9 x 12 inches. Collection Westvaco Corporation, New York

book covers for publishers such as Vintage and Wittenborn Schultz. Sutnar created the trademark for Sweet's Files, and Thompson designed innumerable publications for Westvaco, including his remarkable book *The Red Badge of Courage*, by Stephen Crane.

A new graphic design discipline was required for television—motion graphics distinct from those for film. And in the early 1950s, CBS's leadership in this area was assured through the remarkable work of Bill Golden and later Lou Dorfsman, both of whom made unforgettable contributions to the character and quality of this new field. Less acknowledged is the work of Georg Olden, the first African American to make significant inroads into the hitherto all-white world of media graphics. From 1945 until 1960 Olden was an art director at CBS, where he designed the titles for many prime-time shows and was a major player in the design hierarchy of the network.[27]

182.
Alvin Lustig (American, 1915–1955). Dust Jacket for *Anatomy for Interior Designers* by Francis de N. Schroeder (New York: Whitney Publishing Co., 1948), designed 1946. 10¼ x 18¾ inches. Collection Elaine Lustig Cohen

During World War II, the design of women's clothing was free to go its own way in an America no longer under the pervasive influence of Paris. That freedom produced the first truly American designer, Claire McCardell, who invented what was to become the definitive "American Look" (see figs. 184, 201). Her essential innovation was the creation of comfortable clothes at reasonable prices for contemporary needs.[28] Her swimwear, often made in soft wool, followed the natural lines of the female body. She blurred the boundaries between day and evening wear. The influence of her practical approach to dress was far reaching. Even though Paris temporarily regained its ascendancy after the war (with Christian Dior's "New Look" [see fig. 202], which was actually an "old look," with its long, billowing skirts and wasp waists), McCardell had clearly foreordained the worldwide casual style that has dominated late-twentieth-century clothing. It's been said that "she was to fashion what Graham was to dance." Her clothes were sui generis—never in, never out, of style.[29]

In 1941, Adrian (né Adrian Adolph Greenburg)—the designer of costumes for many Cecil B. DeMille epics and, later, sophisticated contemporary clothing for stars such as Joan Crawford and his wife, Janet Gaynor—started his own couture and ready-to-wear company in Los Angeles. Among the elegant designs he made in wartime was the so-called *Shades of Picasso* gown and cape, produced in several variations, in which appliquéd organic forms were arranged on a brown or gray silk gown (fig. 183).[30]

Charles James was the Dior of America: his clothes featured padded hips and an emphasis on a small waist. James's designs were shunned in some circles because of his extravagant use of fabric. The photographer Bill Cunningham remarked that "he created the first wearable soft sculpture." His *Four-Leaf Clover* ball gown (fig. 185) was the ultimate in biomorphic design. James's clients included Gypsy Rose Lee, Dolores Del Rio, Marlene Dietrich, and Millicent Rogers. Tobi Tobias wrote of his work that "he thought of himself as an artist: sculpture in [his designs'] construction and painting in their color."[31] Of his achievement, James wrote, "My work has never been out of date. It is only a matter of time until I become a new look again."[32]

As painting, sculpture, architecture, and industrial design blossomed in postwar America, there was a parallel craft revival—a "back to the earth" movement, as noted earlier. The American Craftsmen's Cooperative Council had been founded in 1942, two years before the Society of Industrial Designers. But the most important influence on young artisans was the influx of European artists

184.
Designs by **Claire McCardell** (American, 1905–1958) from 1933–53, worn by models at the Perls Gallery, Beverly Hills, 1953. *Look* magazine, courtesy Library of Congress, Washington, D.C.

183.
Adrian (Adrian Adolph Greenburg) (American, 1903–1959). *Modern Museum* or *Shades of Picasso* Evening Dress, 1945. Long dress with cape, made of appliquéd, multicolored crepe, approx. 60 inches long with 28-inch waist (size 8). Brooklyn Museum of Art, New York; Gift of The Roebling Society and H. Randolph Lever Fund, 1997.63

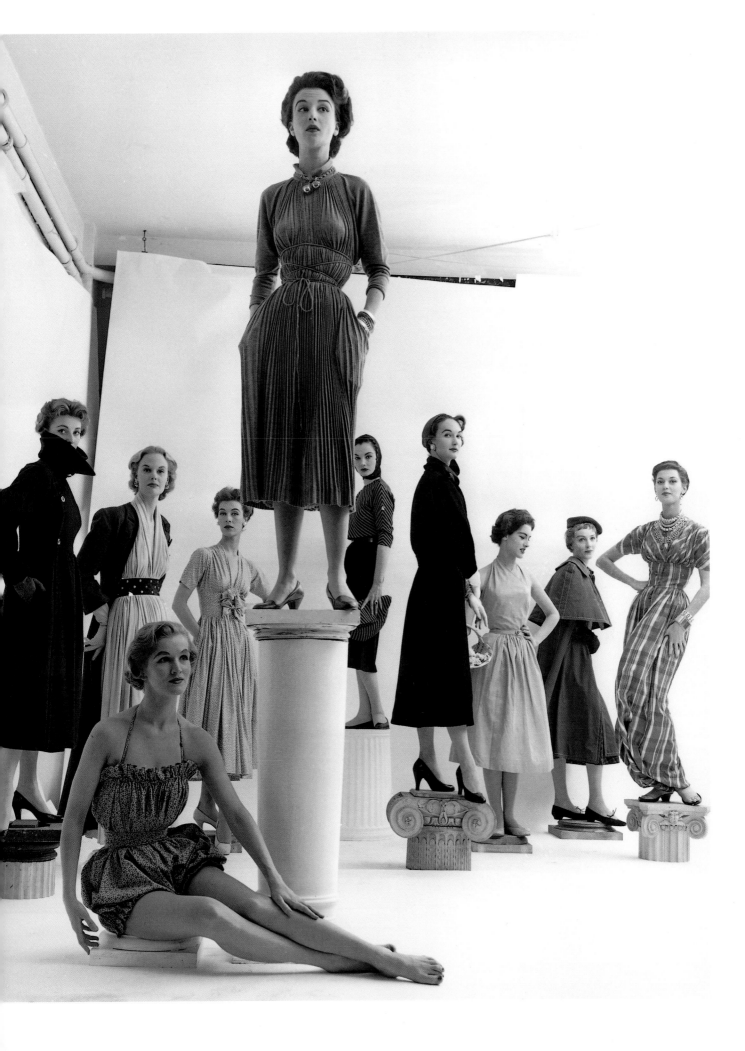

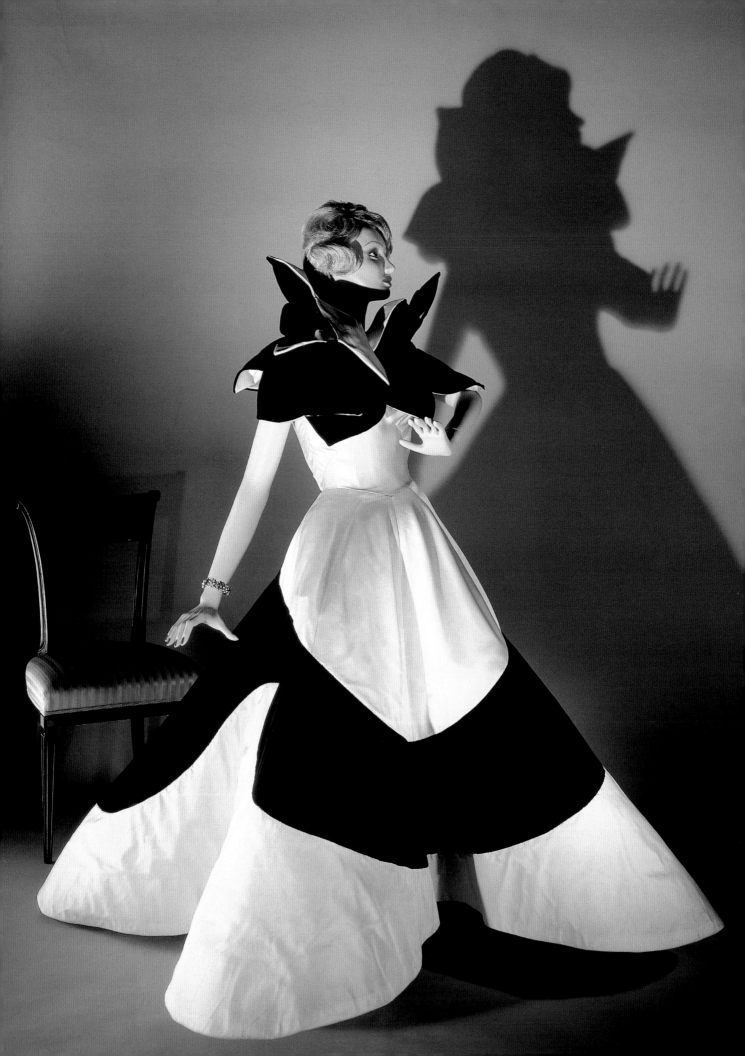

188.
Alexander Calder (American, 1898–1976). Two *Wave* Bracelets, undated. Gold and silver; gold: 2⅞ x 2¼ x 2¼ inches; silver: 3 x 2¼ x 2¼ inches. Private collection

born in the minds of three innovators who were at the center of the American design revolution. In 1953, George Nelson, Charles Eames, and Alexander Girard demonstrated their combined inventive genius with a remarkable teaching experiment called "A Rough Sketch for a Sample Lesson for a Hypothetical Course." Commissioned by the University of Georgia, where it was first shown, and funded by the Rockefeller Foundation, it was shown several times at the University of California, Los Angeles, to groups of wide-eyed students who witnessed their first multi-screen slide presentation. The lesson was accompanied by sounds and smells: the aromas of incense and baking bread were magically wafted into the room (part of the presentation was a six-minute film about bread, a teaser for what was to become the next "lesson"). The focus of the lesson was communications: history, a sense of place, an enriching awareness of the world around us—topics that were preoccupations of Nelson, Eames, and Girard. This pre-McLuhan adventure in total sensory involvement was years in advance of the visual and auditory experiences that would become commonplace in the 1960s. It demonstrated how well-chosen sights and sounds can compensate for what Eames termed students' "vitamin deficiencies." Nelson recalled that "the hall started out half empty; by the second day they were sitting in the aisles; by the third day they were sitting on each other's shoulders."[34] Thus, the era's emphasis on material goods was balanced by a desire to comprehend and embrace the wider cultural world that would become available through remarkable communications technologies anticipated by the "Sample Lesson."

By the late 1950s, Europe was in economic recovery. The United States began to import small European cars, such as the Volkswagen "Beetle." Elegant Italian domestic products, such as Olivetti's *Lettera* typewriter, became available

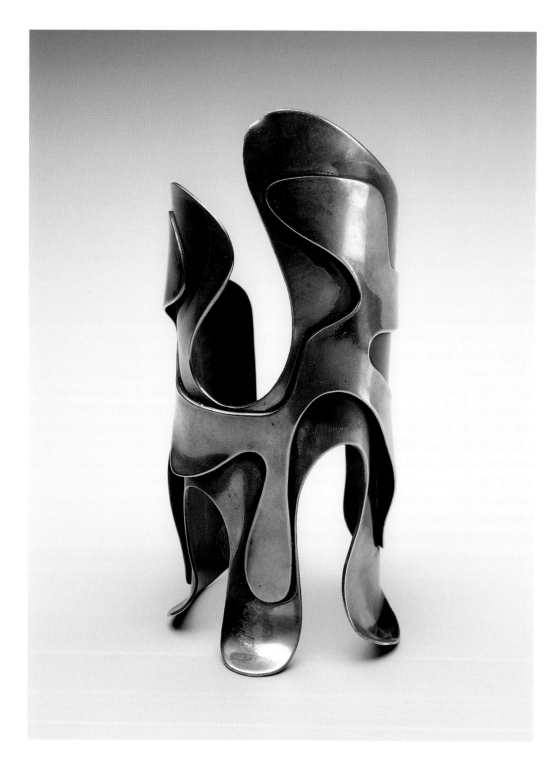

189.
Art Smith (American,
1917–1982). *Lava* Bracelet,
designed and executed
c. 1946. Silver, 5⅞ x 2¼ x
2⅞ inches. Collection of
Charles Russell

in the United States. The civil-rights movement sounded one of its opening salvos in 1955 when Rosa Parks refused to give up her seat on a bus in Montgomery, Alabama. In retrospect, it is clear that the era of optimistic abundance, eroded by the Korean War and the increasingly heated Cold War, was ending, and that the nation was in need of new leadership. One positive aspect of the Russian-American standoff was the initiation of the space program. However, such indicators as Philip Roth's exegesis of suburban life, *Goodbye, Columbus* (1959), and the death of Emily Post in 1960 signaled the fading of an era overrun with banalities.

The initial euphoria of the suburban experience had dimmed by the late 1950s, when new domestic appliances gave women the free time needed to venture outside the home, and a generation of energetic young working mothers made city living a viable option once again.[35] The complexities that would surface in the coming decades were now visible—that little cloud on the horizon of postwar America was expanding. The death of President John F. Kennedy in 1963 marked the close of the period of America's greatest optimism. The Vietnam War and the loss of national dignity it provoked darkened the years that followed. The 1964 New York World's Fair was the "last gasp" of an innocent belief in the idea of progress underlying the glamorous future predicted by the corporate entities whose pavilions dominated both the 1939 and 1964 New York extravaganzas. At the 1964 fair, General Motors again presented an automobile exhibit, designed this time by Albert Kahn. Called *Motorama*, it again focused on a nomadic nation. Somewhat more worldly than its counterpart some two decades earlier, the newly prosperous, family-oriented society would create America's dominant life patterns well into the early years of the twenty-first century.

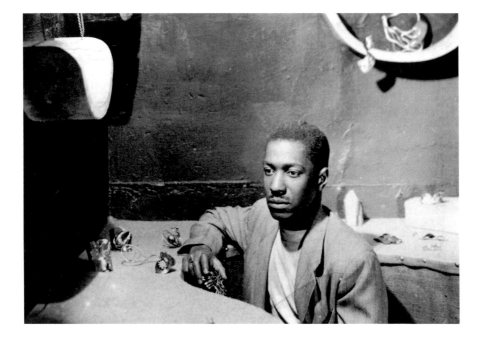

190.
Art Smith (American, 1917–1982) in his New York studio, c. 1953

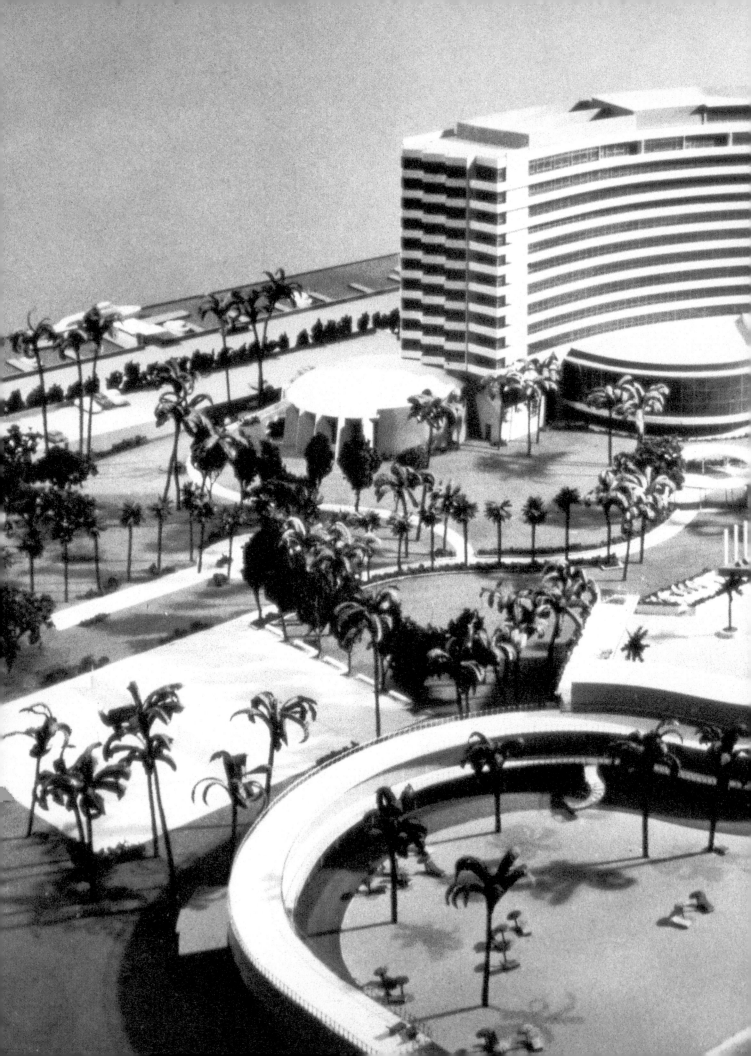

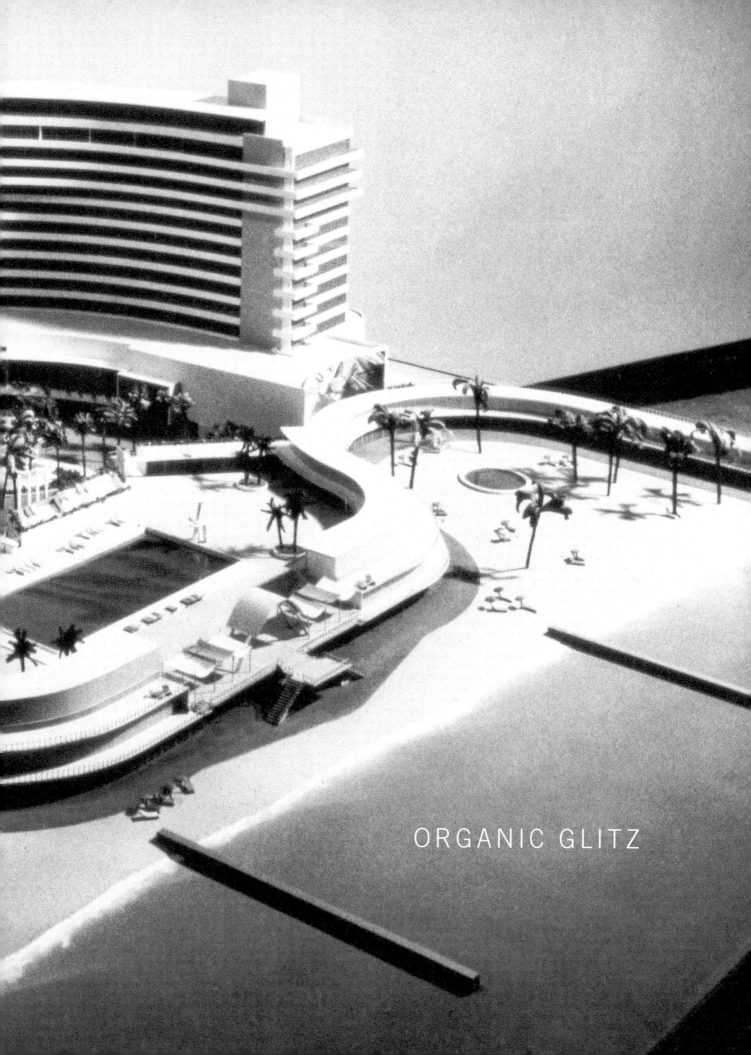

ORGANIC GLITZ

Organic Glitz

DESIGNING POPULAR CULTURE IN THE POSTWAR ERA

Karal Ann Marling

There is no better example of the emerging design ethos of the postwar era than the 1948 Cadillac. In the 1930s, Detroit "dream cars" were discreetly streamlined, which meant that form followed function according to modernist doctrine. Actually, form *defined* function: the potential for speed was suggested by thin bands of horizontal fluting applied to the auto chassis in dynamic groups of three. But toward the end of World War II (during the war, defense imperatives had shut down the civilian auto industry), the head of the General Motors styling department made friends with an Air Force designer who was testing new fighter planes at Selfridge Field, near Detroit. It was there, from a distance of thirty feet, under tight security, that Harley Earl and his team of automotive stylists were allowed to examine a twin-tailed Lockheed P-38 *Lightning* pursuit plane with G.M. engines and stabilizing tail fins. And it was there that the idea for the Cadillac tail fin (see figs. 48, 192) flashed on like a lightbulb in a cartoon. "That viewing," Earl wrote, "after the war ended, blossomed out in the Cadillac fishtail fenders which subsequently spread through our cars and over much of the industry as well."[1]

Airplane imagery was nothing new in American automobiles; 1940s Fords and Studebakers had propeller-like gizmos in front. However, the pleasing little winglet or bump mounted on the rear end of the 1948 Caddy revolutionized the auto business. A housing for the stoplights, it was the first embryonic tail fin, and it was applied to a body the design of which had been roughed out before Pearl Harbor, under the old dispensation of rational form-follows-function thinking. But subsequent Harley Earl models took their cue directly from that fin (see fig. 191). The car became an armature on which to mount a whole panoply of expressive shapes, many of them organic. In time, the car transcended its prosaic function altogether and became—like the 1959 Cadillac, with a tail assembly that soared a full three and a half feet above the pavement—a piece of figural sculpture in steel and chrome, a powerful work of art.[2] It was,

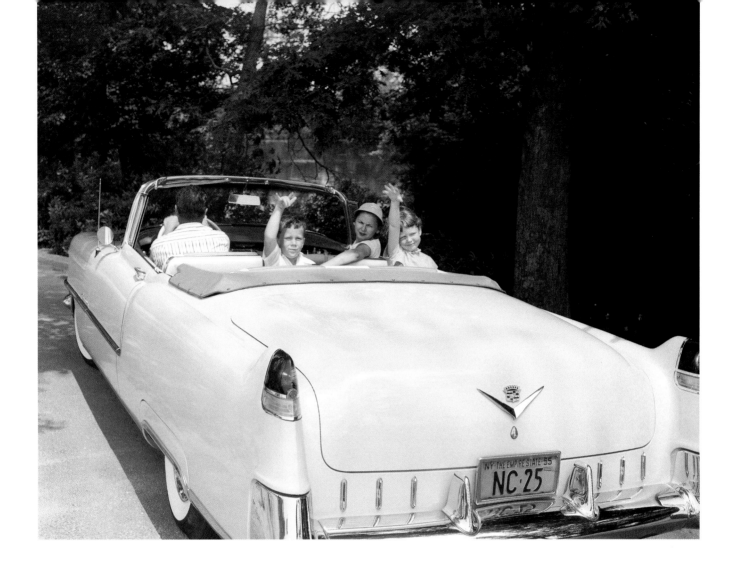

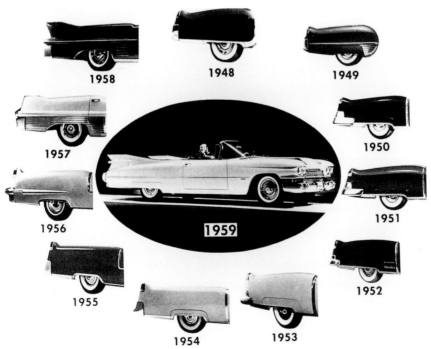

191.
The Cameron family of New York State driving in a Cadillac convertible, c. 1955

192.
Evolution of Cadillac tail fin, 1948–59, under **Harley Earl** (American, 1893–1969), from *Design Quarterly*, no. 146 (1989), p. 9

for a mass audience of Americans on the road to suburbia, a work of popular modern art, the aesthetic equivalent of a Calder mobile (see fig. 193), with the presence of a monumental iron sculpture by David Smith. Best of all, the car was a sculpture that could be parked in one's own driveway or driven proudly to the mall.

In retrospect, Earl believed that fins and "bombs," or Dagmars—bullet-shaped protrusions on the front end, named for a busty T.V. star of the same name—caught on because, as he put it, they gave customers "an extra receipt for their money in the form of a visible prestige marking for an expensive car."[3] Design historian Thomas Hine uses the term *populuxe* to describe a culture awash in similar extras: added touches, luxuries that the neighbors could see for themselves, accessible to anybody who could afford the easy monthly payments.[4] Put another way, fins were a compensatory reward for the deprivations of the Depression era and the rationing of World War II. In the 1950s and early 1960s, no excess was too extreme. The average midline Detroit product of the period carried forty-four pounds of surplus chrome, the sole reason for which was its sheer gorgeousness.

The iconography of the befinned behemoth was a complicated mixture of sex, violence, and conspicuous consumption. Judged on the strength of its added hunks of dysfunctional rubber and chrome (called "gorp"), the American car was the equivalent of Marilyn Monroe coming toward us—the prototype for a fearsome de Kooning *Woman* (see fig. 81)—and a fighter jet going away: love

193.
Alexander Calder (American, 1898–1976). *Red Lily Pads (Nénuphars rouges)*, 1956, installation view. Painted sheet metal, metal rods, and metal wire, 42 x 201 x 109 inches. Solomon R. Guggenheim Museum, New York, 65.1737

and war, domestic togetherness and the terrors of the Cold War all wrapped up in one oversize, multi-colored package complete with deep-pile upholstery and posh, padded interiors. A semiotic anagram of great complexity, the 1950s car—consisting largely of superfluous parts—existed primarily to communicate. Breasts, teeth, wings, bombs, sharks: planes that were women, women who were missiles. These were metaphors, analogues for a whole series of preoccupations that Detroit and its customers shared with many artists in the aftermath of World War II.

Although art criticism grew increasingly arcane with the ascendancy of postwar abstraction, in some circles the vital interplay between art and everyday life was a given. A case in point is Southdale, the first fully enclosed modern shopping mall, which opened in Edina, Minnesota, on the outskirts of Minneapolis, in 1956.[5] The harsh Minnesota climate invited a different approach to the problem of bringing retail stores to the suburbs. Previous centers had featured a cluster of buildings adrift in the middle of a vast parking lot: gardens and fountains between the buildings were amenities designed to draw motorists to a place where walking—not endless motoring—was a part of the retail equation. Architect Victor Gruen, who had designed Northland Center in Detroit on this model in 1954, aimed for a contrast between the stern rectilinearity of his

194.
Birdcage, central Garden Court, Southdale Shopping Center (see fig. 195)

195.
Victor Gruen (American, b. Austria, 1903–1980). Southdale Shopping Center, Edina, Minnesota, 1956. Interior view

196.
Peter Schlumbohm (American, b. Germany, 1896–1962). Coffeemaker, Chemex Corporation, 1941. Glass, wood, and leather, 11¹⁄₁₆ x 6⅜ x 6 inches. Brooklyn Museum of Art, New York; Gift of Dr. Barry R. Harwood, 1997.117

197.
Eva Zeisel (American, b. Hungary, 1906). Wall Divider, designed 1958, at Luciano Mancioli, Montelupo, Italy. Glazed ceramic, dimensions variable. Courtesy of the artist

198.
Ruth Handler (American, b. 1916). Original *Barbie* Doll, designed 1959, manufactured by Mattel, Inc., 1959 to present. Molded hard vinyl, 11½ inches high

International Style facades and the organic forms of the gardens in between, with their flowing water, trees, flowers, and plantlike abstract sculptures (fig. 195).[6] In a world of highways and machines, the pedestrian garden-mall offered a poignant reminder of the natural world and the place of human beings within it.

Southdale brought the garden indoors, with a fresh emphasis on the role of art in sustaining the natural metaphor. Umbrella-shaded tables at the mall's café did not shield diners from the elements but helped create the illusion that Southdale—air-conditioned in summer and heated in winter—was a kind of magical Garden of Eden, sitting atop a system of underground delivery roads and surrounded by parking for 5,200 big family cars. Among the plantings of the central Garden Court stood a cylindrical birdcage, twenty-one feet tall and nipped in just above its midpoint (fig. 194), like a Chemex coffeemaker (fig. 196), or a Dior "New Look" gown (see fig. 202), or the undulating form in Eva Zeisel's 1958 ceramic room divider (fig. 197), or the body of Eve herself. In a space articulated by rigid verticals and horizontals, the wasp-waisted shape of the open cage suggested a biological commonality between beautiful birds and the slim women of fashion who were the mall's hoped-for customers—the kind of idealized female figure immortalized in plastic three years later by the *Barbie* doll (fig. 198), introduced in 1959.

200.
Wasp-waisted lighting fixtures
of the 1950s

The birdcage and a group of hanging light fixtures of similar design were the work of unheralded commercial craftsmen. They were complemented, however, by a pair of 50-foot-tall Golden Trees of lacquered bronze commissioned by Gruen from the sculptor and furniture designer Arieto ("Harry") Bertoia, whose most famous design is his welded-steel diamond-latticework chair for Knoll (fig. 199). Composed of metal "leaves"—soft-cornered rectangles, in the shape of so many T.V. screens—fastened to vertical poles (the antenna?), the Golden Trees embodied in their abstract forms both the hard-edged architecture and the pliant forms of nature. They articulated the relationship between the two and, by extension, the relationship between shopper and woman, between the car fixation of suburbia and the aimless stroll, between commerce and culture. Additional sculptures with the same vertical orientation included Louise Kruger's figures of children playing on stilts and a nonobjective relief by Daniel Soderlind alluding to branches, arms, growth, and slow organic movement.[7]

At Southdale, art of this kind was the advertised amenity. "Center Breaks Art Barrier with Sculpture," crowed the local press.[8] "Birds, art, and 10 acres of stores...under one Minnesota roof!" chirped *Life* magazine.[9] Victor Gruen, discussing his latest project during a talk at the Walker Art Center, declared that the car was a liability. "Humans want to mingle with other humans," he insisted, and that was what Southdale was all about. It was a new kind of cultural center, uniting art, architecture, and daily life.[10]

Gruen's mall was the place where the latest fashions in home furnishings, clothing, and other consumer products were on display in two levels of large plate-glass show windows. Some stores at Southdale seem to have adopted the symbolic language of the center as their own. In the shocking-pink hat bar area at Donaldson's department store, for instance, samples of women's headgear were perched on the branches of a transparent plastic tree illuminated from above by a row of feminized spotlights: wasp-waisted lighting fixtures "in modern metal sheaths"[11] (see fig. 200). After the liberation of Paris, Christian Dior had revived this stereotypically female shape for his *Corolle* line in 1947

199.
Arieto (Harry) Bertoia (American, b. Italy, 1915–1978). *Diamond* Armchair No. 421LU, designed 1950–52, manufactured by Knoll Associates, Inc., New York, c. 1953 to present. Welded steel wires, cushion, 27⅝ x 43⅞ x 31¾ inches

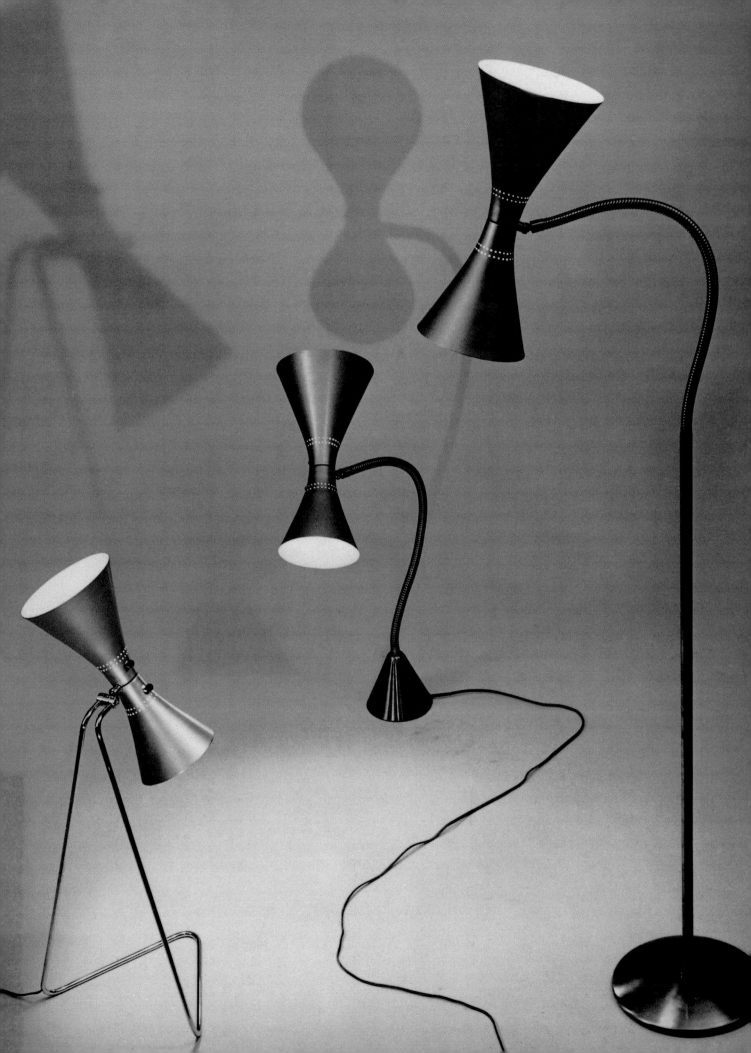

(his first), popularly known as the "New Look" (fig. 202). Dior's dresses were a reaction against the rather masculine style of women's uniforms as well as wartime regulations restricting the amount of fabric that could be used in a given garment.

Women wearing his clothes were to be ballerinas, courtesans, or exotic plants. "I turned them into flowers," he remembered, "with soft shoulders, blooming bosoms, waists slim as vine stems, and skirts opening up like blossoms."[12] Despite the organic contours, however, the "New Look" silhouette was sustained by a rigid infrastructure of boning, crinolines, and padding. The soft shape of the wearer was, in fact, constricted and molded into an ideal image of the eternal female, a universal symbol that aimed to transcend the vagaries of individual bodies. In the United States, Claire McCardell's innovative sportswear of the 1940s, executed in a fluid wool jersey, achieved emblematic femininity by the opposite strategy, with clothing that clung to the planes of the figure (see figs. 184, 201). A Dior dress looked like a woman even when it was displayed on a hanger. A McCardell looked like nothing much at all without the curves of the body to give it shape and substance.

Throughout the period—Jackie Kennedy's trademark pillbox was the last great hat to inspire a crop of cut-rate copies strewn across the mallscape of America—fashion mandated close attention to headgear.[13] Whether "New Look" lookalikes or the sack dresses introduced in 1957, garments that riveted attention on the center of the body demanded corrective measures in the form of notable hats to direct the admiring gaze back toward the face of the wearer. First Lady Mamie Eisenhower, because she was frequently photographed at

202.
Christian Dior (French, 1905–1957). A design from the *Corolle* line, dubbed the "New Look," 1947

194

201.
Claire McCardell (American, 1905–1958) in her studio, 1953

203.
Mamie Eisenhower wearing
Sally Victor's (American,
1905–1977) *Airwave* hat for
the 1953 presidential inaugu-
ration of Dwight D. Eisenhower

public gatherings, became a trendsetter with the *Airwave* hat created specially
for Ike's 1953 inaugural (fig. 203). Shaped like a shallow, inverted bowl or an
iced cupcake, the hat was made of six concentric circles of gray felt, its scal-
loped contours the result of being slashed with vents that showed flashes of a
bright green lining. The presidential inauguration and its attendant ceremonies
were shown on T.V. for the first time: during several uninterrupted hours, in
homes all across the nation, that perky little hat was a focus of attention.[14]

Macy's sold knockoffs of the *Airwave* hat by the gross. Of the seven hun-
dred letters per week sent to Mrs. Eisenhower by the general public in the
months following the inauguration, many expressed a desire to own a hat just
like it. Mamie's thank-you letter to the hat's designer, Sally Victor, was one of
the first pieces of post-inaugural business she attended to. "All your hats were
beautiful and styled so becomingly," Mrs. Eisenhower wrote, "but I think the
one that attracted the most comment and admiration was the soft gray hat with
the lovely green lining peeking through. An attractive, flattering hat always
helps me feel my best and look my most confident, so you can see your selec-
tions were so important in boosting my morale."[15]

Victor had begun her career in the 1930s as a protégée of Dorothy Shaver,
the influential Lord & Taylor vice president who promoted American fashion in
the store's Fifth Avenue windows. The American quality that Victor prized in
fashion was a kind of purposeful playfulness best expressed in her *Sally V* line
of department-store millinery (see fig. 204). Specifically, she thought of hats in
psychological terms, as disguises, indices of character, mirrors of mood, or means
of trying on new aspects of a complex personality. "A woman becomes what her

hat means to the world and to herself," she wrote; what Jungian analysis was to Jackson Pollock, a new hat was to a *Sally V* customer. Recognized by the milliner and the First Lady alike, these same connections between body and spirit, between emotion and artifact, permeated a consumer culture greedy for products that spoke to issues of class, gender, identity, fears, and aspirations in a symbolic language readable in cars, in hats, or in the architecture of malls. Andy Warhol's fashion drawings of the 1950s and early 1960s suggest the mysterious—often erotic—power of accessories bought at Macy's hat bar.[16]

The housewares department was another important repository for mass-produced goods laden with meaning. In 1939, when American china still lacked the prestige of imported ware, Vernon Kilns of California hit upon the notion of hiring "famous American artists" to decorate sets of ceramic dinnerware. Among the artists they chose were Walt Disney and Rockwell Kent. Kent, well known as an artist and illustrator, was responsible for Vernon's *Salamina* set, based on Kent's account of his adventures while painting in Greenland.[17] Encouraged by the Federal art programs of the Roosevelt administration, in the late 1930s the private sector took up the notion of creating a fruitful connection between art and daily life across a broad spectrum of products. In 1939, the Dole Pineapple Company commissioned several artists, including the painter Georgia O'Keeffe and the sculptor Isamu Noguchi, to make artworks that would be used in ads to promote the company's product; one of these was O'Keeffe's painting *Pineapple Blossom* (see fig. 205). In addition, Grant Wood's landscapes were turned into upholstery fabric, and Thomas Hart Benton immortalized the tobacco industry on the back page of *Life* magazine.[18] And Kent

First Showing: A Dole Pineapple Bud from Hawaii

A PINEAPPLE BUD FROM THE DOLE PLANTATIONS IN HAWAII
PAINTED BY GEORGIA O'KEEFFE

Perhaps you have never seen a pineapple bud—and words cannot describe this glowing crater of color which on the Dole plantations grows and ripens into a luscious big pineapple...Perhaps you have never tasted Dole Pineapple Juice—and there is no other way to discover the fragrant, zestful goodness of this pure juice. Just try it for breakfast...after shopping or exercise...with the children when they come from school...whenever you or your family crave refreshment.

Dole Pineapple Juice from Hawaii, U. S. A.

205.
Advertisement for Dole Pineapple, 1939–40, featuring the painting *Pineapple Blossom*, 1939, by **Georgia O'Keeffe** (American, 1887–1986). Honolulu Academy of Arts

decorated dinnerware: according to splashy ads in *Good Housekeeping*, the service-for-four starter set retailed for $10.95.

In the late 1940s, as G.I.'s came home and married, the housewares business began to boom again. But firms like Vernon no longer hired artists to embellish plates and cups. Instead, postwar ceramics reflected the emerging popular emphasis on organic shapes and contours already visible in fashion and automotive design. Eva Zeisel, the Hungarian-born ceramic designer who emigrated to the United States in 1938, noted a new interest in curvilinear, biological forms (exemplified by some of her own designs, as shown in figures 129, 131, and 172, and those of Russel Wright, such as his *American Modern* line, which was in production from 1939 to 1959 [see fig. 127]). "In the 1940s," Zeisel wrote, "modern tables, containers, and all sorts of things suddenly began to melt, to become soft. What had influenced so many designers simultaneously? I thought at the time it might have been Salvador Dalí's paintings, one in particular, with the melting watch."[19] Franciscan's *Contours* dinnerware of 1954 (fig. 206) reflected the new dispensation in its very name. Vernon Kilns' late 1950s *San Marino* teapot, marketed under several names (including *Casual California*) depending on color and finish, droops even as it surges forward, subject to the same gravitational force that pulls the body back to earth, however much the spirit yearns to soar.[20] The teapot seems to ponder the fate of the human hand that holds it.

However, Russel Wright's mid-1940s free-form bowls and plates (see figs. 127, 128), Zeisel's *Town and Country* pitchers for Red Wing Pottery (see fig. 131), and Ben Siebel's celery dish for Raymor (see fig. 133) are not highly practical pieces: the folded lips of many vessels trap foodstuffs inside, and the handles, while as expressive as the tongues they resemble, are too fragile for daily use. Like the pectoral and dorsal ornaments on the family car, these details are best appreciated as domestic sculpture—popular art for the American dining room. Like Mamie Eisenhower's *Airwave* hat, coaxed into shapes that evoke Dalíesque eyelids and mouths by the skill of the designer, the ceramics of the period exist primarily as contemplative objects, and only secondarily as useful ones. In the new American tableware of the 1940s and 1950s, according to Eva Zeisel, "form does not follow function."[21] Only on Tupperware (figs. 207, 208; see fig. 175), the inexpensive plastic food containers that revolutionized leftovers, were sensuous curved edges—so friable in ceramic vessels—turned to practical use to secure a patented locking mechanism.

Houses made of plastic and other modern, space-age synthetics were a constant source of futuristic fascination in the 1950s, at the height of the postwar building boom. Detroit had its "dream cars" and the construction trade had

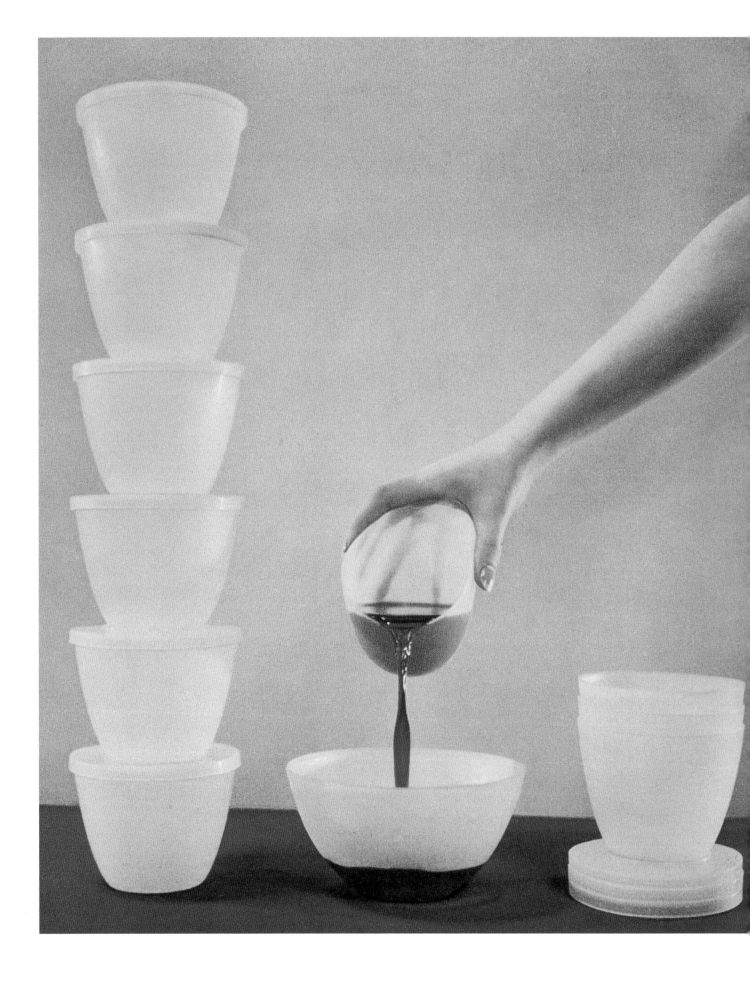

KARAL ANN MARLING

"dream houses," ranging from boxes-on-slabs in Levittown (see fig. 144) to the Monsanto House of the Future (fig. 115), which was installed at Disneyland in February 1957.[22] The latter was a design anomaly: though fabricated from materials concocted in an industrial laboratory—the company's motto was "Better Living Through Chemistry"—the house took the shape of a flower from another galaxy, an abstract sculpture with four, lobate wings or blossoms budding from a central stem. No longer Le Corbusier's "machine for living," the family home was a work of modern art, in which function was subordinate to the dramatized forms of eyes, legs, fingers, lungs, and a pliant skin of sleek white plastic. The all-plastic wings were composed of modular panels in contoured shapes filled with foam insulation. Each one featured a picture window—a huge eye with the proportions of a TV screen. Indeed, like the Monsanto House at Disneyland, Philco's *Predicta* model television set (figs. 23, 209) also peered out at the world from a picture tube–eye balanced atop a single slender support.

209.
Catherine Winkler (American, 1906–1989) and **Richard Whipple** (American, 1916–1964). *Predicta* Television Set, Model 4654, manufactured by Philco Corporation, Philadelphia, 1959. Plastic and brass housing, wood console, 45½ x 24 x 13 inches. Brooklyn Museum of Art, New York; H. Randolph Lever Fund, 1998.44

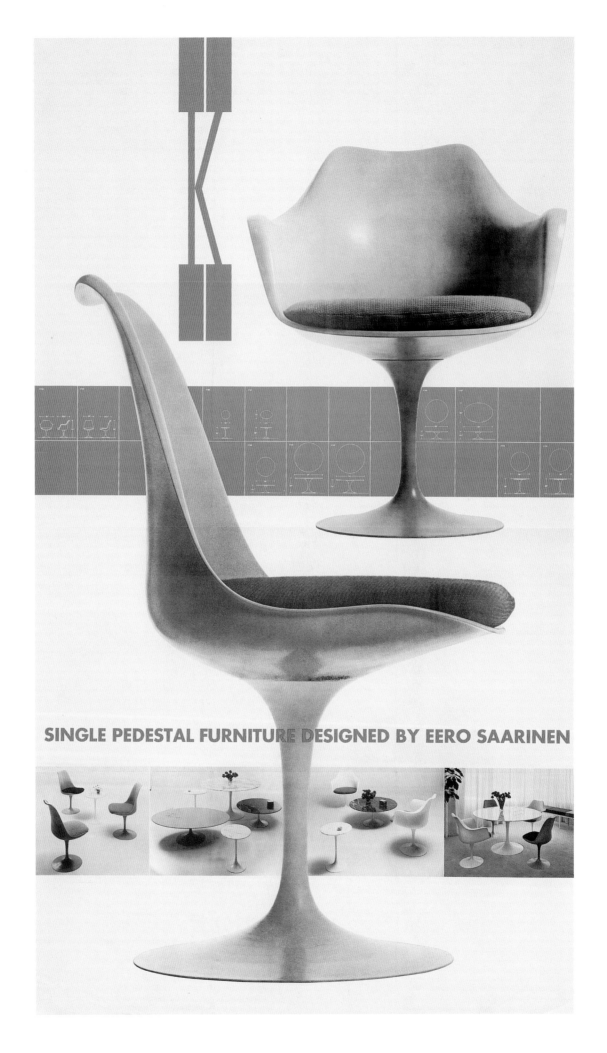

SINGLE PEDESTAL FURNITURE DESIGNED BY EERO SAARINEN

Inside, the House of the Future was furnished with molded plastic furniture balanced, like the house itself, on only one leg (see fig. 210) and a variety of modern conveniences, including push-button appliances and whole-house air conditioning. The centerpiece of Disneyland's Tomorrowland section, which was remodeled in the late 1950s in recognition of the appeal of a kind of domestic futurism focused on new, labor-saving consumer products, the Monsanto House of the Future was a huge hit at the California theme park. Before it was finally demolished in 1967 (no easy feat, since the wrecker's ball merely bounced off the resilient surface), millions had toured the M.I.T.-designed house. Viewing dream houses was a major weekend diversion in any case. New suburban subdivisions advertised furnished model homes open for public inspection. Museums, department stores, architecture magazines, universities, and manufacturers of building supplies all showcased innovative designs and materials in this way. The "dream house" concept fostered an analytic, aesthetic approach to the home as an entity to be seen, studied, and admired.

Despite the use of picture windows on a single face of each of its curved segments, however, the Monsanto House emphasized a primal, cavernous enclosure. In common with Frederick Kiesler's *Endless House* of 1959 (figs. 103, 104), Disneyland's House of the Future was made up of a series of womblike pods, each module containing one of the traditional components of domesticity—the kitchen, the living room, the bedrooms—as an eggshell cradles its vulnerable contents. This sense of enclosure and privacy extended to the most ordinary kinds of suburban housing, in which the ubiquitous picture window barely hinted at the flowing spaces of the typical open-plan interior, where the living and dining rooms and the kitchen were aligned. Inside these homes were push-button stoves, two-door refrigerators, dishwashers with look-in windows of their own, nylon-pile wall-to-wall carpeting, and sectional couches, often in bright new colors endorsed by *House and Garden* magazine—seafoam, turquoise, petal pink. Some even featured modern furniture, such as the leggy plywood chairs designed by Charles and Ray Eames (fig. 154), and the George Nelson clock (see fig. 43) that looked like a model of whirling atoms, or the Eameses' similar coatrack (fig. 211), featuring arms capped by colored balls.

The suburban street was orderly, monotonous, and all of a piece. But within the minimal constraints imposed by the marketplace, the interiors were apt to be a shock, alive with color and movement. Despite its bland exterior—or precisely because of it—the mall subscribed to this same aesthetic of enclosure and calculated surprise. The shopper parked near a nondescript building with no obvious point of entry; only when she had penetrated the Garden Court did a conservatory full of greenery suddenly blossom around her. The mall was a secret garden in a wasteland of asphalt. The family home was a fairy-tale castle hidden away under a magic spell in a wilderness of identical streets curving past a series of identical, partially prefabricated wooden boxes (see fig. 144).

The Monsanto House did not look much like its suburban counterparts.[23] Whereas the dream homes of America's Levittowns sought safety in the outward signs of conformity, the Disneyland House dramatized the act of shelter by isolating its functional components and flinging them up into the air. This same bravado became a commercial design axiom of the 1950s. Automakers understood the uses of exaggerated theatrical display as they extruded and manipulated a repertory of design elements to justify annual model changes and planned obsolescence. But the car, and some fashions—including the pink dress shirt for men—were exceptions to an unwritten rule that limited excesses of shape and color to private, interior settings. Many of the same companies that built cars also built kitchen ranges.[24] Hence the emphasis on a sleek metal carapace, dripping in chrome and custom-color porcelain finish, meant to disguise how the appliance worked while making the very thought of baking a cake exciting.

Color and pattern spread themselves across the interior spaces of suburbia like a coat of yellow margarine on soft white bread. Plaid free-form dishes turned up on bridal wish lists. Carpets were carved into exuberant patterns of leaves and tendrils. Wallpaper was back in style, with X-ray views of plants or undersea life arranged in a denser, tightly spaced allover pattern (see fig. 212), as if they were hieroglyphics. Countertops of Formica laminate sported intricate, interlocked webs of biomorphic shapes in that company's *Skylark* pattern (fig. 214), which conjured up an afterimage of bones, or boomerangs, or inner organs, courtesy of the eminent industrial designer Raymond Loewy and his firm.[25]

212.
Wallpaper, Sidewall, produced by Nancy Warren, a division of United Wallpaper, Chicago, c. 1953. Machine-printed on paper. Cooper-Hewitt, National Design Museum, Smithsonian Institution/Art Resource, NY; Gift of Kathleen Paton, 1992-129-1

The delicate etched forms of Formica's *Skylark* pattern recall the interlocking loops in the paintings of Mark Tobey, Willem de Kooning, and Jackson Pollock, a script full of runes that cannot quite be read, except that, in the most modern of kitchens, they managed to hint at something elemental, universal, and very old. The colors of Russel Wright's popular dinnerware of the 1950s—similar dinnerware, in a wide range of prices, could be purchased at Marshall Field's or Woolworth's—had been scientifically calibrated to enhance the experience of dining.[26] But that diagnostic palette was as peculiar, in its way, as the messages that seemed to be inscribed on sheets of Formica by some vanished race. The grays and pinks and strange, bleak greens favored by 1950s decorators and industrial designers (see fig. 215) had less to do with enhancing the visual appeal of a pot roast than they did with the tonalities of organic matter, and the forms they favored were similarly organic. Fleshy folds of vegetation, the flayed carcasses of animals, or Dalí's melting watches are what comes to mind, evoked by the shapes of casserole dishes and sofas of the period, available in one's choice of pink or gray or green.

Why the free-form kidney shape or ovoid should have figured so prominently in American popular design of the 1950s has been a mystery ever since, although it turned up regularly in products ranging from Isamu Noguchi's glass-topped coffee table (fig. 216) to dime-store yardgoods. The round-cornered rectangle that formed the basis of much of the Eameses' and Eero Saarinen's furniture (see figs. 151, 161, 213) is a variation on the type, a geometric design that has lost any strict mathematical definition but has gained a new kinship with the configuration of the body and its organic irregularities. Tenuously

213.
Charles Eames (American, 1907–1978) and **Ray Eames** (American, 1912–1988). Lounge Chair and Ottoman, No. 670 and No. 671, designed 1956, manufactured by Herman Miller Furniture Company, Zeeland, Michigan, 1956 to present. Rosewood-faced molded plywood seat shells with leather-covered cushions, cast aluminum base; chair: 32¼ x 32½ x 33 inches; ottoman: 16¾ x 25½ x 22 inches

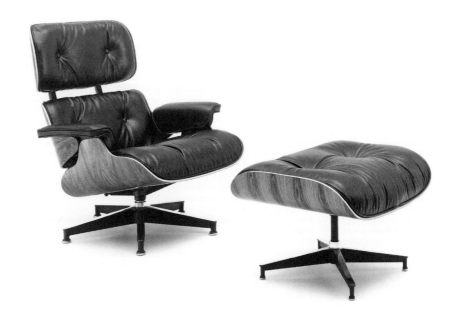

214.
Brooks Stevens (American, 1911–1995) and **Raymond Loewy** (American, b. France, 1893–1986). *Skylark/ Boomerang* Pattern, designed 1950, revised 1954, reissued 1988, manufactured by Formica Corporation. Formica laminate

215.
Advertisement for Kelvinator appliances (detail) from *House Beautiful*, May 1955

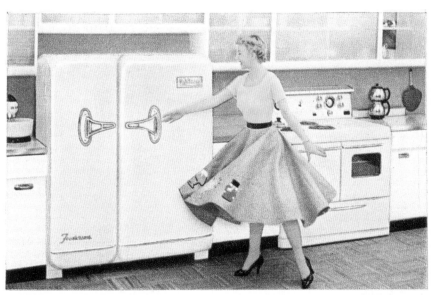

8 glamorous exterior colors to choose from! Select the decorator color that harmonizes with your kitchen decor—that blends with the wallpaper, paint, curtains and floor coverings. Color models have beautiful white and gold interiors. World-famous color consultants have selected FOODARAMA colors. New Kelvinator electric ranges, with disposable aluminum oven linings* and Bonus Broiler, are available in colors to match. *PATENT APPLIED FOR.

| BERMUDA PINK | SPRING GREEN | FERN GREEN | DAWN GRAY | SAND BEIGE | BUTTERCUP YELLOW | HARVEST YELLOW | LAGOON BLUE |

AND CLASSIC WHITE—OF COURSE

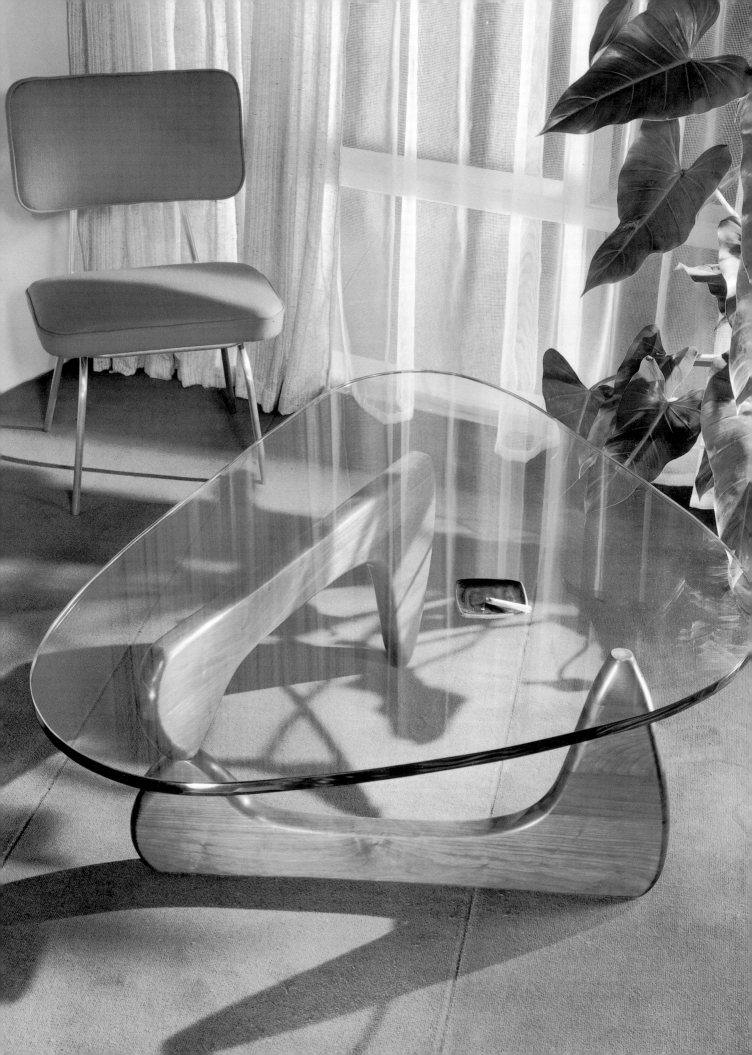

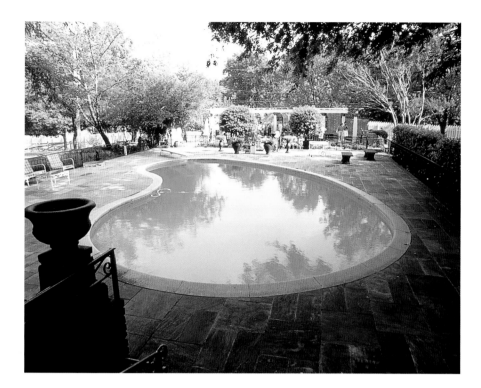

217.
Elvis Presley's swimming
pool at Graceland, Memphis,
Tennessee, c. 1957

related to the curved, streamlined shapes of the preceding decades, the free-form blob—the amoeboid—had the enormous advantage of *not* being a square or a circle. Although patterns of blobs and droplets adorned factory-made goods cranked out by the millions, the symbolic values conveyed by this range of elusive, hard-to-describe shapes are antithetical in spirit to mass production, military regimentation, and straight-ahead business thinking. The fluid kidney shape is fraught with life, uncertainty, and the potential for change. It looks like a square or a circle—either or both, or a triangle—that has somehow escaped from a geometry book and is contemplating a move to the suburbs.

One of the most common appearances of the kidney shape was in the design for swimming pools (see fig. 108). Movie stars were routinely photographed preening at poolside; the young Elvis Presley (fig. 218), dazzled by the glamour of Hollywood, announced his own star status in 1957 by moving into a mansion in Memphis, Tennessee—and putting a kidney-shaped pool in the backyard (fig. 217).[27] Because the movie-star pool was not the usual, institutional rectangle, it was special: a pond—an undiscovered spring in some exotic location, but one with all the modern conveniences. The lazy, wandering contour hinted at

218.
Elvis Presley in concert, 1955

216.
Isamu Noguchi (American,
1904–1988). Lounge Table,
designed 1944, manufactured
by Herman Miller Furniture
Company, Zeeland, Michigan,
1945–48, 1984 to present.
Glass and oiled walnut, 15¾ x
50 x 36 inches overall. Photo-
graph by **Ezra Stoller** (Ameri-
can, 1915–1989)

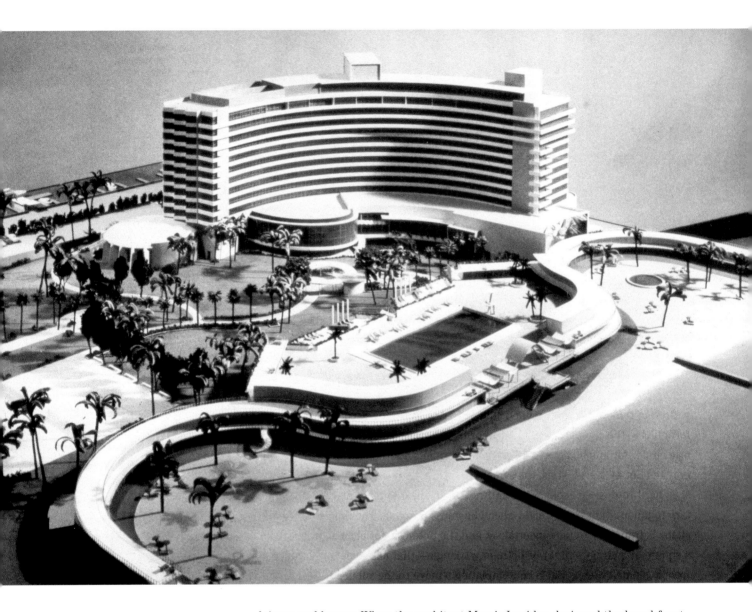

leisure and luxury. When the architect Morris Lapidus designed the beachfront cabanas at the fabulous Fontainebleau Hotel in Miami Beach in 1954, he arranged them in a slow, looping parabola along the oceanfront (fig. 219), as languid as a sunbath in the midday heat of a Florida winter. The whole hotel, in fact, from the profile of the building itself to the rococo arches in the coffee shop, was a study in unpredictable, sinuous curves redolent of lassitude and pleasure.[28] Bertrand Goldberg's Marina City in Chicago (see fig. 116) and Frank Lloyd Wright's Guggenheim Museum in New York (see figs. 47, 92, 95) respond to the same impulse. Because they make a point of *not* being boxes, both

219.
Morris Lapidus (American, b. Russia, 1902–2001). Fontainebleau Hotel, Miami Beach, 1954. View of model showing swimming pool and cabanas. Estate of Morris Lapidus

buildings disrupt the urban streetscape and declare their independence from the business-as-usual geometry of the corporate city. Wright's museum is a seashell, an ear, a spiral passageway into the heart of a living organism. Goldberg's skyscraper is all fins and gills that undulate with the rhythms of the waves in Lake Michigan.

Paradoxically, the public architecture of Wright, Goldberg, and Eero Saarinen is often private and inward-looking—see, for example, the interior of Saarinen's T.W.A. Terminal (see fig. 101)—womblike in the manner of the shopping center, the dream house, Saarinen's *Womb* chair (see fig. 161), and the site plan for the street layout of Levittown. But while popular art and high culture intersect at this point of profound, dreamy introspection in both form and imagery, there is also evidence of a countervailing taste for in-your-face glitter, big statements, big cars, and pink refrigerator-freezer units by the gross. In the 1950s, abstract paintings, like Detroit's cars, got larger and louder in their rhetoric, and much of the sculpture bristled with aggressive protuberances, bearing a strong family resemblance to tail fins (see figs. 220, 221). There is, in the design ethos of the 1940s, 1950s, and early 1960s, a fundamental duality, a schizophrenic split between private and public consciousness, inside and out, meditation and display.

220.
Leo Amino (American, b. Japan, 1911–1989). *Winter Scene*, 1951. Polyester resin and wood, 24 x 7½ x 4 inches. Jane Voorhees Zimmerli Art Museum, Rutgers, The State University of New Jersey; Gift of Mrs. Julie Amino

221.
Leo Amino (American, b. Japan, 1911–1989). *Stamen*, 1951. Polyester resin and wood, 21¾ inches high. Estate of the artist, courtesy Douglas Berman and Peter Daferner

Television—and the not-quite rectangle of the T.V. screen—is an accurate metaphor for a culture that watched great public events unfold for the first time on an electronic hearth (see fig. 23) in the family living room.[29] Inaugurations, coronations, the opening of Disneyland: you could see them all from the comfort of your own home. But if television offered a picture window on the world, it also succeeded in shrinking global affairs to the size of the sofa opposite the set. Television confused issues of scale, magnitude, location, and meaning. If Disneyland was no larger than a nine-inch screen, then just how big should a Cadillac be? What was more real in T.V.-land: the commercial, the drama, or the news? Was the desperate character in the 9 p.m. teleplay only an actor or one of the family? The cars and appliances and household products shown on television were often the very same items that surrounded the viewer at home. The set of dishes, the toaster, and the kitchen range were validated, somehow, because they existed simultaneously in the public arena and in the private home—because they were exactly "as seen on T.V."[30]

Except for the lack of color, of course. There is a special irony in the fact that a culture in love with color—bright colors, brand-new shades, synthetic colors that nature never intended—should have seen the world, for the most part, on black-and-white T.V. Network television was a two-tone affair, and movies clung to stark blacks and whites for effect. From *Double Indemnity* (1944) to *Sunset Boulevard* (1950), the black-and-white ambience of *film noir* had been one of evasion, distrust, and angst. Salvador Dalí's melodramatic sets for the Alfred Hitchcock psychological thriller *Spellbound* (1945) portrayed the landscape of inner torment through the use of dream motifs, including dark staring eyes silhouetted against a white background (fig. 222). Eventually, however, with the audience for movies diminished by competition from television, Hollywood gave up the gritty *noir* sensibility and fought back, with mega-color and a giant-size screen as its major weapons. What television—and the movies—lacked, in the absence of color, was a nuanced emotional spectrum that could differentiate between the pink button-down shirt, a pink abstraction by Philip Guston, and Elvis Presley's famous Pepto-Bismol–pink Cadillac. In tones of gray, they were all very much the same.

Television was also about motion, about animate beings alive on the home screen. Some of the most startling moments in the history of the Golden Age of television were memorable because figures previously viewed only in still pictures or heard as disembodied voices could be seen actually moving. Elvis Presley's from-the-waist-up appearance on Ed Sullivan's Sunday-night variety show in January 1957 is a noteworthy example: if Sullivan could not stop Presley's

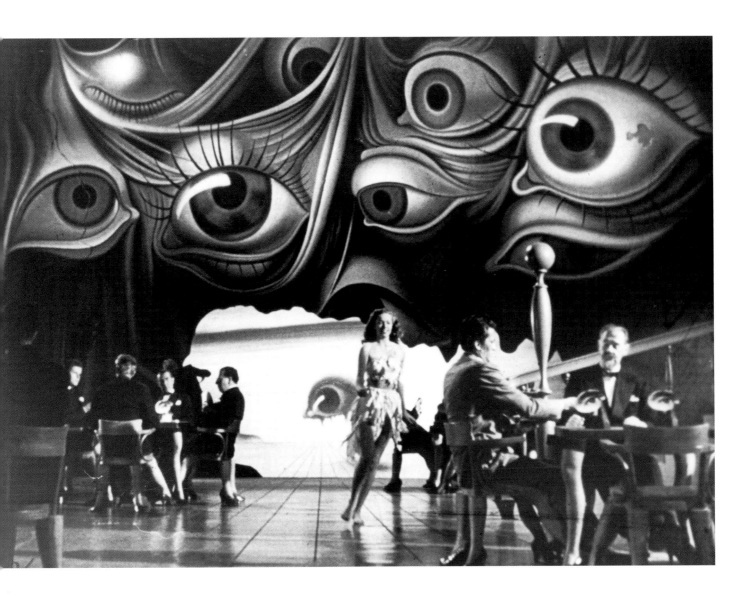

222.
Set design by **Salvador Dalí**
(Spanish, 1904–1989) for
the film *Spellbound*, 1945,
directed by Alfred Hitchcock.
Selznick Studios

"unseemly" gyrations, he could and did censor them. But the nature of the medium suited physical motion and an illusion of movement created by the use of multiple cameras. For television news coverage of the opening of Disneyland in July 1955, ABC used twenty-four live cameras to cut quickly from one scene to another, giving the viewer the impression of having explored every nook and cranny of the park.

The motion celebrated by T.V. is the same motion that flowed into the dynamic contours of dishware and jewelry and chairs, into the wave and spiral forms of buildings, into the writhing pseudo-script of paintings and decorative surfaces, into the wobbling progress of the *Slinky* toy (figs. 223, 224) as it climbed down stairs. The same heightened sense of motion made the 1959 Cadillac *Eldorado* look as if it were surging forward even when it was parked in a lot outside the mall.

It is impossible—and not very profitable—to trace these impulses back to a single event, a single generative force: the bomb, the Beats, Jackson Pollock, the mall, Harley Earl's first tail fin. The vital forms of American design in the postwar era are vital precisely because they were ubiquitous. From art gallery to auto showroom to our parents' and grandparents' living rooms, form in motion—breathing, reactive form—was an aesthetic principle that made itself manifest in virtually every object of visual and material culture, in every price range. A Pollock drip painting could turn up as fabric in a "New Look" dress. The free-form plate that held a cake baked from a Betty Crocker cake mix looked like the free-form sculpture in the mall. The expensive lounge chair in the boardroom (fig. 213) was imitated in cheaper and more colorful versions, for placement in front of T.V. sets in living rooms everywhere. Vital form was vital to Americans' sense of well-being, of possibility, of starting over from principles exemplified as clearly in bracelets (see fig. 189), in cars, and in tableware as they were in fine art. Vital form was vital because those principles so often existed in a taut dialectical tension with their opposites. An intense need for privacy was counterbalanced by a love of public display, introspection by extroversion, the primitive and simple by the technologically complex. Vital form exists in a state of precarious coming-to-be and passing away that mirrors the vital force of life itself.

223.
Children playing with *Slinky*®
Toy, c. 1950

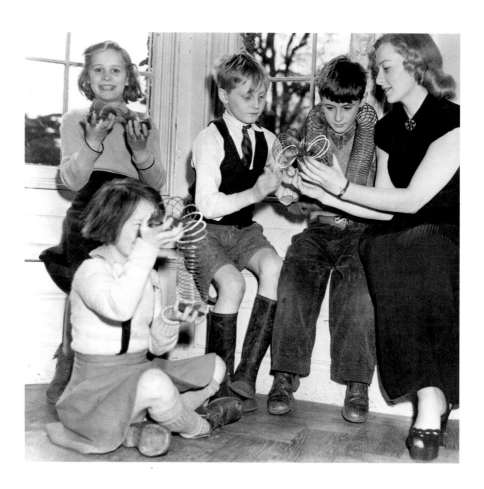

224.
Richard James (American,
b. 1918 or 1919). *Slinky*®
Toy, designed 1945, manufac-
tured by James Industries,
Philadelphia and Hollidaysburg,
Pennsylvania, 1945 to present.
Metal, 2½ inches high x 3
inches diameter

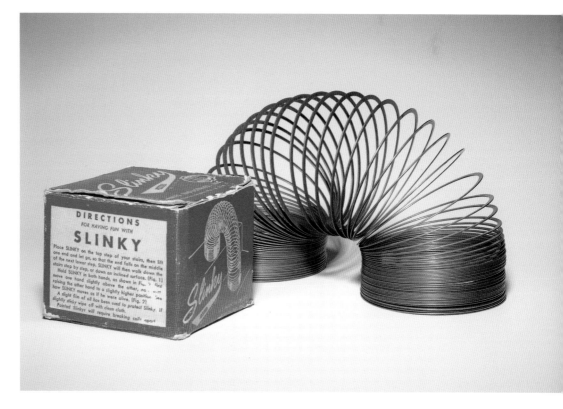

Notes

STAYTON NOTES

1. This eclecticism allowed a happy marriage between well-selected antiques and contemporary design, now that the total banishment of ornament had been rescinded.
2. Sidney Janis, *Abstract and Surrealist Art in America* (New York: Reynal & Hitchcock, 1944), p. 9.
3. Jack Burnham, *Beyond Modern Sculpture: The Effects of Science and Technology on the Sculpture of This Century* (New York: George Braziller, 1968), p. 67.
4. Ibid., pp. 50, 76.
5. Morris Lapidus, interview with the author, August 23, 2000.
6. Cara Greenburg, "Mid-Century Design: Towards an Appreciation," in *Mid-Century Design: Decorative Arts, 1940–1960* (Miami Beach, Fla.: Bass Museum of Art, 1985), unpag.

RAPAPORT NOTES

1. The terms *organic* and *biomorphic* are often used interchangeably to describe works of art initially inspired by natural forms. Lawrence Alloway connects biomorphism to Art Nouveau; see Alloway, "The Biomorphic Forties," *Artforum* 4, no. 1 (September 1965), pp. 18–22. See also Romy Golan, *Modernity and Nostalgia: Politics in France Between the Wars* (New Haven: Yale University Press, 1995), chapter 3: "A Crisis of Confidence: From Machinism to the Organic."
2. Stephen Polcari, *Abstract Expressionism and the Modern Experience* (Cambridge and New York: Cambridge University Press, 1991), p. 8.
3. Nevelson wrote: "When he went to Egypt or Russia and it was secret, they couldn't inform us, and six months at a time I didn't hear from him. It threw me into a great state of despair. And I recall that my work was black and it was all enclosed…[and] this was a place of great secrecy within myself. I didn't even realize the motivation of it; it was all subconscious…. But it isn't only *one son*. It's also that the *world* was at war and *every* son was at war." Louise Nevelson, *Dawns + Dusks: Taped Conversations with Diana MacKown* (New York: Charles Scribner's Sons, 1976), p. 76.
4. Adolph Gottlieb and Mark Rothko, "The Portrait and the Modern Artist," transcript of a conversation broadcast on the WNYC radio program *Art in New York*, October 13, 1943. Reprinted in Sanford Hirsch et al., *Adolph Gottlieb: A Retrospective* (New York: The Arts Publisher, 1981), p. 171.

5. See Sanford Hirsch et al., *The Pictographs of Adolph Gottlieb* (New York: Hudson Hills Press, in association with the Adolph and Esther Gottlieb Foundation, 1994).
6. Nevelson, interview with Arnold Glimcher, January 30, 1973, transcript, p. 1. Louise Nevelson Papers, Archives of American Art, Smithsonian Institution, New York.
7. Isamu Noguchi, *The Isamu Noguchi Garden Museum* (New York: Harry N. Abrams, 1987), p. 152. For six months in 1942, between the creation of the Central Park proposal and *This Tortured Earth*, Noguchi voluntarily entered a Japanese-American relocation center in Poston, Arizona, to help develop park and recreation areas there.
8. Pollock, radio interview with William Wright, Westerly, Rhode Island, 1951.
9. Mullican, interview with Paul J. Karlstrom at the artist's home or studio, Santa Monica, California, May 1992; January, February, and March 1993, p. 33, Lee Mullican Papers, Archives of American Art, Smithsonian Institution. Following studies at the University of Oklahoma at Norman, about 40 miles from his hometown of Chickasha, and the Kansas City Art Institute, Mullican was inducted into the army in 1942. As a young man with little experience away from home, he "cried most of the way" as he reluctantly boarded a train from Oklahoma City to Fort Sill in Comanche County to begin basic training and was relieved to join a battalion as a topographical draftsman.
10. Brenda Richardson, *Barnett Newman: The Complete Drawings, 1944–1969* (Baltimore: Baltimore Museum of Art, 1979), p. 15. Richardson quotes from a transcript of a public conversation between Barnett Newman and *Art News* editor Thomas B. Hess held at the Solomon R. Guggenheim Museum in New York in 1966.
11. Vitalist philosophers believe in the following general ideas: "Life…consists in movement and becoming, rather than in static being. Reality is organic, not mechanical: biology, and often history, are more central than physics. Life is known empirically or by intuition, rather than by concepts and logical inference…. Vitalism stresses the diversity of life and tends towards pluralism." *The Oxford Companion to Philosophy*, ed. Ted Henderich (New York: Oxford University Press, 1995), p. 901.
12. Henri Bergson, *Creative Evolution* (New York: Henry Holt and Company, 1911; translated into English from *Evolution créatrice* [1907]), p. 42. There is also a more recent, authorized translation by Arthur Mitchell (New York: Modern Library, 1944).
13. Willem de Kooning et al., "What Abstract Art Means to Me," *Bulletin of The Museum of Modern Art* 18, no. 3 (Spring 1951), p. 7.

14. According to Stephen Polcari, some of the Abstract Expressionists were familiar with Read's work, including Herbert Ferber, Barnett Newman, Mark Rothko, and Clyfford Still. "Ferber, in fact, has stated that everyone read Read. This is not surprising since, in a number of books from the 1920s until his death in 1968, Read affirmed and elaborated the value, importance and achievements of the style and content of modern art." Stephen Polcari, "The Intellectual Roots of Abstract Expressionism" (Ph.D. diss., University of California, Santa Barbara, 1980), p. 123. Gordon Onslow Ford said recently that he knew Herbert Read's work in the 1950s; interview with the author, July 22, 1998.
15. Read cites Theodore Roszak and David Smith as among the sculptors whose work embodied the vitalist tradition. *A Concise History of Modern Sculpture* (New York: Thames and Hudson, 1998; reprint of the original 1964 edition), p. 212.
16. Herbert Read, *Art and Society* (New York: Macmillan, 1937), p. 259.
17. Herbert Read, Introduction to *Henry Moore* (London: Lund Humphries, 1944), reprinted in Read's *The Philosophy of Modern Art: Collected Essays* (London: Faber and Faber, 1964; first published 1952), pp. 202–3.
18. Ibid., p. 207.
19. Jack Burnham, *Beyond Modern Sculpture: The Effects of Science and Technology on the Sculpture of This Century* (New York: George Braziller, 1968), p. 80. See also Stephen Polcari's discussion of vitalism in his *Abstract Expressionism and the Modern Experience*, pp. 52–53, 255–56.
20. Burnham, *Beyond Modern Sculpture*, p. 81.
21. Steve Wheeler, in the Preface to his self-published book *Hello, Steve* (New York: Press Eight, 1947), unpag.; Wheeler, in a press release for his 1951 show at the New Gallery; Wheeler, in a letter to Lawrence Campbell, 1946; quoted in Gail Stavitsky, "Steve Wheeler: An Introduction," and Appendix in *Steve Wheeler: The Oracle Visiting the 20th Century* (Montclair, N.J.: Montclair Art Museum, 1997), pp. 13, 9, 48.
22. For this information, I am grateful to Barbara Hollister, archivist, Steve Wheeler Archive, New York.
23. Read, *Philosophy of Modern Art*, p. 213.
24. Onslow Ford, interview with the author, July 22, 1998.
25. Jackson Pollock, "My Painting," *Possibilities*, Winter 1947–48, p. 79.
26. Read, *A Concise History of Modern Sculpture*, p. 212.
27. Noguchi, interview with Paul Cummings, 1973, transcript, p. 86, Archives of American Art, Smithsonian Institution, New York.

28. Lipton, interview with Sevin Fesci, 1968, transcript, p. 6, Archives of American Art, Smithsonian Institution, New York.

29. Weston, entry in his Daybooks, April 26, 1930, quoted in *Edward Weston: The Flame of Recognition,* ed. Nancy Newhall (Millerton, N.Y.: Aperture, 1975), p. 42.

30. Weston, entry in his Daybooks, August 8, 1930, quoted in ibid., p. 34.

31. In New York, the Museum of Modern Art opened in 1929, acquiring works by these and other modern artists throughout the following decades, and mounting numerous influential exhibitions, including Klee (1930 and 1941), Léger (1935), *Fantastic Art, Dada, and Surrealism* (1936), Picasso (1939), and Miró (1941); the Léger retrospective also went to Chicago, and the Picasso retrospective traveled to Chicago, San Francisco, and seven other U.S. cities. The Museum of Living Art, showcasing Albert Gallatin's collection of European modernists (including Braque, Gris, Léger, Picasso, and many geometric abstractionists) was on view in the library of New York University from 1927 to 1943, while the Société Anonyme (a collection featuring works by Arp, Brancusi, Max Ernst, Kandinsky, Klee, Léger, and Miró and a large concentration of Cubists, Futurists, German Expressionists, and Constructivists, along with some American modernists) was housed in rented rooms on Forty-seventh Street from 1920 to 1941. The Museum of Non-Objective Painting (now called the Solomon R. Guggenheim Museum) opened in New York in 1939, featuring the single largest group of Kandinsky's paintings anywhere and works by Klee, Léger, and other European modernists. Dove and O'Keeffe both had shows regularly at An American Place gallery in New York between 1930 and 1945, and there were retrospectives of O'Keeffe's work at the Art Institute of Chicago in 1943 and at the Museum of Modern Art in New York in 1946.

32. Herbert Read, *A Concise History of Modern Painting* (New York and Toronto: Oxford University Press, 1959; revised edition, 1974), pp. 188–89, 228.

33. Ibid., pp. 174, 186, 233.

34. Ibid., pp. 90, 140, 156-57, 159.

35. John Wilmerding, *American Art,* Pelican History of Art series (Harmondsworth, England, and New York: Penguin Books, 1976), p. 193.

36. After a group show of Surrealist artists at the Julien Levy gallery in 1932, there were solo exhibitions of Man Ray, Max Ernst, and André Masson (all 1932), Salvador Dalí (1933), Miró (1933), Masson (1934), and Alberto Giacometti (1935), and, in 1936, shows of Yves Tanguy, René Magritte, and Giorgio de Chirico. See Dore Ashton, *The New York School* (Harmondsworth, England, and New York: Penguin Books, 1979), p. 94.

The Museum of Modern Art exhibition in 1936 included works by Arp, Ernst, Kandinsky, Klee, Miró, and Picasso, among others.

37. Masson returned to France in 1945, Breton in 1946, Matta in 1948, and Ernst in 1953, but Tanguy became a U.S. citizen in 1948.

38. For further discussion on the Surrealist influence in American art, see Robert C. Hobbs and Gail Levin, *Abstract Expressionism: The Formative Years* (Ithaca, N.Y.: Herbert F. Johnson Museum of Art, Cornell University, 1978); Martica Sawin, *Surrealism in Exile and the Beginning of the New York School* (Cambridge, Mass.: MIT Press, 1995); and Dickran Tashjian, *A Boatload of Madmen: Surrealism and the American Avant-Garde* (New York: Thames and Hudson, 1995).

39. Polcari, *Abstract Expressionism and the Modern Experience,* p. 22.

40. In the spring 1941 New School catalogue, the topics and dates of Onslow Ford's four lectures were listed as follows: "Giorgio di Chirico—the child of dreams," January 22, 1941; "Max Ernst—the creative forces of evil" and "Joan Miró—the primitive in the subhuman," February 5, 1941; "René Magritte—poetry of the object" and "Yves Tanguy—the internal landscape," February 19, 1941; and "Adventures in surrealist painting during the last four years," March 5, 1941. In a 1984 interview at Onslow Ford's home, he recalled these lectures: "I went through all the surrealist paintings in chronological order, doing my best to show all the paintings and to talk about them, to introduce them. And the lectures were greeted with great enthusiasm.... So my lectures consisted of looking at the paintings, of seeing what there was in the paintings—I didn't dwell on theory too much, but I tried to find out the adventure the painter was living." Interview with Ted Lindberg, transcript, p. 29, Gordon Onslow Ford Papers, Archives of American Art, Smithsonian Institution, New York. Among the scholarly histories dealing with this period, Martica Sawin's contains the most thorough critical discussion of Onslow Ford's contributions to date; see Sawin's *Surrealism in Exile and the Beginning of the New York School,* pp. 155–67. Sawin also discusses Onslow Ford's lectures and their impact on members of the New York School; she states that those attending the lectures included William Baziotes, Jimmy Ernst, David Hare, and Robert Motherwell. Susan M. Anderson, in her exhibition catalogue *Pursuit of the Marvelous: Stanley William Hayter, Charles Howard, Gordon Onslow Ford* (Laguna Beach, Calif.: Laguna Art Museum, 1990), p. 42, mentions those four plus Jackson Pollock, Stanley William Hayter, and the Surrealists Matta, Kurt Seligmann, and Yves Tanguy. Polcari, in his *Abstract Expressionism and the*

Modern Experience, p. 54, states merely that "Rothko and other Abstract Expressionists were in the audience." Dore Ashton, in Michael Auping, et al., *Arshile Gorky: The Breakthrough Years* (Fort Worth, Tex.: Modern Art Museum of Fort Worth, 1995), p. 54, wrote that Gorky also attended; and in her book *The New York School,* p. 124, she names Baziotes, Ernst, Gorky, and Hare as being among the attendees.

41. Gordon Onslow Ford, *Towards a New Subject in Painting* (San Francisco: San Francisco Museum of Art, 1948), pp. 48, 12.

42. Hare, interview with Dorothy Seckler, New York, January 17, 1968, transcript, p. 26, Archives of American Art, Smithsonian Institution, New York.

The first issue of *VVV,* which appeared in June 1942, had a cover by Max Ernst and included Onslow Ford's own analysis of *Temptations of the Painter;* the last issue, was published in February 1944 (fig. 71).

43. Gottlieb, Introduction to the catalogue of an exhibition, *Selected Paintings by the Late Arshile Gorky* (New York: Kootz Gallery, 1950), p. 1, quoted in Irving Sandler, *The Triumph of American Painting: A History of Abstract Expressionism* (New York: Harper & Row, 1975), p. 60.

44. See Ashton, *The New York School,* p. 126.

45. Sandler, *Triumph of American Painting,* p. 108.

46. Read, *Concise History of Modern Painting,* pp. 262–63, 267.

47. "Charles Seliger: Conversation with the Artist," interview with George Perret for the Andrew Crispo Gallery, Spring 1979, unpublished transcript, p. 1; and Seliger, interview with the author, August 18, 1998.

48. Seliger, interview with the author, May 22, 1995.

49. Ibid.

50. Marla Prather provides a detailed account of this work in her exhibition catalogue *Willem de Kooning: Paintings* (Washington, D.C.: National Gallery of Art, 1994), p. 94. In note 8 on page 102, Prather discusses Milton Resnick's claim of having been involved in painting this large canvas.

51. De Kooning, interview with Thomas Hess, quoted in Sally Yard, *Willem de Kooning: The First Twenty-Six Years in New York, 1927–1952,* Ph. D. diss., Princeton University, 1980 (New York and London: Garland Publishing, 1986), p. 146.

52. Wheeler studied with Hofmann from 1935 to 1937, along with his friends Robert Barrell and Peter Busa, with whom he stayed closely associated through the 1940s and 1950s. Unlike Barrell and Busa, Wheeler did not exhibit as part of the Indian Space group in 1946–47.

53. In striving to create their new kind of pictorial space, the Indian Space painters were influenced by the work of European modernists and by Northwest Coast Indian art, as several of the Abstract Expressionists were at about the same time. The collections of Native American art at the Museum of Natural History, the Brooklyn Museum, and the Heye Foundation, as well as the Museum of Modern Art's 1941 exhibition *Indian Art of the United States* (which presented more than a thousand objects), had a particular impact.

54. Mullican, interview with the author, January 25, 1993. Other information about Mullican from the Lee Mullican Papers, Archives of American Art, Smithsonian Institution, New York.

55. Seymour Lipton, "Experience and Sculptural Form," *College Art Journal* 9 (Autumn 1949), pp. 52–54, quoted in Sam Hunter, *Modern American Painting and Sculpture* (New York: Dell, 1959), pp. 177–78.

56. Sidney Janis, *Abstract and Surrealist Art in America* (New York: Reynal & Hitchcock, 1944), p. 89.

57. Katharine Kuh and Frederick A. Sweet, *Abstract and Surrealist American Art* (Chicago: Art Institute of Chicago, 1947), pp. 4, 13. Kuh wrote in her catalogue essay (p. 14): "These… artists are found everywhere, not alone in New York but also on the West Coast, very particularly in Boston…and surprisingly in small communities like Laramie, Wyoming; Norman, Oklahoma; Albuquerque, New Mexico; and Iowa City."

58. *Momentum*'s organizers also included students from the New Bauhaus (later the Institute of Design) founded in 1937 by László Moholy-Nagy. The Institute of Design students, who sustained the geometric designs of Bauhaus modernism, worked together with those from the School of the Art Institute to plan these exhibitions and create the catalogues for them. By 1951, the Art Institute withdrew its practice of banning students from entering work into its annual juried exhibition, but *Momentum* continued. Between 1952 and 1954, the show was titled *Exhibition Momentum Midcontinental* and its outreach expanded to eighteen states.

59. The stated reason for the East Coast–weighted jury was that the participation of those outside of the Chicago loop "would insure an unprejudiced selection." See *Momentum, 1948–1956* (Chicago, 1956), unpaginated exhibition brochure.

60. In 1955, Golub wrote: "The abstract expressionists deal with spontaneity and although there are many levels of spontaneity, it remains doubtful whether these bravura skirmishings can evoke universals…. The questions become *farcical*: what is the difference (and how can these differences be recorded)

between a subliminal impulse, the cosmos, and a fanciful doodle?" Leon Golub, "A Critique of Abstract Expressionism," *College Art Journal* 15 (Winter 1955), p. 146.

61. From Notes taken during the lecture on his work at Pratt Institute, New York, October 27, 1958, in Jeffrey Weiss, *Mark Rothko* (Washington, D.C.: National Gallery of Art, 1998), Chronology, p. 346.

62. Kirk Varnedoe with Pepe Karmel, *Jackson Pollock,* exh. cat. (New York: Museum of Modern Art, 1998), p. 47.

63. George Cohen, conversation with the author, June 1998.

64. Golub, interview with the author, September 24, 1997.

65. Ibid.

66. Louise Nevelson, *Dawns + Dusks,* p. 128.

67. In 1962, the Museum of Modern Art sponsored *Recent Paintings USA: The Figure,* May 23 to September 4, 1962, which featured contemporary figuration; it traveled to six venues: Columbus, Ohio; Colorado Springs; Baltimore; Saint Louis; San Francisco; and Minneapolis. The next year, the Museum of Modern Art showcased Pop art and Op art in *Americans 1963,* organized by Dorothy C. Miller.

FRIEDMAN NOTES

1. See Michael and Katherine McCoy's Introduction to Hugh Aldersey-Williams, *New American Design* (New York: Rizzoli, 1988).

2. By 1947 the United States was producing 50 percent of the world's manufactured goods, 43 percent of its electricity, 62 percent of its oil, and Americans owned 75 percent of the world's automobiles; as described in John Kenneth Galbraith, *The Affluent Society* (Boston: Houghton Mifflin, 1958).

3. See Barbara Kelly, "Houses of Levittown in the Context of Postwar American Culture," in *Preserving the Recent Past,* ed. Deborah Slaton and Rebecca Shiffer (Washington, D.C.: Historic Preservation Educational Foundation, 1995), vol. 2, p. 148.

4. Charles and Ray Eames were not only the preeminent American furniture designers of mid-century; they also created amazing exhibitions dealing with scientific and historical topics, and made brilliant films that were both entertaining and filled with information. In addition, Charles, who was an architect, designed his own distinguished private house, where he and Ray carried out many of their most innovative design ideas.

5. See the 1998 film *The Truman Story,* and Herbert Muschamp's *New York Times* piece "Beneath the Lawns, Seeds of Discontent," November 7, 1999, pp. 51, 54.

6. In the comedy *Mr. Blandings Builds His Dream House,* Cary Grant plays an

executive who encounters problem after problem as he builds a house in Connecticut for his family.

7. See Arthur J. Pulos, *The American Design Adventure, 1940–1975* (Cambridge, Mass., and London: MIT Press, 1988), pp. 130, 136.

8. See Thomas Hine, *Populuxe* (New York: Alfred A. Knopf, 1986).

9. Eero Saarinen's illustrious father, Eliel, was president of Cranbrook Academy and its resident architect from 1932 until his death in 1950.

10. See John and Marilyn Neuhart and Ray Eames, *Eames Design: The Work of the Office of Charles and Ray Eames* (New York: Harry N. Abrams, 1989).

11. Reprinted in *Arts and Architecture: The Entenza Years,* ed. Barbara Goldstein (Santa Monica: Hennessey & Ingalls, 1998), p. 66, from Eliot Noyes, "Charles Eames," *Arts and Architecture,* September 1946.

12. The architect George Nelson was a consultant to the magazine *Architectural Forum*; Henry Wright was its managing editor.

13. *Everyday Art Quarterly* (Walker Art Center, Minneapolis), no. 3 (Winter/ Spring 1946–47), p. 5.

14. See *Eero Saarinen on His Work,* ed. Aline Saarinen (New Haven and London: Yale University Press, 1962), p. 68.

15. Noguchi's lunar ceiling for the American Stove Company Building in Saint Louis, now owned by the U-Haul Company, has been hidden by a newly installed dropped ceiling.

16. In *Frederick Kiesler Artist-Architect,* exh. cat. (Paris: Centre Georges Pompidou, 1996).

17. R. Craig Miller, quoted in *Formica and Design: From the Counter Top to High Art,* ed. Susan Grant Lewin (New York: Rizzoli, 1991), p. 13.

18. A number of plastic materials were developed in the late nineteenth and early twentieth centuries, but materials such as celluloid and cellophane, for example, have limited uses and have largely been replaced by more diverse and more durable polymers.

19. Jeffrey L. Meikle, *American Plastic* (New Brunswick: Rutgers University Press, 1995), p. 155.

20. See *Raymond Loewy, Pioneer of American Industrial Design,* ed. Angela Schönberger (Munich: Prestel, 1990).

21. Ibid.

22. Reyner Banham, quoted in Karal Ann Marling, *As Seen on TV: The Visual Culture of Everyday Life in the 1950s* (Cambridge, Mass., and London: Harvard University Press, 1994), p. 133.

23. Ibid., p. 6.

24. "Cadillac Ranch," 1980, quoted by Karal Ann Marling in "America's Love Affair with the Automobile in the Television Age," *Design Quarterly,* no.146 (1989), p. 18. The sculptor Ed Kienholz

may have heard Springsteen's song, for in 1995 he was laid to rest seated in his beloved 1940 Packard.

25. In 1956, Southdale, one of America's first shopping malls, was constructed on the edge of Minneapolis (see figs. 194, 195). In 1992, the Mall of America—the biggest of its kind, replete with theme-park entertainment—was inaugurated in Bloomington, a suburb strategically placed between the Twin Cities of Minneapolis and Saint Paul.

26. David Halberstam, *The Fifties* (New York: Villard Books, 1993).

27. See Julie Lasky, "The Search for Georg Olden," *Print*, March–April 1994.

28. See Caroline Rennolds Milbank, *Couture: The Great Designers* (New York: Stewart, Tabori & Chang, 1985), pp. 352–59.

29. See Mary Cantwell, "Claire Voyant," *Mirabella*, September 1994, pp. 50, 52. Describing a photograph of herself in a McCardell red sundress, she writes, "The dress is impossible to date. So, consequently, am I."

30. Bevis Hillier, in *The Style of the Century, 1900–1980*, 2nd ed. (New York: Watson-Guptill, 1998), states that camouflage patterns led to amorphous patterning in graphics and textiles.

31. Tobi Tobias, "A Man of the Cloth," *Dance Ink*, Winter 1994–95.

32. James, quoted in Ann Coleman, *The Genius of Charles James* (New York: The Brooklyn Museum, 1982).

33. See Toni Greenbaum, "The Studio Jewelry Movement, 1940–80: Roots and Results," in Susan Grant Lewin, *One of a Kind: American Art Jewelry Today* (New York: Harry N. Abrams, 1994).

34. George Nelson, interview with the author, 1974.

35. In recent years, many articles, books, and exhibitions by enthusiastic young feminists have promulgated the notion that the proliferation of domestic appliances in the postwar period only further enslaved the American housewife, holding her to a new standard of cleanliness; see, for example, Ellen Lupton, *Mechanical Brides: Women and Machines from Home to Office* (New York: Cooper-Hewitt, National Museum of Design, and Princeton Architectural Press, 1993). Yet, an older generation of equally enthusiastic feminists who lived through that period can testify to the fact that work outside the servantless household was indeed made both feasible and rewarding in part because of the newly efficient domestic accoutrements.

MARLING NOTES

1. Harley Earl with Arthur W. Baum, "I Dream Automobiles," *Saturday Evening Post*, August 7, 1954, p. 82. See also Karal Ann Marling, *As Seen on TV: The Visual Culture of Everyday Life in the 1950s* (Cambridge, Mass., and London: Harvard University Press, 1994), pp. 138–41.

2. See Karal Ann Marling, "America's Love Affair with the Automobile in the Television Age," *Design Quarterly*, no. 146 (1989), p. 8.

3. Earl, "I Dream Automobiles," p. 82.

4. Thomas Hine, *Populuxe* (New York: Alfred A. Knopf, 1986), pp. 83–106.

5. Chester H. Liebs, *Main Street to Miracle Mile: American Roadside Architecture* (Boston: Little, Brown, 1985), pp. 31–32.

6. Victor Gruen, *Centers for the Urban Environment: Survival of the Cities* (New York: Van Nostrand Reinhold, 1973), p. 26.

7. "$20,000,000 Southdale Center Opens Monday," *Minneapolis Sunday Tribune*, October 7, 1956. See also "A Break-Through for Two-Level Shopping Centers," *Architectural Forum* 105 (December 1956), pp. 114–23.

8. John K. Sherman, "Center Breaks Art Barrier with Sculpture, Murals," *Minneapolis Sunday Tribune*, October 7, 1956.

9. "The Splashiest Shopping Center in the U.S.," *Life*, December 10, 1956, p. 61.

10. "Architect Says Southdale Planned as 'Cultural Center' for Its Patrons," *Minneapolis Sunday Tribune*, March 14, 1954.

11. "Spotlight on Hats," *Minneapolis Sunday Tribune*, October 7, 1956.

12. Dior, quoted in "Dictator by Demand," *Time*, March 4, 1957, p. 34.

13. See Wayne Koestenbaum, *Jackie Under My Skin* (New York: Plume, 1996), p. 131. In the photograph that Andy Warhol used to make his photo-silkscreen painting *Sixteen Jackies* (1964), the former First Lady is wearing the hat.

14. See Marling, *As Seen on TV*, pp. 31–34; Susan Eisenhower, *Mrs. Ike* (New York: Farrar, Straus, & Giroux, 1996), pp. 281–82.

15. Mamie Doud Eisenhower to Sally Victor, January 26, 1953, WHSF, Box 22, Folder "Vi," Eisenhower Library Collection, Abilene, Kansas.

16. See, for example, Andy Warhol, *Style, Style, Style* (Boston: Little, Brown, 1997), unpag.

17. *Serving Art: Rockwell Kent's Salamina Dinnerware* (Minneapolis: Frederick R. Weisman Art Museum, 1996), pp. 8–12.

18. Mitchell Douglas Kahan, *Art Inc.* (Montgomery, Ala.: Montgomery Museum of Fine Arts, 1979), pp. 9–41; *Art, Design, and the Modern Corporation* (Washington, D.C.: National Museum of American Art, 1985), pp. 8–30. See also Michele H. Bogart, *Artists, Advertising, and the Borders of Art* (Chicago: University of Chicago Press, 1995).

19. Zeisel, quoted in Lesley Jackson, *The New Look: Design in the Fifties* (London: Thames & Hudson, 1991), p. 109. The painting by Dalí that Zeisel was referring to is *The Persistence of Memory*, 1931 (Museum of Modern Art, New York).

20. Maxine Feek Nelson, *Collectible Vernon Kilns* (Paducah, Ky.: Collector Books, n.d.), pp. 217–22.

21. Zeisel, quoted in Jackson, *The New Look*, p. 22.

22. See H. Ward Jandl, *Yesterday's Houses of Tomorrow* (Washington, D.C.: Preservation Press, 1991), p. 206; Karal Ann Marling, *Designing Disney's Theme Parks: The Architecture of Reassurance* (Paris: Flammarion, 1997), p. 151.

23. See Gwendolyn Wright, *Building the Dream: A Social History of Housing in America* (New York: Pantheon, 1981), pp. 240–61. See also Barbara M. Kelly, *Expanding the American Dream: Building and Rebuilding Levittown* (Albany: State University of New York Press, 1993).

24. Penny Sparke, *As Long As It's Pink: The Sexual Politics of Taste* (San Francisco: HarperCollins, 1995), p. 194.

25. Richard Sexton, *American Style* (San Francisco: Chronicle Books, 1987), p. 63. The original *Skylark* pattern was designed by Brooks Stevens (American, 1911–1995) in 1950 for the Formica Corporation. In 1954 Formica commissioned Raymond Loewy to "revise and revitalize" the color and design pattern. See Simon Leung, "Brooks Stevens," and Barbara Goldstein, "Formica in the Fifties," in *Formica and Design: From the Counter Top to High Art*, ed. Susan Grant Lewin (New York: Rizzoli, 1991), pp. 93–97. The pattern, now known as *Boomerang*, was reissued by Formica between 1988 and 1999.

26. For Wright's flatware, designed to fit the human hand, see Arthur J. Pulos, *The American Design Adventure, 1940–1975* (Cambridge, Mass., and London: M.I.T. Press, 1988), p. 160. For the international politics involved in displaying American products abroad during this era, see Robert H. Haddow, *Pavilions of Plenty* (Washington, D.C.: Smithsonian Institution Press, 1997).

27. See Karal Ann Marling, *Graceland: Going Home with Elvis* (Cambridge, Mass., and London: Harvard University Press, 1996), pp. 211–12.

28. See Morris Lapidus, *Too Much Is Never Enough* (New York: Rizzoli, 1996), pp. 156–81.

29. See Cecelia Tichi, *Electronic Hearth: Creating an American Television Culture* (New York: Oxford University Press, 1991).

30. See Marling, *As Seen on TV*, p. 81, on the relationship between television and painting in the 1950s.

Acknowledgments

Many colleagues and friends have contributed to the realization of *Vital Forms: American Art and Design in the Atomic Age, 1940–1960*, which has been ten years in planning. We deeply appreciate the generosity of all involved.

First, we wish to thank Arnold L. Lehman, Director of the Brooklyn Museum of Art, for his valuable insights and abiding support of the project.

We are grateful to our colleagues at the other institutions on the exhibition tour— Siri Engberg and Howard Oransky at the Walker Art Center, Chase Rynd at the Frist Center for the Visual Arts, Carol Eliel at Los Angeles County Museum of Art, and Michael Komanecki at the Phoenix Art Museum—for their enthusiasm and commitment to the exhibition.

Our consulting curators, Mildred Friedman and Martin Filler, have from the outset inspired us with their expertise about design of the 1940s and 1950s and their intimate acquaintance with pertinent collections. Their essays in this volume add to the substantial contribution that each has made to the design field. Paul Boyer graciously shared his vast knowledge of the history of the period and provided a lively essay to the book that establishes the historical context for the works in the exhibition. Karal Ann Marling contributed a wonderful iconoclastic view of popular culture of the postwar era to this volume and suggested superb examples for inclusion in the exhibition and this publication.

Practically every department in the Museum has helped to bring this complex exhibition and its accompanying publication to fruition. We extend our gratitude to Charlotta Kotik, Chair and Curator, Department of Contemporary Art, for her thoughtful guidance and constant support. Rui Sasaki, Departmental Assistant, managed many details concerning loans and the publication. Robbin Lockett, Research Associate, provided invaluable and skillful assistance with the exhibition and book. Generous help was provided by our volunteers, past and present: Maggie Hartnick, Moriah Evans, Mary Ann Jung, Peter Karol, Ron Labaco, Erica Smatana, and Lynn Von Salis. We are also grateful to our former research assistants: Ariella Budick and Susan Rosenberg made significant contributions to the scholarly materials assembled, and Judith Gura generously shared her expertise in the design field. For their support and counsel, we also thank our colleagues in other departments: Teresa A. Carbone, Linda S. Ferber, Barbara D. Gallati, Barry R. Harwood, Marilyn S. Kushner, Patricia Mears, Barbara Millstein, Robert Thill, and William Siegmann.

Many other members of the Museum staff contributed their talents and energy to the project: Cynthia Mayeda; Judith Frankfurt; Dean Brown; Elizabeth Reynolds, Maryl Hosking, and Terri O'Hara; Hannah Mason and Melissa Mates; Cathryn Anders; Sallie Stutz; Sally Williams; Kenneth Moser, Richard Kowall, Carolyn Tomkiewicz, Antoinette Owen, Ellen Pearlstein, and Joanna Hill; Deirdre Lawrence, Ed McLoughlin, Jeff Couteau, and Keith DuQuette; Charles Froom, Matthew Yokobosky, and John DiClemente; Judith Paska and Peter Trippi; Stan Zwiren; Harry Soldati; Joel Hoffman and Mona Smith. We also thank James Lantz of Red Seed Productions for the original and creative video program that accompanies the exhibition.

For their guidance, we are also indebted to former Brooklyn Museum colleagues, including Robert T. Buck, Barbara Burch, Layla S. Diba, Roy R. Eddey, Diana Fane, Marianne Lamonaca, Dianne Pilgrim, Ellen Reeder, Deborah Schwartz, and Melissa M. N. Seiler.

Many individuals contributed to the successful publication of this volume: Stephen Robert Frankel edited a large and complex manuscript with insight and intelligence; James Leggio and Joanna Ekman skillfully oversaw the project at the Brooklyn Museum; Margaret L. Kaplan and Nicole Columbus guided the book's progress at Harry N. Abrams; and Miko McGinty created its elegant design.

We deeply appreciate the generosity of the lenders. For important assistance in securing loans, we are indebted to the following lenders and their assistants: Philip E. Aarons; Nicholas Fox Weber, The Josef and Anni Albers Foundation; Douglas Berman and Peter Daferner and the Estate of Leo Amino; John Zukowsky and Luigi Mumford, The Art Institute of Chicago; Ruth Asawa; Frances Baer; Doreen Bolger and Helen Molesworth, The Baltimore Museum of Art; Louise Bourgeois, Jerry Gorovoy, and Wendy Williams, Louise Bourgeois studio; Alexander Rower and Jessica Olivieri, Calder Foundation; Simona and Jerome Chazen; Elaine Lustig Cohen; Linda Dunne, Deborah Sampson Shinn, Gregory Herringshaw, and Cordelia Rose, Cooper-Hewitt, National Design Museum; Georgia and Michael de Havenon; Denis Doherty, Doherty and Sons; Michele Oka Doner; Sandra Donnell; Erica Stoller, ESTO; Daphne Farago; Edith Ferber; Ivan Gaskell, Sarah B. Kianovsky, and Harry Cooper, Fogg Art Museum; William Roush and Renée Hytry, Formica Corporation; Barry Friedman; Mark McDonald, Gansevoort Gallery; Joan E. Goody, Goody, Clancy & Associates; Sanford Hirsch and Nancy Litwin, Adolph and Esther Gottlieb Foundation; Marc Selwyn and Anthony Grant, Grant Selwyn Fine Art; Lisa Dennison, Meryl Cohen, and Beatriz Zengotitabengoa, Solomon R. Guggenheim Museum; Barry R. Harwood; Samuel and Ronnie Heyman; Galen Howard Hilgard; Gerome Kamrowski; Alexander Kaplen; Robert Landrio; Estate of Morris Lapidus; Jack Lenor Larsen, Miry Park, Katherine Croner, and Crystal Cooper, Larsen Design Studio/Cowtan and Tout; Robert Warshaw, Esq., and the Estate of Madeleine Lejwa; Carol Eliel, Kaye Spilker, and Debby Freund, Los Angeles County Museum of Art; Ann Glorioso, Levittown Public Library; Harold Koda, The Metropolitan Museum of Art; Robert W. Viol and Linda M. Baron, Herman Miller, Inc.; Evan M. Maurer, Brian Kraft, and Patrick Noon, The Minneapolis Institute of Arts; Guy Cogeval, Diane Charbonneau, and Anne-Marie Chevrier, The Montreal Museum of Fine Arts; Paul D. Schweitzer and Mary Murray, Munson-Williams-Proctor Institute; Robert Fitzpatrick and Elizabeth Smith, Museum of Contemporary Art, Chicago; Kirk Varnedoe and Cora Rosevear, The Museum of Modern Art; Earl A. Powell III, Jeffrey Weiss, and Judith Cline, National Gallery of Art; Norman M. Cary and Thomas E. Pickenpaugh, Naval Historical Center; Diane Jacobus, Susan Moyer, Jane P. McMullen, and Douglas L. Eakin, Naval Supply Systems Command; Kathy Goncharov, former curator, and Stefano Basilico, New School University; Julia Van Haaften and Jean Mihich, The New York Public Library; Shoji Sadao, Bonnie Rychlak, Amy Hau, and Lynn A. Tondrick, The Isamu Noguchi Foundation; Dennis Power and Joy Walker, Oakland Museum of California; Gordon Onslow Ford, Deborah Gorman, and Zea Morovitz, Gordon Onslow Ford studio; Herbert Palmer, Herbert Palmer Gallery; Pollock-Krasner Foundation, Inc., Courtesy Robert Miller Gallery, New York; Joel Press; Peter Bunnell and Maureen McCormick, The Minor White Archive, Princeton University; Peter Reginato; Michael Rich; Peter C. Papademetriou, Saarinen Archive, Kevin Roche John Dinkeloo & Associates; Rowe International, Inc.; Charles L. Russell; Fayez Sarofim and Emily Kilgore, Fayez Sarofim Collection; Deborah Schwartz; Mary MacNaughton and Kirk Delman, Ruth Chandler Williamson Gallery, Scripps College; Mimi Gates, Chiyo Ishikawa, and Lisa Corrin, Seattle Art Museum; Julius Shulman; Allan Stone and Claudia Barry

Stone, Allan Stone Gallery; Blake Summers; Robert Simon, Transport Consultants International Inc.; the late Morrison S. Cousins and Florence D'Emilia, Tupperware Americas; Waverly B. Lowell, College of Environmental Design, University of California at Berkeley; Julia Moore Converse and William Whitaker, Louis I. Kahn Collection, University of Pennsylvania; former director Peter C. Sutton, Elizabeth Mankin Kornhauser, Mary Herbert-Busick, and Amy Ellis, Wadsworth Atheneum Museum of Art; Karen Elder, Westvaco Corporation; Ann Lampe, Barbara Haskell, Barbi Spieler, and Joelle Laferrara, Whitney Museum of American Art; Margo Stipe, The Frank Lloyd Wright Foundation; Jock Reynolds and Jennifer Bossman, Yale University Art Gallery; Richard York and Meredith Ward, Richard York Gallery; Philip Dennis Cate, Jeffrey Wechsler, Cathleen Anderson, and Lynn Ferrara, Jane Voorhees Zimmerli Art Museum, Rutgers University; and those lenders who prefer to remain anonymous.

We are grateful to the following for assistance in securing photographs for the book and the exhibition installation: A & S Book Company; Katarina Pakoma, Alvar Aalto Museum; Fay Dolnick, American Planning Association; Ann E. Bartholomew and Elisabeth Hooks, American Red Cross Museum; Camille Ruggiero, AP/Wide World Photos; Hsiu-ling Huang and Nicole Finzer, The Art Institute of Chicago; Sarah Balcomb, Artists Rights Society (ARS); Nancy Press and Stephanie B. Revak, The Baltimore Museum of Art; Patrick Jablonski, Morley Baer Archives; Morley Baer Memorial Photographic Fund, Monterey Peninsula Museum of Art; Camille Billops, Hatch Billops Collection; Robert Walz, Boeing; Sophia Soguercia and Elaine Krogius, Brooklyn Public Library; Peter Gollub and Alvin S. Hochberg, Broude and Hochberg, LLP, Attorneys for Capp Enterprises, Inc.; David Lombard, CBS Photo Archive; Steven Nash, California Palace of the Legion of Honor, Fine Arts Museums of San Francisco; Keshia Whitehead and Leith Rohr, Chicago Historical Society; Jane Padelford, Christie's Images, Inc.; Jennifer B. Calder, Commerce Graphics Ltd., Inc.; Jill Bloomer, Cooper-Hewitt, National Design Museum; Alyssa Sachar, Corbis Images; Couturier Gallery; Charles Cowles Gallery; Amy James, Cranbrook Archives; Carole L. Lee, Denver Art Museum; Sylvia Inwood, Detroit Institute of Arts; Janice M. Nicols, Dole Food Company, Inc.; Paul Donzella; Shelley Mills and Eames Demetrios, Eames Office; Linda Patterson Eger; Kathy Struss, The Dwight D. Eisenhower Library; Christine Cordazzo, ESTO; Max D. Lederer, Jr., *European and Pacific Stars and Stripes*; Stephanie Breaux, The Fairchild Aerial Photograph Collection at Whittier College; Evelyn Bavier, Fogg Art Museum; James Elliot, *Franciscan Newsletter*; Cristo Datini, General Motors Corporation Media Archives; Valerie Zars, gettyimages; Bertrand Goldberg Associates; Leon Golub and Samm Kunce, Leon Golub studio; Kate Carr and Kim Bush, Solomon R. Guggenheim Museum; Jack O. Hedrich, Hedrich Blessing; Peter Ryan, Joseph Helman Gallery; Jennifer Saville and Pauline Sugino, Honolulu Academy of the Arts; Erin Chase, The Huntington Library, Art Collections and Botanical Gardens; Paul Carlos, *Interiors* magazine; Betty James, James Industries; Alan Goodrich, John Fitzgerald Kennedy Library; Denis Kitchen, Denis Kitchen Art Agency; Lauren Cadmus, Knoll, Inc.; Balthazar Korab, Balthazar Korab Ltd.; Deborah Desilets, Morris Lapidus Archive; Sandy Lawson, Sharon Bishop, and Jennifer Brathovde, The Library of Congress; Carolyn Cole, Los Angeles Central Library; Shaula Coyl, Los Angeles County Museum of Art; Shannon Loughrey, Los Angeles Modern Auctions; James Elkind, Lost City Arts; Adrian Rosenfeld, Mathew Marks Gallery; Danny Palumbo, Mattel, Inc.; Jason McCoy and Stephen Cadwalader, Jason McCoy Inc.; Rose Brittain, McDonald's Corporation; Jayne Adlin, Rebecca Akhan, and Deanna Cross, The Metropolitan Museum of Art; Marie-Claude Saia, The Montreal Museum of Fine Arts; Thomas D. Grischkowsky, Jennifer Botts, and Terry Geesken, The Museum of Modern Art; Nancy Stanfield, National Gallery of Art; Jeff Lansing, New York State Thruway Association; Jerry Ohrlinger's Movie Material Store; Ray Dellavecchia and Pamela Shelby, Poof Products, Inc.; Kelly C. Hill,

Graceland, Division of Elvis Presley Enterprises, Inc.; Hsu-Han Shang, Queens Museum of Art; Marion Rand and Georgette Balance, Paul Rand Archives; David White, Robert Rauschenberg Studio; Thomas Rockwell, Norman Rockwell Family Trust; Elizabeth Aldred and Kimberly Rawson, The Norman Rockwell Museum; Mark Renovitch, Franklin D. Roosevelt Library; Judy McKee, Julius Shulman Photography of Architecture; Suzanne Royce Silk, Suzanne Royce & Associates; Linda Sell, Southdale Center; Ron Radecki, Andrew Beckman, and Robert Denham, Studebaker National Museum; Wendy E. Chmielewski, Swarthmore College Peace Collection; Diane Cooter, Department of Special Collections, Bird Library, Syracuse University; David M. Riedel, Telstar Electronics/ Predicta; Jennifer McAlwee, Time Inc.; Thomas Gilbert, TimePix; Pauline Testerman, Harry S. Truman Library; Alan K. Lathrop, University of Minnesota Libraries; Tony Vaccaro; Alison Gallup, Visual Artists and Galleries Association (VAGA); Peter Voulkos and Sam Jornlin, Voulkos and Co.; Lynn Mervosh and Erica Scherzer, Wadsworth Atheneum Museum of Art; Shari Obrentz, Washington University Gallery of Art; Anita Duquette and Jennifer Belt, Whitney Museum of American Art; Karen E. Hudson, Paul R. Williams Archives; Dorinda Hartmann, Wisconsin Center for Film and Theater Research; Russel Wright Education Center, Manitoba Preserve; and Suzanne Warner, Yale University Art Gallery.

In April 1997, the Museum hosted a scholarly colloquium, *Vital Forms in America*, which refined the exhibition's themes and the selection of objects. We deeply appreciate the generously shared expertise of Paul Boyer, Ned Cooke, Lois Craig, Ann Eden Gibson, Neil Harris, Barbara Johns, Karal Ann Marling, Derek Ostergard, Stephen Polcari, Robert Rosenblum, and Franz Schulze. We would also like to express our gratitude to the many artists, designers, and art dealers who consented to be interviewed, including Ruth Asawa, Ethel Baziotes, William Theophilis Brown and Paul Wonner, George Cohen, Lin Emery, Richard Feigen, Allan Frumkin, Leon Golub and Nancy Spero, the late Bertrand Goldberg, Richard Gray, Olga Gueft, Ellen Lanyon and Roland Ginzel, the late Morris Lapidus, Ibram Lassaw, Frank Lobdell, Naomi Marshall, the late Lee Mullican, Otto Natzler, Nathan Oliveira, Gordon Onslow Ford, Franz Schulze, Evelyn Statsinger, Peter Voulkos, Susan Weininger, and Eva Zeisel.

We are grateful to the following for assisting us in locating works of art and documents: Gina Bowden, Scott Braznell, Sheila Levrant de Bretteville, Carl Burgwardt, Miles Morris at Christie's Automotive Department, Deborah Desilets, Martin Friedman, Dorothy Globus, Elyse Grinstein, Scot van der Hann, Eric W. Baumgartner at the Hirschl and Adler Galleries, Historical Design, Jeff Alter at Hobie Designs, Barbara Hollister, Barbara Jakobson, Miani Johnson, Wendy Kaplan, Janet Kardon, Gere Kavanaugh, Ellsworth Kelly and Jack Shear, Lillian Kiesler, Stephen Mazoh, David McFadden, Tony Moletiere, Matt Mullican, the late Paul Rand, Ruth Adler Schnee, Second Hand Rose, Mike Spangler, Gertrude Stein, Jewel Stern, Marc Trieb, Jennifer Vorbach, Ron Warren, and Richard Wright. We also thank Ann Eden Gibson, Stephen Polcari, and Natasha Staller, who generously read drafts of the manuscript of this book and offered outstanding suggestions and valuable research source materials.

Finally, Richard A. Rapaport, Blair Kamin, Barbara Mahany, and Virginia and Arthur Z. Kamin offered abundant encouragement during the planning of this project.

B.K.R. and K.L.S.

Selected Bibliography

Ades, Dawn, et al. *The Twentieth-Century Poster: Design of the Avant-Garde.* Minneapolis: Walker Art Center; New York: Abbeville Press, 1984.

Albrecht, Donald, Margaret Crawford, and Michael Sorkin. *World War II and the American Dream: How Wartime Building Changed a Nation.* Washington, D.C.: National Building Museum; Cambridge, Mass.: M.I.T. Press, 1995.

Albright, Thomas. *Art in the San Francisco Bay Area, 1945–1980: An Illustrated History.* Berkeley: University of California Press, 1985.

Anderson, Susan M. *Pursuit of the Marvelous: Stanley William Hayter, Charles Howard, Gordon Onslow Ford.* Laguna Beach, Calif.: Laguna Beach Art Museum, 1990.

Arceneaux, Marc. *1947: Atomic Age.* San Francisco: Troubadour Press, 1984.

Ashton, Dore, et al. *New York, 1940–1965.* New York: Rizzoli, 1988.

Auping, Michael, et al. *Abstract Expressionism: The Critical Developments.* New York: Harry N. Abrams; Buffalo: Albright-Knox Art Gallery, 1987.

Automobile and Culture. Los Angeles: The Museum of Contemporary Art; New York: Harry N. Abrams, 1984.

Banham, Reyner. *The Architecture of the Well-Tempered Environment.* Chicago: University of Chicago Press, 1969.

———. *Design by Choice.* New York: Rizzoli, 1981.

Boyer, Paul. *By the Bomb's Early Light: American Thought and Culture at the Dawn of the Atomic Age.* New York: Random House, 1985.

———. *Fallout: A Historian Reflects on America's Half-Century Encounter with Nuclear Weapons.* Columbus: Ohio State University Press, 1998.

Bradford, Peter. *Chair.* New York: Thomas Crowell, 1978.

Burnham, Jack. *Beyond Modern Sculpture: The Effects of Science and Technology on the Sculpture of This Century.* New York: George Braziller, 1968.

Burns, Mark. *Fifties Homestyle.* New York: Harper & Row, 1988.

Caplan, Ralph. *The Design of Herman Miller.* New York: Whitney Library of Design, 1976.

Carington, N. *Design and Decoration in the Home.* London: Batsford, 1952.

Castleman, Riva. *Art of the Forties.* New York: The Museum of Modern Art, 1991.

Clark, Robert Judson, et al. *Design in America: The Cranbrook Vision, 1925–1950.* New York: Harry N. Abrams and The Metropolitan Museum of Art; Detroit: The Detroit Institute of Arts, 1984.

Coleman, Ann. *Changing Fashions, 1800–1970.* Brooklyn, New York: The Brooklyn Museum, 1972.

Constantine, Mildred. *Beyond Craft: The Art of Fabric.* New York: The Museum of Modern Art, 1978.

Conway, Patricia. *Art for Everyday.* New York: Clarkson N. Potter, 1990.

Design 1935–1965: What Modern Was. New York: Harry N. Abrams in association with Le Musée des Arts Décoratifs de Montréal, 1991.

Designer Craftsmen U.S.A. Brooklyn, New York: The Brooklyn Museum, 1953.

DiNoto, Andrea. *Art Plastic: Designed for Living.* New York: Abbeville, 1984.

Doblin, Jay. *One Hundred Great Product Designs.* New York: Van Nostrand Reinhold, [1970].

Dobriner, William M., ed. *The Suburban Community.* New York: Putnam, 1958.

Dorner, Jane. *Fashion in the 40s and 50s.* London: Ian Allen, 1975.

Dreyfuss, Henry. *Designing for People.* New York: Simon & Schuster, 1955.

———. *Industrial Design: A Pictorial Accounting 1929–1957.* New York: Henry Dreyfuss, 1957.

Dubois, J. *Plastic History USA.* Cambridge, Mass.: M.I.T. Press, 1972.

Ehrlich, Susan. *Pacific Dreams: Currents of Surrealism and Fantasy in California Art, 1934–57.* Los Angeles: U.C.L.A. at the Armand Hammer Museum of Art and Cultural Center, 1995.

Ewen, Stuart. *All Consuming Images: The Politics of Style in Contemporary Culture.* New York: Basic Books, 1988.

Explorations in the City of Light: African-American Artists in Paris, 1945–1965. New York: The Studio Museum in Harlem, 1996.

Fehrman, Cherie, and Kenneth Fehrman. *Postwar Interior Design, 1945–1960.* New York: Van Nostrand Reinhold, 1987.

Filler, Martin. "He'd Rather Be Wright." *The New York Review of Books,* January 13, 1994, pp. 28–34.

———. "All About Eames." *The New York Review of Books,* June 20, 1996, pp. 42–44.

———. "Giant in the Woods." *The New York Review of Books,* April 19, 1998, pp. 16–20.

Fogarty, Anne. *Wife Dressing: The Fine Art of Being a Well-Dressed Wife.* New York: Julian Messner, 1959.

Four Hundred Examples of American Plastics. Washington, D.C.: Smithsonian Institution Traveling Exhibition Service, 1956.

Fraser, Kennedy. *The Fashionable Mind: Reflections on Fashion, 1970–1981.* New York: Alfred A. Knopf, 1981.

Freud, Sigmund. *Civilization and Its Discontents.* Edited and translated by James Strachey. New York: W. W. Norton, 1961.

Friedman, Mildred, et al. *Graphic Design in America: A Visual Language History.* Minneapolis: Walker Art Center; New York: Harry N. Abrams, 1989.

Friedman, William. *Twentieth-Century Design: USA.* Buffalo: Buffalo Fine Arts Academy, 1959.

Galbraith, John Kenneth. *The Affluent Society.* Boston: Houghton Mifflin, 1958.

Gibson, Ann, and Stephen Polcari, eds. "New Myths for Old: Redefining Abstract Expressionism." *Art Journal* 47 (Fall 1988). Complete issue.

Giedion, S. *Mechanization Takes Command: A Contribution to Anonymous History.* New York: Oxford University Press, 1948.

Girard, Alexander, ed. *An Exhibition for Modern Living.* Detroit: The Detroit Institute of Arts, 1949.

Goulden, Joseph C. *The Best Years: 1945–1950.* New York: Atheneum, 1976.

Greenberg, Cara. *Mid-Century Modern: Furniture of the 1950s.* New York: Harmony Books, 1984.

Hanks, David. *Innovative Furniture in America from 1800 to the Present.* New York: Horizon Press, 1981.

Harris, Neil. *Cultural Excursions: Marketing Appetites and Cultural Tastes in Modern America.* Chicago: University of Chicago Press, 1990.

Hayden, Dolores. *Redesigning the American Dream: The Future of Housing, Work, and Family Life.* New York: W. W. Norton, 1984.

Heisinger, Kathryn B., and George H. Marcus. *Design Since 1945.* Philadelphia: Philadelphia Museum of Art, 1983.

———. *Landmarks of Twentieth-Century Design: An Illustrated Handbook.* New York: Abbeville, 1993.

Hennessey, William John. *Modern Furnishings for the Home.* New York: Reinhold, 1952.

Hitchcock, Henry Russell, and Arthur Drexler, eds. *Built in the U.S.A.: Post-War Architecture.* New York: The Museum of Modern Art, 1952.

Hobbs, Robert Carleton, and Gail Levin. *Abstract Expressionism: The Formative Years.* Ithaca, N.Y.: Herbert F. Johnson Museum of Art, Cornell University, 1978.

Horn, Richard. *Fifties Style: Then and Now.* New York: Beech Tree Books, 1985.

Hornung, Clarence Pearson. *Treasury of American Design.* New York: Harry N. Abrams, 1972.

Industrial Design in America. New York: Farrar, Strauss & Young in association with the Society of Industrial Designers, 1954.

Isaacson, Mark. *Structure and Ornament: American Modernist Jewelry, 1940–1960.* New York: Fifty/50, 1984.

Jackson, Lesley. *The New Look: Design in the Fifties.* London: Thames & Hudson, 1991.

Johns, Barbara, ed. *Jet Dreams: Art of the Fifties in the Northwest.* Seattle and London: Tacoma Art Museum in association with the University of Washington Press, 1995.

Kelly, Barbara M. *Expanding the American Dream: Building and Rebuilding Levittown.* Albany: State University of New York Press, 1993.

Kepes, Gyorgy, ed. *The Man-Made Object.* New York: George Braziller, 1966.

Kline, Katy. *The Aesthetics of Progress: Forms of the Future in American Design, 1930s/1980s.* Cambridge, Mass.: List Center for the Visual Arts, Massachusetts Institute of Technology, 1984.

Koppe, Shelly. "Idiom of the Fifties: What Really Happened in Los Angeles." *Architecture California* 8, no. 6 (November/December 1986), pp. 15–25.

Kuh, Katharine, and Frederick Sweet. *Abstract and Surrealist American Art.* Chicago: The Art Institute of Chicago, 1947.

Larrabee, Eric. *Knoll Design.* New York: Harry N. Abrams, 1981.

Lewin, Susan Grant, ed. *Formica and Design: From the Counter Top to High Art.* New York: Rizzoli, 1991.

Lifshey, Earl. *The Housewares Story: A History of the American Housewares Industry.* Chicago: National Housewares Manufacturers Association, 1973.

Lippincott, J. Gordon. *Design for Business.* Chicago: Paul Theobald, 1947.

Littleton, Harvey K. *Glassblowing: A Search for Form.* New York: Van Nostrand Reinhold, 1972.

Loewy, Raymond. *Never Leave Well Enough Alone.* New York: Simon & Schuster, 1941.

——. *Industrial Design.* Woodstock, N.Y.: Overlook, 1979.

Lucie-Smith, Edward. *A History of Industrial Design.* New York: Van Nostrand Reinhold, 1983.

Lupton, Ellen. *Mechanical Brides: Women and Machines from Home to Office.* New York: Cooper-Hewitt, National Design Museum, and Princeton Architectural Press, 1993.

Lupton, Ellen, and J. Abbott Miller. *The Bathroom, the Kitchen, and the Aesthetics of Waste: A Process of Elimination.* Cambridge, Mass.: M.I.T. Press, 1992.

Lurie, Alison. *The Language of Clothes.* New York: Random House, 1981.

Marling, Karal Ann. *As Seen on TV: The Visual Culture of Everyday Life in the 1950s.* Cambridge, Mass., and London: Harvard University Press, 1994.

McCoy, Esther. *Case Study Houses, 1945–62.* Los Angeles: Hennessey & Ingalls, 1977.

McLuhan, Marshall. *The Mechanical Bride: Folklore of Industrial Man.* New York: Vanguard Press, 1951.

Meikle, Jeffrey. *Twentieth Century Limited.* Philadelphia: Temple University Press, 1979.

Milbank, Caroline Rennolds. *Couture: The Great Designers.* New York: Stewart, Tabori & Chang, 1985.

Miller, Craig. *Modern Design, 1890–1990.* New York: Harry N. Abrams, 1990.

Modern Jewelry Design. New York: The Museum of Modern Art, 1946.

Modern Jewelry from the Helen Drutt Collection. Montreal: Musée des Arts Décoratifs de Montréal, 1985.

Moore, Charles, Peter Becker, and Regula Campbell. *The City Observed: Los Angeles.* New York: Random House, 1984.

Mumford, Lewis. *From the Ground Up: Observations on Contemporary Architecture, Housing, Highway Building, and Civic Design.* New York: Harcourt Brace, 1956.

Nader, Ralph. *Unsafe at Any Speed.* New York: Grossman, 1965.

"Nelson, Eames, Girard, Propst: The Design Process at Herman Miller." Special issue of *Design Quarterly* (Walker Art Center, Minneapolis), nos. 98/99 (1975).

Nelson, George, and Henry Wright. *Tomorrow's House: A Complete Guide for the Home Builder.* New York: Simon & Schuster, 1945.

Noyes, Eliot. *Organic Design in Home Furnishings.* New York: The Museum of Modern Art, 1941; rpt. New York: Arno Press, 1969.

Phillips, Lisa, et al. *High Styles: Twentieth-Century American Design.* New York: Whitney Museum of American Art, 1985.

Plastic as Plastic. New York: Museum of Contemporary Crafts, 1968.

Polcari, Stephen. *Abstract Expressionism and the Modern Experience.* Cambridge and New York: Cambridge University Press, 1991.

——. *From Omaha to Abstract Expressionism: American Artists' Responses to World War II.* Potsdam, N.Y.: Roland Gibson Gallery, Potsdam College of the State University of New York, 1992.

Proddow, Penny. *Hollywood Jewels: Movies, Jewelry, Stars.* New York: Harry N. Abrams, 1992.

Pulos, Arthur J. *The American Design Adventure, 1940–1975.* Cambridge, Mass., and London: M.I.T. Press, 1988.

Read, Herbert. *Art and Industry.* London: Faber & Faber, 1934.

——. *A Concise History of Modern Sculpture.* New York: Frederick A. Praeger, 1964.

Remington, Roger. *Nine Pioneers in American Graphic Design.* Cambridge, Mass.: M.I.T. Press, 1989.

Riley, Robert. *The Fashion Makers.* New York: Crown, 1968.

Robinson, Julian. *Fashion in the Forties.* New York: Harcourt Brace Jovanovich, 1976.

Rosenberg, Harold. *The Tradition of the New.* New York: Horizon Press, 1959.

Roylance, Dale. *Graphic Americana.* Princeton: Princeton University Press, 1992.

Rudofsky, Bernard. *Are Clothes Modern?* New York: Paul Theobald, 1947.

Sawin, Martica. *Surrealism in Exile and the Beginning of the New York School.* Cambridge, Mass.: M.I.T. Press, 1995.

Schimmel, Paul, et al. *The Interpretive Link: Abstract Surrealism into Abstract Expressionism; Works on Paper, 1938–1948.* Newport Beach, Calif.: Newport Harbor Art Museum, 1986.

Selz, Peter. *New Images of Man.* New York: The Museum of Modern Art, 1959.

Silk, Gerald I., et al. *Automobile and Culture.* New York: Harry N. Abrams, 1984.

Smith, Elizabeth A. T., et al. *Blueprints for Modern Living: History and Legacy of the Case Study Houses.* Cambridge, Mass., and London: M.I.T. Press, 1989.

Sokolov, Joel. *Textile Designs.* New York: Library of Applied Design, 1991.

Troy, Nancy N. *Mondrian and Neo-Plasticism in America.* New Haven: Yale University Art Gallery, 1979.

Tuckers, Jean. *Light Abstractions.* Saint Louis: University of Missouri, 1980.

Van Doren, Harold. *Industrial Design: A Practical Guide.* New York: McGraw-Hill, 1940.

Wallance, Don. *Shaping America's Products.* New York: Reinhold, 1956.

Warren, Lynne, et al. *Art in Chicago, 1945–1995.* Chicago: Museum of Contemporary Art, 1996.

Weart, Spencer R. *Nuclear Fear: A History of Images.* Cambridge, Mass.: Harvard University Press, 1988.

White, Lawrence. *The Automobile Industry Since 1945.* Cambridge, Mass.: Harvard University Press, 1971.

Wildenhain, Marguerite. *Pottery: Form and Expression.* New York: American Craftsmen's Council, 1959.

Wilson, Richard Guy, et al. *The Machine Age in America, 1918–1941.* Brooklyn, New York: The Brooklyn Museum; New York: Harry N. Abrams, 1986.

Wright, Frank Lloyd. *The Future of Architecture.* New York: Horizon Press, 1953.

Wright, Russel, and Mary Wright. *Guide to Easier Living.* New York: Simon & Schuster, 1950.

Index

Photograph Credits

Photographs of works of art reproduced in this book have for the most part been provided by the owners or custodians of the works identified in the captions. The following list refers to photographs for which an additional acknowledgment is due. Every effort has been made to locate, and obtain permission from, rights owners. Please contact the Brooklyn Museum of Art concerning any possible oversights. Unless otherwise specified, figure numbers follow credits.

© Berenice Abbott/Commerce Graphics Ltd., Inc. 64

Jack Abraham 220

© 2001 The Josef and Anni Albers Foundation/Artists Rights Society (ARS), New York page 6

Courtesy of the American Red Cross Museum. All Rights Reserved in All Countries. 19

AP/Wide World Photos 25, 26, 38, 41

© 2000 The Art Institute of Chicago. All Rights Reserved. 67, 102

Oliver Baker © 2001 Estate of Louise Nevelson/Artists Rights Society (ARS), New York 85

Courtesy James F. Bishop 206

© 2000 Boeing Management Company 15

© 2001 Estate of Alexander Calder/Artists Rights Society (ARS), New York 46, 186, 188

Charles Campbell Gallery, San Francisco 69

© Capp Enterprises, Inc. 2000. All Rights Reserved. 51

Franklin Carisse 113

CBS Photo Archive 27, 28, 49

© Christie's Images 34

© Bettmann/CORBIS 18, 32, 146, 191

Courtesy of Cranbrook Archives 123

Frank Cronican 142

Laurence Cuneo, Jr. page 7

© Denver Art Museum 2001 and Courtesy Harper's Bazaar 179

© 1996 Detroit Institute of Arts and © 2001 The Saul Steinberg Foundation/Artists Rights Society (ARS), New York page 3

© Disney Enterprises, Inc. 9

Craig Dugan © Hedrich Blessing 116

© 2001 Lucia Eames/Eames Office (www.eamesoffice.com) 153, 154, 157, 158, 211, 213

© ESTO 90, 91, 98, 99, 100, 101, 112, 114, 162, 216, cover

European and Pacific Stars and Stripes, a Department of Defense publication 16

Fairchild Aerial Surveys, Inc. 119

Sam Falk/NYT Pictures 92

Ferlise, Levittown, New York 106, 144

© 1978 GM Corp. Used with permission of GM Media Archives 48, 173, 174

© The Solomon R. Guggenheim Foundation, New York 93

© The Solomon R. Guggenheim Foundation, New York and © 2001 Estate of Alexander Calder/Artists Rights Society (ARS), New York 193

Hatch-Billops Collection, New York 190

Courtesy Harper's Bazaar 202

© President and Fellows, Harvard College, Harvard University Art Museums 86

Hedrich Blessing 110

Hedrich Blessing © The Isamu Noguchi Foundation, Inc. 116

R. H. Hensleigh 171

Gene Herrick/AP/Wide World Photos 40

Eva Heyd 4

Bernard Hoffman/TimePix 21

John Huggins, Thin Angel Arts 5

© Hulton Getty/Liaison Agency 175

James Isberner © Museum of Contemporary Art, Chicago 83

Patrick Jablonski/Morley Baer Archives, Seaside, California 108

Bill Jacobson 79, cover

M. Kapanen © Alvar Aalto Foundation 132

John Fitzgerald Kennedy Library, Boston, Massachusetts 13

John B. Kenny 126

Estate of André Kertész © 2001/1945 and © The Isamu Noguchi Foundation, Inc. page 2

© Frederick Kiesler Estate 167

Knoll, Inc. 160, 161, 199

Bob Kolbrener © 2001 Estate of Alexander Calder/Artists Rights Society (ARS), New York 56

© Balthazar Korab 97

Schecter Lee 127, 187

Keith Major/Lost City Arts 159

Courtesy Mathew Marks Gallery, New York 88

© Mattel, Inc. 198

Jason McCoy Inc., New York 103

© McDonald's Corporation page 10

© 1985, 1995 The Metropolitan Museum of Art 73, 74, 204

Herman Miller, Inc. 155, 163

Jack Lenor Larsen Collection, Northwest Architectural Archives, University of Minnesota Libraries 169

© 2000 The Museum of Modern Art, New York 151, 210

© 2000 The Museum of Modern Art, New York and © 2001 Pollock-Krasner Foundation/Artists Rights Society (ARS), New York 80

© 2001 The Museum of Modern Art, New York page 8

The Museum of Modern Art, New York/Film Stills Archives 22

The Museum of Modern Art, New York/Film Stills Archives © Argos Films 50

The Museum of Modern Art, New York/Film Stills Archives © 2001 DeMart Pro Arte BV 222

The Museum of Modern Art, New York/Film Stills Archives © RKO Pictures, Inc. All Rights Reserved. 145

National Archives 200, 203

© Board of Trustees, National Gallery of Art, Washington, D.C. 62

© Kevin Noble 58, 165

© The Isamu Noguchi Foundation, Inc. 117, 164

Lotte Nossaman, Courtesy of Couturier Gallery, Los Angeles 121

© Designor Oy/Iittala Glass 134

© Peter C. Papademetriou 96

Ken Pelka 212

Angelo Pinto © Ocotober 1947. Hearst Communications, Inc. All Rights Reserved. Reprinted/Shown by permission from House Beautiful 208

© 2001 Pollock-Krasner Foundation/Artists Rights Society (ARS), New York 87

© Elvis Presley Enterprises, Inc. 217, 218

© 1982 The Trustees of Princeton University. All Rights Reserved. 66

Courtesy of Marion Rand 177, 178

© 2001 Norman Rockwell Family Trust 17, 20

Franklin D. Roosevelt Library, Hyde Park, New York 11, 14

William Short © The Solomon R. Guggenheim Foundation, New York 47, 95

© Julius Shulman page 11

SITES, Washington, D.C. 129

Slinky® and Spring Image are registered trademarks of James Industries, Inc. Courtesy of Poof Products, Inc., Plymouth, Michigan 223, 224, and cover

Steve Sloman © 2001 The Georgia O'Keeffe Foundation/Artists Rights Society (ARS), New York 68

Peter Stackpole/TimePix 33

© 2001 The Saul Steinberg Foundation/Artists Rights Society (ARS), New York page 3

Studebaker National Museum 176

Courtesy of the Records of SANE, Swarthmore College Peace Collection 39

Page 2: **Isamu Noguchi**'s (American, 1904–1988) studio at 33 MacDougal Alley, New York, c. 1945. Photograph by **André Kertész** (American, b. Hungary, 1894–1985)

Page 3: **Saul Steinberg** (American, b. Romania, 1914–1999). *Untitled*, 1949. Pen and black ink over pencil on white wove paper, 23⅛ x 14⁹⁄₁₆ inches. The Detroit Institute of Arts; Gift of the J. L. Hudson Gallery, 49.565.

Page 4: **Herbert Matter** (American, b. Switzerland, 1907–1984). Page from Knoll Associates Inc. Trade Catalogue, 1947–48. 8¾ x 11¾ inches. Brooklyn Museum of Art, New York; Art Reference Library

Page 5: **Charles Howard** (American, 1899–1978). *The Ascending Aperture*, 1949. Oil on canvas board, 12 x 16 inches. Courtesy of Galen Howard Hilgard

Page 6: **Josef Albers** (American, b. Germany, 1888–1976). *Leaf Study*, 1942. Leaves on rice paper, 11 x 16½ inches. The Josef and Anni Albers Foundation, Bethany, Connecticut, JAF:97

Page 7: **Ruth Asawa** (American, b. 1926). *Untitled Wire Sculpture*, 1959. Monel, tubular knit, 84 inches high x 24 inches diameter. Collection of the artist

Page 8: **Herbert Ferber** (American, 1906–1991). *He Is Not a Man*, 1950. Bronze with welded metal rods (unique cast, from original in lead), 67¼ x 19½ x 13⅜ inches, set in concrete base 18 x 22 x 12 inches. The Museum of Modern Art, New York; Gift of William S. Rubin, 680.71

Page 9: **Gerome Kamrowski** (American, b. 1914). *The Competitive Lover*, 1945. Oil on canvas, 71¾ x 48 inches. The Minneapolis Institute of Arts; The John R. Van Derlip Fund, 88.65.1

Page 10: The first McDonald's Hamburger Restaurant, Des Plaines, Illinois, 1955

Page 11: **Paul R. Williams** (American, 1894–1980) and **A. Quincy Jones** (American, 1913–1979). Palm Springs Tennis Club, California, 1947. Interior view. Photograph by **Julius Shulman** (American, b. 1910)

Page 12: **Herbert Matter** (American, b. Switzerland, 1907–1984). Cover for *Arts and Architecture* magazine, December 1946. 12 x 9 inches. Brooklyn Museum of Art, New York; Art Reference Library